Astronomy | 365 Days

JERRY T. BONNELL | ROBERT J. NEMIROFF

Abrams | New York

Have you ever wanted to explore the cosmos?

Sunsets on Mars, interstellar clouds adrift in the Milky Way, and galaxies flung across the distant universe are all at your fingertips in the pages of this book—*Astronomy: 365 Days*.

It provides a wide-ranging selection of 365 daily entries from the Astronomy Picture of the Day (APOD) website (http://apod.gsfc.nasa.gov) for the years 2002 to 2006, with contributions from major Earth- and space-based observatories and professional and amateur cosmic tourists alike. In fact, *Astronomy: 365 Days* continues where *The Universe: 365 Days* (Harry N. Abrams, Inc., 2003) left off, as a compilation of the best APOD images and descriptions from the website's earlier years.

The APOD website was born on June 16, 1995, at NASA's Goddard Space Flight Center. On that fateful day, with the World Wide Web still in its infancy, the authors were having lunch together when the idea first emerged. While APOD now appears on the Internet translated into most major languages daily, the authors' understanding of the World Wide Web has evolved only a little. But the material presented on the website—and here—has evolved a lot.

In recent years, human exploration of our solar system has produced some amazing discoveries and new perspectives close to home. As a result, these pages feature images that include highlights of NASA and European Space Agency missions to Mars orbit and the Martian surface (notably in search of water and evidence for an independent origin of life on the solar system's second-most-habitable planet), the orbiting Cassini spacecraft's views of Saturn's rings and moons, the descent of the Huygens probe to Saturn's moon Titan, the robotic exploration of comets, and—in late January 2006—the New Horizons mission launched to explore the Pluto system and the distant icy worlds of the Kuiper belt.

Meanwhile, large ground-based observatories have continued to grow and improve their capabilities. The Hubble Space Telescope has produced sharper, deeper views of the distant cosmos. Spitzer, Chandra, and other space-based observatories have extended the exploration of the universe far beyond the spectrum of visible light.

But in a sense, amateur astronomy seems to have enjoyed the greatest awakening in recent years. Imaging with relatively small telescopes has entered a golden age, ushered in by now-available digital cameras and computer technologies. And so the stunning works of a cadre of talented and skilled astro-imagers are also found within these pages.

The information provided in the text is as accurate as up-to-date scientific knowledge permits. But a word of warning to more ambitious readers: distances and many other details cited herein probably should not be used for navigational purposes!

Part of the impact of this compilation, we hope, will be found in the broad context and many connections that bringing together such a wide variety of work engenders. As always, most hopefully, the material in this book will entertain, educate, and expand the appreciation of humanity's efforts to explore the universe.

It still does it for us.

JERRY T. BONNELL, Universities Space Research Association

ROBERT J. NEMIROFF, Michigan Technological University

Since the publication of our first book, *The Universe: 365 Days*, the universe has remained pretty much the same. Our understanding of it, however, has evolved even in these short years. Below are the latest numbers that define our universe.

The Universe in Numbers

Universe	Number (UNCERTAINTY ESTIMATE)	How This Is Known
AGE	13.7 billion years (0.2 billion light-years)	Appearance of early universe gravity imprints on the cosmic microwave background radiation, the distribution of galaxies, and the ages of the oldest objects.
SIZE	13.7 billion light-years (0.2 billion light-years)	[Age] times [speed of light]. This size is only for the "visible universe," the part we can see. Other parts of the universe are mostly conjecture.
TEMPERATURE	2.728 Kelvins (0.004 Kelvins)	Measuring the temperature to which cosmic background light would heat a perfectly absorbing object. This is very cold—most large objects in our universe generate more heat and so are hotter. The universe was much hotter in the past and continues to cool.
EXPANSION RATE	72 kilometers per second per megaparsec (5 km/sec/mpc)	Measuring how fast galaxies move away. One megaparsec, or 1 million parsecs, is roughly the distance to the next major galaxy. One megaparsec is about 3 million light-years.

Universe	Number (UNCERTAINTY ESTIMATE)	How This Is Known
COMPOSITION	70% dark energy (3%) 25.6% dark matter (1%) 4.4% normal matter (0.2%)	Measuring the brightness and distance to supernova explosions, and measuring how gravity has perturbed the matter that emitted the cosmic microwave background light.
DARK ENERGY COMPOSITION	?	The nature of dark energy is currently unknown. Its existence is no longer controversial, however.
DARK MATTER COMPOSITION	?	The nature of dark matter is currently unknown, but its properties continue to become more constrained by observational astronomy. The existence of dark matter is no longer controversial, however.
NORMAL MATTER COMPOSITION	73.4% hydrogen (3%) 24.9% helium (3%) 1.7% heavy elements (0.3%)	Observations of the Sun, the stars, and the gas between the stars. Computation of element production in the early universe. Includes all other elements such as oxygen and carbon.

V838 Mon: Echoes from the Edge

Variable star V838 Monocerotis lies near the edge of our Milky Way Galaxy, about 20,000 light-years from the Sun. Despite its remote location, this enigmatic star has taken the center of an astronomical stage ever since a sudden outburst was detected there in January 2002. Researchers are trying to understand where it fits into the picture of stellar evolution. As light from the stellar flash echoes across pre-existing dust shells around the star, its appearance changes dramatically. This portion of a dust shell, revealed in a sharp snapshot recorded in February 2004 by the Hubble's Advanced Camera for Surveys, is about 6 light-years in diameter. Because light reflected from the dust follows only a slightly indirect path compared to the direct line of sight to the star, the visible light echoes lag only about two years behind the outburst itself. Astronomers expect the expanding echoes to continue to light up the dusty environs of V838 Mon at least through 2010.

Credit: NASA & the Hubble Heritage Team (AURA/STScI)

January 1

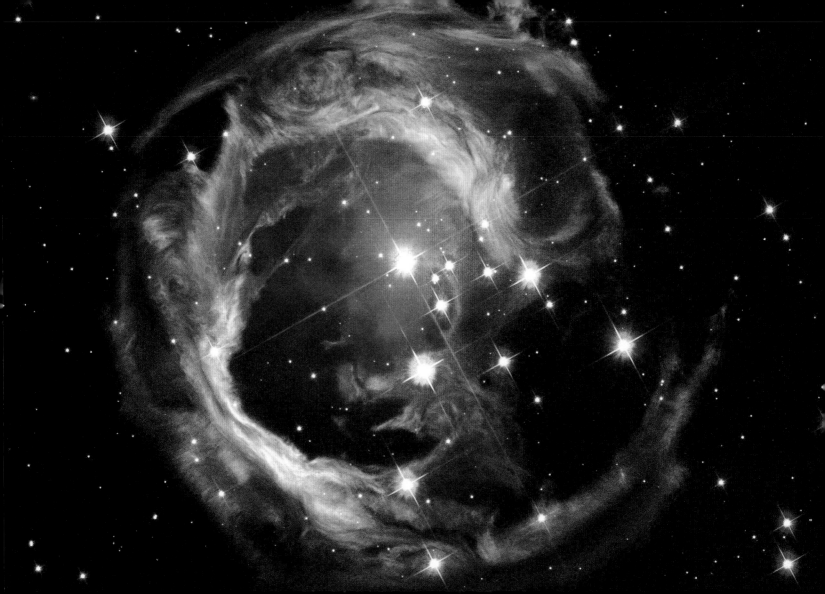

Sol 5 Postcard from Mars

A Martian sol—the average Martian solar day—is about thirty-nine minutes longer than Earth's familiar twenty-four hours. Operating on Martian time, the Spirit rover recently sent back this color postcard image, recorded on Sol 5, of its stay on the Martian surface. The view looks north across the floor of Gusev Crater, with the smooth-looking, 9-meter-wide circular feature dubbed Sleepy Hollow at the left side of the scene. Within it are round, dark marks that the lander, swaddled in airbags, left as it bounced across the Martian surface. Other examples of disturbances, likely made by the lander's retracting airbags, can be seen in the foreground just beyond Spirit's deck, covered in solar cells.

Credit: Mars Exploration Rover Mission, JPL, NASA

January 2

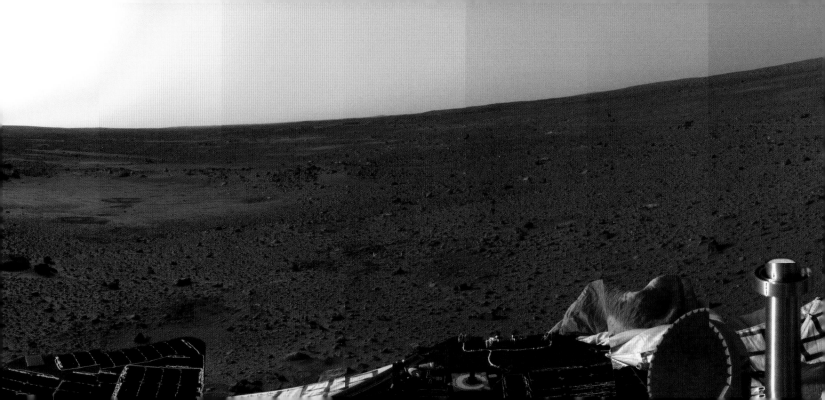

Dust Sculptures in the Rosette Nebula

What creates the cosmic dust sculptures in the Rosette Nebula? Also known as NGC 2244, the nebula is noted for the beauty of its overall shape, but parts of it are lovely even when viewed up close. Visible in this picture are globules of dark dust and gas that are slowly being eroded away by the energetic light and winds from nearby massive stars. Left alone long enough, the molecular-cloud globules would likely form stars and planets. This image was taken in very specific colors emitted by sulfur (shaded red), hydrogen (green), and oxygen (blue). The Rosette Nebula spans about 50 light-years, lies about 4,500 light-years away, and can be seen with a small telescope in the direction of the constellation Monoceros.

Credit & copyright: Ken Crawford (Rancho Del Sol Observatory)

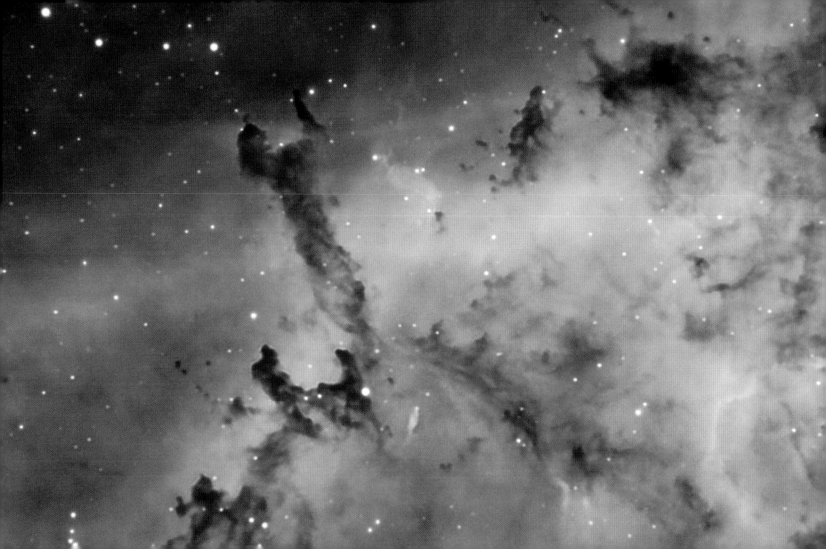

The Longest Eclipse

The first eclipse of the third millennium occurred on January 9, 2001, as the Full Moon passed through the long but not-so-dark shadow of planet Earth. The total lunar eclipse was mainly visible from Europe, Asia, and Africa—but why was the shadow not darker? Sunlight is actually scattered and refracted into Earth's shadow by the atmosphere, a circumstance that can result in some striking photographs. For example, this image is a composite of photographs taken during the total lunar eclipse in July 2000. Early and late phases of the eclipse flank a deep exposure made during totality. The feeble sunlight still shining on the lunar surface gives the Moon a dramatic dark red cast. Although the July 2000 eclipse was not the first or last of any millennium, it was remarkable for being the longest eclipse for about the next thousand years, with totality lasting an impressive 1 hour and 47 minutes. Totality for the January 2001 eclipse lasted just over one hour.

Credit & copyright: Fred Espenak (courtesy of www.MrEclipse.com)

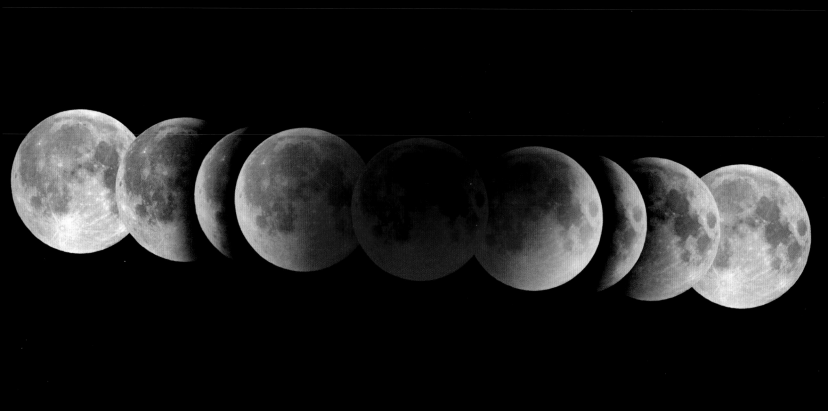

Awkward and angular looking, Apollo 17's lunar module, Challenger, was designed for flight in the vacuum of space. This sharp picture from the command module, America, shows Challenger's ascent stage in lunar orbit. Small reaction-control thrusters are at the sides of the moonship, with the bell of the ascent rocket engine underneath. The hatch allowing access to the lunar surface is visible in the front, and a round radar antenna appears at the top. This spaceship performed gracefully, landing on the Moon and then returning the Apollo astronauts to the orbiting command module in December 1972—but where is Challenger now? Its descent stage remains at the Apollo 17 landing site, Taurus-Littrow. The ascent stage was intentionally crashed nearby after being jettisoned from the command module prior to the astronauts' return to planet Earth. Apollo 17's mission was the sixth and last time astronauts landed on the Moon. Eric Jones, editor of the *Apollo Lunar Surface Journal,* reckons that the bright arc in the dark triangular window at the right of the image is mission commander Gene Cernan's helmet reflecting the sunlight.

Credit: Apollo 17, NASA (image scanned by Kipp Teague)

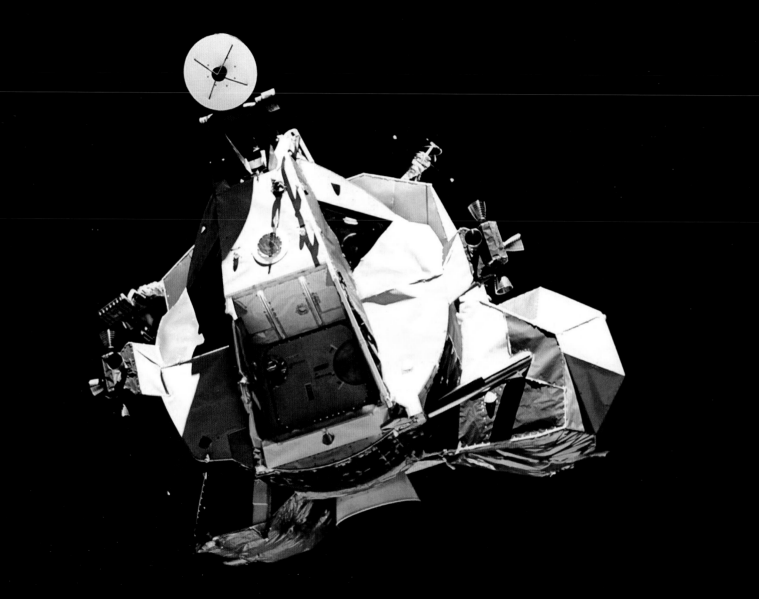

S Is for Venus

Planet Venus traced out this S shape in Earth's sky during 2004. Following the second planet from the Sun in a series of twenty-nine images recorded from April 3 through August 7 (top right to bottom left) of that year, astronomer Tunç Tezel constructed this composite illustrating the wandering planet's path against the background stars. The series reveals the apparent retrograde motion of Venus, transporting it from a brilliant evening star to morning's celestial beacon. In 2004, after sinking into the evening twilight but before rising above the predawn horizon, the planet was seen in silhouette against the Sun (near center)—the first Transit of Venus since 1882. The next time Venus will wander across the solar disk is in 2012.

Credit & copyright: Tunç Tezel

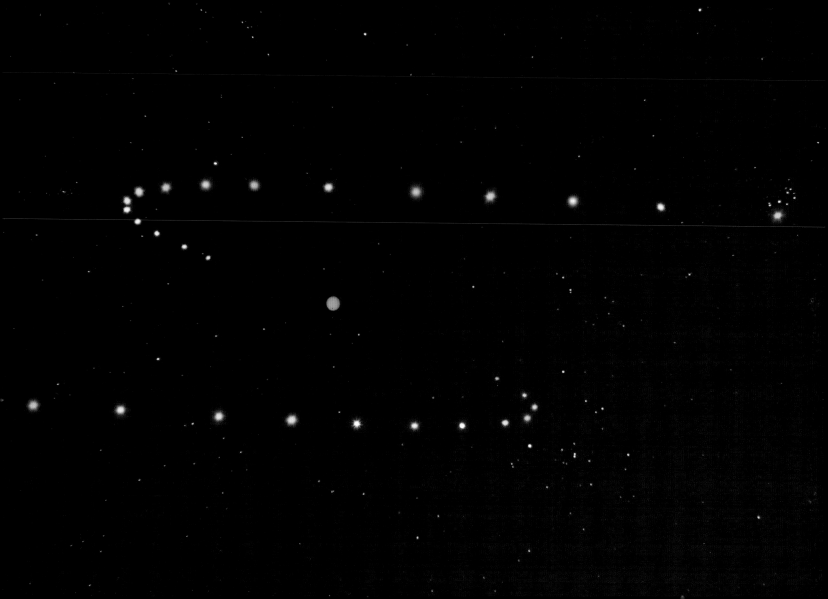

Stars, Pillars, and the Eagle's EGGs

The Hubble Space Telescope's 1995 image of pillars of dust and gas, light-years long, within the Eagle Nebula (M16) was sensational. The three prominent pillars in that close-up visible-light picture also appear below center in this wide-field mosaic, along with massive, bright young stars of cluster NGC 6611 (upper right), whose winds and radiation are shaping the dusty pillars. Made in near-infrared light with the European Southern Observatory's 8.2-meter ANTU telescope, this image makes the pillars seem more transparent, as longer wavelengths partially penetrate the obscuring dust. While the Hubble image showed the pillars' startling surface details—over 70 opaque, finger-shaped lumps of material dubbed evaporating gaseous globules, or EGGs—the near-infrared view has allowed astronomers to peer inside. Comparing the two views reveals that nearly a dozen of the EGGs do indeed have stars embedded close to their tips. More stars within EGGs may be detected if longer-wavelength observations of the region are made. But which came first, the stars or the EGGs?

Credit: Mark McCaughrean & Morten Andersen (AIP), ESO

January 7

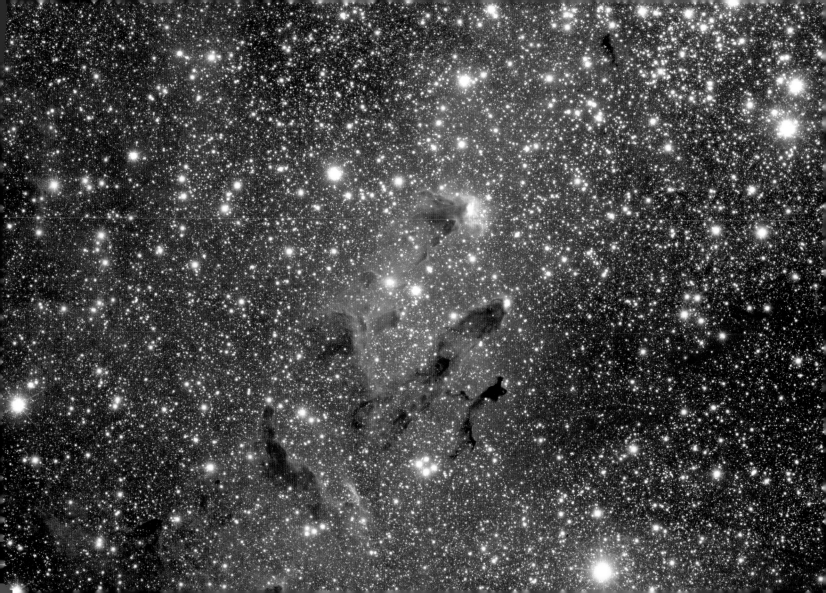

Seyfert's Sextet

Known as Seyfert's Sextet, this intriguing group of galaxies is in the head portion of the split constellation Serpens. However, the "sextet" actually contains only four interacting galaxies. Below the center of this Hubble Space Telescope picture, the small face-on spiral galaxy lies in the distant background and appears aligned with the main group only by chance. In addition, the prominent condensation at the lower right is likely not a separate galaxy at all, but a tidal tail of stars flung out by the galaxies' gravitational interactions. About 190 million light-years away, the interacting galaxies are tightly packed into a region about 100,000 light-years across, comparable to the size of our own Milky Way Galaxy—making this one of the densest known galaxy groups. Bound by gravity, the close-knit group may coalesce into a single large galaxy over the next few billion years.

Credit: J. English (University of Manitoba), C. Palma (PSU), et al., NASA

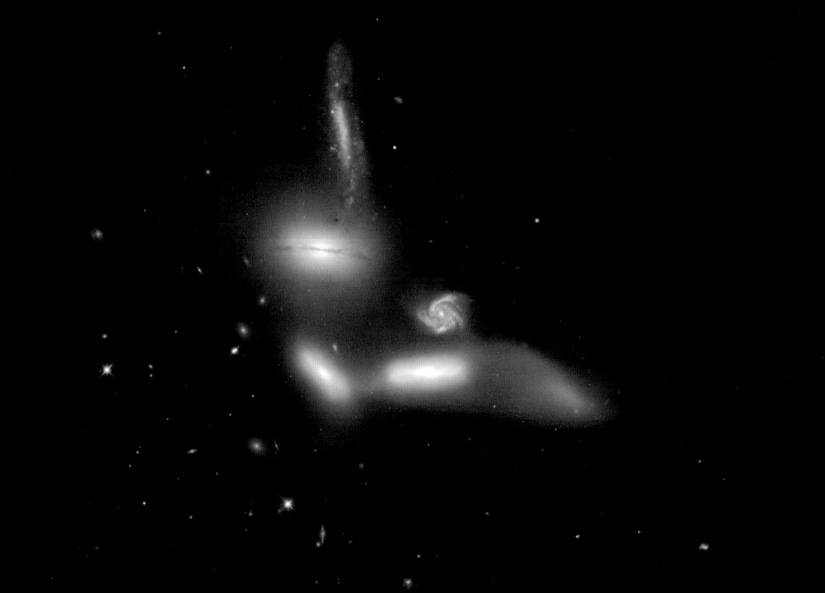

Local Group Galaxy NGC 6822

Nearby galaxy NGC 6822 is unusual in several ways. The galaxy's distribution of stars merits a formal classification of dwarf irregular, and from our vantage point the small galaxy appears nearly rectangular. What strikes astronomers as even more peculiar, however, is NGC 6822's unusually high abundance of HII regions, locales of ionized hydrogen that surround young stars. Large HII regions, also known as emission nebulae, are visible surrounding the galaxy, particularly above and to the right in this image. Below and to the left are bright stars that are loosely grouped into an arm. NGC 6822, also known as Barnard's Galaxy, is located only about 1.5 million light-years away and so is a member of our Local Group of galaxies. The galaxy, home to famous nebulae including Hubble V, is visible with a small telescope toward the constellation Sagittarius.

Credit & copyright: Local Group Galaxies Survey Team, NOAO, AURA, NSF

January 9

UKIRT:
Aloha Orion

Filaments of gas, cosmic dust, and a multitude of young stars beckon in this penetrating image of the Orion Nebula, at the edge of a dense molecular cloud. Alluring structures in the well-known star-forming region are revealed here as viewed in infrared light by a Hawaiian eye—WFCAM, a powerful wide-field camera commissioned at the United Kingdom Infrared Telescope (UKIRT) on Mauna Kea. Representing only a fraction of WFCAM's full field, this picture covers about 11 light-years at the 1,500-light-year distance of the nebula. Otherwise-invisible infrared light has been mapped into visible colors, with red representing narrow-band infrared emission from hydrogen molecules at a wavelength of 2.12 microns; green, emission at 2.2 microns; and blue, emission at 1.25 microns. Visible light has a wavelength of about 0.5 microns (micrometers).

Credit: Joint Astronomy Centre; image processing by C. Davis, W. Varricatt

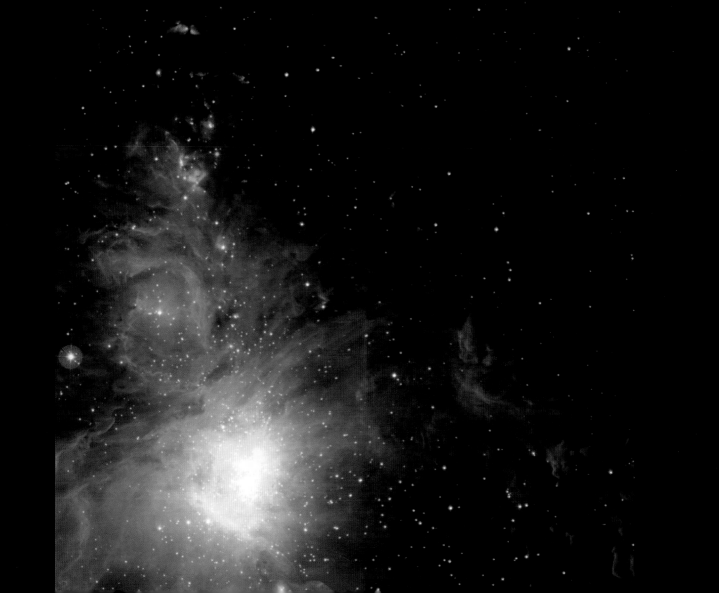

M42:
Wisps of the
Orion Nebula

The Great Nebula in Orion, the closest large star-forming region, is probably the most famous of all astronomical nebulae. Here, glowing gas surrounds hot young stars at the edge of an immense interstellar molecular cloud only 1,500 light-years away. Faint wisps and sheets of dust and gas are particularly evident in this deep image. In the sky, the Great Nebula can be found with the unaided eye just below and to the left of the easily identifiable belt of three stars in the familiar constellation Orion. In addition to housing a bright open cluster of stars known as the Trapezium, the Orion Nebula contains many stellar nurseries. These nurseries contain hydrogen gas, hot young stars, proplyds (protoplanetary disks), and stellar jets spewing material at high speeds. Also known as M42, the Orion Nebula spans about 40 light-years and is located in the same spiral arm of our galaxy as the Sun.

Credit & copyright: John P. Gleason (Celestial Images)

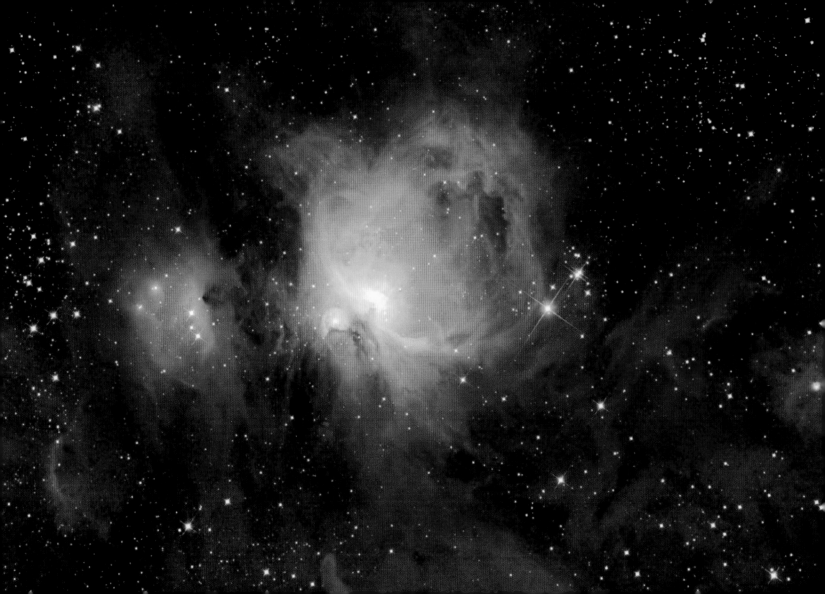

Barred Spiral Galaxy NGC 1300

Big, beautiful, barred spiral galaxy NGC 1300 lies some 70 million light-years away on the banks of the constellation Eridanus. This Hubble Space Telescope composite view of the gorgeous island universe is one of the largest Hubble images ever made of a complete galaxy. NGC 1300 spans over 100,000 light-years, and the Hubble image reveals striking details of the galaxy's dominant central bar and majestic spiral arms. On close inspection, the nucleus of this classic barred spiral shows a remarkable region of spiral structure about 3,000 light-years across. Unlike other spiral galaxies, NGC 1300 is not presently known to have a massive central black hole.

Credit: Hubble Heritage Team, ESA, NASA

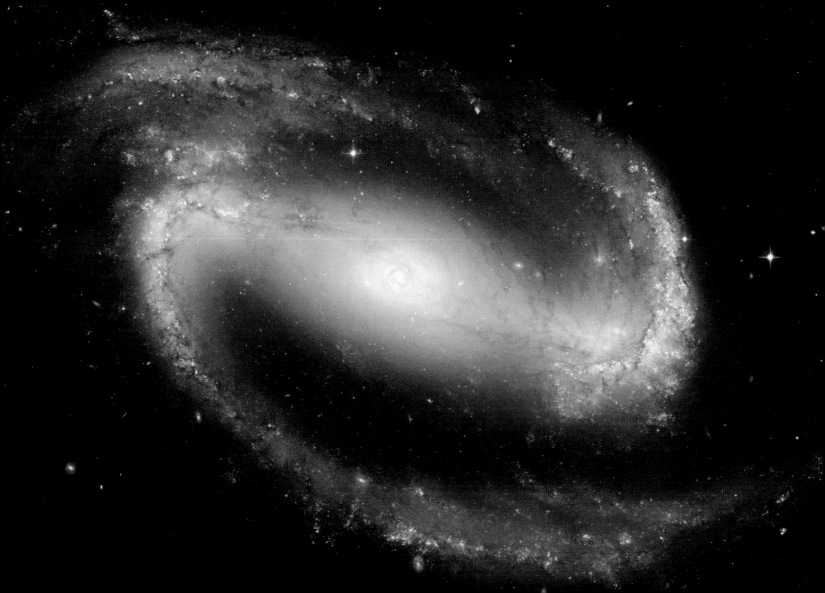

An Orion Deep Field

Adrift 1,500 light-years away in one of the night sky's most recognizable constellations, the glowing Orion Nebula and the dark Horsehead Nebula are contrasting cosmic vistas. They are both visible in this dazzling composite digital image assembled from over twenty hours of data, including exposures filtered to record emission from hydrogen atoms. The view reveals extensive nebulosities associated with the giant Orion Molecular Cloud complex, itself hundreds of light-years across. The magnificent emission region, the Orion Nebula (aka M42), lies at the upper right of the picture. Immediately to its left is a cluster of prominent bluish reflection nebulae, sometimes called the Running Man. The Horsehead Nebula appears as a dark cloud, a small silhouette notched against the long red glow at the lower left. Alnitak, the easternmost star in Orion's belt, is seen as the brightest star to the left of the Horsehead. Below Alnitak is the Flame Nebula, with clouds of bright emission and dramatic dark dust lanes. Fainter tendrils of glowing hydrogen gas are easily traced throughout the region in this Orion deep field.

Credit & copyright: Robert Gendler

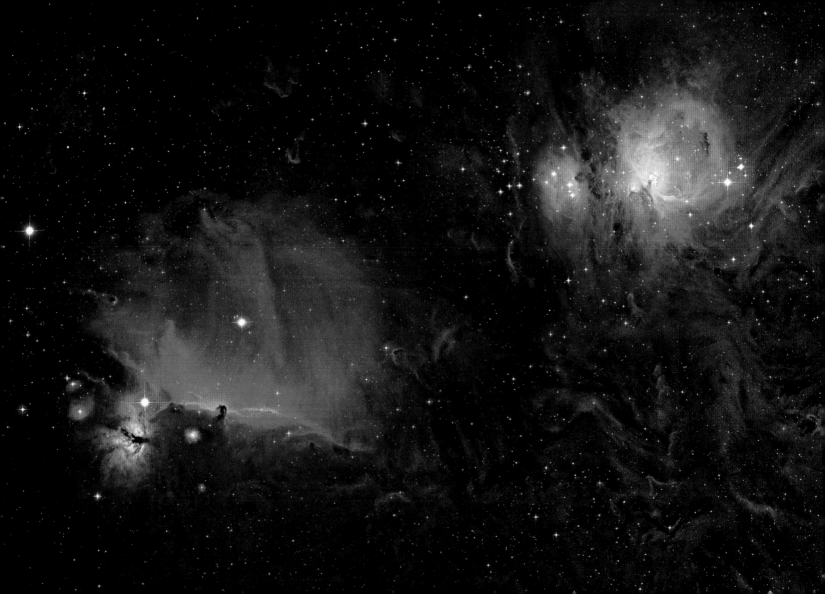

Going Wild

Dynamic jets of gas and dust surround one of the most active planetary surfaces in the solar system in this wild-looking picture of a comet nucleus. The comet's designation is 81P/Wild 2, of course (sounds like "vilt 2"), and the picture is a composite of two images recorded by the Stardust spacecraft's navigation camera during its flyby on January 2, 2004. The composited images consist of a short exposure, recording startling surface details of Wild 2's nucleus, and a longer exposure taken ten seconds later, revealing material streaming from the surface. The left edge of the nucleus appears extremely jagged due to a strong shadow. Pitted and eroded after billions of years of outgassing and meteorite impacts, the nucleus is only about 5 kilometers in diameter, while the jets of dust and gas ultimately leave trails millions of kilometers long.

Credit: Stardust Team, JPL, NASA

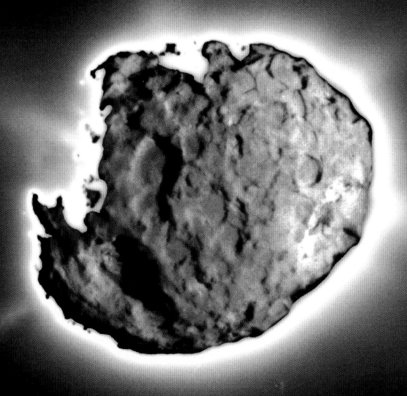

Stardust Capsule Returns to Earth

After being tracked by radar and chased by helicopters and airplanes, NASA's Stardust sample return capsule successfully landed at the U.S. Air Force Utah Test and Training Range at 3:10 A.M. Mountain time on January 15, 2006. The capsule contained cometary and interstellar samples gathered by the Stardust spacecraft from Comet 81P/Wild 2 during a rendezvous with the ancient comet just over two years earlier. The bits of Wild 2 stored in the return capsule are likely older than the Sun. The capsule was placed in a temporary clean room in Utah before part of it was shipped to NASA's Johnson Space Center in Houston for intensive study over the next few years for clues about the early years of our solar system. Surprisingly, results so far suggest that the comet is a mixture of materials formed at both low and high temperatures—from regions both close to and far from the early Sun.

Credit: NASA

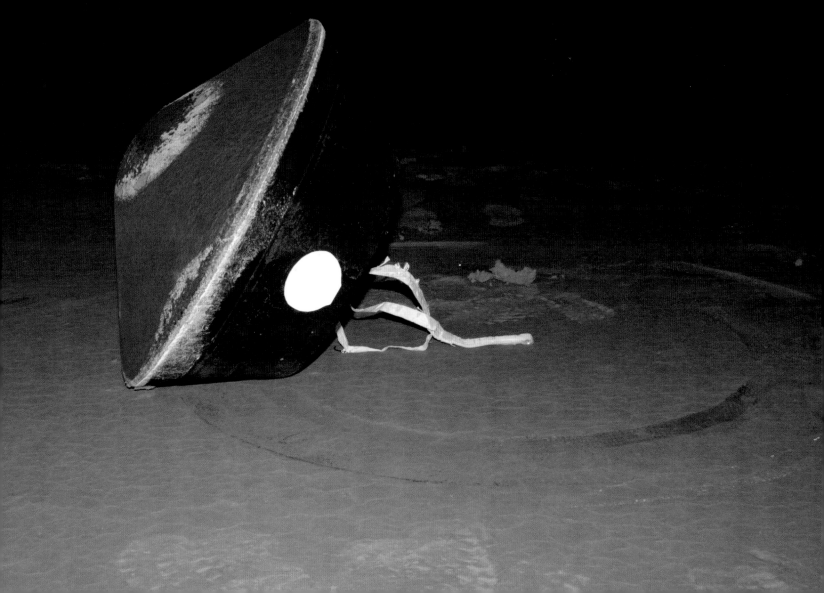

NGC 6946: The Fireworks Galaxy

Why is this galaxy so active? Nearby spiral galaxy NGC 6946 is undergoing a tremendous burst of star formation, with no obvious cause. In many cases, spirals light up when interacting with another galaxy, but NGC 6946 appears relatively isolated in space. Located just 10 million light-years away in the direction of the constellation Cepheus, this beautiful face-on spiral spans about 20,000 light-years and is visible through a field of foreground stars from our Milky Way Galaxy. The center of NGC 6946 is home to a nuclear starburst, and picturesque dark dust is seen lacing the disk, along with bright blue stars, red emission nebulae, fast-moving gas clouds, and frequent supernovae. A suggested explanation for the high rate of star formation is the recent accretion of many primordial low-mass neutral hydrogen clouds from the surrounding region. The 8-meter Gemini North Telescope in Hawaii took this image.

Credit & copyright: T. A. Rector (University of Alaska, Anchorage), Gemini Observatory, AURA

January 16

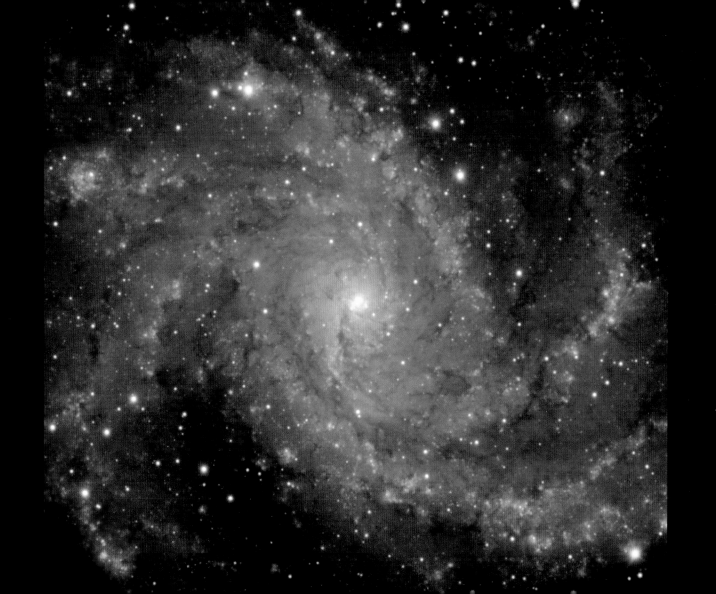

Machholz Meets the Pleiades

Sweeping northward in planet Earth's sky, Comet Machholz extended its long ion tail—with the Pleiades star cluster in the background—on January 7, 2005. This stunning view, recorded with a telephoto lens in skies over Oberjoch, Bavaria, Germany, emphasizes the faint, complex tail structures and the scene's lovely blue and green colors. Merging with the blue dust-reflected starlight of the Pleiades, colors are produced in the comet's ion tail and coma as gas molecules fluoresce in sunlight. Dust from the comet, visible in reflected sunlight, trails along its orbit and forms the whitish tail jutting down and toward the right. While the visible coma spans about 500,000 kilometers, the nucleus of the comet, likely only a few kilometers across, lies hidden within. Comet tails can extend many millions of kilometers from the nucleus, but they appear substantially foreshortened because of the tricks of perspective.

Credit & copyright: Stefan Seip

January 17

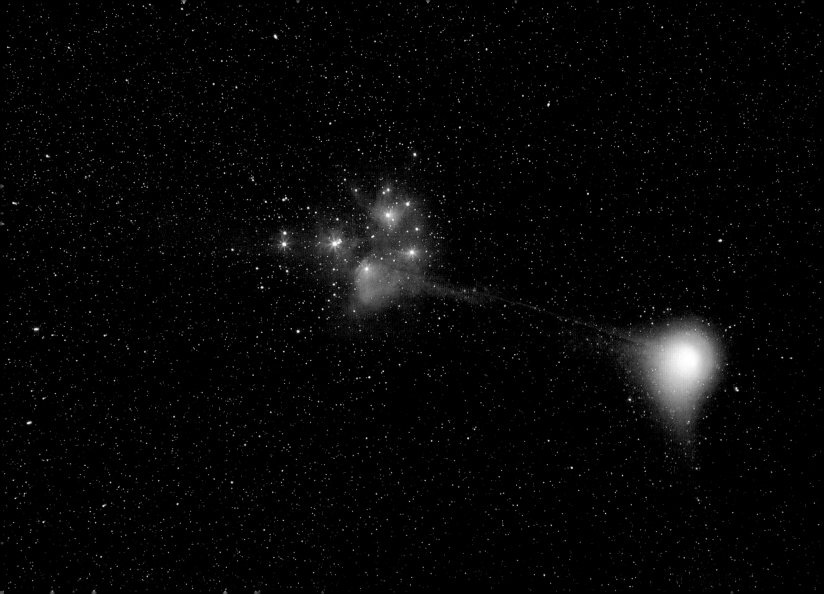

W̲hat do you get when you combine one of the world's most powerful telescopes with an extremely strong laser? The answer is an artificial star. Monitoring fluctuations in brightness of a genuine bright star can indicate how Earth's atmosphere is changing, but often no bright star exists in the direction where atmospheric information is needed. So astronomers have developed the ability to create an artificial star where they need it—with a laser. Subsequent observations of the artificial laser star can reveal information so detailed about the blurring effects of Earth's atmosphere that much of this blurring can be removed by rapidly flexing the telescope's mirror. Such adaptive optic techniques permit high-resolution, ground-based observations of real stars, planets, nebulae, and the early universe. Here, a laser beam shoots out of the 10-meter Keck II telescope on Mauna Kea, Hawaii, creating an artificial star in 2002.

Credit & copyright: Adam R. Contos, 2002

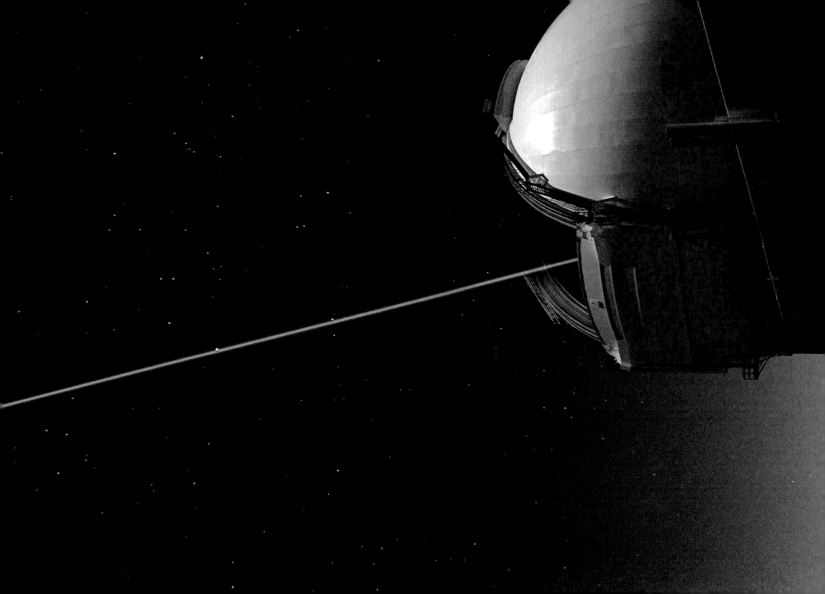

Off to Pluto

A top a powerful Atlas V rocket, the New Horizons spacecraft roared off its launchpad at Cape Canaveral in Florida on January 19, 2006, toward adventures in the distant outer solar system. Destination: Pluto and beyond. The craft is one of the fastest spaceships ever launched by humans, passing the Moon only nine hours after launch; it is scheduled to buzz Jupiter in early 2007. Even traveling over 75,000 kilometers per hour, the New Horizons craft will not arrive at Pluto until 2015. Pluto is the only remaining planet that has never been visited by a spacecraft or photographed up close. After that encounter, the robot spaceship will visit one or more objects in the Kuiper belt, orbiting the Sun even farther out than Pluto.

Credit & copyright: Ben Cooper (www.LaunchPhotography.com)

January 19

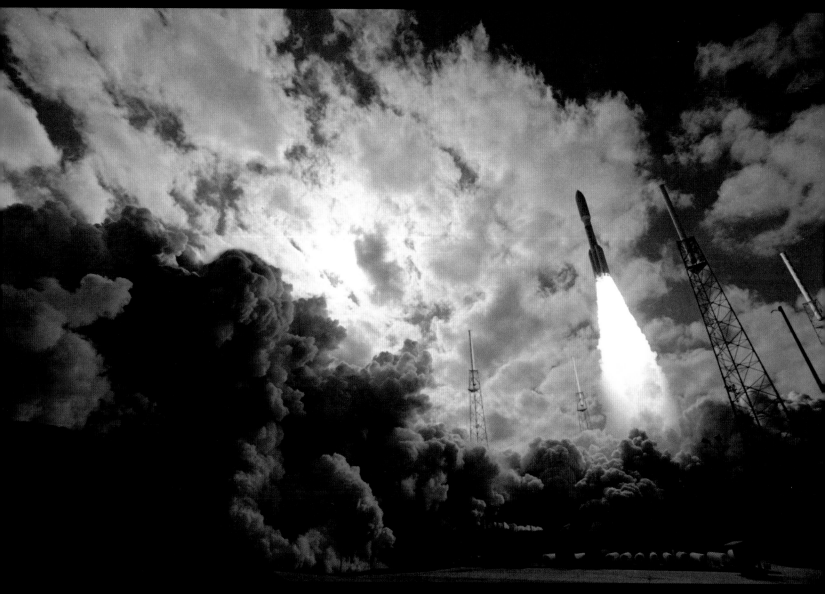

X-Ray Milky Way

If you had x-ray vision, the central regions of our galaxy would not be hidden from view by immense cosmic dust clouds opaque to visible light. Instead, the Milky Way toward the constellation Sagittarius might look something like this vivid mosaic of images from the orbiting Chandra X-ray Observatory. Pleasing to look at, this gorgeous false-color representation of the x-ray data shows high-energy x-rays in blue, medium energies in green, and low energies in red. Hundreds of white dwarf stars, neutron stars, and black holes immersed in a fog of multimillion-degree gas are included in the x-ray vista. Within the white patch at the center of the image lies the galaxy's central supermassive black hole. Chandra's sharp x-ray vision will likely lead to a new appreciation of our Milky Way's most active neighborhood; it has already indicated that the hot gas itself may have a temperature of a mere 10 million degrees C, instead of 100 million degrees as previously thought. The full mosaic is composed of thirty separate images and covers a swath 900 by 400 light-years at the galactic center.

Credit: D. Wang (University of Massachusetts) et al., CXC, NASA

January 20

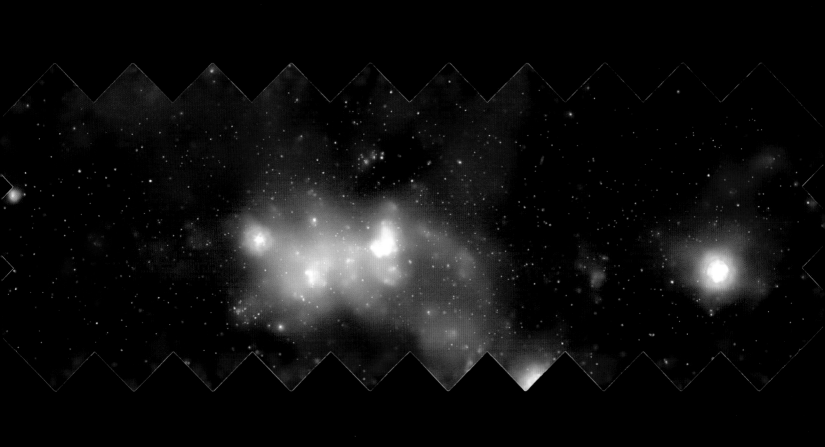

Titan Landscape

This color view gazes across a suddenly familiar but distant landscape on Saturn's largest moon, Titan. The scene was recorded by the European Space Agency's Huygens probe after a two-and-a-half-hour descent through a thick atmosphere of nitrogen laced with methane. The saucer-shaped probe, touching down at 4.5 meters per second (16 kilometers per hour), is believed to have penetrated 15 centimeters or so into a surface with the consistency of wet sand or clay. Bathed in an eerie orange light at ground level, rocks strewn about the scene could well be composed of water and hydrocarbons frozen solid at an inhospitable temperature of −179 degrees C. The flat, light-toned rock below and left of center is only about 15 centimeters across and lies 85 centimeters away. Huygens's batteries are now exhausted, but the probe transmitted data for more than ninety minutes after landing. Titan's bizarre chemical environment may bear similarities to that on planet Earth before life evolved.

Credit: ESA, NASA, Descent Imager/Spectral Radiometer Team (LPL)

January 21

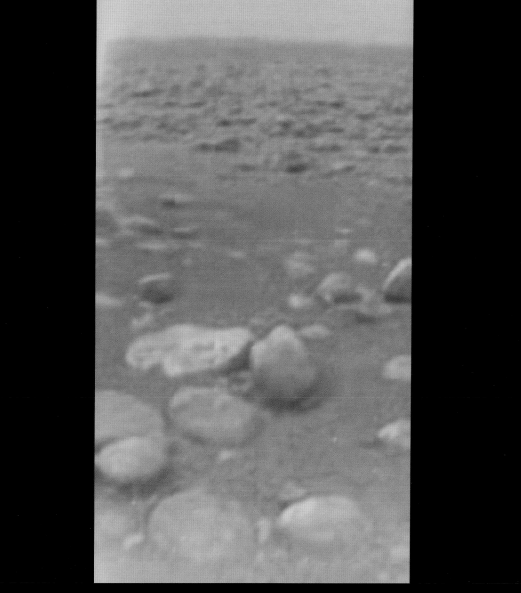

Columbia Memorial Station

The Spirit rover captured this spectacular view over the Columbia Memorial Station and the floor of Gusev Crater on the 16th sol (Martian day) of its visit to Mars. That corresponds to January 18–19, 2004, on planet Earth. The sharp picture looks toward the northeast. The lander platform, over 2 meters wide and surrounded by deflated airbags, and the egress ramp, used by the rover to complete its journey to the Martian surface, are in the foreground. In the background lie Spirit's likely future waypoints and destinations— initially toward a ridge at the left bordering a 200-meter-wide impact crater about 250 meters away, and finally toward the hills visible on the horizon at the right, which are about 3 kilometers distant. Searching for evidence of ancient watery environments, Spirit's scientific instruments have returned data on the composition of the surface in the lander's vicinity, suggesting the presence of iron-bearing volcanic minerals.

Credit: Mars Exploration Rover Mission, JPL, NASA

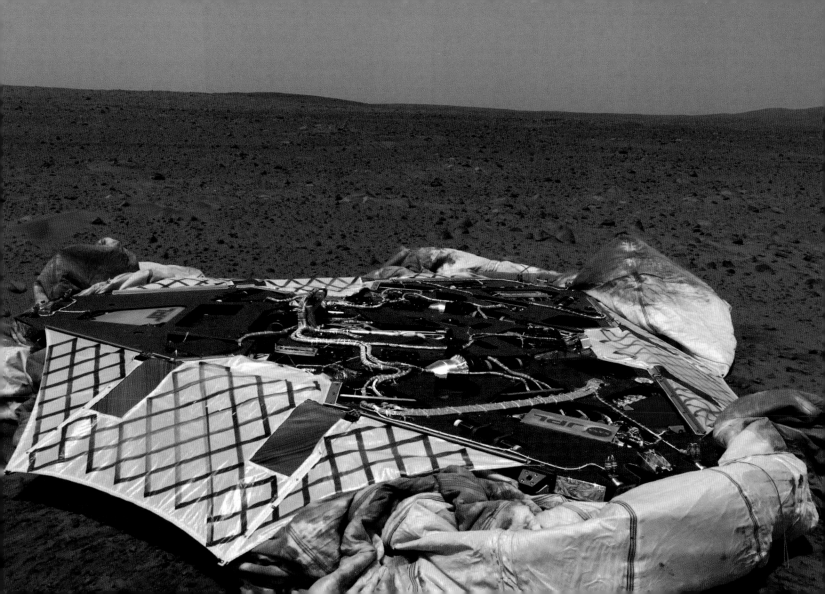

**A Landing
at Meridiani
Planum**

After an interplanetary journey of nearly 300 million miles, Opportunity bounced down on the Martian surface at about 9:05 P.M. Pacific time on January 24, 2004, its final plunge cushioned by airbags. Now the second NASA rover on Mars, Opportunity landed at Meridiani Planum, on the opposite side of the Red Planet from its twin rover, Spirit. Described as unlike any ground ever seen on Mars, the dark, undulating terrain at Meridiani Planum (aka Terra Meridiani) is pictured here in the stunning first color view from Opportunity (top is at left). This area is thought to be rich in gray hematite, an iron-bearing mineral that can form in watery environments. Part of the rover's deck is in the foreground, while circular impressions and drag marks made by the airbags are visible just beyond it.

Credit: Mars Exploration Rover Mission, JPL, NASA

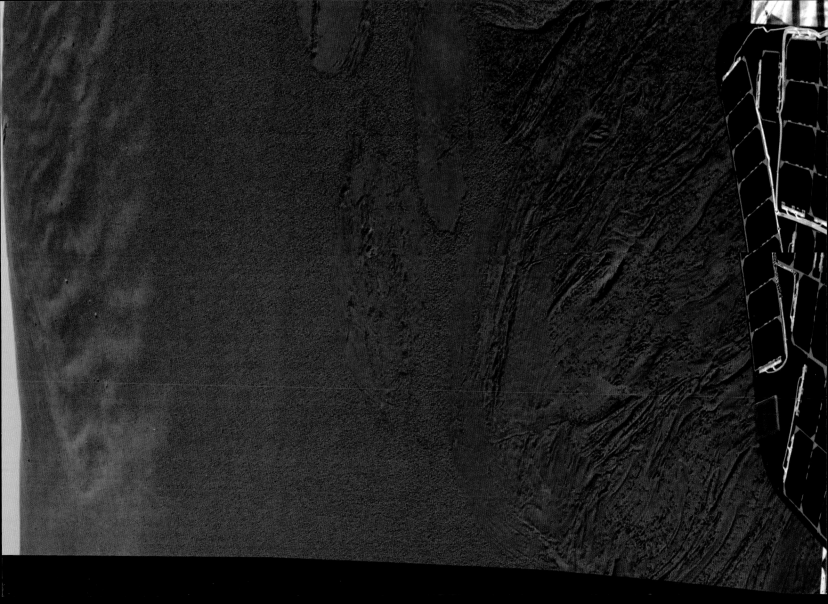

Supernova Remnant N63A

Shells and arcs abound in this false-color, multiwavelength view of supernova remnant N63A, the debris of a massive stellar explosion. The x-ray emission (blue) is from gas heated to 10 million degrees C as knots of fast-moving material from the cosmic blast sweep up surrounding interstellar matter. Radio (red) and optical (green) emissions are brighter near the central regions, where the x-rays seem to be absorbed by denser, cooler material on the side of the expanding debris cloud facing Earth. Located in the neighboring galaxy known as the Large Magellanic Cloud, this supernova remnant is apparently between 2,000 and 5,000 years old, and its extended glow spans about 60 light-years. The intriguing image is a composite of x-ray data from the orbiting Chandra X-ray Observatory, optical data from the Hubble Space Telescope, and radio data from the Australia Telescope Compact Array.

Credit: X-ray: J. Warren (Rutgers University) et al., CXC, NASA; optical: You-Hua Chu (University of Illinois at Urbana-Champaign), STScI, NASA; radio: J. Dickel (University of Illinois) et al., ATCA

Infrared Trifid

The Trifid Nebula, aka M20, is easy to find with a small telescope; it is a well-known stop in the nebula-rich constellation Sagittarius. But where visible-light pictures show the nebula (at left) divided into three parts by dark, obscuring dust lanes, this penetrating infrared image—a spectacular false-color view courtesy of the Spitzer Space Telescope—reveals filaments of luminous gas and newborn stars. Astronomers have used the Spitzer infrared image data to count newborn and embryonic stars that otherwise can lie hidden in the natal dust and glowing clouds of this intriguing stellar nursery. The part of the Trifid visible here is about 30 light-years across and lies only an estimated 5,000 light-years away.

Credit: J. Rho (SSC/Caltech), JPL-Caltech, NASA

January 25

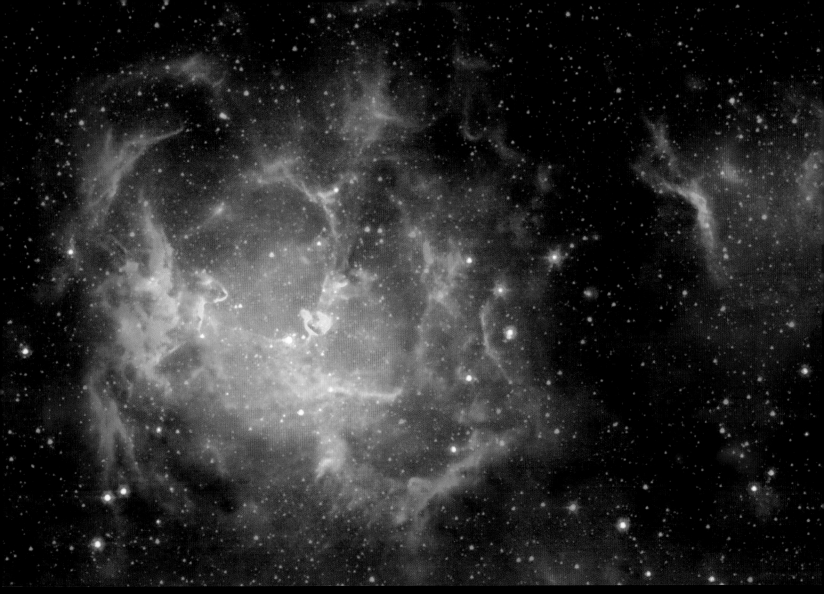

NGC 4631: The Whale Galaxy

NGC 4631 is a sizable spiral galaxy seen edge on only 25 million light-years away, in the direction of the small northern constellation Canes Venatici. This galaxy's slightly distorted wedge shape suggests to some a cosmic herring, but to others it brings to mind a whale—thus its popular moniker, the Whale Galaxy. Either way, it is similar in size to our own Milky Way. In this gorgeous color image, the Whale's dark interstellar dust clouds, young blue-star clusters, and purplish star-forming regions are easy to spot. A companion galaxy, the small elliptical NGC 4627, also appears here. Out of view, off the lower left corner of the picture, lies another distorted galaxy, the hockey stick–shaped NGC 4656. The distortions and mingling trails of gas and dust detected at other wavelengths suggest that the three galaxies had close encounters with one another in their past. X-rays reveal that the Whale Galaxy is also known to have spouted a halo of hot gas.

Credit: Diane Zeiders, Adam Block (KPNO Visitor Program), NOAO, AURA, NSF

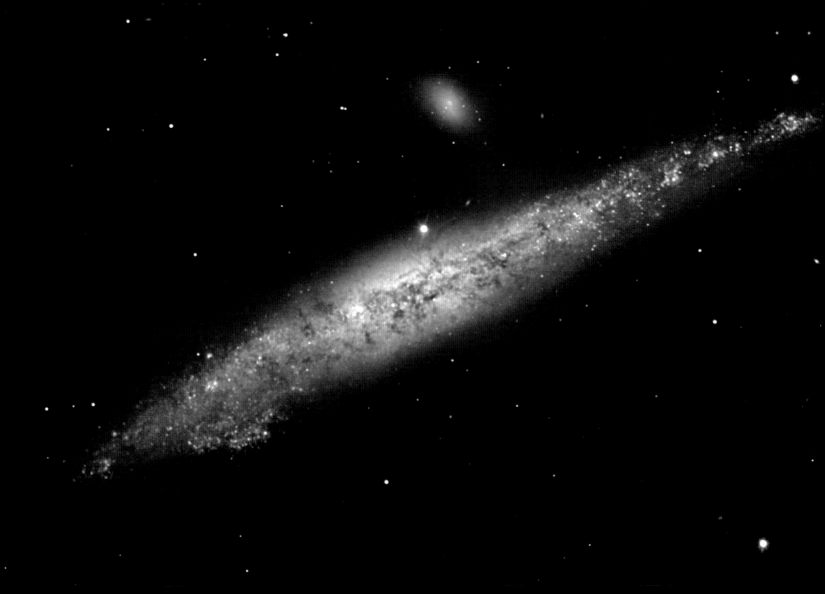

**BHR 71:
Stars, Clouds,
and Jets**

What is happening to molecular cloud BHR 71? Evidence suggests that it might be giving birth to a binary star system. Most stars in our galaxy are part of such systems, but few have ever been seen in formation. Isolated BHR 71 spans about 1 light-year and lies only about 600 light-years away in the southern sky. The brighter embedded star—not visible here—is about ten times as bright as the Sun and drives the jet that swept out the empty lane. This gorgeous color image was taken at the Paranal Observatory in Chile.

Credit & copyright: J. Alves (ESO), E. Tolstoy (Groningen), R. Fosbury (ST-ECF), R. Hook (ST-ECF), VLT

The Swarm

What do you call a group of black holes: a flock, a brace, a swarm? Monitoring a region around the center of our galaxy, astronomers have found evidence of a surprisingly large number of variable x-ray sources—likely black holes or neutron stars in binary star systems—swarming around the Milky Way's own central supermassive black hole. The orbiting Chandra X-ray Observatory combined x-ray image data from the astronomers' monitoring program to reveal four variable sources circled and labeled A–D. While four sources may not make a swarm, these all lie within only 3 light-years of that central black hole, Sagittarius A* (the bright source just above C). Their detection implies that a much larger concentration of black hole systems is present. Repeated gravitational interactions with other stars are thought to cause the black hole systems to spiral inward toward the region surrounding the galactic center.

Credit: M. P. Muno (UCLA) et al., CXC, NASA

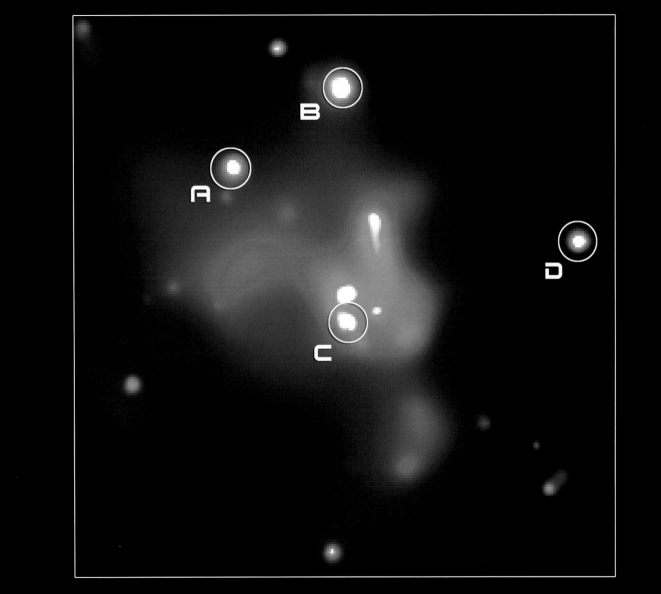

Valles Marineris Perspective from Mars Express

Part of an armada of spacecraft exploring the Red Planet, the European Space Agency's Mars Express satellite has returned detailed color images. In 2004, the orbiting satellite began to photograph the Martian surface at a resolution of 10 meters or higher, map the mineral composition to 100-meter resolution, and investigate the global circulation of the atmosphere. Pictured here is a 3-D perspective of the first image released from Mars Express—a stunning computer reconstruction of part of the Valles Marineris region, a canyon nicknamed the Grand Canyon of Mars. However, Valles Marineris is four times longer and five times deeper than its Arizona counterpart. The picture shows a portion of Valles Marineris roughly 65 kilometers across, detailing many ridges and valleys.

Credit: G. Neukum (FU Berlin) et al., Mars Express, DLR, ESA

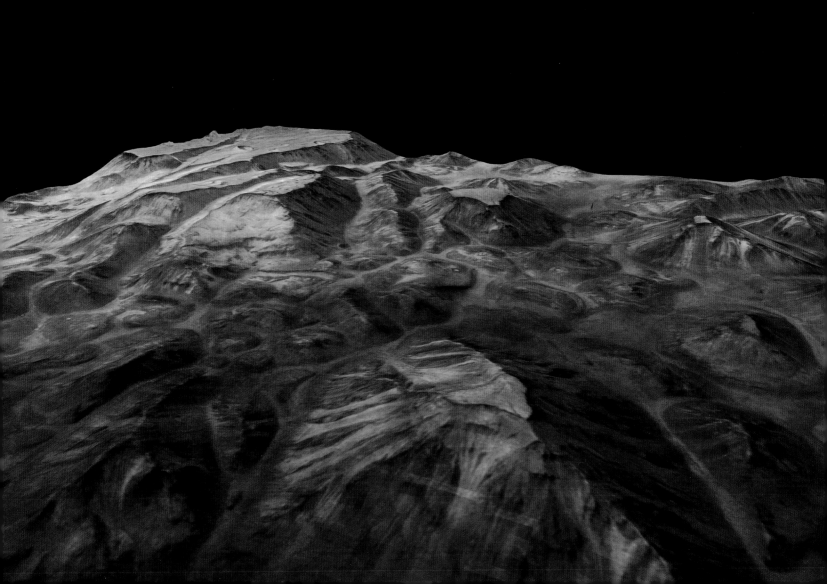

McNeil's Nebula

It was a clear, cold western Kentucky night on January 23, 2004, as seasoned amateur astronomer Jay McNeil tried out his recently acquired 3-inch refracting telescope by imaging the area around a familiar object, the M78 reflection nebula in Orion. Days later, while processing the images, he noted a substantial but totally unfamiliar nebulosity in the region. With a little help from his friends, his discovery was initially recognized as a newly visible reflection nebula surrounding a newborn star: McNeil's Nebula. It is at the center of this recent close-up view, with its illuminating young star at the tip. While the nebula is not seen in some survey images dating back to 1951, it is present in pictures of the field recorded in the mid-1960s. The intriguing reflection nebula and illuminating star are thus variable, rather than newly emerging; still, the appearance of McNeil's Nebula is a rare event to witness, and astronomers are eagerly following its development. The Orion Nebula complex itself is about 1,500 light-years away; at that distance, this image spans less than 10 light-years.

Credit: Adam Block (KPNO Visitor Program), NOAO, AURA, NSF

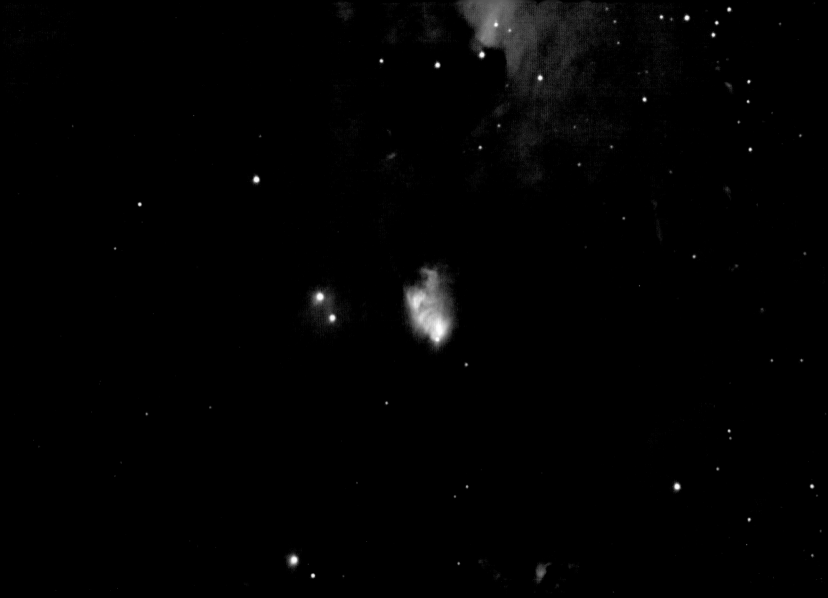

Shadow Set

A nearly Full Moon and planet Earth's shadow set were captured together in this scene on January 24, 2005, from snowy Mount Jelm, home of the Wyoming Infrared Observatory. For early morning risers (and late-to-bed astronomers), shadow set in the western sky is a daily apparition whose subtle beauty is often overlooked in favor of the more colorful eastern horizon. Extending through the dense atmosphere, Earth's setting shadow is seen here as a dark blue band along the distant horizon, bounded above by a pinkish glow, or antitwilight arch, that is also known as the Belt of Venus. The arch's lovely color is due to backscattering of reddened light from the rising Sun. The setting Moon's light is also reddened by the long sight line through the atmosphere and echoes the dawn sky's yellow-orange hues.

Credit: J. Bonnell, A. Kutyrev, J. Norris, R. Canterna, WIRO

January 31

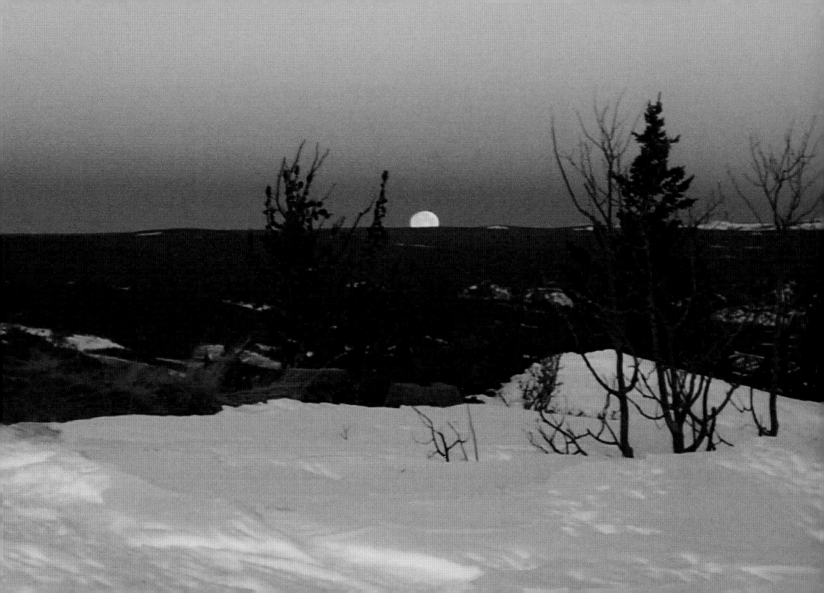

Melas, Candor, and Ophir

First imaged by the Mariner 9 spacecraft, Valles Marineris, the Grand Canyon of Mars, is a system of enormous chasmas, or depressions, that stretch some 4,000 kilometers along the Martian equator. Looking north over the canyon's central regions, dark Melas Chasma lies in the foreground of this spectacular perspective view. Behind it are Candor Chasma and the steep walls of Ophir Chasma near the horizon. Melas, Candor, and Ophir are about 200 kilometers wide and 5 to 7 kilometers deep. Faulting, surface collapse, and landslides are seen to be part of the complex geologic history of these dramatic features, with layered deposits also found within the canyon system. Recorded in 2004, the image represents data from the High Resolution Stereo Camera on board the European Space Agency's Mars Express spacecraft.

Credit: G. Neukum (FU Berlin) et al., Mars Express, DLR, ESA

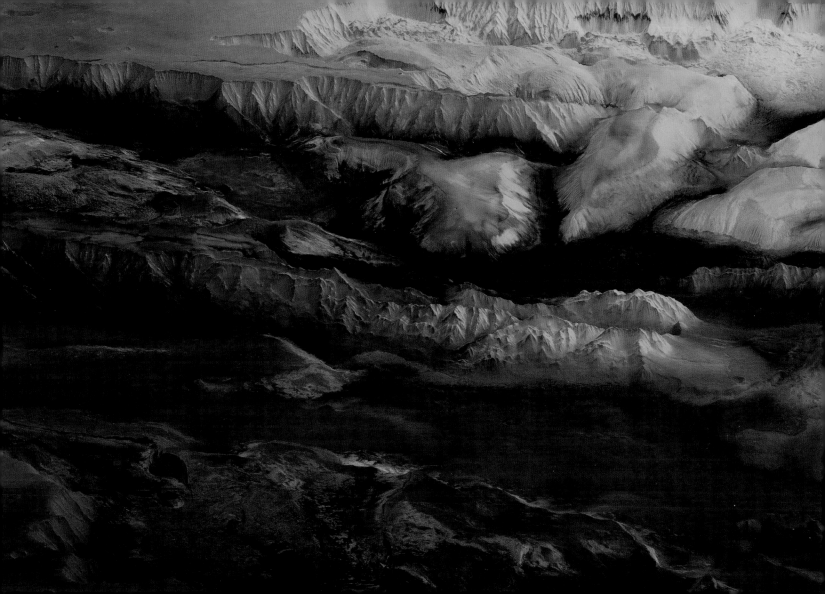

The Farthest Known Galaxy

Almost all of the bright objects in this Hubble Space Telescope image are galaxies in the cluster known as Abell 2218. The cluster is so massive and compact that it acts as a huge telescope, its gravity bending and focusing the light from galaxies that lie behind it. As a result, multiple images of these background galaxies are distorted into long, faint arcs—a simple lensing effect analogous to viewing distant streetlamps through a glass of wine. Abell 2218 is itself about 2 billion light-years away in the northern constellation Draco. This massive cluster telescope allowed astronomers to detect a galaxy at a redshift of about 7, the most distant galaxy or quasar yet measured. Images of this young, still-maturing galaxy are visible in the picture, notably as a faint red arc at the lower right. The recorded light left this galaxy when the universe was only about 5 percent of its current age.

Credit: ESA, NASA, J.-P. Kneib (Caltech/Observatoire Midi-Pyrenees) & R. Ellis (Caltech)

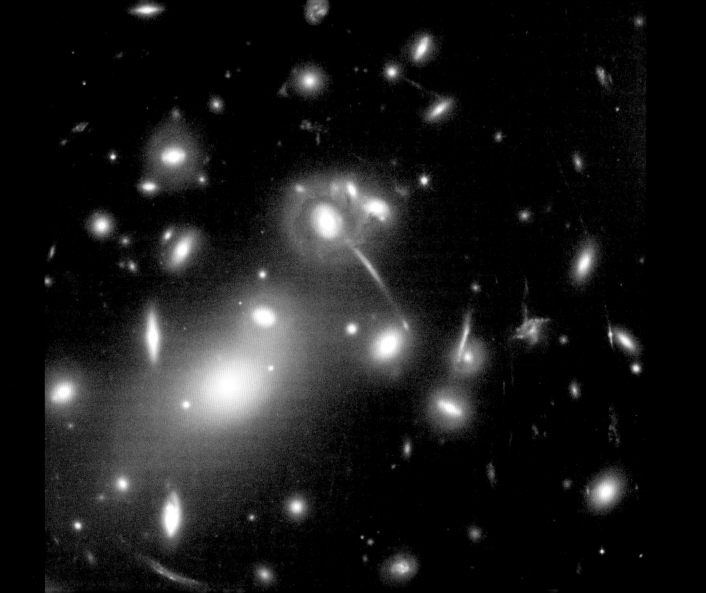

Saturn's Moon Rhea

Each moon of Saturn seems to come with its own mystery. Rhea, the planet's second-largest moon after Titan, shows unusual wisps, visible in this picture as light-colored streaks. Higher-resolution images of similar wisps on another of Saturn's moons, Dione, indicate that they might be made of long braided fractures. Rhea is composed mostly of water ice, but it likely has a small rocky core. The moon's rotation and orbit are locked together, just like Earth's Moon, so that one side always faces Saturn. A consequence of this is that one side always leads the other as the moon orbits Saturn. Rhea's leading surface is much more heavily cratered than the trailing surface, pictured here. The image, in natural color, was taken in January 2005 by the robot Cassini spacecraft, in orbit around Saturn.

Credit: Cassini Imaging Team, SSI, JPL, ESA, NASA

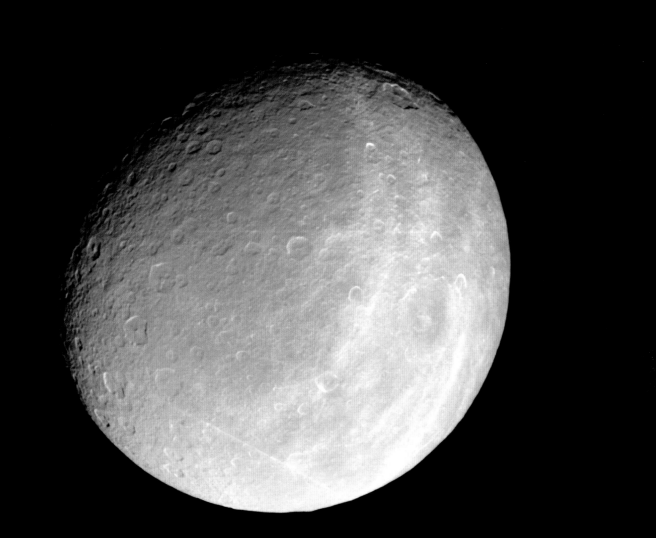

A Lunar Eclipse
over Time

During the total lunar eclipse in January 2000, our Moon seemed to disappear. As Earth moved between the Moon and the Sun, the planet's shadow fell on its satellite, making it quite dark. In this four-hour exposure, Earth's rotation causes the Moon and stars to appear as streaks. As Earth's shadow engulfed the Moon, the lunar streak became less and less bright, practically vanishing during totality. At this time, the Moon, which normally shines by reflecting direct sunlight, shone only by sunlight refracted through Earth's atmosphere. Later, clouds obscured the reappearing Moon. In the foreground of this image is the eleventh-century abbey of the Benedictine monastery of Sant Llorenc del Munt, in Gerona, Spain.

Credit & copyright: Juan Carlos Casado

White Boat on Mars

On Mars in February 2004, the robot Spirit rover stopped to examine a rock dubbed "White Boat," so named for its unusually light color and shape. The large rock near the center of this color composite image, White Boat was examined just after Spirit evaluated Adirondack, a football-sized rock determined to be composed of volcanic basalt. Soon after, Spirit ceased scientific operations for two weeks, due to a computer memory problem. Spirit recovered, and Opportunity, its twin rover on the other side of Mars, continued to roam the Red Planet in search of clues to the ancient past of Earth's most hospitable neighbor.

Credit: Mars Exploration Rover Mission, JPL, NASA

February 5

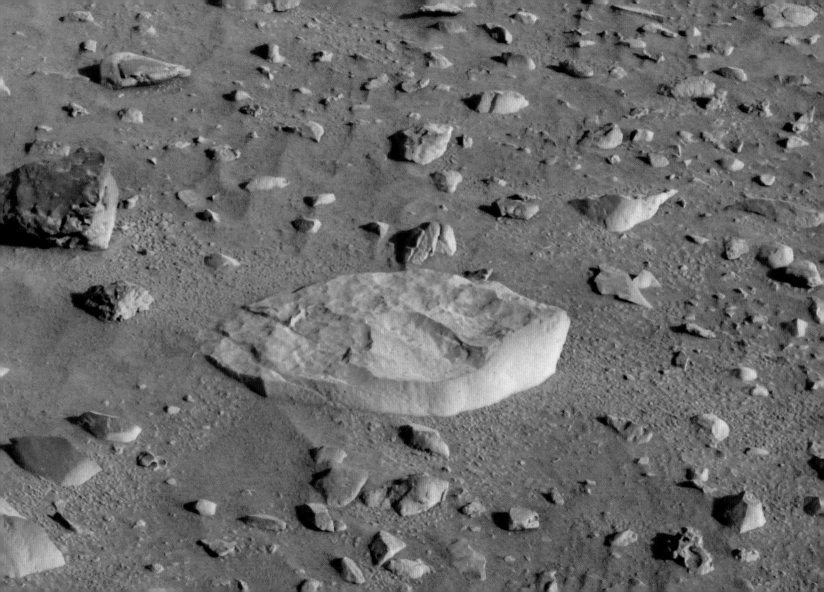

Infrared Helix

About 700 light-years from Earth, in the constellation Aquarius, a Sun-like star is dying. Its last few thousand years have produced the Helix (NGC 7293), a well-studied and nearby example of a planetary nebula, typical of this final phase of stellar evolution. In this infrared Spitzer Space Telescope image of the Helix, emission comes mostly from the nebula's molecular hydrogen gas. The gas appears to be clumpy, forming thousands of comet-shaped knots, each spanning about twice the size of our solar system. Bluer, more energetic radiation is seen to come from the heads, with redder emission from the tails—suggesting that they are shielded more from the central star's winds and intense ultraviolet radiation. The nebula itself is about 3 light-years across. The Sun is expected to go through its own planetary nebula phase . . . in another 5 billion years.

Credit: J. Hora (Harvard-Smithsonian CfA) et al., (SSC/Caltech), JPL-Caltech, NASA

February 6

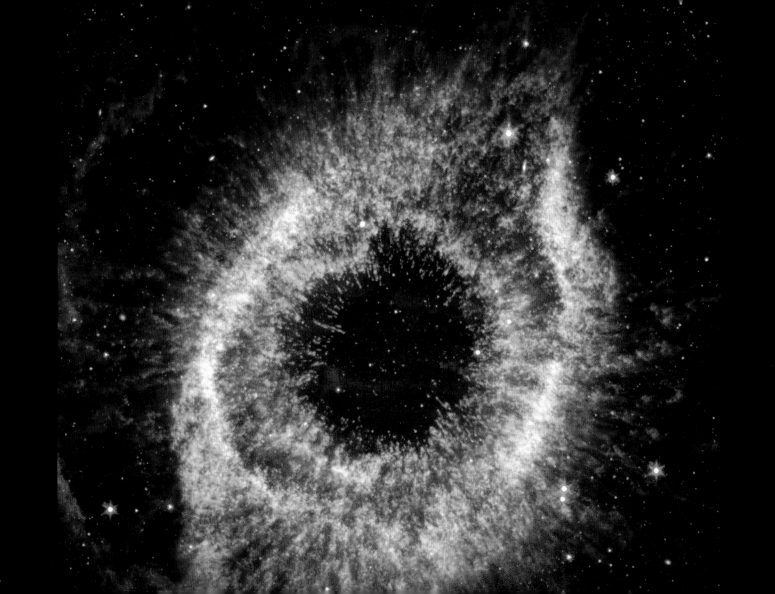

NGC 613:
A Spiral of Dust and Stars

When morning twilight came to the Paranal Observatory in Chile, astronomers Mark Neeser and Peter Barthel interrupted their search for faint quasars billions of light-years away. Just for a moment, they used Very Large Telescopes at the European Southern Observatory to appreciate the beauty of the nearby universe. One result was this stunning view of beautiful barred spiral galaxy NGC 613, a mere 65 million light-years away in the southern constellation Sculptor. Over 100,000 light-years across, NGC 613 seems to have more than its fair share of spiral arms laced with cosmic dust clouds and bright star-forming regions near the ends of a dominant central bar. Radio emission indicates the presence of a massive black hole at the center of the galaxy.

Credit: M. Neeser (Universitäts-Sternwarte München), P. Barthel (Kapteyn Astronomical Institute), H. Heyer, H. Boffin (ESO), ESO

February 7

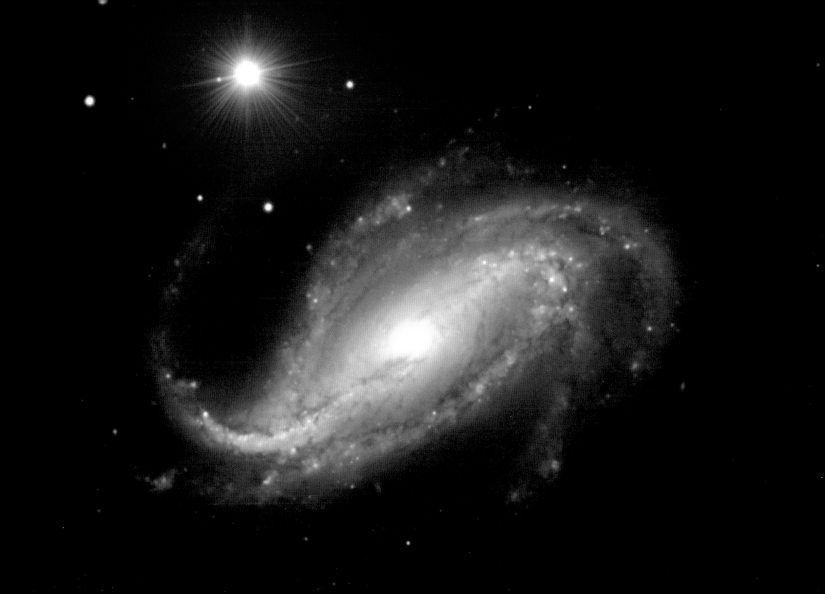

Saturn's Dragon Storm

The convoluted, swirling cloud features of the "Dragon Storm" are tinted orange in this false-color, near-infrared image of Saturn's southern hemisphere. The storm was found to be responsible for mysterious bursts of radio static monitored by Cassini instruments as the spacecraft orbited the ringed planet in 2004. It is now thought to be a giant Saturnian thunderstorm, like storms on Earth, with radio noise produced in high-voltage lightning discharges. The Cassini observations are also consistent with the Dragon Storm being a long-lived turbulence, deep within the gas giant's atmosphere, that periodically flares up to produce large, visible storm regions.

Credit: Cassini Imaging Team, SSI, JPL, ESA, NASA

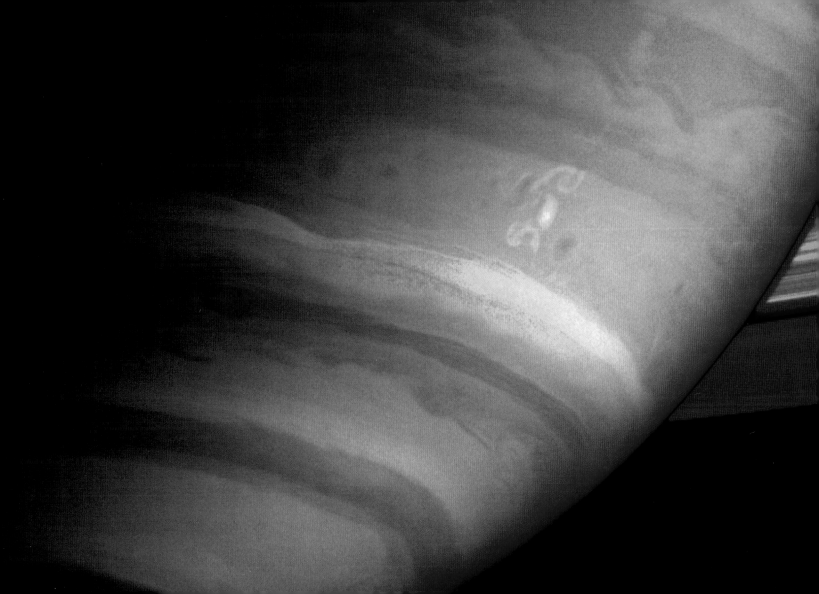

Heat Shield
Impact Crater
on Mars

Broken metal and the scorched Martian landscape make the impact site of Opportunity's heat shield one of the more interesting locations that the rolling robot inspected. The conical outer hull of the shattered heat shield (left) was expelled by Opportunity as it plummeted toward the Red Planet in 2004. The heat shield and the impact site itself lie to the right. The site is of interest partly because its creation is relatively well understood. The impact splattered light red dirt from the subsurface, while a darker material appears to track toward the large debris. Behind the impromptu space exhibit is a vast alien landscape of featureless plains and rust-tinted sky.

Credit: Mars Exploration Rover Mission, JPL, NASA

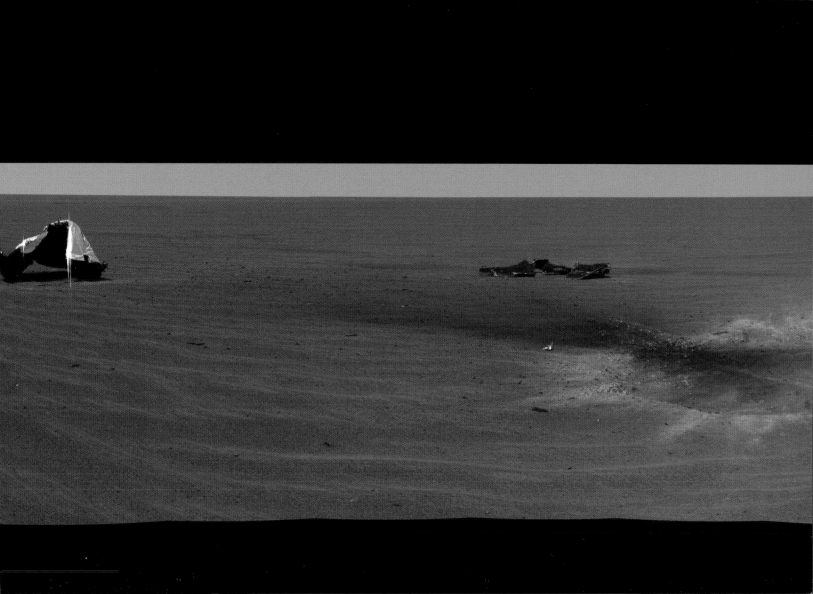

Big Dipper Castle

The stars of the Big Dipper, a well-known asterism in the constellation Ursa Major, are easy to recognize in this dramatic skyscape. In fact, northern hemisphere skygazers often follow along the line indicated by the two stars at the far right. Extending off the top of this image, that line leads to Polaris, the North Star, conveniently located near the north celestial pole. Following the arc of the Dipper's handle normally leads to red giant star Arcturus, another well-known celestial beacon of the northern sky—yet this dreamlike scene takes you instead to a shining mountaintop castle. Big Dipper Castle might be an appropriate name, given this stunning view, but it is traditionally called Castle Hohenzollern. Poised above a sea of clouds that mute the city lights below, the castle lies in the Swabian Alb range of southern Germany, an area that was once a reef in an ancient sea.

Credit & copyright: Till Credner (AlltheSky.com)

February 10

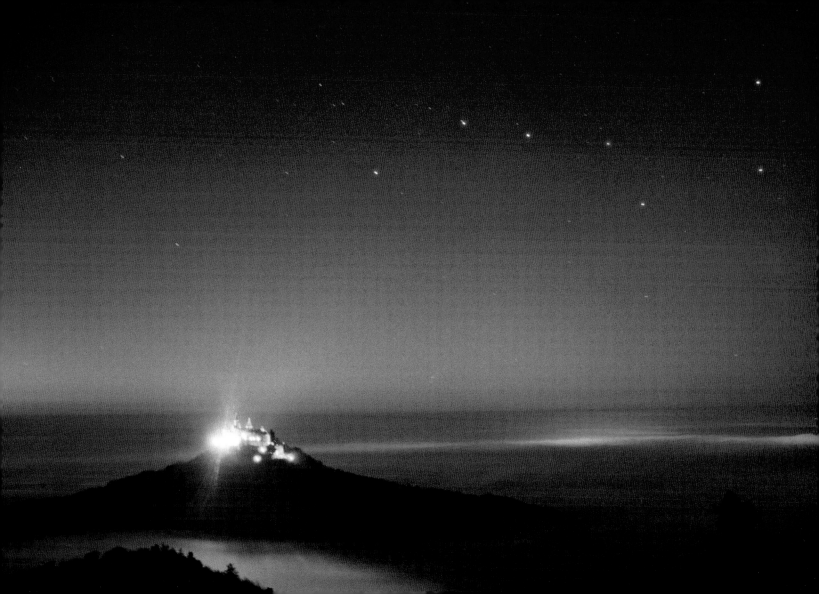

Persistent Saturnian Auroras

Are Saturn's auroras like Earth's? To help answer this question, the Hubble Space Telescope and the Cassini spacecraft simultaneously monitored Saturn's south pole as Cassini closed in on the gas giant in January 2004. Hubble snapped images in ultraviolet light, while Cassini recorded radio emissions and monitored the solar wind. Like the auroras on Earth, those on Saturn make total or partial rings around its magnetic poles. However, Saturn's auroras are much longer lived, persisting for days, as opposed to only minutes on Earth. Although surely created by charged particles entering the atmosphere, Saturn's auroras also appear to be more closely modulated by the solar wind than those on Earth. This sequence shows three Hubble images of Saturn, taken at two-day intervals.

Credit: J. Clarke (Boston University) & Z. Levay (STScI), ESA, NASA

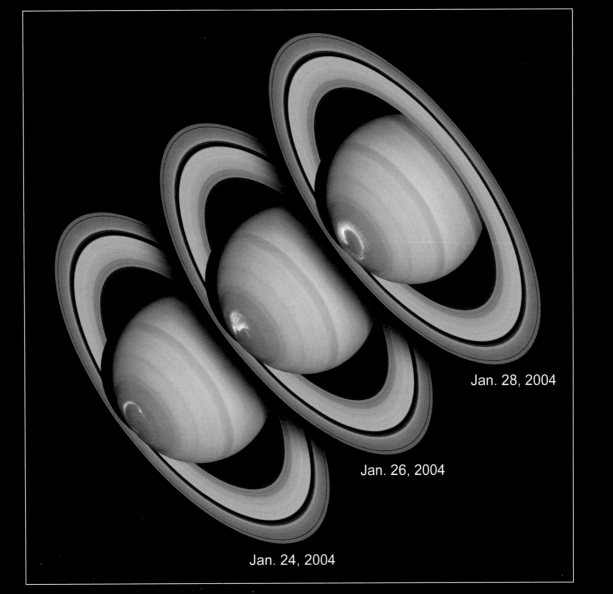

Jan. 28, 2004

Jan. 26, 2004

Jan. 24, 2004

LL Ori and the Orion Nebula

This aesthetic close-up of cosmic clouds and stellar winds features LL Orionis, interacting with the Orion Nebula flow. Adrift in Orion's stellar nursery and still in its formative years, variable star LL Orionis produces a wind more energetic than what comes from our own middle-aged Sun. As the fast stellar wind runs into slow-moving gas, a shock front is formed, analogous to the bow wave of a boat moving through water or a plane traveling at supersonic speed. The small, arcing, graceful structure just to the right of center is LL Ori's cosmic bow shock, measuring about half a light-year across. The slower gas is flowing away from the Orion Nebula's hot central star cluster, the Trapezium, located off the upper left corner of the picture. In three dimensions, LL Ori's wrap-around shock front is shaped like a bowl that appears brightest when viewed along the "bottom" edge. The beautiful picture is part of a large mosaic view of the complex stellar nursery in Orion, filled with a myriad of fluid shapes associated with star formation.

Credit: NASA, ESA, & the Hubble Heritage Team

February 12

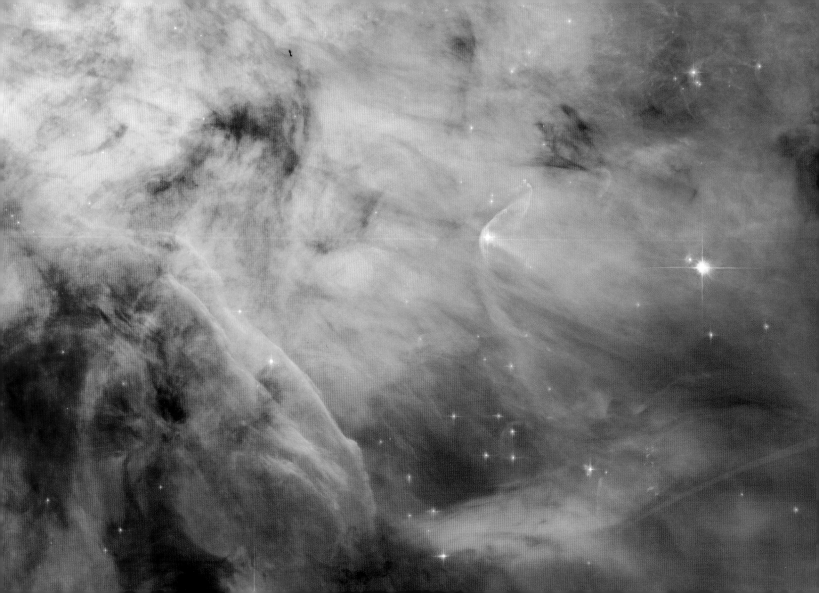

Saturn's Iapetus: Moon with a Strange Surface

What happened to Saturn's moon Iapetus? A strange ridge that crosses it close to the equator, visible near the bottom of the image, gives Iapetus a resemblance to a peach pit. Half of the moon is so dark that it can almost disappear when viewed from Earth. Detailed observations show that the degree of darkness of the terrain is strangely uniform, as if a dark coating had somehow recently been applied to an ancient and highly cratered surface. The other half of Iapetus is relatively bright but oddly covered with long, thin, dark streaks. A 400-kilometer-wide impact basin is visible near the center of the image, delineated by deep scarps that drop sharply to the crater floor. The image was taken by the Saturn-orbiting Cassini spacecraft during a flyby of Iapetus at the end of 2004.

Credit: Cassini Imaging Team, SSI, JPL, ESA, NASA

February 13

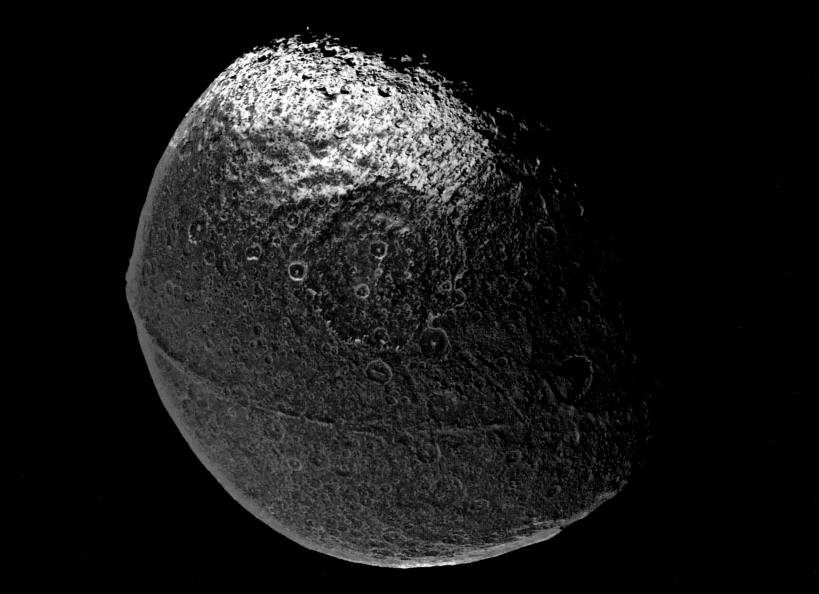

Stereo Eros

Get out your red/blue 3-D glasses and float next to asteroid 433 Eros, 170 million kilometers away. Orbiting the Sun once every 1.8 Earth years, Eros is a diminutive 40-by-14-by-14-kilometer world of undulating horizons, craters, boulders, and valleys. Its unsettling scale and bizarre shape are emphasized in this picture—a mosaic of images from the NEAR Shoemaker spacecraft, processed to yield a stereo anaglyphic view. Along with dramatic chiaroscuro, NEAR's 3-D imaging provided important measurements of the asteroid's landforms and structures, as well as clues to the origin of this city-sized chunk of the solar system. The smallest features visible here are about 30 meters across. On February 12, 2001, after spending a year in orbit around Eros, the NEAR Shoemaker spacecraft made the historic first-ever landing on an asteroid's surface.

Credit: NEAR Project, JHU APL, NASA

February 14

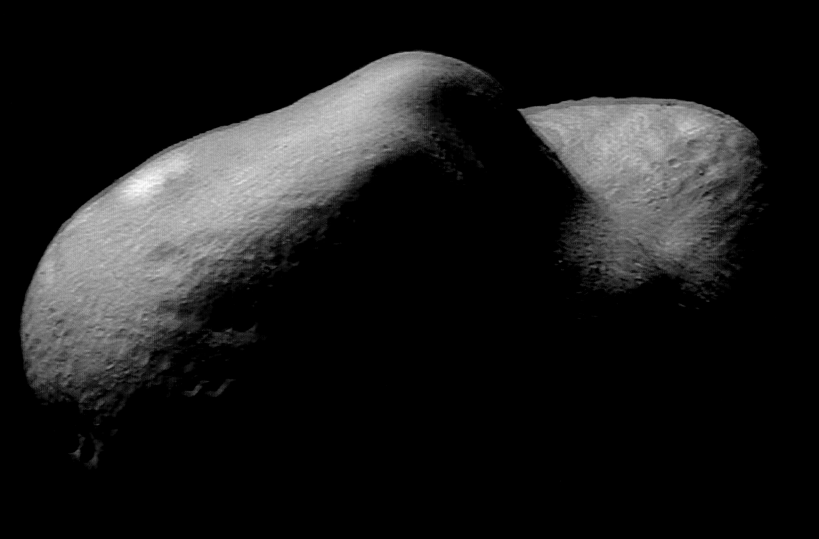

M64: The Sleeping Beauty Galaxy

The Sleeping Beauty Galaxy may appear peaceful, but it is actually tossing and turning. Unexpectedly, observations have shown that the gas and the stars in the outer regions of this photogenic spiral are rotating in opposite directions! Collisions between gas in the inner and outer regions are creating many hot blue stars and pink emission nebulae. This image was taken by the Hubble Space Telescope in 2001. The fascinating internal motions of M64, also cataloged as NGC 4826, are thought to be the result of a collision between a small galaxy and a large galaxy, creating a mix that has not yet settled down.

Credit: NASA & the Hubble Heritage Team (AURA/STScI), S. Smartt (IoA), D. Richstone (University of Michigan), et al.

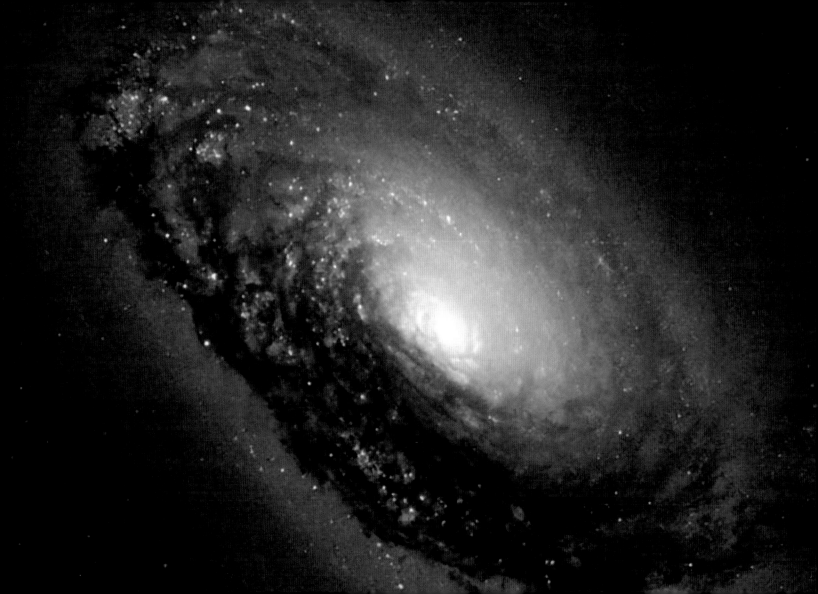

Unusual Plates on Mars

What are those unusual plates on the surface of Mars? A leading interpretation holds that they are blocks of ice floating on a recently frozen, dust-covered sea. The region lies near the Martian equator, far from either of the planet's frozen polar caps, so any water or ice would quickly evaporate into the atmosphere if it were not covered by dust. Evidence that these plates really are dust-covered water ice includes a similarity in appearance to ice blocks off Earth's Antarctica, nearby surface fractures from which underground water could have flowed, and the shallow depth of the craters, indicating that something is filling them in. If this theory proves correct, the low number of craters suggests that water may have flowed on Mars as recently as 5 million years ago. The structures were photographed by the European Space Agency's orbiting Mars Express spacecraft.

Credit: G. Neukum (FU Berlin) et al., Mars Express, DLR, ESA

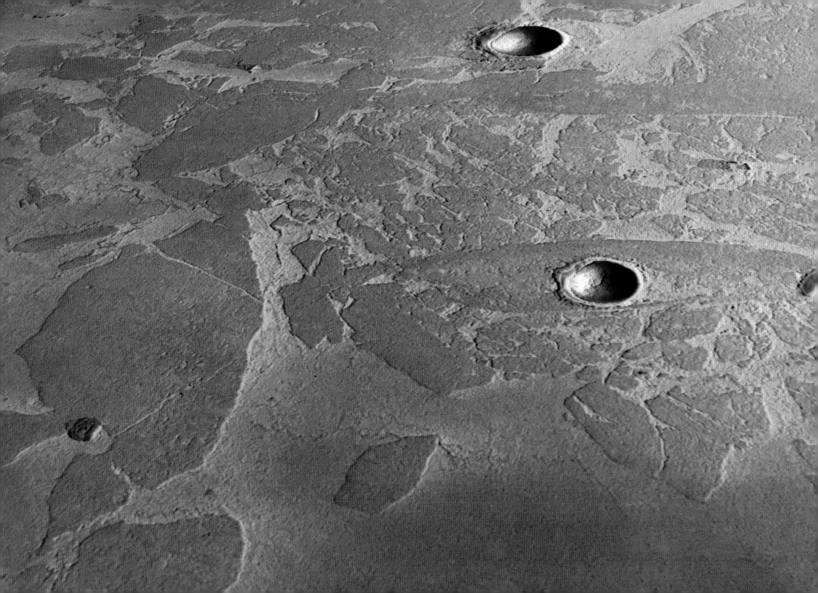

WMAP
Resolves
the Universe

Analyses of a new high-resolution map of microwave light emitted only 380,000 years after the Big Bang appear to define our universe more precisely than ever before. The eagerly awaited results from the Wilkinson Microwave Anisotropy Probe resolve several long-standing disagreements in cosmology rooted in less precise data. Specifically, present analyses of this WMAP all-sky image indicate that the universe is 13.7 billion years old (accurate to 1 percent); is composed of 73 percent dark energy, 23 percent cold dark matter, and only 4 percent atoms; is currently expanding at the rate of 71 kilometers per second per megaparsec (accurate to 5 percent); underwent episodes of rapid expansion called inflation; and will expand forever.

Credit: WMAP Science Team, NASA

February 17

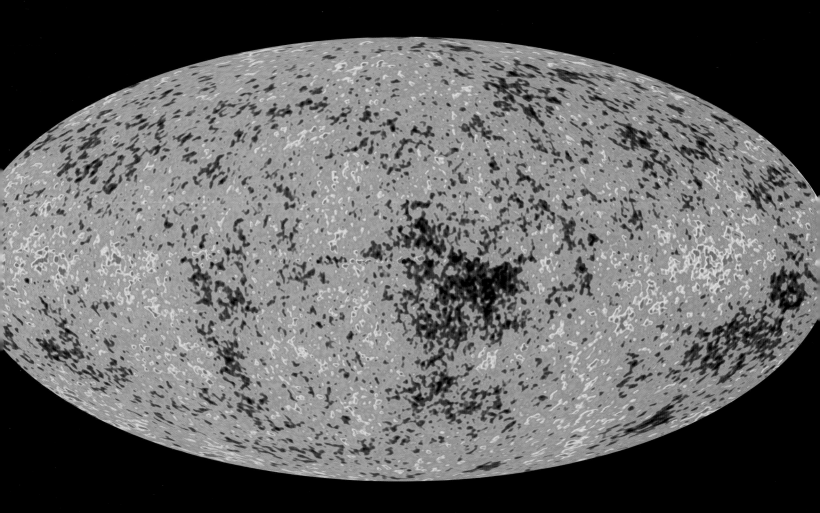

This sky map tells us the universe is 13.7 billion years old—but how do we know that? The image seems only to reveal the microwave glow of gas from our Milky Way Galaxy, coded red, and a spotty pattern of microwaves emitted from the early universe, coded in gray. The gray cosmic microwave background is light that used to bounce around randomly but traveled directly to us when the expanding universe became cool enough for nearly transparent atoms to form. A close inspection of the spots reveals an average angular distance between them. One expects such a pattern to be generated by sound emanating from slightly over-dense regions of the early universe. Since it takes time for sound waves to generate such a pattern, the present age of the universe can be directly calculated. The age of 13.7 billion years is estimated to be accurate to better than 0.2 billion years. This map shows data from the WMAP satellite orbiting the Sun at the L2 point, just outside the orbit of planet Earth.

Credit: WMAP Science Team, NASA

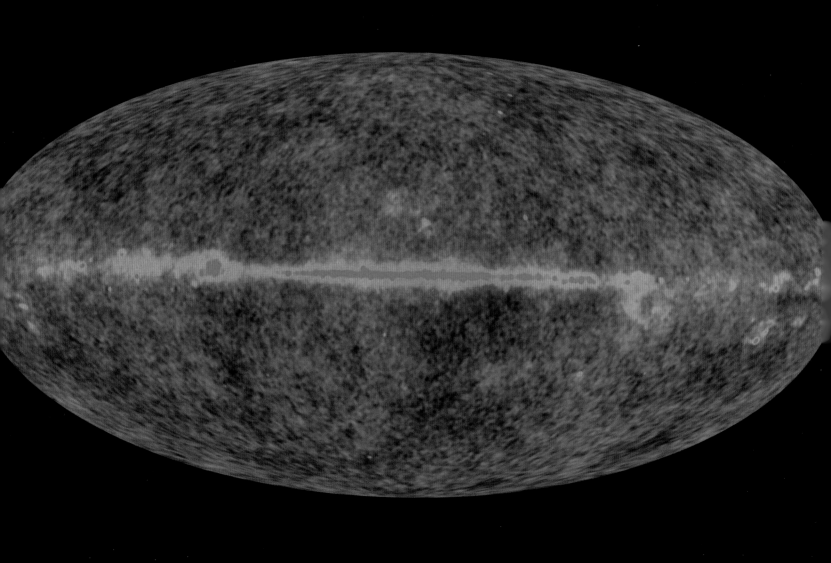

Starburst in a Small Galaxy

Grand spiral galaxies often seem to get all the glory, flaunting their young, bright, blue star clusters in beautiful, symmetrical spiral arms. But small, irregular galaxies form stars too. In fact, as pictured here, dwarf galaxy NGC 1569 is apparently undergoing a burst of star-forming activity, thought to have begun over 25 million years ago. The resulting turbulent environment is fed by supernova explosions as the cosmic detonations spew out material and trigger further star formation. Two massive star clusters—youthful counterparts to globular star clusters in our own spiral Milky Way Galaxy—are seen left of center in the gorgeous Hubble Space Telescope image. The picture spans about 1,500 light-years across NGC 1569. A mere 7 million light-years distant, in the long-necked constellation Camelopardalis, this relatively close starburst galaxy offers astronomers an excellent opportunity to study stellar populations in rapidly evolving galaxies.

Credit: ESA, NASA, P. Anders (Göttingen University), et al.

February 19

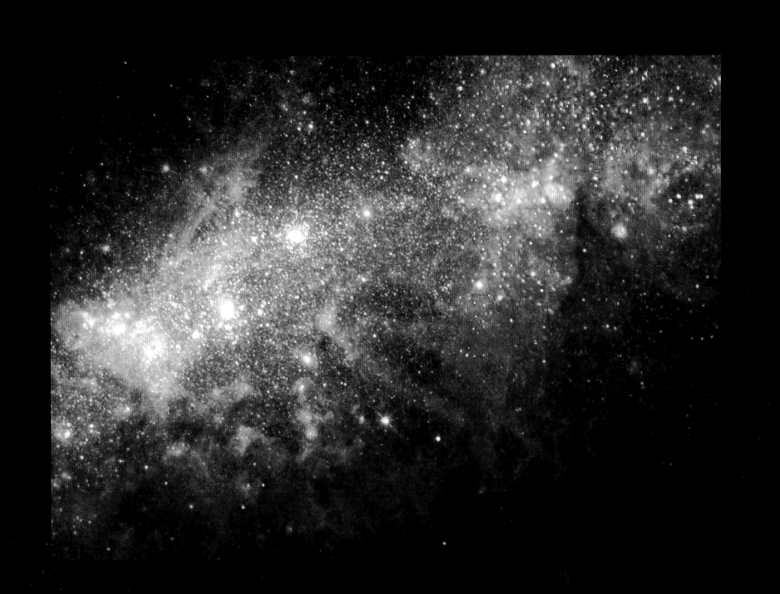

Blue Saturn

Serene blue hues highlight this view of Saturn's northern hemisphere from the Cassini spacecraft. The image has been adjusted to approximate the natural blue color of visible sunlight scattered by the gas giant's upper atmosphere. Saturn's famous rings cast the dark shadows stretching across the frame, with the cratered moon Mimas—infamous for its *Star Wars* Death Star–like appearance—lurking at the lower right. Orbiting beyond the main inner rings, Mimas is 400 kilometers across and lies nearly 200,000 kilometers—more than three Saturn radii—from the center of the planet. Still, it orbits within Saturn's faint and tenuous outer E ring.

Credit: Cassini Imaging Team, SSI, JPL, ESA, NASA

February 20

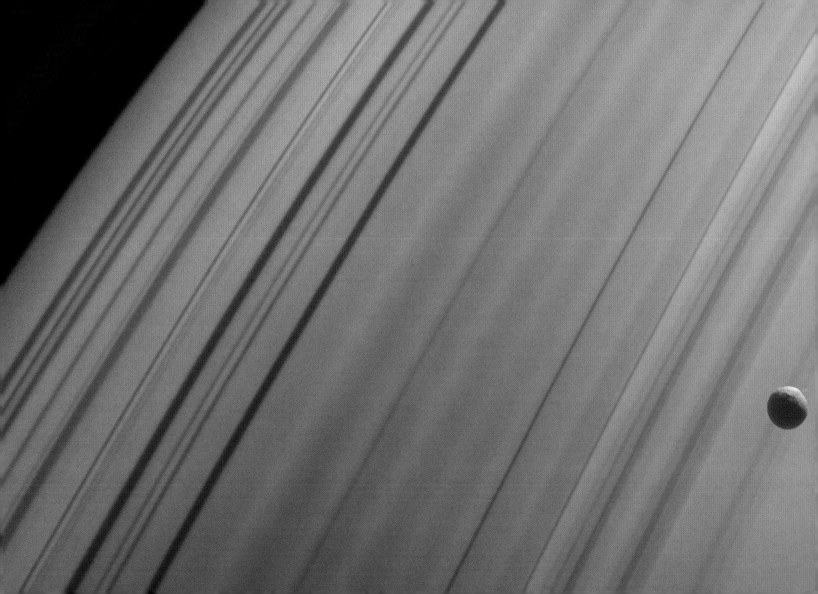

Thousands of unusual gray spherules, made of iron and rock but dubbed "blueberries," were found embedded in and surrounding rocks near the landing site of the robot Opportunity rover on Mars. In April 2004, investigating their origin, Opportunity found this surface (the "Berry Bowl") with an indentation that was rich in the mysterious orbs. By analyzing a circular area in the rock surface to the left of the densest patch of spherules, Opportunity obtained data showing that the underlying rock is quite different in composition from the hematite-rich blueberries. This contributes to the growing consensus that these small, strange gray orbs were slowly deposited from a bath of dirty water.

The average blueberry is only about 4 millimeters in diameter.

Credit: Mars Exploration Rover Mission, JPL, NASA

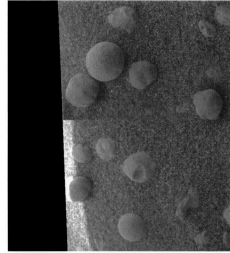

February 21

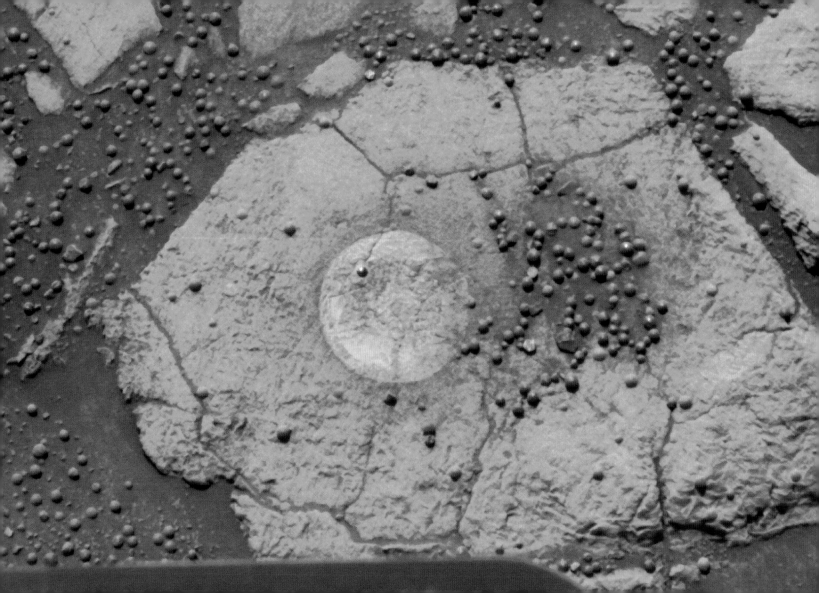

The Eagle Nebula from CFHT

Bright blue stars are still forming in the dark pillars of the Eagle Nebula, made famous by a picture from the Hubble Space Telescope in 1995. Near the upper left lies the heart of the associated open cluster M16. The blue stars of M16 have been forming continually over the past 5 million years, most recently in the central gas and dust pillars known as elephant trunks. Light takes about 7,000 years to reach us from M16. The young star cluster spans about 20 light-years and can be seen with binoculars in the direction of the constellation Serpens.

Credit & copyright: Canada-France-Hawaii Telescope / J. C. Cuillandre / Coelum

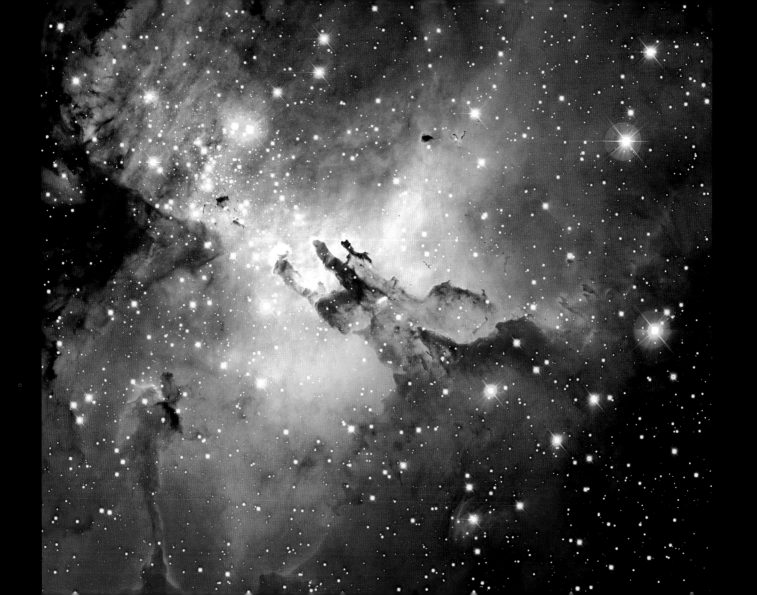

In the Heart of the Tarantula

In the heart of monstrous Tarantula Nebula lies one of the most unusual star clusters. Known as NGC 2070 or R136, it is home to a great number of hot young stars. The energetic light from these stars continually ionizes nebular gas, while their energetic particle wind blows bubbles and defines intricate filaments. The new Spitzer Space Telescope took this representative-color infrared image of the great Large Magellanic Cloud cluster. The image details the gas, dust, and young stars at the cluster's tumultuous center. The Tarantula (aka 30 Doradus) Nebula is one of the largest star-forming regions known, and it has been creating unusually strong episodes of star formation every few million years. In the heart of this heart is a central knot of stars that is so dense it was once thought to be a single star.

Credit: B. Brandl (Cornell & Leiden) et al., JPL, Caltech, NASA

February 23

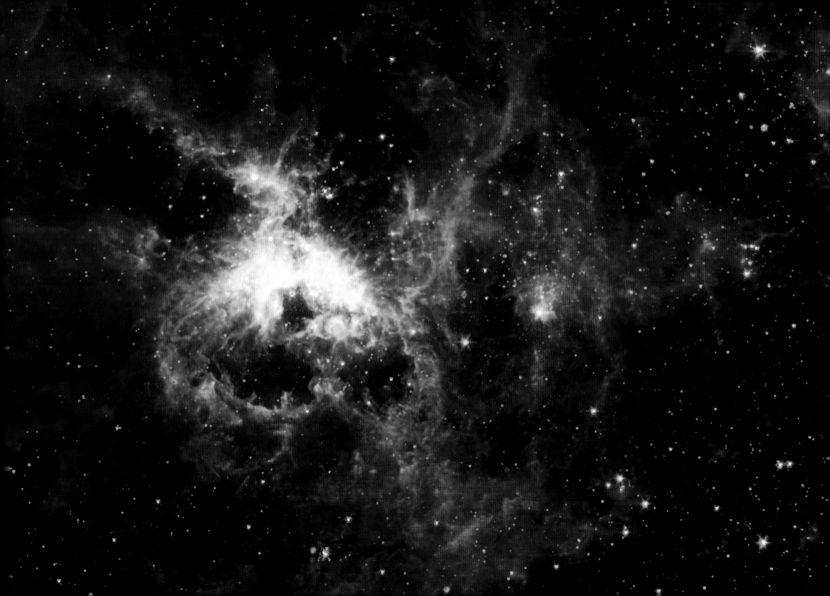

What's happening above the horizon? Although the scene may seem supernatural, it is just the result of the setting Sun and some well-placed clouds. Pictured here are anticrepuscular rays. To understand them, start with common crepuscular rays, which are seen anytime sunlight pours though scattered clouds. Sunlight travels along straight lines, but the projections of these lines onto the spherical sky are great circles. Therefore, the crepuscular rays from a setting sun seem to reconverge on the other side of the sky. At the antisolar point, 180 degrees from the position of the Sun in the sky, they are referred to as anticrepuscular rays. While enjoying the sunset after dinner near Horseshoe Canyon in Utah, the photographer chanced to find that an even more spectacular sight was occurring in the other direction just over the canyon—a particularly vivid set of anticrepuscular rays.

Credit & copyright: Peggy Peterson

Heaven on Earth

Do not despair that the entire Milky Way Galaxy is raining down on your head. This phenomenon takes place twice a day. As the Sun rises in the east, the wonders of the night sky become less bright than the sunlight scattered by Earth's atmosphere, and so they fade away. They will rotate back into view only at dusk, when Earth again eclipses the bright Sun. This battle between heaven and Earth was captured dramatically in a digitally enhanced double exposure over Arizona's Kofa Mountains in May 2003. Dark dust, millions of stars, and brightly glowing red gas highlight the plane of the Milky Way, which lies, on average, thousands of light-years behind Earth's mountains.

Credit & copyright: Richard Payne (Arizona Astrophotography)

February 25

Why We Do Not Implode

What prevents matter from just bunching up? The same principle that keeps neutron stars and white dwarf stars from imploding also saves people from the same fate, along with making normal matter mostly empty space. The observed reason is known as the Pauli Exclusion Principle. It states that identical fermions (atoms and particles with half-integral spin—such as protons, electrons, and neutrons) cannot be in the same place at the same time and with the same orientation. The other type of matter, bosons (atoms and particles with integral spin—such as photons), do not have this property. Recently, the Pauli Exclusion Principle was demonstrated graphically in this picture of clouds of two isotopes of lithium; the left cloud is composed of bosons, while the right cloud is composed of fermions. As the temperature drops, the bosons bunch together (in a Bose-Einstein condensate), while the fermions keep their distance. The reason the Pauli Exclusion Principle is true and the physical limits of the principle remain unknown.

Credit & copyright: Andrew Truscott & Randall Hulet (Rice University)

Bosons Fermions

810 nK

510 nK

240 nK

Fox Fur,
the Unicorn,
and a
Christmas Tree

Glowing hydrogen gas fills this gorgeously detailed skyview centered on the bright variable star S Mon, in the faint but fanciful constellation Monoceros, the Unicorn. A star-forming region (NGC 2264), the complex jumble of cosmic gas and dust is about 2,700 light-years distant and mixes reddish emission nebulae, excited by energetic light from newborn stars, with dark interstellar dust clouds. Where the otherwise obscuring dust clouds lie close to stars, they also reflect starlight, forming blue reflection nebulae. The wide vista covers about 1.5 degrees on the sky or nearly three Full Moons, spanning 70 light-years at the distance of NGC 2264. Its cast of cosmic characters includes the Cone Nebula (far left); the Fox Fur Nebula, whose convoluted pelt lies just below S Mon; and the Christmas Tree star cluster. That triangular cluster appears sideways here, with its apex at the Cone Nebula and its broader base over the Fox Fur and S Mon.

Credit & copyright: Russell Croman

The Dumbbell Nebula in Close-up

What causes unusual knots of gas and dust in planetary nebulae? Seen previously in the Ring Nebula, the Helix Nebula, and the Eskimo Nebula, the knots' existence was not predicted before and is still not well understood. Pictured here is an image of the Dumbbell Nebula by the Hubble Space Telescope, showing details of its gaseous knots. Visible as well are many bright young stars and dark sheets of interstellar dust. Also known as M27, this is a planetary nebula thought to be similar to what our Sun will become when it runs out of core fuel for nuclear fusion. Recent study of similar cometary knots indicates that they include concentrations of relatively cold molecular gas, and that they change significantly as the planetary nebula ages.

Credit: C. R. O'Dell (Vanderbilt) et al., Hubble Heritage Team (STScI/AURA), NASA

February 28

The Witch's Broom Nebula

Ten thousand years ago, before the dawn of recorded human history, a bright light must suddenly have appeared in the night sky and then faded after a few weeks. Today we know it was an exploding star, and we call the colorful expanding cloud the Veil Nebula. Its west end, pictured here, is known technically as NGC 6960 and less formally as the Witch's Broom Nebula. The rampaging gas gains its colors by colliding with and exciting existing nearby gas. The supernova remnant lies about 1,400 light-years away in the direction of the constellation Cygnus and spans over three times the angular size of the Full Moon. The bright star 52 Cygnus, in the middle of the image, is visible with the unaided eye from a dark location; it is unrelated to the ancient supernova.

Credit & copyright: T. A. Rector (University of Alaska, Anchorage), WIYN, NOAO, AURA, NSF

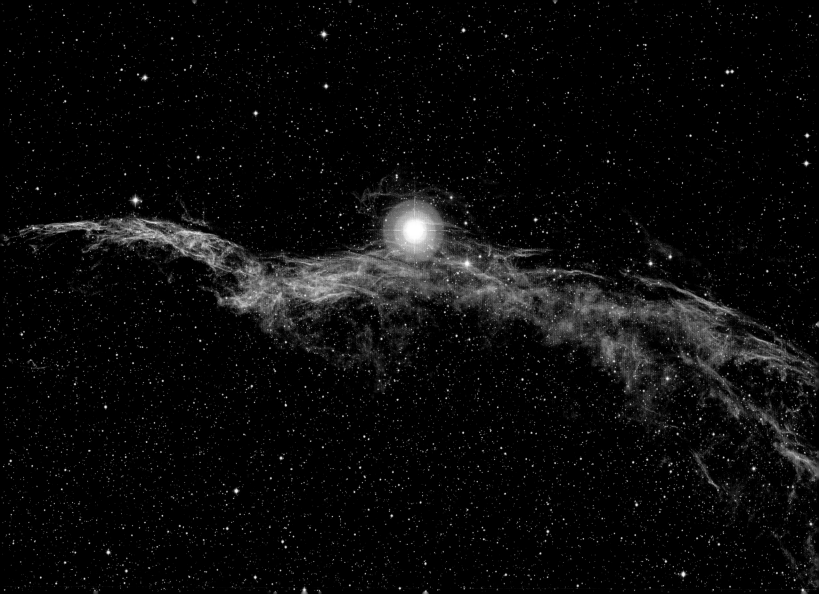

Crescents of Titan and Dione

What would it be like to see a sky with many moons? Such is the sky above Saturn. When appearing close to each other, moons will show a similar phase. A view with two of the more famous moons of Saturn in crescent phase was captured in early 2005 by the robot Cassini spacecraft orbiting the planet. Titan, at the lower left, is among the largest moons in the solar system and is perpetually shrouded in clouds. In January 2005, the Huygens probe landed on Titan and gave humanity its first view of the moon's unusual surface. Dione, at the upper right, has less than a quarter of Titan's diameter and no significant atmosphere. Although it looks much farther away, Dione was only half the distance to Titan when the spacecraft took this image.

Credit: Cassini Imaging Team, SSI, JPL, ESA, NASA

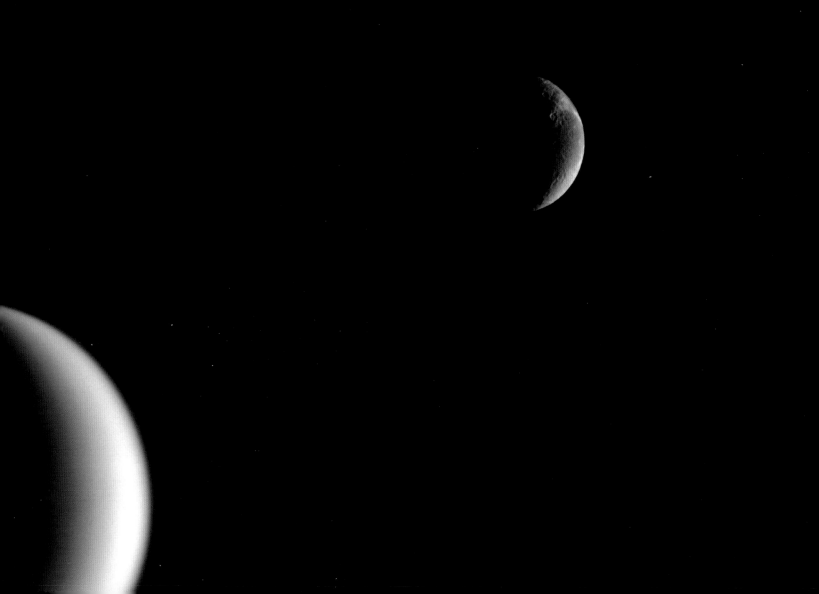

Will the Universe End in a Big Rip?

How will our universe end? Speculation, based on analysis of recent cosmological measurements, now includes the possibility of a pervasive growing field of mysterious repulsive energy that will tear apart virtually everything—a Big Rip, ending what began with a Big Bang. As soon as a few billion years from now, the controversial scenario holds, dark energy will grow to such a magnitude that our own galaxy—along with all others—will no longer be able to hold itself together. After that, stars, planets, and then even atoms might not be able to withstand the expansive internal force. Previously, speculation about the ultimate fate of the universe centered on either the massive collapse of a Big Crunch or the perpetual expansion and cooling of the universe—a Big Chill. Although the universe's fate is still a puzzle, piecing it together will likely follow from an increased understanding of the nature of dark matter and dark energy.

Credit & copyright: Lynette Cook

Simeis 147: Supernova Remnant

It is easy to get lost following the intricate filaments in this detailed image of faint supernova remnant Simeis 147. Seen toward the constellation Taurus, it covers nearly 3 degrees (six Full Moons) on the sky, corresponding to a width of 150 light-years at the stellar debris cloud's estimated distance of 3,000 light-years. The color composite image includes eight hours of exposure time with an H-alpha filter, transmitting only the light from recombining hydrogen atoms in the expanding nebulosity and thus tracing the regions of shocked, glowing gas. This supernova remnant has an apparent age of about 100,000 years—meaning that light from the massive stellar explosion first reached Earth 100,000 years ago—but this expanding remnant is not the only aftermath. The cosmic catastrophe also left behind a spinning neutron star, or pulsar, all that remains of the original star's core.

Credit & copyright: Robert Gendler

March 4

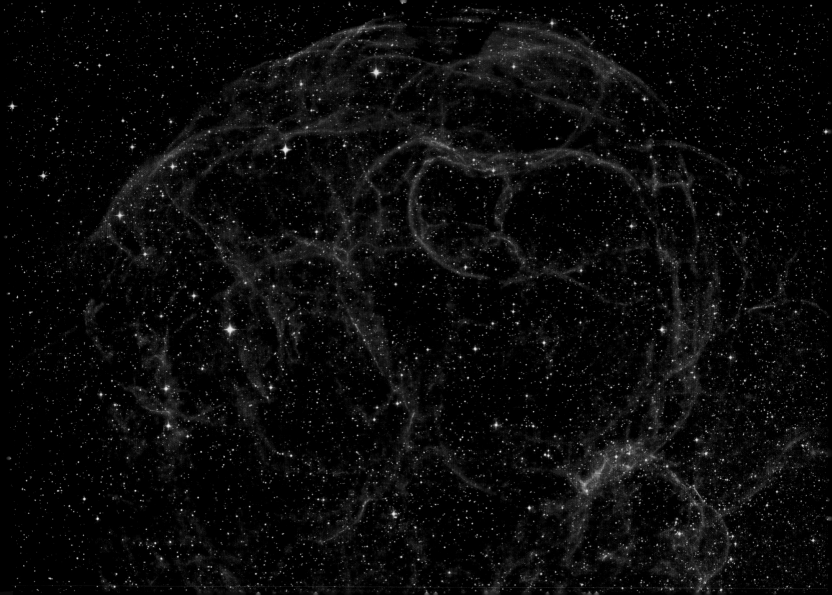

NGC 1531 and NGC 1532: Interacting Galaxies

This dramatic image of an interacting pair of galaxies was made using the 8-meter Gemini South Telescope at Cerro Pachon, Chile. NGC 1531 is the background galaxy, with a bright core just above the center of the image, and NGC 1532 is the foreground spiral galaxy, laced with dust lanes. The two are about 55 million light-years away in the southern constellation Eridanus. These galaxies lie close enough together so that each feels the influence of the other's gravity. The gravitational tug-of-war has triggered star formation in the foreground spiral, as evidenced by the young, bright blue star clusters along the upper edge of the front spiral arm. Although the spiral galaxy in this pair is viewed nearly edge on, astronomers believe the system is similar to the face-on spiral and companion known as M51, the Whirlpool Galaxy.

Credit & copyright: T. A. Rector (University of Alaska, Anchorage), Gemini Observatory, AURA, NSF

March 5

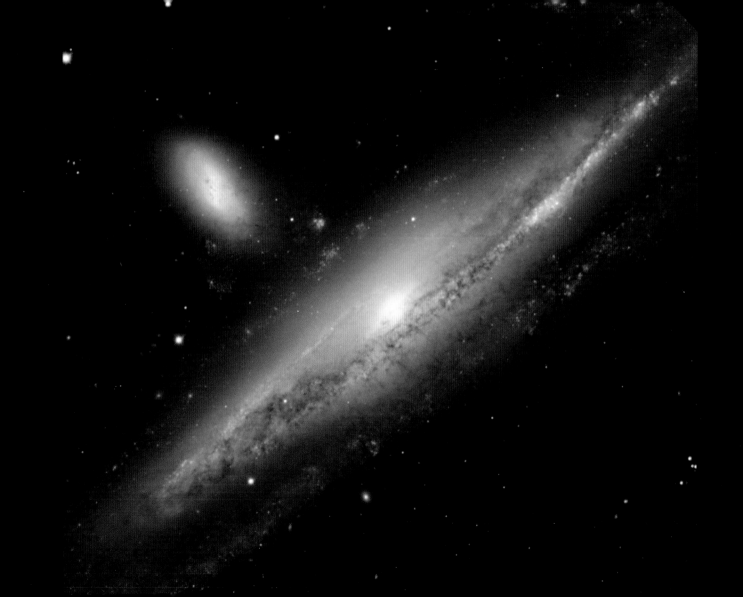

What did the first galaxies look like? To help answer this question, the Hubble Space Telescope recorded the Hubble Ultra Deep Field (HUDF), the deepest image of the universe ever taken in visible light. The HUDF shows a sampling of the oldest galaxies ever seen—they formed just after the dark ages, 13 billion years ago, when the universe was only 5 percent of its present age. The Hubble Space Telescope's NICMOS camera and Advanced Camera for Surveys took the image. Capturing a view made by staring at the same spot for nearly three months, the HUDF is four times more sensitive, in some colors, than the original Hubble Deep Field (HDF). Astronomers the world over use the HUDF data to explore how stars and galaxies formed in the early universe.

Credit: S. Beckwith & the HUDF Working Group (STScI), HST, ESA, NASA

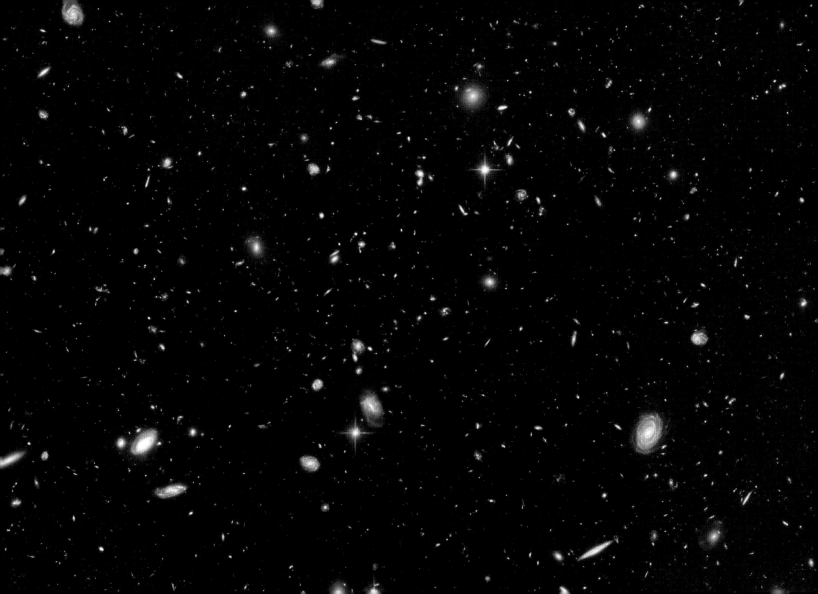

Urban Constellation

Do you recognize this intriguing globular cluster of stars? It is actually the constellation of city lights surrounding London, England, planet Earth, as recorded with a digital camera from the International Space Station in February 2003. North is toward the top and slightly left in this nighttime view. The encircling "London Orbital" highway bypass, the M25 (not to be confused with Messier 25, in the famous eighteenth-century catalog), is easiest to pick out south of the city. Even farther south are the lights of Gatwick Airport, and just inside the western (left-hand) stretch of the Orbital is Heathrow Airport. The darkened Thames River estuary fans out to the city's east. In particular, two small "dark nebulae"—Hyde Park and Regent's Park—stand out slightly west of the densely packed lights at the city's core.

Credit: ISS Crew, Earth Sciences and Image Analysis Lab, JSC, NASA

March 7

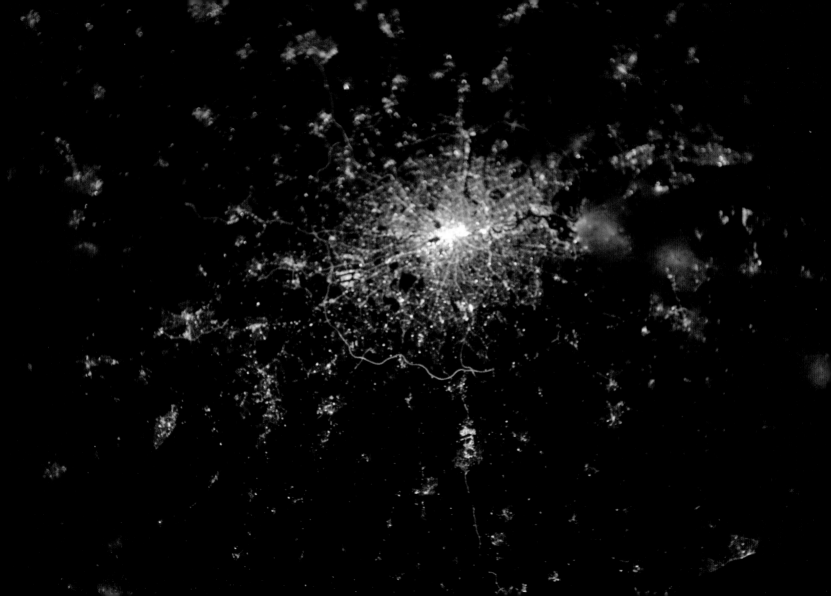

Still Life with NGC 2170

In this beautiful celestial still life composed with a cosmic brush, dusty nebula NGC 2170 shines at the upper left. Reflecting the light of nearby hot stars, NGC 2170 is joined against a backdrop of stars by other bluish reflection nebulae and a compact red emission region. Like the ordinary household items that still-life painters often choose for their subjects, the clouds of gas, dust, and hot stars pictured here are commonly found in this setting—a massive, star-forming molecular cloud in the constellation Monoceros. The giant molecular cloud Mon R2 is impressively close, estimated to be only 2,400 light-years or so away. At that distance, this canvas would be about 15 light-years across.

Credit & copyright: Stefan Seip

March 8

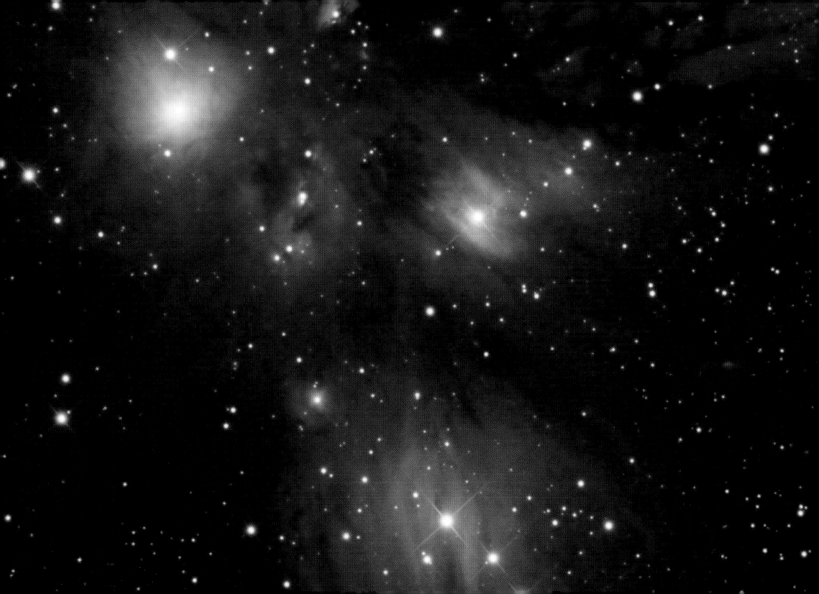

NGC 1427A: Galaxy in Motion

In this tantalizing image, young blue star clusters and pink star-forming regions abound in NGC 1427A, a galaxy in motion. The small, irregular galaxy's backswept outline points toward the top of this picture from the Hubble Space Telescope—and that is indeed the way that NGC 1427A is moving as it travels in the direction of the center of the Fornax cluster of galaxies, some 62 million light-years away. Over 20,000 light-years long and similar to the nearby Large Magellanic Cloud, NGC 1427A is speeding through the Fornax cluster's intergalactic gas at about 600 kilometers per second. The resulting pressure gives the galaxy its arrowhead outline and triggers beautiful but violent episodes of star formation. Still, it is understood that interactions with cluster gas and the other cluster galaxies during its headlong flight will ultimately disrupt galaxy NGC 1427A. Many unrelated background galaxies are visible in the sharp Hubble image, including a striking face-on spiral galaxy at the upper left.

Credit: Hubble Heritage Team (AURA/STScI), ESA, NASA

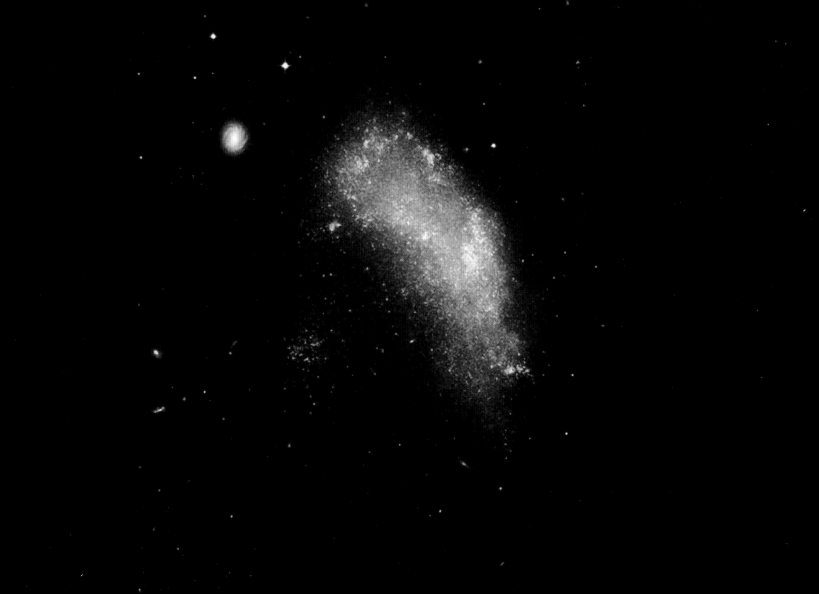

Open Cluster
M39

Lying just at the limit of human perception is a picturesque star field containing one of the bigger open clusters in the northern sky. Spanning an angle larger than the Moon, M39's relatively few stars lie only about 800 light-years distant toward the constellation Cygnus. This picture of M39 is a mosaic of thirty-three images taken by the WIYN telescope on Kitt Peak in Arizona. The stars in the cluster are all about 300 million years old, much younger than the 5 billion years of our Sun. Open clusters, also called galactic clusters, contain fewer and younger stars than globular clusters. Also unlike globular clusters, open clusters are generally confined to the plane of our galaxy.

Credit & copyright: Heidi Schweiker, WIYN, NOAO, AURA, NSF

Mir Dreams

This dreamlike image of Mir was recorded by astronauts in the space shuttle Atlantis as it approached the Russian space station prior to docking during the STS-76 mission. Sporting spindly appendages and solar panels, Mir resembles a whimsical flying insect hovering about 350 kilometers above New Zealand's South Island and the city of Nelson, near Cook Strait, in this image. After becoming operational in 1986, Mir was visited by over 100 spacefarers from nations of planet Earth, including Russia, the United States, Great Britain, Germany, France, Japan, Austria, Kazakhstan, and Slovakia. Following joint shuttle-Mir training missions in support of the International Space Station, continuous occupation of Mir ended in August 1999, and Mir was taken out of orbit in March 2001.

Credit: STS-76 Crew, NASA

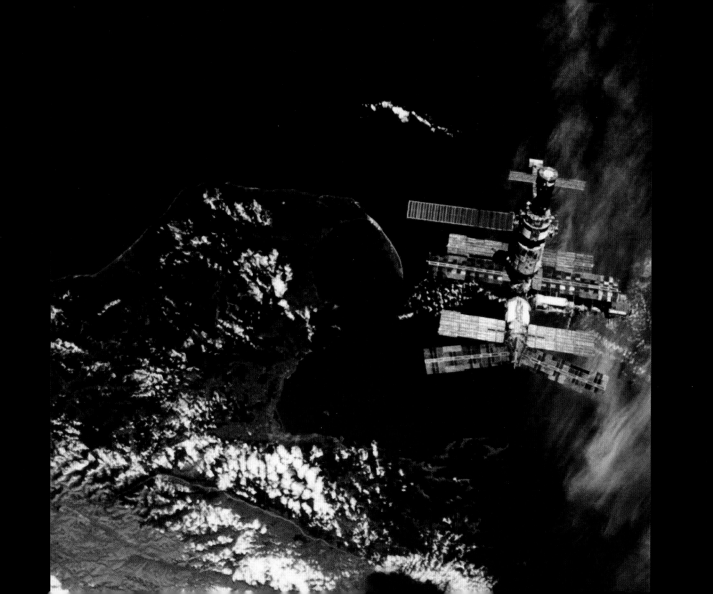

Crater on Mimas

Whatever hit Mimas nearly destroyed it. What remains is one of the largest impact craters on one of Saturn's smallest moons, giving Mimas a dramatic visage reminiscent of the Death Star in the *Star Wars* movies. The crater, named Herschel after Sir William Herschel, who discovered the moon in 1789, spans about 130 kilometers. The low mass of Mimas produces a surface gravity just strong enough to create a spherical body but weak enough to allow such relatively large surface features. Mimas is made of mostly water ice with a smattering of rock—so it is accurately described as a big dirty snowball. The image was recorded during the January 2005 flyby of the robot Cassini spacecraft.

Credit: Cassini Imaging Team, SSI, JPL, ESA, NASA

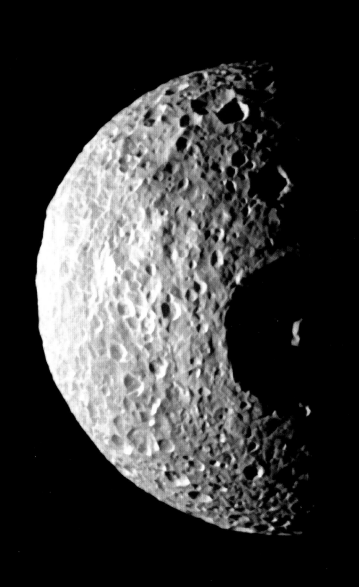

It is not the bright white object—surely a brown dwarf star—but the faint red one that might be a historic find. It is quite possibly the first direct image of a planet beyond our solar system. When the intriguing possibility was reported in 2005, many astronomers were unconvinced that the "planet" was not just a background star; 2M1207 was imaged twice more in an effort to resolve the issue. To the delight of the scientific team, the objects maintained the same separation, indicating that they are gravitationally bound and part of the same star system. Though located near each other, the dim red object, 2M1207b, is 100 times fainter, intrinsically, than the bright white brown dwarf, 2M1207a— a characteristic well explained by its being a planet roughly five times the mass of Jupiter. The discovery is considered a step toward the ambitious goal of imaging Earth-like planets orbiting distant stars. This image was taken with the high-resolution adaptive-optic NaCo camera attached to the 8-meter Very Large Telescope unit named Yepun at the Paranal Observatory in Chile.

Credit: NaCo, VLT, ESO

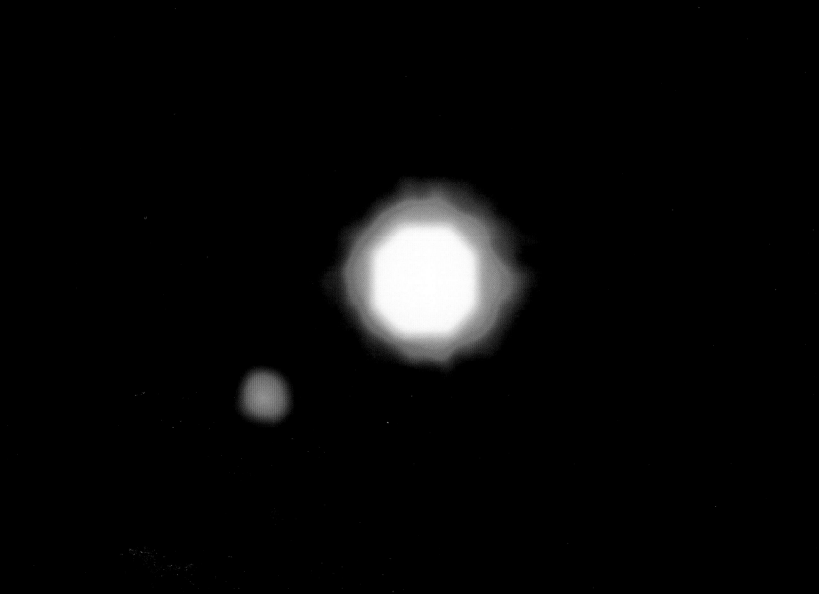

NGC 1499: California Nebula

Drifting through the Orion Arm of the spiral Milky Way Galaxy, this cosmic cloud happens to echo the shape of California on the west coast of the United States. Our own Sun also lies within the Milky Way's Orion Arm, only about 1,500 light-years from the California Nebula. Also known as NGC 1499, the classic emission nebula is approximately 100 light-years long. It glows with the red light characteristic of hydrogen atoms recombining with long-lost electrons, stripped away (ionized) by energetic starlight. In this case, the star most likely providing the energetic starlight is the bright, hot, bluish Xi Persei, just to the right of the nebula and above the center of the image. Fittingly, this composite picture was made with images from a telescope in California—the 48-inch (1.2-meter) Samuel Oschin Telescope—taken as a part of the second National Geographic Palomar Observatory Sky Survey.

Credit: Caltech, Palomar Observatory, Digitized Sky Survey, courtesy of Scott Kardel

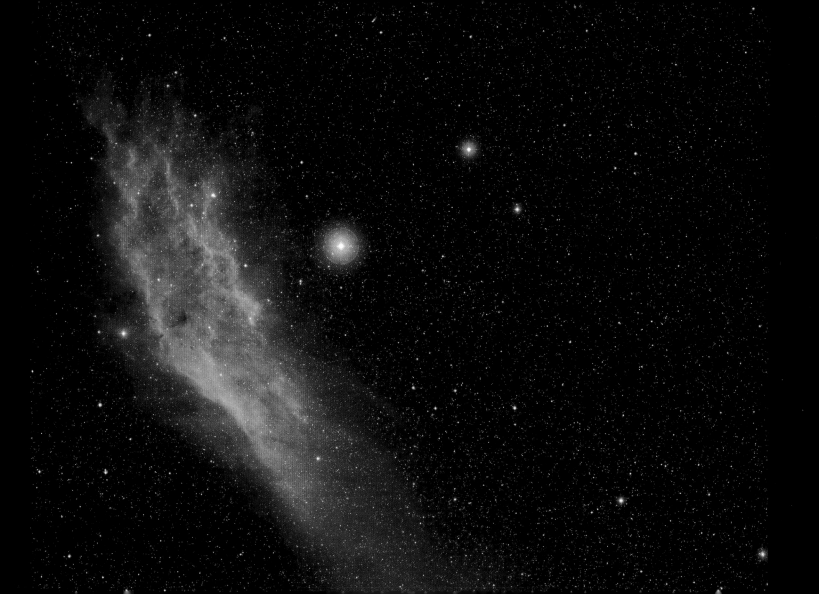

Iridescent Clouds

Why would clouds appear to be different colors? Iridescent clouds, a relatively rare phenomenon, can show unusual colors vividly or a whole spectrum of colors simultaneously. Such clouds are formed of small water droplets of nearly uniform size. When the Sun is in the right position and mostly hidden by thick clouds, these thinner clouds significantly diffract sunlight in a nearly coherent manner, with each color being deflected by a different amount. Therefore, the colors will come to the observer from slightly different directions. Many clouds start with uniform regions that could show iridescence but quickly become too thick, too mixed, or too far from the Sun to exhibit striking colors. These iridescent clouds were photographed over Norway.

Credit & copyright: Arne Danielsen

Infrared Ring Nebula

The classic appearance of the popular Ring Nebula (or M57) is understood to be due to perspective—our view from planet Earth looks down the center of a roughly barrel-shaped cloud of gas. But graceful looping structures are seen to extend even beyond the Ring Nebula's familiar central regions in this false-color infrared image from the Spitzer Space Telescope. Of course, in this well-studied example of a planetary nebula, the glowing material does not come from planets. Instead, the gaseous shroud represents outer layers expelled from a dying Sun-like star. The central ring of the Ring Nebula is about 1 light-year across and 2,000 light-years away. By chance, spiral galaxy IC 1296 is visible in the upper right of this view in the direction of the constellation Lyra. This galaxy is much bigger and, hence, farther away—about 200 million light-years distant.

Credit: J. Hora (Harvard-Smithsonian CfA) (SSC/Caltech), JPL-Caltech, NASA

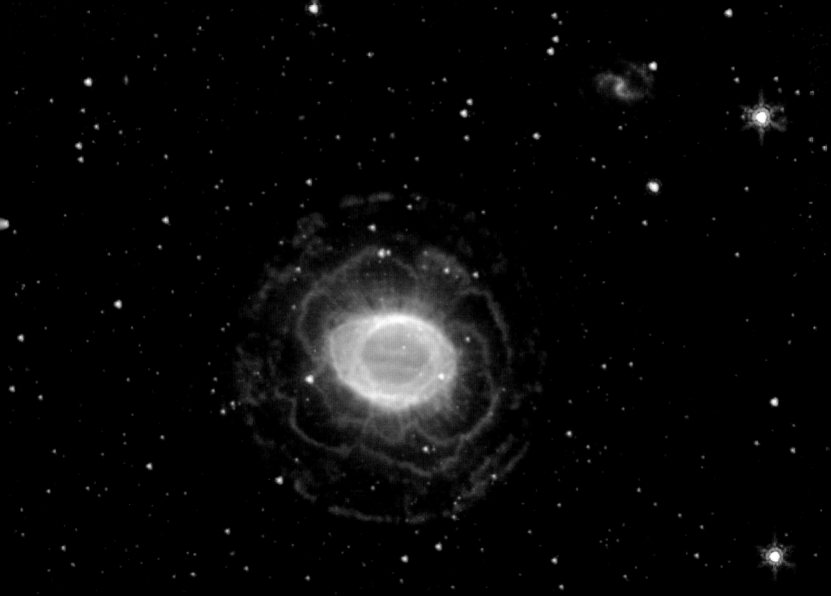

The Star Trails
of Kilimanjaro

The night had no moon, but the stars were out. And camped at 16,000 feet on Mount Kilimanjaro, photographer Dan Heller recorded this marvelous three-and-a-half-hour-long exposure. Here the landscape is lit mostly by the stars. Flashlights give the tents an eerie internal radiance, while the greenish glow from the distant city lights of Moshi, Tanzania, filters through the clouds below. The view from this famous equatorial African mountain is toward the south, putting the south celestial pole close to the horizon at the far left, near the center of the graceful concentric arcs of the star trails in this time exposure. In the thin air and clear, dark skies, even the ghostly Milky Way left a faint triangular glow as it swept across the middle of the vivid scene.

Credit & copyright: www.danheller.com

Steep Cliffs on Mars

Vertical cliffs nearly 2 kilometers high can be found near the north pole of Mars. Also visible are red areas of rock and sand, white areas of ice, and dark areas of unknown composition hypothesized to be volcanic ash. The cliffs are thought to border volcanic caldera. Although the drop of the Martian cliffs is extreme, it is not as dramatic as other areas in our solar system, including the 3.4-kilometer-deep Colca Canyon (in Peru) on Earth and the Verona Rupes cliff on Uranus's moon Miranda, which rises 20 kilometers. This picture, digitally reconstructed into a perspective view, was taken from orbit by the High Resolution Stereo Camera on board the European Space Agency's robot Mars Express spacecraft.

Credit: G. Neukum (FU Berlin) et al., Mars Express, DLR, ESA

Across the heart of the Virgo Cluster lies a striking string of galaxies known as Markarian's Chain, highlighted near the top center by two large but featureless lenticular galaxies, M84 and M86, and connecting to the large spiral at the lower left, M88. Prominent toward the lower right, but not part of Markarian's Chain, is the giant elliptical galaxy M87. The Virgo Cluster is the nearest cluster of galaxies, containing more than 2,000 of them, and has a noticeable gravitational pull on the galaxies of the Local Group surrounding our Milky Way. The center of the Virgo Cluster is located about 70 million light-years away, in the direction of the constellation Virgo. At least seven galaxies in the chain appear to move coherently, although others seem to be superposed by chance.

Credit & copyright: R. Gilbert, J. Harvey, et al. (SSRO)

The Equal Night

O n the Vernal Equinox, the Sun crosses the celestial equator heading north, marking the first day of spring in the northern hemisphere and autumn in the south. The Vernal Equinox occurs each year on or around March 20. Equinox means "equal night," and with the Sun on the celestial equator, Earthlings experience twelve hours of daylight and twelve hours of darkness. For those in the northern hemisphere, the days then continue to grow longer, with the Sun marching higher in the sky, as summer approaches. The situation is reversed on or around September 21, during the Autumnal Equinox. A few weeks after the northern Autumnal Equinox of 1994 (the first day of spring in the southern hemisphere), the crew of the space shuttle Endeavor recorded this image of the Sun poised above Earth's limb (edge). Glare illuminates Endeavor's vertical tail (pointing toward Earth), along with radar equipment in the payload bay.

Credit: STS-68 Crew, NASA

An analemma is the figure-eight loop that results from marking the position of the Sun at the same time each day throughout the year. In this remarkable example, thirty-eight separate exposures (and one foreground exposure) were recorded on a single piece of film between January 12 and December 21, 2002, at 0600 Universal time (6:00 A.M.). The tilt of planet Earth's axis and the variation in speed as it moves around its elliptical orbit combine to produce the predictable analemma curve. The top and bottom of the figure-eight correspond to the solstices—the northern and southern limits of the Sun's sky motion. The two equinoxes find the Sun at points along the analemma curve exactly halfway between the summer and winter solstices. Here, the analemma's southern portion is partly hidden by mountains. In the foreground lie the stone ruins of the Tholos at the ancient site of Delphi, Greece.

Credit & copyright: Anthony Ayiomamitis

March 21

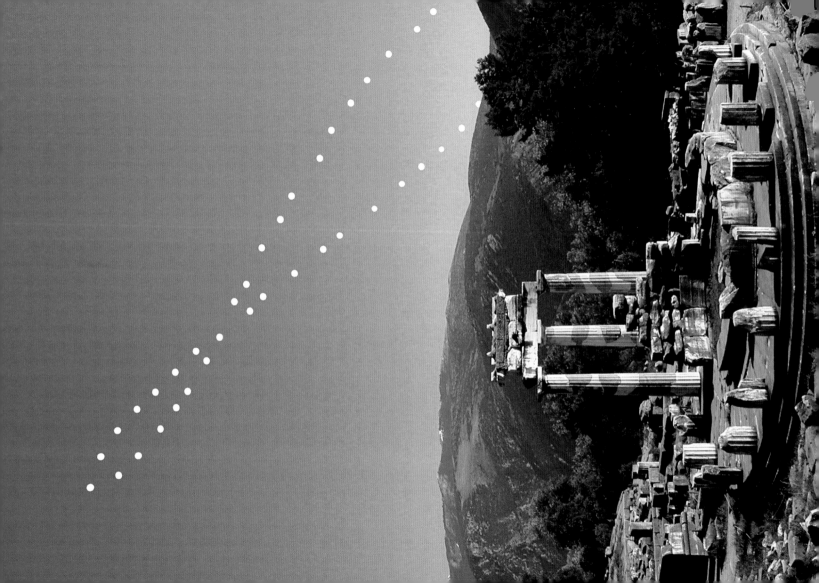

Cartwheel of Fortune

The collision of two galaxies has created a surprisingly recognizable shape on a cosmic scale: the Cartwheel Galaxy. It is part of a group of galaxies about 400 million light-years away in the constellation Sculptor (two smaller ones in the group can be seen below and left). Its rim is an immense ringlike structure over 100,000 light-years in diameter, composed of star-forming regions filled with extremely bright, massive stars. When a smaller galaxy passes through a large one (rarely involving the collision of individual stars), it creates gravitational disruption, compressing the interstellar gas and dust and causing a star-formation wave to move out like a ripple on the water—resulting in this ringlike shape. Several space-based observatories joined forces in the creation of this false-color composite image of the Cartwheel Galaxy: the orbiting Chandra X-ray Observatory's data is in purple, the Galaxy Evolution Explorer's ultraviolet view is in blue, the Hubble Space Telescope's visible-light picture is in green, and the Spitzer Space Telescope's infrared image is in red.

Credit: Chandra, GALEX, Hubble, Spitzer; composite: NASA / JPL / Caltech / P. Appleton et al.

March 22

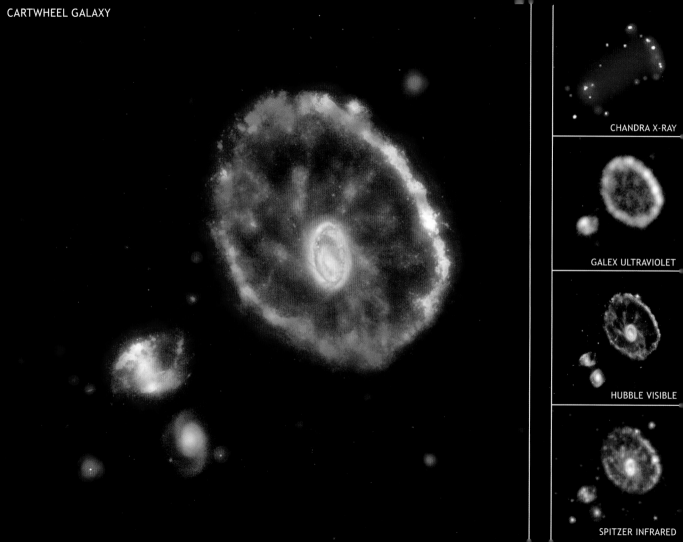

CARTWHEEL GALAXY

CHANDRA X-RAY

GALEX ULTRAVIOLET

HUBBLE VISIBLE

SPITZER INFRARED

Solar System Rising over Fire Island

If you wait long enough, the entire solar system will rise before you. To see such a sight, however, you will need to look in the direction of the ecliptic, the plane in which the planets and their moons orbit the Sun. From Earth, this means that each day they will all rise in nearly the same direction—and later set on the opposite side of the sky. (Smaller members of our solar system, including most comets and many asteroids, do not always move along the ecliptic plane.) In 1995, a series of time exposures caught, left to right, the Sun, Venus, the Moon, and Jupiter, all rising in the ecliptic plane over Fire Island, New York. Exposures were taken every six minutes and digitally superimposed on an image photographed from the same location at sunrise. The picturesque Fire Island Lighthouse, visible in the foreground, was built in 1826.

Credit & copyright: Larry Landolfi (Landolfi Photography)

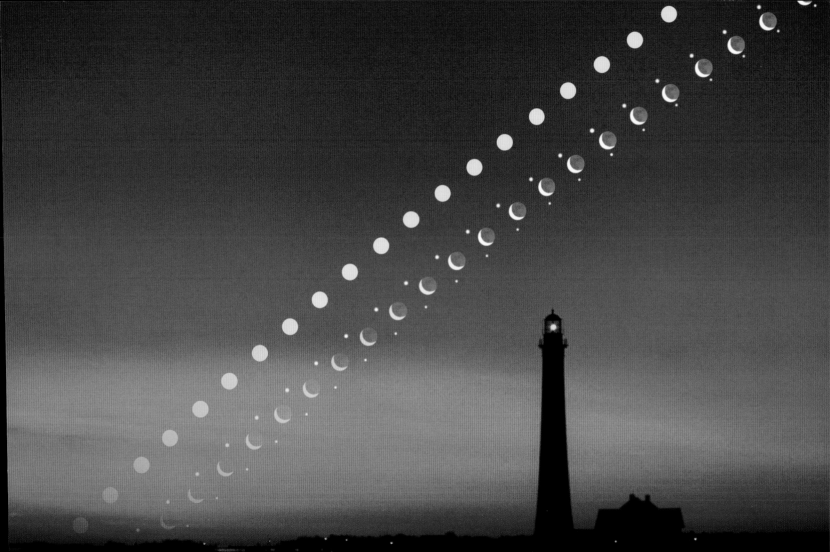

Why is the picture of Cassiopeia A changing? Two images of the nearby supernova remnant, taken a year apart in infrared light, appear to show outward motion at tremendous speeds. This was unexpected, since the supernova that created the picturesque nebula was seen 325 years ago. The reason is likely light echoes. Light from the supernova heated up distant ambient dust that is just beginning to show its glow. As time goes by, more distant dust lights up, giving the appearance of outward motion. This image is a composite of x-ray-, optical-, and infrared-light exposures that have been digitally combined. The infrared-light image was taken by the orbiting Spitzer Space Telescope and was used in the discovery of the light echo. The portion of Cassiopeia A shown spans about 15 light-years and lies 10,000 light-years away toward the constellation Cassiopeia.

Credit: O. Krause (Steward Observatory) et al., SSC, JPL, Caltech, NASA

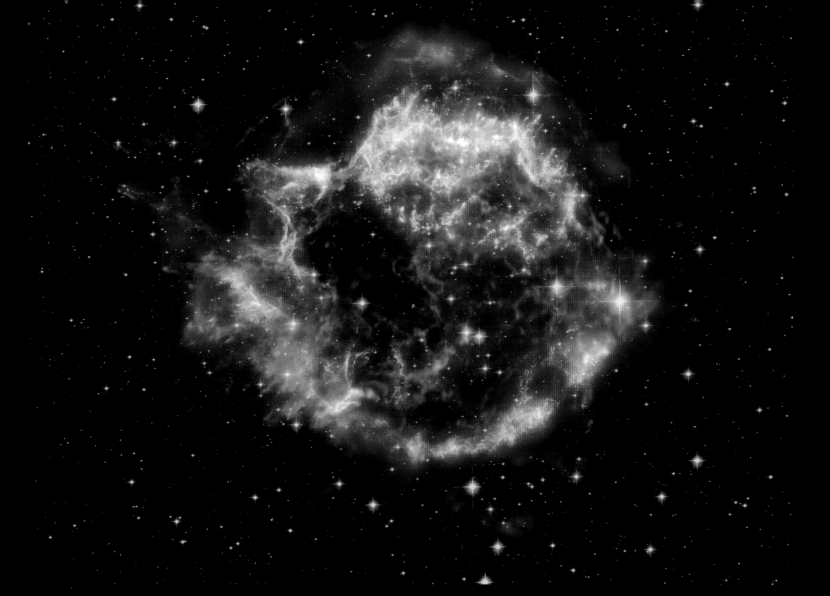

On March 25, 1655, Dutch astronomer Christiaan Huygens discovered Luna Saturni—now known as Saturn's moon Titan. This intriguing picture shows his telescope's lens, all that remains of the instrument he designed, constructed, and used in collaboration with his brother, Constantijn. The lens itself measures 57 millimeters (just over 2 inches) in diameter and is inscribed along the border "X 3 FEBR. MDCLV": its focal length (10 Rhineland feet) and the date of its final polishing, February 3, 1655. It also bears a verse from the Roman poet Ovid: "Admovere oculis distantia sidera nostris" (They brought the distant stars closer to our eyes). Huygens used the verse as part of an anagram announcing his discovery. The use of an anagram, a practice common in his time, established a date for his discovery but kept its details secret until he wished to reveal them. Decoded and translated, the anagram reads, "A moon revolves around Saturn in 16 days and 4 hours"—a good agreement with the modern value for Titan's orbital period.

Credit & copyright: Utrecht University Museum, Institute for History and Foundations of Science, courtesy of Rob van Gent, Tiemen Cocquyt, & Carl Koppeschaar

D azzling in binoculars or a small telescope, the Moon is pocked with impact craters. During partial lunar phases, the craters along the terminator (the dividing line between what is illuminated and what is not) are cast in dramatic relief by strong shadows. But when the Moon is full, some craters seem to sprout systems of bright radial lines, or rays. This detailed close-up of the Full Moon features two prominent ray craters, Copernicus (upper left) and Tycho (bottom center), each with extensive ray systems of light-colored debris blasted out by the crater-forming impacts. In general, ray craters are relatively young; their rays overlay the lunar terrain. In fact, at 85 kilometers wide, Tycho, with its far-reaching rays, is the youngest large crater on the near side. Copernicus, surrounded by dark maria that contrast nicely with its bright rays, is 93 kilometers in diameter.

Credit & copyright: Steve Mandel, Hidden Valley Observatory

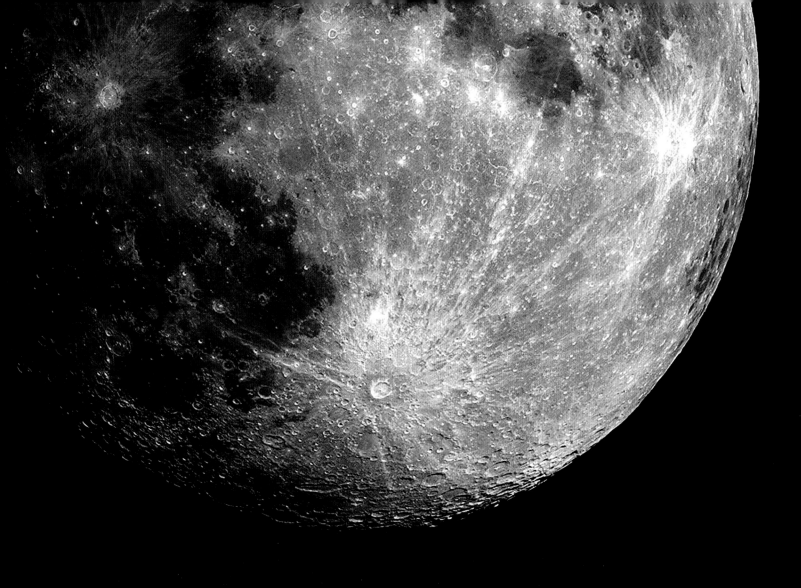

WIRO at Jupiter

Gazing out over the mountaintops from the Wyoming InfraRed Observatory (WIRO), astronomers recently recorded this bizarre-looking image of the solar system's ruling planet, gas giant Jupiter. The false-color picture is a composite of images taken to test a sophisticated digital camera operating at liquid helium temperatures and sensitive to wavelengths about three times longer than visible red light. At those infrared wavelengths (near 2.1 microns), the molecular hydrogen and methane gas in Jupiter's dense lower atmosphere strongly absorb sunlight, so the normally bright, banded planet looks very dark. But particles and haze over the equator and poles rise above the absorbing layers into Jupiter's stratosphere and reflect the infrared sunlight. Also clearly extending into the Jovian stratosphere is the famous Great Red Spot, seen here in yellow just below the equatorial band at the right. North is up in this view, and Jupiter's rapid ten-hour rotation will soon carry the Great Red Spot behind the planet's right limb (edge).

Credit: A. Kutyrev (SSAI/GSFC), D. Rapchun (GST/GSFC), J. Norris (NASA/GSFC), R. Canterna & R. Martin (University of Wyoming)

March 27

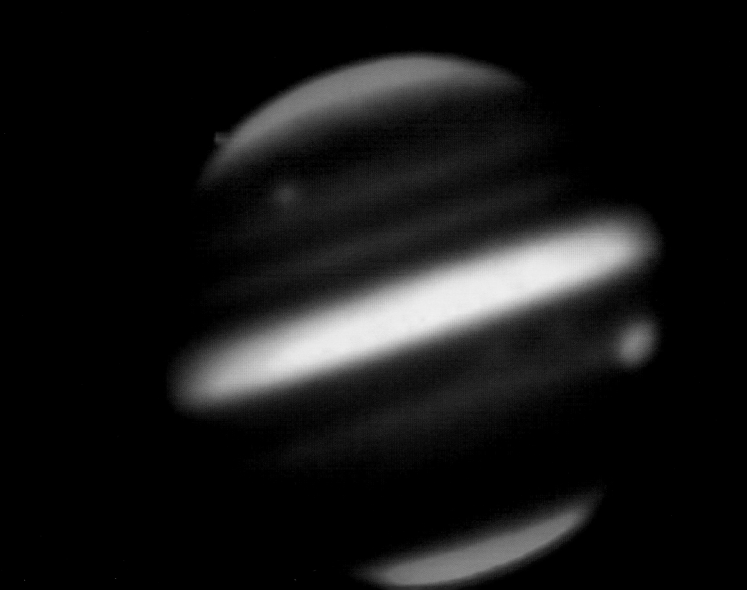

DEM L71: When Small Stars Explode

Large, massive stars end their furious lives in spectacular supernova explosions—but small, low-mass stars may encounter a similar fate. In fact, instead of simply cooling off and quietly fading away, some white dwarfs in binary star systems are thought to draw enough mass from their companions to become unstable, triggering a nuclear detonation. The resulting standard-candle stellar explosion is classified as a Type Ia supernova. Perhaps the best example yet of the aftermath is this expanding cloud of shocked stellar debris, DEM L71, in the nearby Large Magellanic Cloud. This sharp, false-color x-ray image from the orbiting Chandra X-ray Observatory shows the predicted bright edges of the outer blast-wave-shock region and the x-ray glow of an inner region of reverse-shock heated gas. Based on the Chandra data, estimates for the composition and total mass of expanding gas strongly suggest that this is all that remains of a white dwarf. Light from this small star's self-destructive explosion would have first reached planet Earth several thousand years ago.

Credit: *J. Hughes, P. Ghavamian, & C. Rakowski (Rutgers University), et al., CXC, NASA*

March 28

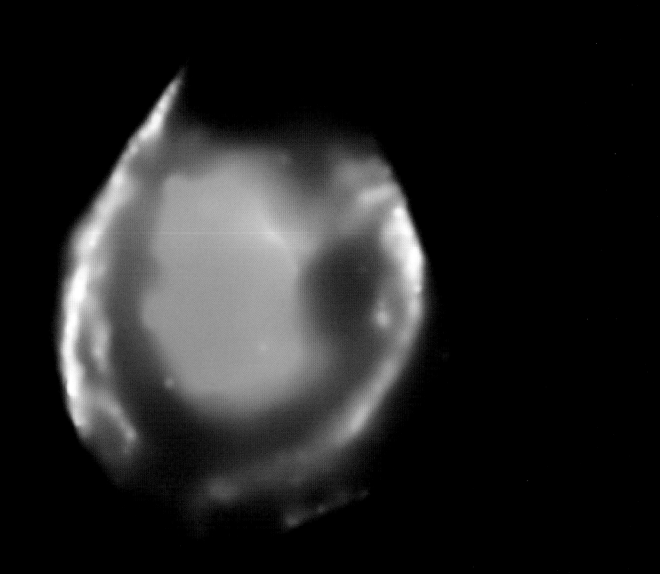

A Lenticular Cloud over Wyoming

Is that a cloud or a flying saucer? Both, although it is surely not an alien spacecraft. Lenticular clouds can be shaped like saucers, and can fly, in the sense that (like most clouds) they are composed of small water droplets that float on air. Lenticular clouds, which can take on strange, layered shapes, are typically formed by high winds over rugged terrain and are particularly apparent when few other clouds are in the sky. A couple stopped their car near Yellowstone National Park in Wyoming to photograph this lenticular cloud above a row of windmills.

Credit & copyright: Mark Meyer (Photo-Mark.com)

March 29

A Green Flash
from the Sun

Many think it is just a myth; others think it is true, but its cause is not known. It is a green flash from the Sun. The green flash really does exist—and its cause is well understood. Just as the setting Sun disappears completely from view, one final glimmer appears startlingly green. The effect is typically visible only from locations with a low, distant horizon, and it lasts just a few seconds. A green flash also can be seen with a rising Sun, but it requires better timing to spot. Why does this happen? The Sun itself does not turn partly green; the effect is caused by layers of Earth's atmosphere acting like a prism. This dramatic green flash was caught in a 1992 photograph from Finland.

Credit & copyright: Pekka Parviainen (Polar Image)

Gamma-Ray Earth

This pixelated planet is actually our own Earth seen in gamma rays, the most energetic form of light. In fact, the gamma rays used to construct this view pack over 35 million electron volts (MeV), compared to a mere 2 electron volts (eV) for a typical visible-light photon. Earth's gamma-ray glow is indeed very faint, and this image was made by combining data from seven years of exposure during the life of the Compton Gamma Ray Observatory, operating in Earth orbit from 1991 to 2000. Brightest near the edge and faint near the center, the picture indicates that the gamma rays are coming from high up in Earth's atmosphere. The gamma rays are produced as the atmosphere interacts with high-energy cosmic rays from space, blocking the harmful radiation from reaching the surface. Astronomers need to understand Earth's gamma-ray glow well, as it can interfere with observations of such cosmic gamma-ray sources as pulsars, supernova remnants, and distant active galaxies powered by supermassive black holes.

Credit: Dirk Petry (GLAST Science Support Center), EUD, EGRET, NASA

March 31

The First Space Quidditch Match

On April Fools' Day, 2001, the historic first space quidditch match came to a spectacular conclusion as astronaut Michael Lopez-Alegria caught the golden snitch, giving the Americans a hard-fought victory over Russia. "The Russians used brilliant strategy, but only NASA had the T2KQMU (Thunderbolt 2000 Quidditch Maneuvering Unit)," said Lopez-Alegria, who is pictured squeezing the elusive golden snitch in his left hand. (When not practicing space quidditch, he and fellow astronaut Jeff Wisoff helped build the International Space Station in October 2000.)

Credit: STS-92 Crew, NASA

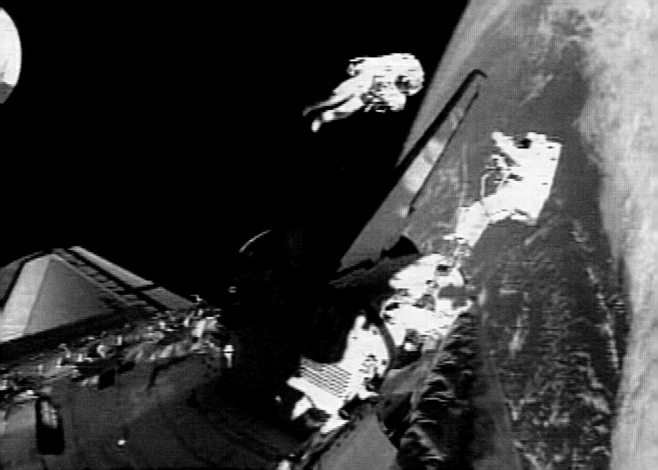

The small Saturnian moon Epimetheus (ep-ee-MEE-thee-us) is at most 116 kilometers across. Its cratered surface and irregular shape are highlighted by dramatic shadows in this composite close-up image from the Cassini spacecraft. However, orbiting 91,000 kilometers above Saturn's cloud tops, Epimetheus is not alone. Similar in size, Saturnian moon Janus occupies an orbit separated from that of Epimetheus by only about 50 kilometers. The two actually approach each other once every four years, but instead of colliding, the moons deftly exchange orbits and move apart again! In fact, co-orbiting Epimetheus and Janus both consist mostly of porous water ice and could have formed from the breakup of a single parent body. The small moons are also believed to play a role in maintaining the outer edge of Saturn's A ring.

Credit: Cassini Imaging Team, SSI, JPL, ESA, NASA

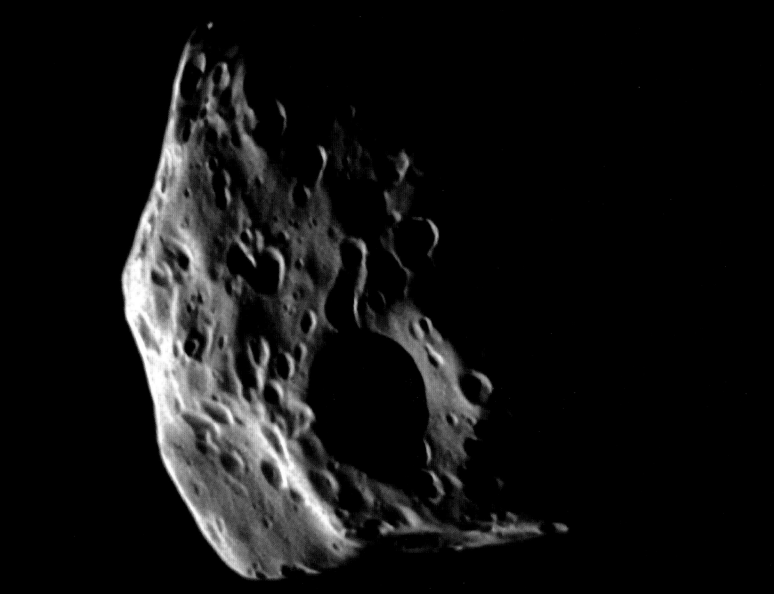

The Fairy of
Eagle Nebula

The greater Eagle Nebula, M16, is actually a giant evaporating shell of gas and dust, inside of which is a growing cavity filled with a spectacular stellar nursery currently forming an open cluster of stars. As powerful starlight whittles away its cold cosmic mountains, the statuesque pillars that remain might be imagined as mythical beasts. This one might be described as a gigantic alien fairy—but this particular fairy is 10 light-years tall and spews radiation much hotter than common fire. The vertical image (top is at left), with scientifically reassigned colors, was released in 2005 as part of the fifteenth-anniversary celebration of the launch of the Hubble Space Telescope.

Credit: Hubble Heritage Team (STScI/AURA), ESA, NASA

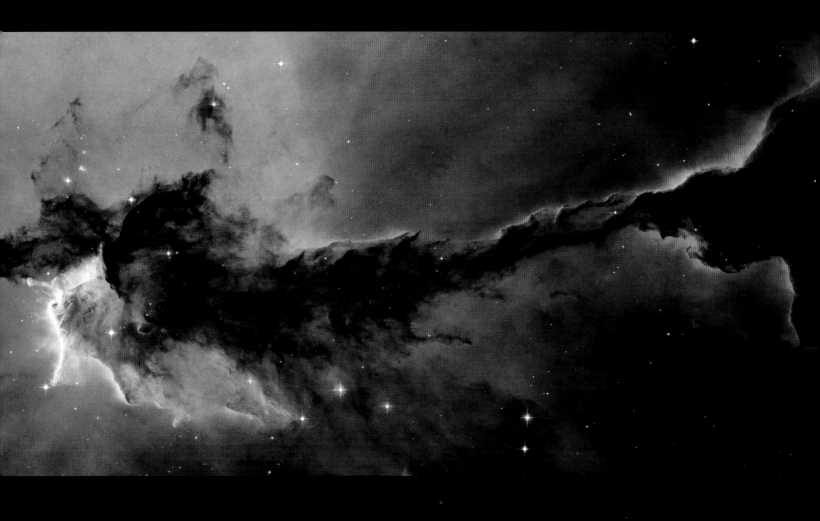

M51: Cosmic Whirlpool

Follow the handle of the Big Dipper away from its bowl, until you get to the handle's last bright star. Then just slide your telescope a little south and west, and you might find this stunning pair of interacting galaxies, the fifty-first entry in Charles Messier's famous eighteenth-century catalog. Perhaps the original spiral nebula, the large galaxy with a well-defined spiral structure is also cataloged as NGC 5194. Its spiral arms and dust lanes clearly sweep in front of its companion galaxy, NGC 5195 (right). The pair are about 31 million light-years distant and officially lie within the boundaries of the small constellation Canes Venatici. Although M51 (also called the Whirlpool Galaxy) looks faint and fuzzy in small, Earthbound telescopes, this sharpest-ever picture of it was made in January 2005 with the Advanced Camera for Surveys on board the Hubble Space Telescope.

Credit: S. Beckwith (STScI), Hubble Heritage Team, ESA, NASA

April 4

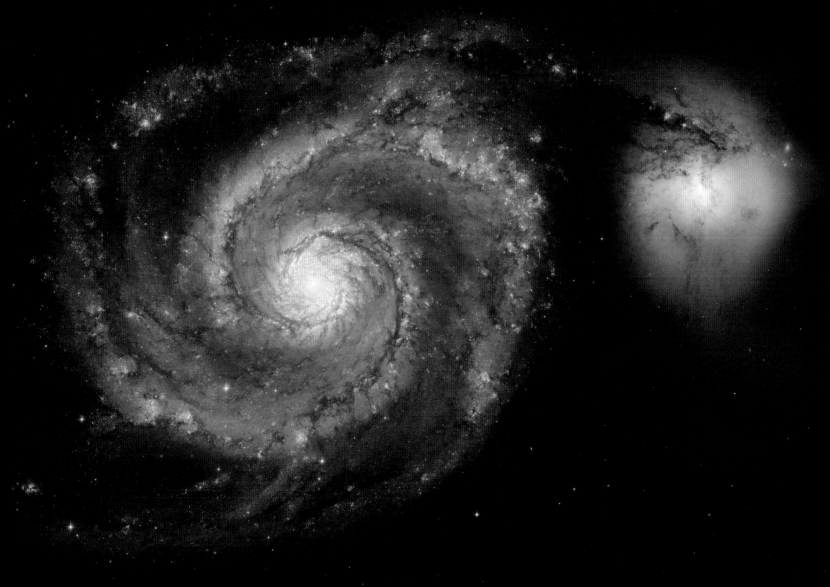

Double Eruptive Prominences

Lofted over the Sun on looping magnetic fields, large solar prominences are composed of relatively cool, dense plasma. When seen in front of the brilliant solar disk, they appear as dark filaments, but these structures are bright when viewed against the blackness of space. In a rare visual treat, these two solar prominences arising from the Sun's southern hemisphere were captured in extreme ultraviolet light by the Extreme ultraviolet Imaging Telescope (EIT) camera on board the space-based Solar and Heliospheric Observatory (SOHO) on March 21, 2003. In a matter of hours, these enormous prominences—reaching a height of about twenty times the diameter of planet Earth—apparently erupted away from the Sun's surface and may have been associated with a flare and coronal mass ejection.

Credit: SOHO–EIT Consortium, ESA, NASA

April 5

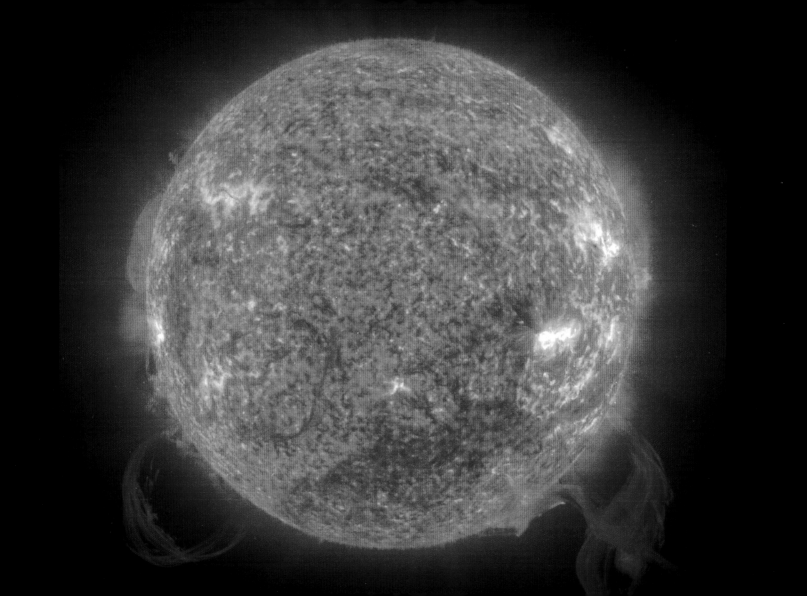

Barnard's Loop around Orion

Why is Orion's belt—seen as the three bright stars diagonally across this image (center), the upper two noticeably blue—surrounded by a bubble? Although the bubble, known as Barnard's Loop, glows like an emission nebula, its origin is currently unknown. Progenitor hypotheses include the winds from bright Orion stars and the supernovae of stars long gone. Barnard's Loop is too faint to be identified with the unaided eye; it was discovered only in 1895, by E. E. Barnard, on long-duration film exposures. Just below the lowest star in Orion's belt is a slight indentation in an emission nebula that, when seen at higher magnification, resolves into the Horsehead Nebula. Farther below the belt's stars is the bright, famous, and photogenic Orion Nebula.

Credit & copyright: W. H. Wang (IfA, University of Hawaii)

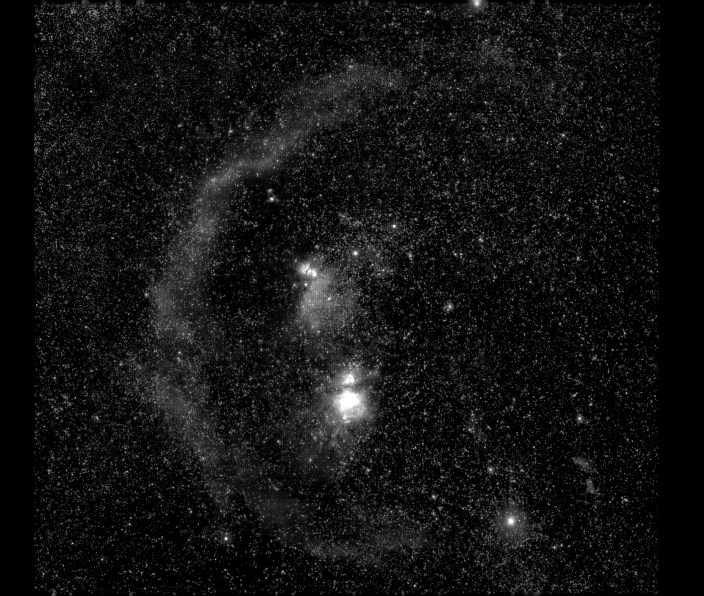

Comet C/2001 Q4

Inbound from the distant solar system, comet C/2001 Q4 passed just inside planet Earth's orbit, becoming one of two comets visible in southern skies to the naked eye in May 2004. First spotted three years earlier by the Near Earth Asteroid Tracking (NEAT) project, Q4 appears in these stunning telescopic views recorded from a site near Alcohuaz, Chile, on April 18 (left) and 19, 2004. A comparison of the two photos reveals remarkable changes in the structure of the long, graceful tail, including the dramatic kink seen close to its midpoint on April 19. The apparent motion of the comet sweeping across the sky is evident when you compare the position of the tail relative to background galaxy NGC 1313, visible as a smudge toward the top of each image. Q4's closest approach to the Sun was on May 15, and to planet Earth on May 7.

Credit & copyright: Loke Kun Tan (StarryScapes)

April 7

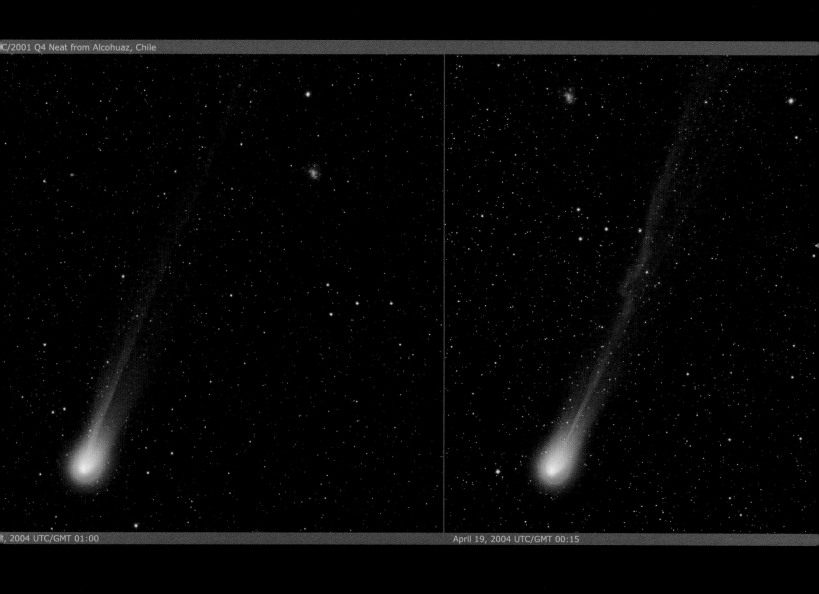

C/2001 Q4 Neat from Alcohuaz, Chile

, 2004 UTC/GMT 01:00

April 19, 2004 UTC/GMT 00:15

I t takes a big rocket to go into space. This huge Russian R7 rocket, which spans the width of a football field and has a fueled mass of about a half-million kilograms, was launched toward the Earth-orbiting International Space Station (ISS) in April 2003, carrying two American astronauts who made up the new Expedition 7 crew. Seen here during rollout at the Baikonur Cosmodrome, the rocket was originally developed as a prototype intercontinental ballistic missile in 1957; the white top is a Soyuz TMA-2, the most recent version of the longest-serving type of human-carrying spacecraft. Russian rockets were the primary means of transportation to the ISS while NASA studied the reasons behind the tragic breakup of the space shuttle Columbia.

Credit: Scott Andrews, NASA

The Last Titan

On October 19, 2005, a rocket blasted off from Vandenberg Air Force Base—the last Titan rocket. Carrying a payload for the U.S. National Reconnaissance Office, the successful Titan IV B launch brought to a close the Titan program, which had its first launch back in 1959. Originally designed as an intercontinental ballistic missile, the Titan rocket ultimately evolved into a heavy-lift workhorse, launching defense, commercial, and scientific payloads into Earth orbit and beyond. In fact, many historic space voyages began with Titan launches, including manned Gemini missions, the Viking missions to Mars, the Voyager tours of the outer solar system, and the Cassini spacecraft's exploration of the Saturnian system. Cassini's Huygens probe accomplished the most distant landing on another world, while Voyager 1 is now humanity's most distant spacecraft.

Credit: Courtesy of 30th Space Wing, Vandenberg Air Force Base

April 9

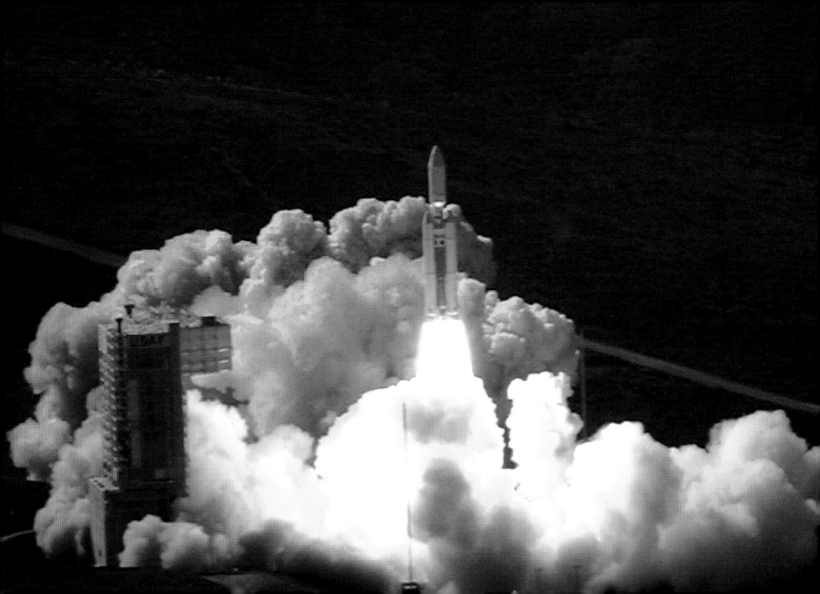

Sideways Galaxy
NGC 3628

Dark dust lanes cutting across the middle of this gorgeous island universe strongly hint that NGC 3628 is a spiral galaxy seen sideways. About 35 million light-years away in the northern springtime constellation Leo, NGC 3628 also bears the distinction of being the only member of the well-known Leo triplet of galaxies not in Charles Messier's famous catalog. Otherwise similar in size to our Milky Way Galaxy, the disk of NGC 3628 is clearly seen to fan out near the galaxy's edge. A faint arm of material also extends up and to the left in this deep view of the region. The distorted shape and tidal tail suggest that NGC 3628 is interacting gravitationally with the other spiral galaxies in the Leo triplet, M66 and M65.

Credit & copyright: Russell Croman

April 10

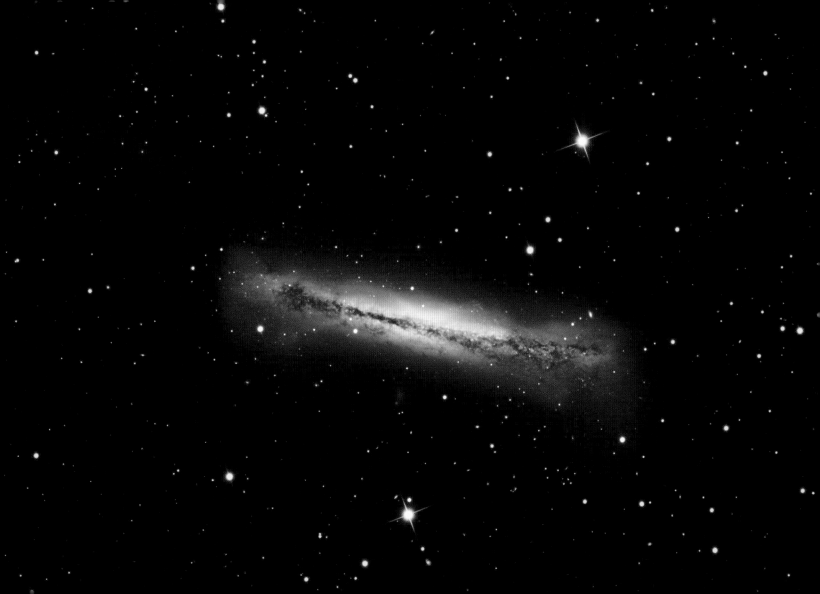

M7 is one of the most prominent open clusters of stars. Dominated by bright blue stars, the cluster can be seen with the naked eye in a dark sky in the tail of the constellation Scorpius. M7 contains about 100 stars in total, is about 200 million years old, spans 25 light-years, and lies about 1,000 light-years away. It has been known since ancient times, at least as far back as Ptolemy in A.D. 130. This color picture was taken in 2005 at the Kitt Peak National Observatory in Arizona, as part of the Advanced Observers Program. Also visible in this image is a dark dust cloud near the bottom of the frame, along with literally millions of unrelated stars toward the galactic center.

Credit & copyright: Allan Cook & Adam Block, NOAO, AURA, NSF

NGC 1316:
After Galaxies
Collide

How did this strange-looking galaxy form? Astronomers turn detective when trying to figure out the cause of unusual jumbles of stars, gas, and dust such as NGC 1316. A preliminary inspection indicates that NGC 1316 is an enormous elliptical galaxy that includes dark dust lanes usually found in a spiral. This image taken by the Hubble Space Telescope, however, shows details that help in reconstructing the history of this gigantic jumble. Close inspection finds fewer low-mass globular clusters of stars toward NGC 1316's center. Such an effect is expected in galaxies that have undergone collisions or merger with other galaxies in the past few billion years. After such collisions, many star clusters would be destroyed in the dense galactic center. The dark knots and lanes of dust indicate that one or more of the devoured galaxies were spirals. NGC 1316 spans about 60,000 light-years and lies about 75 million light-years away in the direction of the constellation of the Furnace (Fornax).

Credit: P. Goudfrooij (STScI), Hubble Heritage Team (STScI/AURA), ESA, NASA

April 12

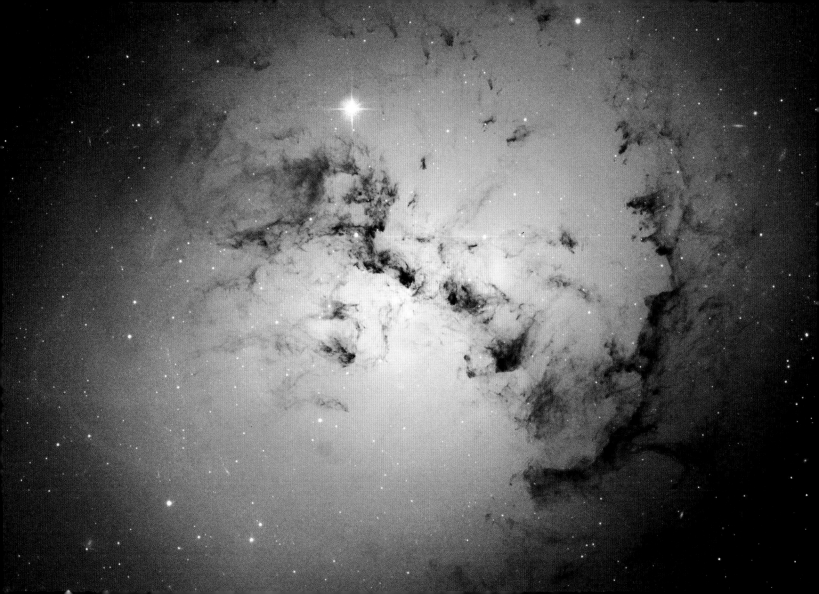

Saturnian Moon and Rings

A robot can produce art when it glides past the rings of Saturn. As the Cassini spacecraft crossed outside the famous photogenic ring plane of the expansive planet, Saturn's rings were imaged from the outside, nearly edge on, and in the gas giant's shadow. From the left, ring features include the A ring, the Cassini gap, the B ring, and the darker C ring, which includes the Titan gap and an as-yet-unnamed gap. When the image was taken in 2005, the gliding spacecraft was about 1 million kilometers from Enceladus, a small Saturnian moon only about 500 kilometers across.

Credit: Cassini Imaging Team, SSI, JPL, ESA, NASA

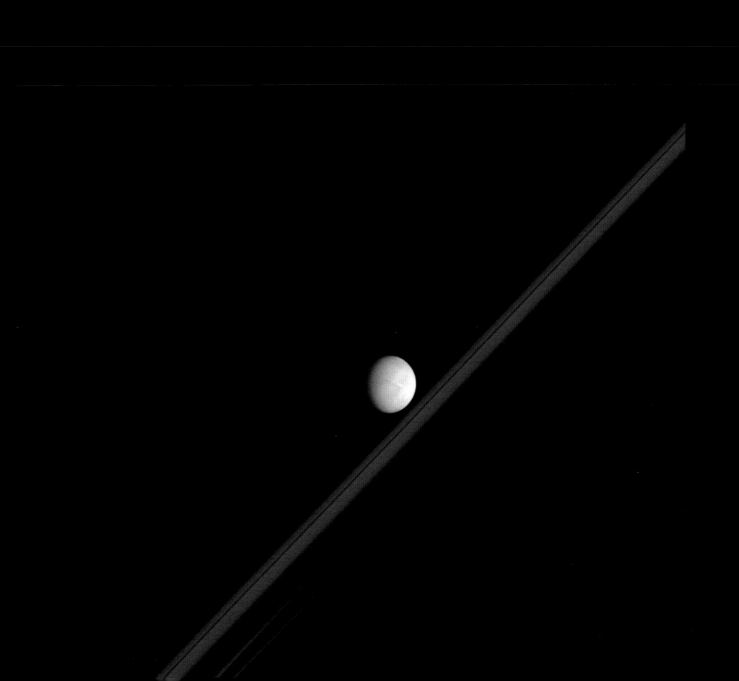

A Window to the Once-Secret Sky

If there were a nearby window to the distant universe, would you look through it? Why not take advantage of a local skykeeper—a relative, friend, or stranger with a small telescope who is proud to show off the sky free of charge? Looking through the eyepiece on a dark, cloudless night, you can see clusters of stars, rings around Saturn, glowing nebulae of gas, craters on the Moon, and galaxies across the universe. The technology to create this window and the secret sky it reveals were unknown only 400 years ago. This small telescope is deployed at picturesque Hohe Wand, about 50 kilometers south of Vienna, Austria. The long star trails make the spin of planet Earth visible.

Credit & copyright: Peter Wienerroither (Universität Wien)

Magma Bubbles from Mount Etna

Mount Etna, which erupted spectacularly in June 2001, was photographed expelling bubbles of hot magma, some of which measured more than 1 meter across. One reason planetary geologists study Earth's Mount Etna is its likely similarity to volcanoes on Mars. A basalt volcano located in Sicily, Italy, Mount Etna is composed of material similar to that of the Red Planet; in addition, it produces lava channels very much like those on Mars. Mount Etna is not only one of the most active volcanoes on Earth, it is one of the largest, measuring over 50 kilometers at its base and rising nearly 3 kilometers high.

Credit & copyright: Marco Fulle (stromboli.net)

April 15

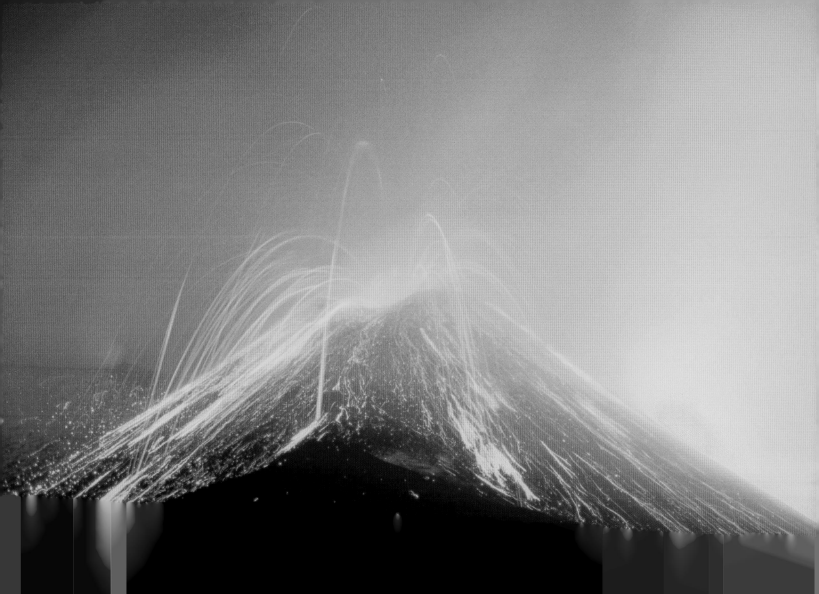

Stars of the Galactic Center

The center of our Milky Way Galaxy is hidden from the prying eyes of optical telescopes by clouds of obscuring dust and gas. But in this stunning vista, the Spitzer Space Telescope's infrared cameras penetrate much of the dust, revealing the stars of the crowded galactic center. A mosaic of many smaller snapshots, this detailed, false-color image shows older, cool stars in bluish hues; reddish glowing dust clouds are associated with hot young stars in stellar nurseries. The galactic center lies some 26,000 light-years away, toward the constellation Sagittarius. At that distance, this picture spans about 900 light-years.

Credit: Susan Stolovy (SSC/Caltech) et al., JPL-Caltech, NASA

April 16

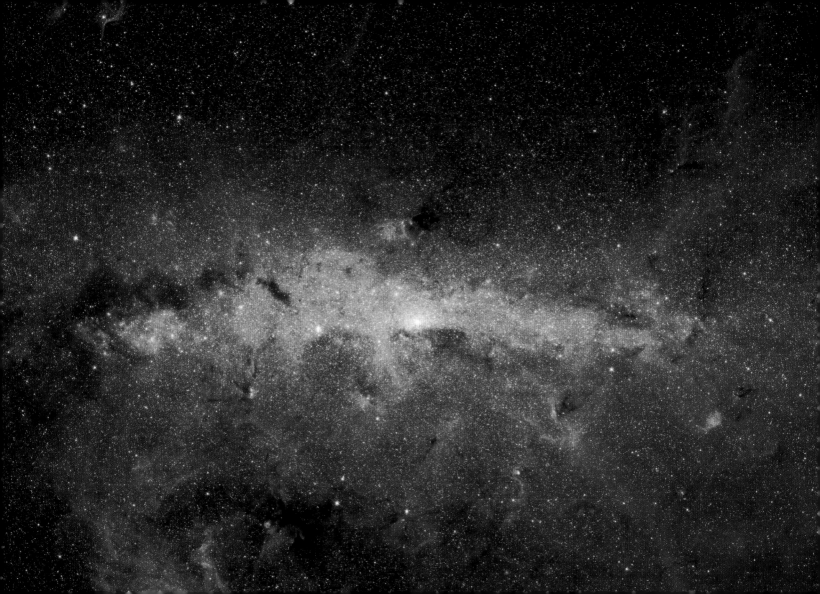

Aurora from Space

From the ground, auroras dance high above clouds, frequently causing spectacular displays. What do they look like from space? The International Space Station (ISS) offers a valuable vantage point since it orbits at approximately the same height as many auroras. Sometimes it flies over them, but at other times it passes right through. The auroral electron and proton streams are too thin to be a danger to the ISS, just as clouds pose little danger to airplanes. ISS Science Officer Don Pettit captured a green aurora in this digitally sharpened image. From orbit, Dr. Pettit reports, changing auroras can appear to crawl around like giant green amoebas. Far below, on planet Earth, the Manicouagan Impact Crater can be seen in northern Canada.

Credit: Don Pettit, ISS Expedition 6, NASA

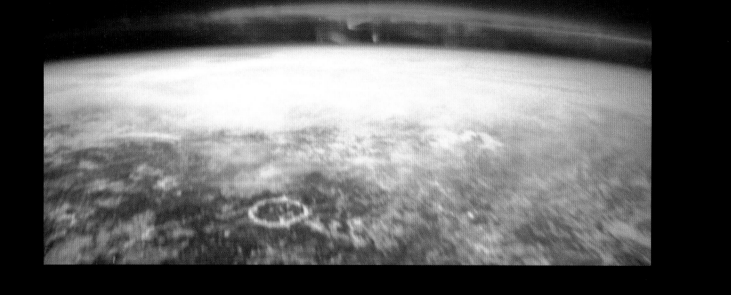

RCW 79: Stars in a Bubble

A cosmic bubble of gas and dust, nebula RCW 79 has grown to about 70 light-years in diameter, blown by the winds and radiation from hot young stars. Infrared light from its embedded dust is tinted red in this gorgeous false-color view from the Spitzer Space Telescope. A good 17,000 light-years away in the grand southern constellation Centaurus, the expanding nebula has itself triggered star formation as it plows into the gas and dust surrounding it. In fact, this penetrating infrared picture reveals groups of new stars as yellowish points scattered along the bubble's edge. One remarkable group still lies within its own natal bubble at about seven o'clock (lower left), while another can be seen near the upper gap at about three o'clock (right) from the bubble's center.

Credit: E. Churchwell (University of Wisconsin–Madison) et al., JPL-Caltech, NASA

April 18

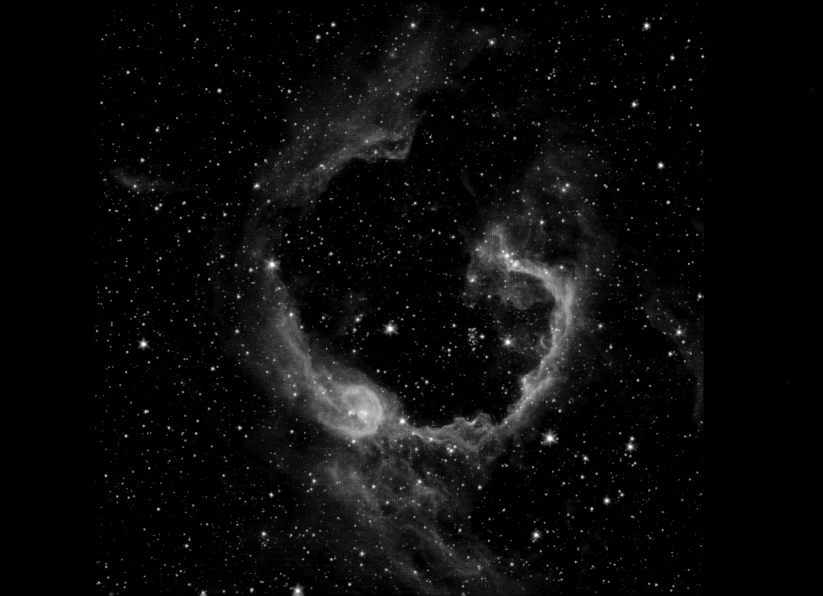

Clouds, Plane, Sun, Eclipse

How can part of the Sun just disappear? When it is hiding behind the Moon. During a solar eclipse, the Sun, Moon, and Earth are aligned. The April 2005 total solar eclipse was primarily visible from the southern Pacific Ocean, while a partial solar eclipse was seen across South America and lower North America. This vertical composite image was taken with a handheld digital camera. After a day of rain in Mount Holly, North Carolina, a partially eclipsed Sun momentarily peeked through a cloudy sky. After taking a sequence of images, the photographer digitally combined the best eclipse shot with one that featured a passing airplane.

Credit & copyright: Dorothy Verdin

Deep in the normally hidden recesses of giant molecular cloud DR21, a stellar nursery has been found, creating some of the most massive stars yet recorded. In 2004, the orbiting Spitzer Space Telescope's Infrared Array Camera opened a window into the cloud, using mid-infrared light. The cloud is opaque to visible light because of dense interstellar dust. Noticeable in this representative-color infrared Spitzer image are huge bubbles, a complex tapestry of dust and gas, and very massive stars. The infrared filaments actually glow because of organic compounds known as PAHs (polycyclic aromatic hydrocarbons). The intricate patterns are caused by complex interactions between interstellar winds, radiation pressures, magnetic fields, and gravity. The pictured region spans about 100 light-years and lies about 6,000 light-years distant toward the constellation Cygnus.

Credit: A. Marston (ESTEC/ESA) et al., JPL, Caltech, NASA

April 20

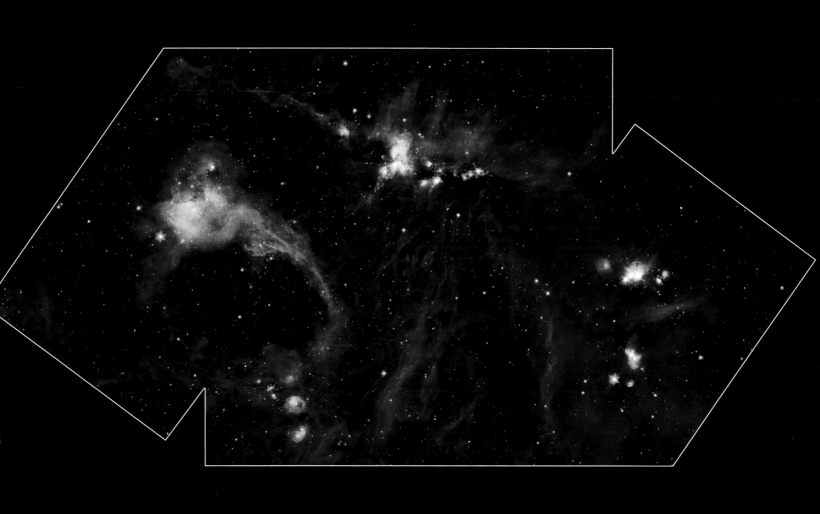

Moon-Slide Slim

No special filters—or even a telescope—are required to enjoy a leisurely lunar eclipse. In fact, watched from all over the nightside of planet Earth, these regular celestial performances have entertained many casual skygazers. Still, this eye-catching picture of a lunar eclipse may look unfamiliar. To make it, astrophotographer Doug Murray set his camera on a tripod and locked the shutter open during the total lunar eclipse of January 2000. The resulting image records the trail of the Moon sliding through the night, steadily progressing toward the total eclipse phase as seen from Florida. Haunting red hues of diminished moonlight, common during the total phase of a lunar eclipse, are evident at the far right, along the slimmer portion of the trail.

Credit & copyright: Doug Murray

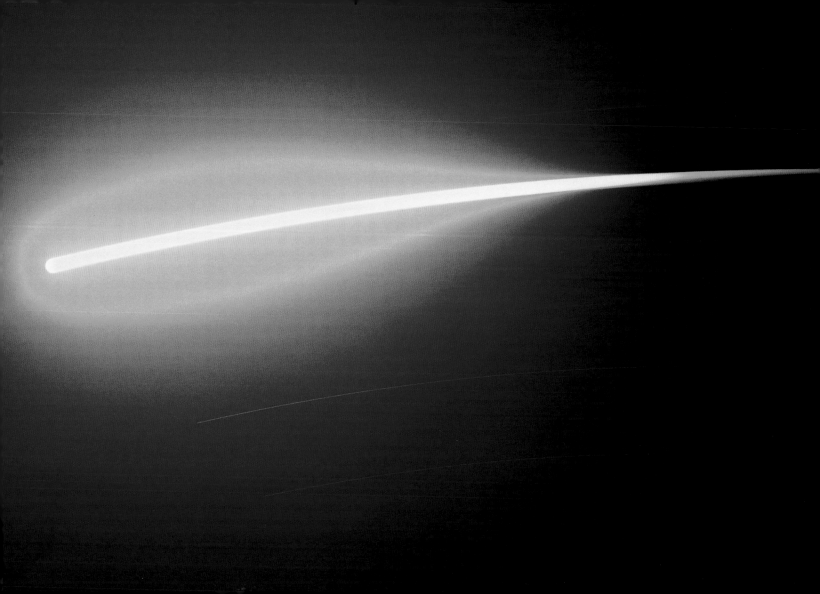

A Crescent Nebula Star Field

Looking like a butterfly emerging from a space cocoon, the Crescent Nebula was created by the brightest star in its center. A leading progenitor hypothesis has the Crescent Nebula beginning to form about 250,000 years ago. At that time, the massive central star had evolved to become a hot Wolf-Rayet star (WR 136), shedding its outer envelope in a strong stellar wind, ejecting the equivalent of our Sun's mass every 10,000 years. This wind compacted the surrounding gas left over from a previous phase, making it into a series of complex shells, and lit it up. The Crescent Nebula, also known as NGC 6888, lies about 4,700 light-years away in the constellation Cygnus. Star WR 136 will probably undergo a supernova explosion sometime in the next million years.

Credit & copyright: T. A. Rector (NRAO), NOAO, AURA, NSF

Ring Galaxy
AM 0644-741

How could a galaxy become shaped like a ring? The rim of the blue galaxy pictured here, AM 0644-741, is an immense structure, 150,000 light-years in diameter, composed of newly formed, extremely bright, massive stars. Known as a ring galaxy, it was created by an immense galactic collision. When galaxies collide, they pass through each other—their individual stars rarely come into contact. The ringlike shape results from the gravitational disruption that occurs when an entire small intruder galaxy passes through a large one. Interstellar gas and dust become condensed, causing a wave of star formation to move out from the impact point like a ripple across the surface of a pond. The intruder galaxy has long since moved out of the frame taken by the Hubble Space Telescope. Ring galaxy AM 0644-741 lies about 300 million light-years away.

Credit: Hubble Heritage Team (AURA/STScI), J. Higdon (Cornell) ESA, NASA

April 23

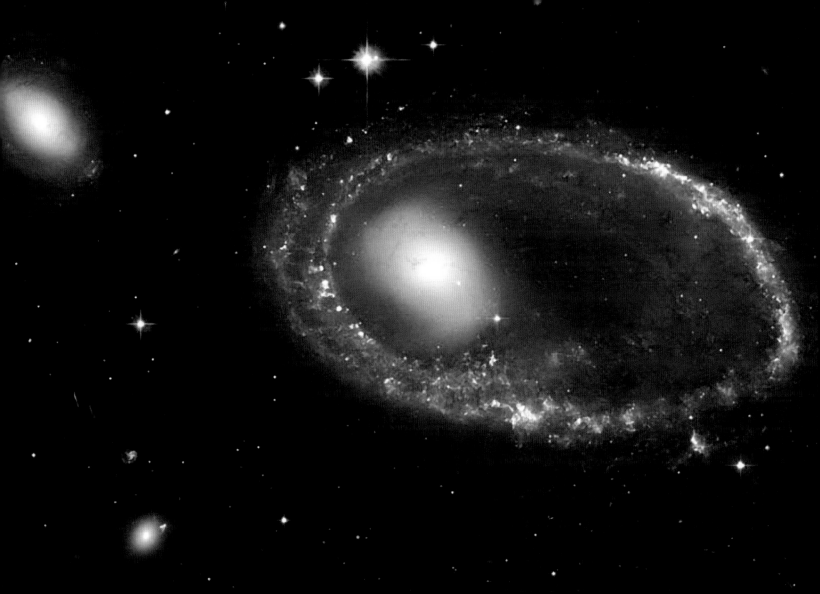

Does gravity have a magnetic counterpart? Spin any electric charge and you get a magnetic field. Spin any mass and, according to Albert Einstein, you should get a very slight effect that acts something like magnetism. This effect is expected to be so small that it is beyond practical experience and even beyond laboratory measurement—until now. In a bold attempt to directly measure gravitomagnetism, NASA launched into space the smoothest spheres ever manufactured, to see how they spin. These four spheres, each roughly the size of a Ping-Pong ball, are the key to the ultraprecise gyroscopes at the core of Gravity Probe B. Will the gyroscopes feel gravitomagnetism and wobble at the rate Einstein would have predicted? Stay tuned. A better understanding of space, time, and gravity can have untold long-term effects, as well as likely shorter-term benefits such as better clocks and global positioning trackers.

Credit: Gravity Probe B Team, Stanford, NASA

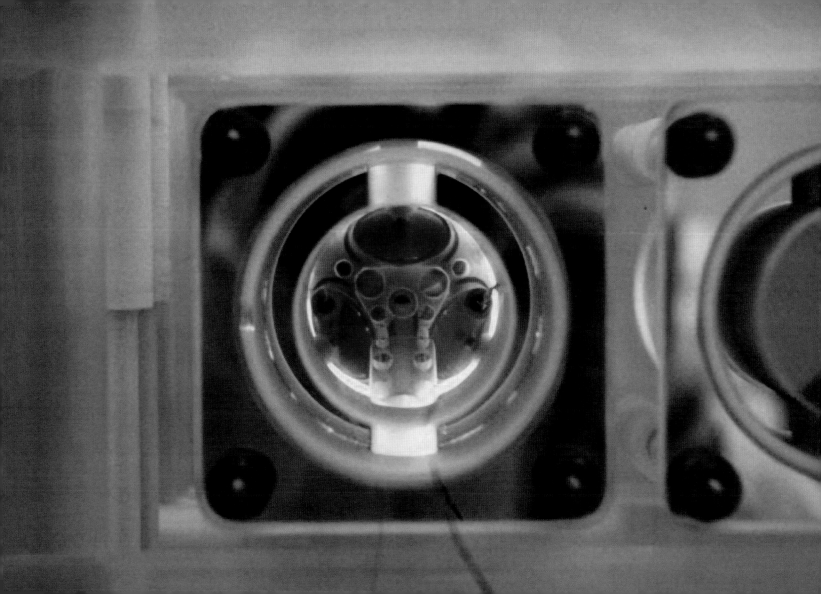

Crab Nebula Mosaic from Hubble

The Crab Nebula is cataloged as M1, the first object on Charles Messier's famous eighteenth-century list of things in space that are not comets. The cosmic Crab is now known to be a supernova remnant, an expanding cloud of debris from the explosion of a massive star. Astronomers on planet Earth first witnessed light from that stellar catastrophe in the year 1054. This Hubble Space Telescope mosaic, composed of twenty-four exposures taken in October 1999, January 2000, and December 2000, spans about 12 light-years. Colors in the intricate filaments trace the light emitted from atoms of hydrogen, oxygen, and sulfur in the debris cloud. The spooky blue interior glow is emitted by high-energy electrons, accelerated by the Crab's central pulsar. One of the most exotic objects known to modern astronomers, the pulsar is a neutron star, the spinning remnant of the collapsed stellar core. The Crab Nebula lies about 6,500 light-years away in the constellation Taurus.

Credit: NASA, ESA, J. Hester, A. Loll (ASU); acknowledgment: Davide De Martin (www.skyfactory.org)

April 25

Elusive Jellyfish Nebula

Normally faint and elusive, the Jellyfish Nebula is caught in the net of this spectacular wide-field telescopic view. Flanked by two yellow-tinted stars at the foot of a celestial twin—Mu and Eta Geminorum—the Jellyfish Nebula is the brighter arcing ridge of emission just right of center, with tentacles dangling toward the lower right. Here, the cosmic jellyfish is seen to be part of the bubble-shaped supernova remnant IC 443, the expanding debris cloud from an exploded star some 5,000 light-years away. Also in view, emission nebula IC 444, dotted with small blue reflection nebulae, nearly fills the field at the upper left. Like its cousin in astrophysical waters, the Crab Nebula, IC 443 is known to harbor a neutron star, the collapsed core of a massive star that exploded over 30,000 years ago.

Credit & copyright: Johannes Schedler (Panther Observatory)

Earth at Twilight

No sudden, sharp boundary marks the passage from day into night in this gorgeous view of ocean and clouds of our fair planet Earth. Instead, the shadow line, or terminator, is diffuse and shows the gradual transition to darkness that we experience as twilight. With the Sun illuminating the scene from the right, the cloud tops reflect gently reddened sunlight filtered through the dusty troposphere, the lowest layer of the planet's nurturing atmosphere. A clear high-altitude layer, visible along the dayside's upper edge, scatters blue sunlight and fades into the blackness of space. This picture actually is a single digital photograph, taken in June 2001 from the International Space Station, orbiting at an altitude of 211 nautical miles.

Credit: ISS Crew, Earth Sciences and Image Analysis Lab, JSC, NASA

April 27

The Hercules Cluster of Galaxies

These are galaxies of the Hercules Cluster, an archipelago of so-called island universes a mere 650 million light-years distant. This cluster is loaded with gas- and dust-rich star-forming spiral galaxies but has relatively few elliptical galaxies, which lack gas and dust and the associated newborn stars. Colors in the composite image show the star-forming galaxies with a blue tint and ellipticals with a slightly yellowish cast. In this cosmic vista, many galaxies appear to be colliding or merging, while others seem distorted—clear evidence that cluster galaxies commonly interact. Over time, the galactic interactions are likely to affect the content of the cluster itself. Researchers believe that the Hercules Cluster is significantly similar to young clusters of galaxies in the distant, early universe, and that exploring different types of galaxies and their interactions in nearby Hercules will help unravel the threads of galactic and cluster evolution.

Credit & copyright: Jim Misti (Misti Mountain Observatory)

April 28

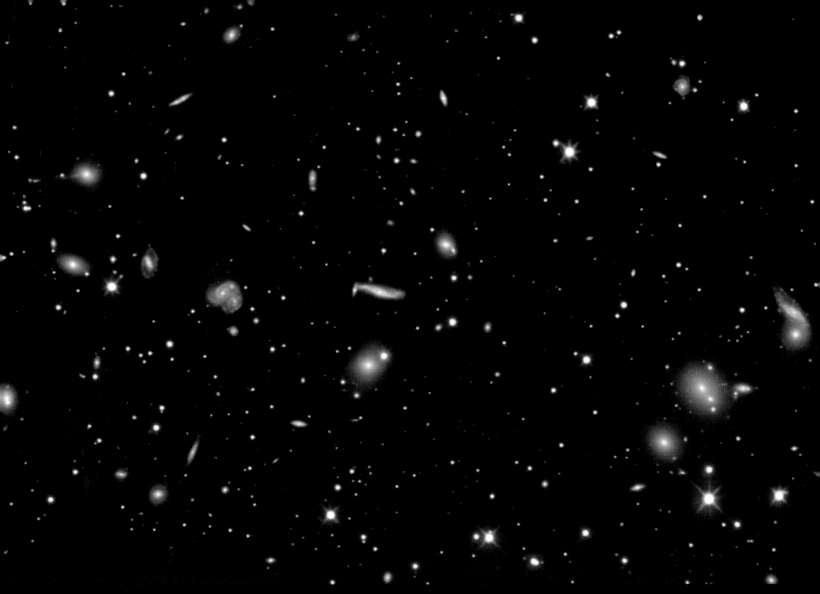

Earth or Mars?

Which image is Earth, and which is Mars? One of these images was taken by the robot Spirit rover while climbing Husband Hill on Mars. The other was taken by a human looking across the desert south of Morocco on Earth. Both show vast plains covered with rocks and sand, and neither shows water or obvious signs of life. Each planet has a surface so complex that it is not possible for any one image to do it justice. Understanding either one, it turns out, helps explain the other. Does the one on the left look like home? Possibly not, but it is Earth.

Earth image credit & copyright: Filipe Alves; Mars image credit: Mars Exploration Rover Mission, JPL, NASA

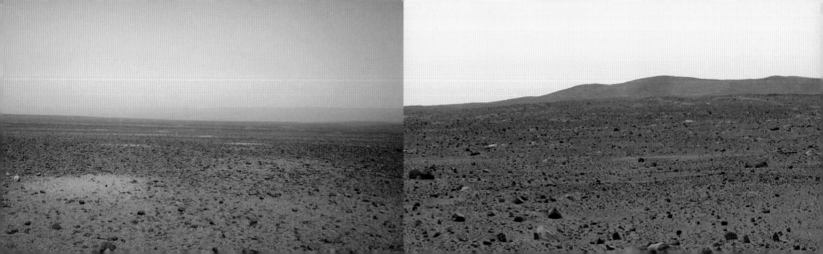

peak of a distant iceberg in this stunning view. The Moon's shape is due to atmospheric bending of light, or refraction—an effect that is more severe closer to the horizon. Skimming low along the stark features of the frozen landscape, the Moon's lower edge appears noticeably more distorted than the upper limb. Along with about seventy other people present at Davis Station, Dr. Jim Behrens had a chance to enjoy the view while studying the ongoing detachment of a large iceberg known as "Loose Tooth."

Credit & copyright: James Behrens (IGPP, Scripps Institution of Oceanography)

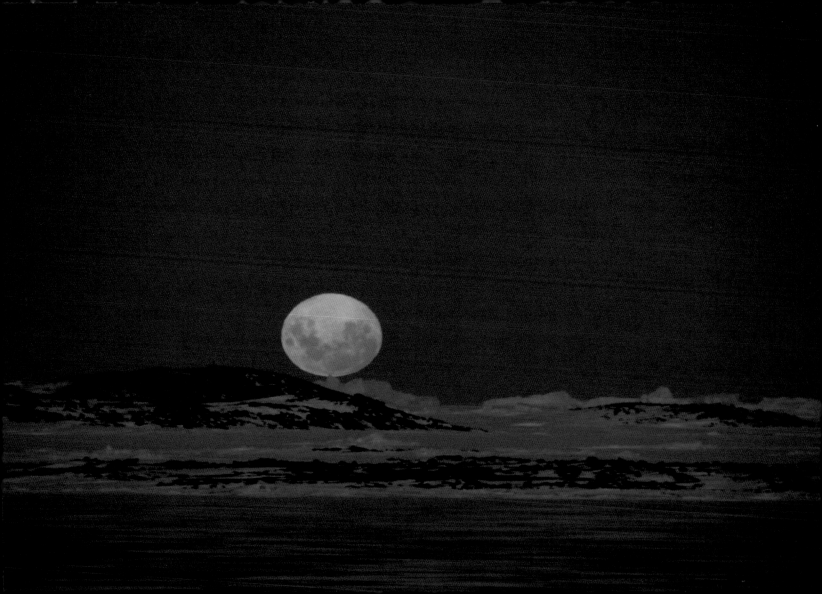

NGC 3370:
A Sharper View

Similar in size and grand design to our own Milky Way, spiral galaxy NGC 3370 lies about 100 million light-years away toward the constellation Leo. Recorded here in exquisite detail by the Hubble Space Telescope's Advanced Camera for Surveys, the big, beautiful face-on spiral does steal the show, but the sharp image also reveals an impressive array of background galaxies in the field, strewn across the more distant universe. From the look within NGC 3370, the image data has proved good enough to study individual pulsating stars known as Cepheids, which can be used to accurately determine this galaxy's distance. NGC 3370 was chosen for this study because in 1994 the spiral galaxy was also home to a well-examined stellar explosion—a type Ia supernova. Combining the known distance to this standard-candle supernova, based on the Cepheid measurements, with observations of supernovae at even greater distances can reveal the size and expansion rate of the universe itself.

Credit: Hubble Heritage Team, A. Riess (STScI), NASA

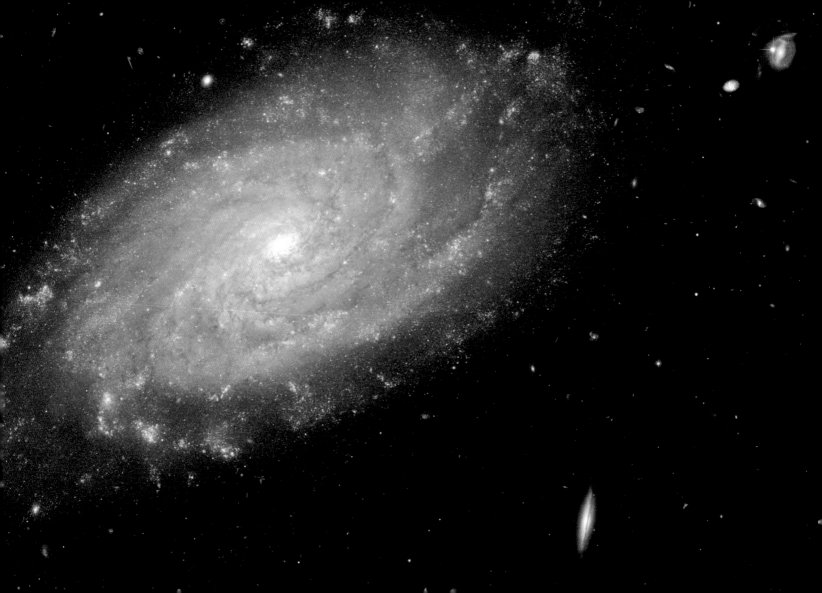

Rungs of the Red Rectangle

A distinctive X shape and ladder-like rungs appear in this Hubble Space Telescope image of the intriguing Red Rectangle Nebula. The dusty cosmic cloud was originally identified as a strong source of infrared radiation and is now believed to contain icy dust grains and hydrocarbon molecules, formed in the cool outflow from an aging central star. So why does it look like a big X? A likely explanation is that the central star—actually a close pair of stars—is surrounded by a thick dust torus, which pinches the otherwise spherical outflow into tip-touching cone shapes. Because we view the torus or doughnut shape edge on, the boundary edges of the cone shapes seem to form an X. The distinct rungs suggest that the outflow occurs in fits and starts. About 2,300 light-years away toward the fanciful constellation Monoceros, the Red Rectangle Nebula should be transformed into a glorious planetary nebula as its cool central star becomes a hot white dwarf over the next few thousand years. This sharp Hubble picture spans only about one-third of a light-year at the distance of the Red Rectangle.

Credit: H. Van Winckel (KU Leuven), M. Cohen (UC Berkeley), H. Bond (STScI), T. Gull (GSFC), ESA, NASA

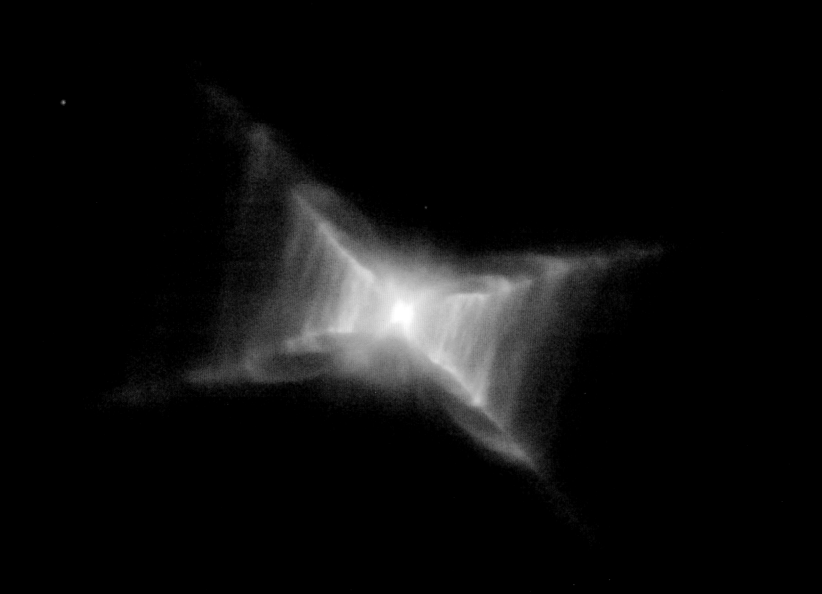

In January 2005, the robot Cassini spacecraft orbiting Saturn released the Huygens probe through the dense cloud decks of Titan, one of the solar system's most mysterious moons. As it descended, the probe took images of the approaching surface; it took several more from the surface after it landed. Many of the images have been digitally merged and scaled into this perspective from a height of 3,000 meters. This stereographic projection shows a 360-degree wide-angle view of Titan's surface. The bright areas at the top and left of the image are thought to be relatively high ground laced with drainage channels cut by rivers of methane. The bright shapes at the right are now hypothesized to be ridges of ice gravel. Huygens's landing site (labeled) appears to be on a type of dark, dry lake bed, once fed by a large, dark flow channel at the left. The Huygens probe lasted an unexpectedly long three hours on Titan's harsh surface.

Credit: ESA, NASA, Descent Imager/Spectral Radiometer Team (LPL)

May 3

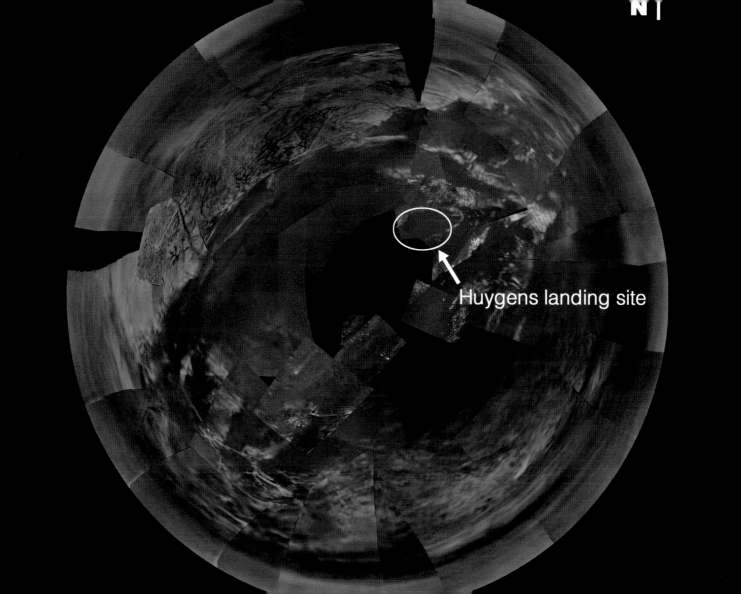

Huygens landing site

Cassini Spacecraft Crosses Saturn's Ring Plane

If this is Saturn, where are the rings? When Saturn's "appendages" vanished in 1612, Galileo did not understand why. Later that century, it became understood that Saturn's unusual protrusions were rings and that when Earth crosses their plane, the edge-on rings will seem to disappear. This is because Saturn's rings are confined to a plane many times thinner, in proportion, than a razor blade. In modern times, the robot Cassini spacecraft also crosses Saturn's ring plane while orbiting the planet. A series of plane-crossing images from late February 2005 was dug out of the vast online Cassini raw-image archive by interested Spanish amateur Fernando Garcia Navarro. Digitally cropped and set in representative colors, this is the striking result. The thin ring plane appears in blue, bands and clouds in Saturn's upper atmosphere are shown in gold, and dark shadows of the rings curve across the top of the gas giant. Moons are visible as bumps in the rings.

Credit: Cassini Imaging Team, SSI, JPL, ESA, NASA

May 4

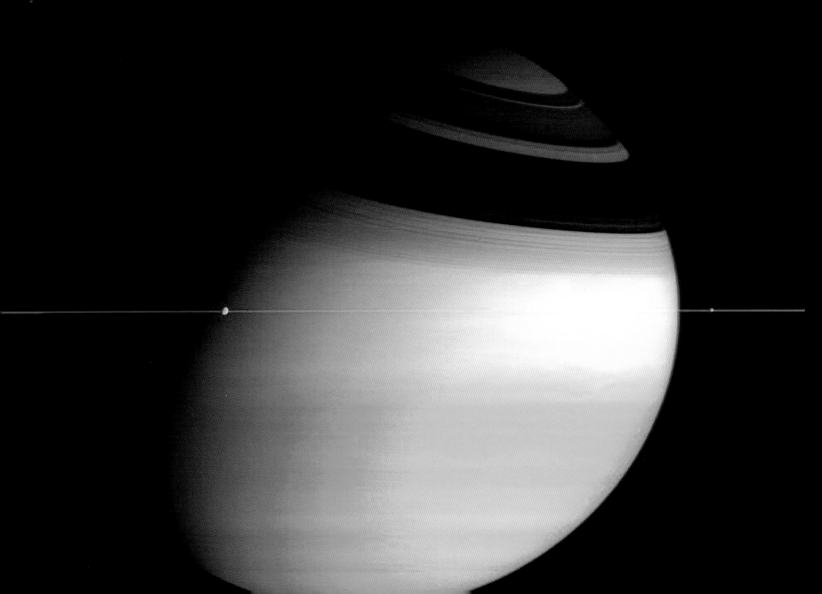

Planets over Easter Island

It is not every day that planets line up behind a stone giant. For one thing, it helps to have a good planet lineup, as occurred in the sky in April 2004. For another, it helps to be on Easter Island, where over 800 large stone statues exist. The Easter Island statues (called *moais*) stand, on average, over twice as tall as a person and have over 200 times as much mass. Few specifics are known about the history or meaning of the unusual giant heads, but many believe that they were created about 500 years ago in the images of local leaders of a lost civilization. In this picture, the Moon, Venus (near the statue's left ear), and Mars (to the left of the Moon) can be seen behind Ahu Tahai, a famous Easter Island statue. The bright star Aldebaran is also visible (near the statue's right eye).

Credit & copyright: Magnus Galfalk (Stockholm Observatory)

May 5

The Tails of Q4

Comet Q4 (NEAT) is showing its tails. As the large snowball officially dubbed Comet C/2001 Q4 (NEAT) fell toward the inner solar system in 2004, it passed nearest to planet Earth on May 7 and reached its closest approach to the Sun eight days later. Reports placed the comet at third magnitude, making it easily visible to the unaided eye for northern skygazers observing from a dark location just after sunset. This image was captured on May 8 from Happy Jack, Arizona. It shows a long blue ion tail, a blue coma surrounding the comet's nucleus, and a shorter but brighter sunlight-reflecting dust tail. Q4 dropped from easy visibility during the next month as it receded from both planet Earth and the Sun. Another naked-eye comet, Comet C/2002 T7 (LINEAR), was also as bright as third magnitude and remained bright into June.

Credit & copyright: Chris Schur

May 6

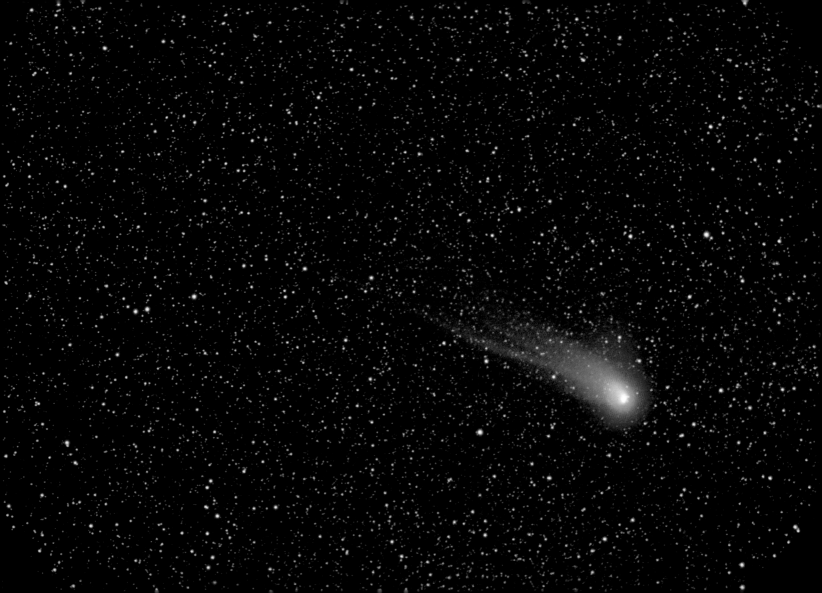

Big, Bright Bug Nebula

The bright clusters and nebulae of planet Earth's night sky are often named for flowers or insects, and NGC 6302 is no exception. With an estimated surface temperature of about 250,000 degrees C, however, the central star of this particular planetary nebula is exceptionally hot—shining brightly in ultraviolet light but hidden from direct view by a dense torus of dust. This image is a dramatically detailed close-up of the dying star's nebula, recorded by the Hubble Space Telescope. Cutting across a bright cavity of ionized gas, the dust torus surrounding the central star is in the upper left corner of this view, nearly edge on to the line of sight. Surprisingly, minerals including water ice, along with complex hydrocarbon molecules, have been detected in this hot star's dusty cosmic shroud. NGC 6302 lies about 4,000 light-years away in the arachnologically correct constellation Scorpius.

Credit: A. Zijlstra (UMIST) et al., ESA, NASA

May 7

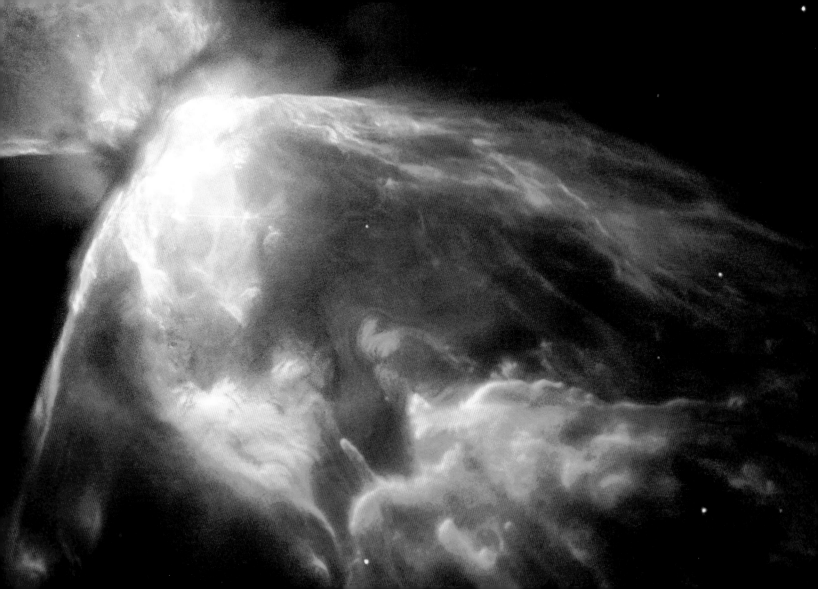

The spectacular geocentric celestial event in April 2005 was a rare hybrid eclipse of the Sun—either a total or an annular eclipse could be seen, depending on the observer's location. For Fred Espenak, aboard a gently swaying ship within the middle of the Moon's shadow track about 2,200 kilometers west of the Galápagos Islands, the eclipse was total, the lunar silhouette exactly covering the bright solar disk for a few brief moments. His camera captured a picture of totality (left) revealing the extensive solar corona and prominences rising above the Sun's edge. But for Stephan Heinsius, near the end of the shadow track at Penonomé Airfield, Panama, the Moon's apparent size was just small enough to create an annular eclipse (right), showing a complete annulus of the Sun's bright disk as a dramatic ring of fire. How rare is such a hybrid eclipse? Calculations show that during the twenty-first century, just 3.1 percent (7 out of 224) of solar eclipses are hybrid, while hybrids constitute about 5 percent of all solar eclipses that will have taken place between 2000 B.C. and A.D. 4000.

Credit & copyright: Left: Fred Espenak (courtesy of www.MrEclipse.com); right: Stephan Heinsius

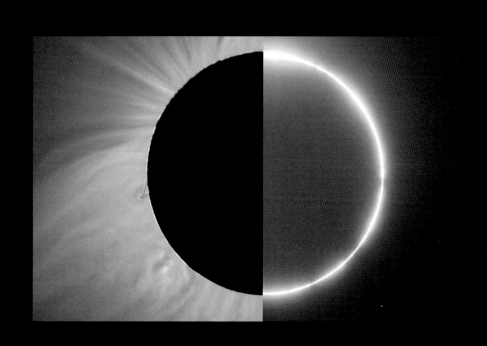

Stars, Dust, and Nebulae in NGC 6559

When stars are born, pandemonium reigns. A textbook case is the star-forming region NGC 6559. Visible here are red-glowing emission nebulae of hydrogen, blue reflection nebulae of dust, dark absorption nebulae of dust, and the stars that formed from them. The first massive stars created from the dense gas will emit energetic light and winds that erode, fragment, and sculpt their birthplace. And then they explode. The resulting morass can be as beautiful as it is complex. After tens of millions of years, the dust boils away, the gas gets swept off, and all that is left is a naked open cluster of stars.

Credit & copyright: Canada-France-Hawaii Telescope/J. C. Cuillandre/Coelum

May 9

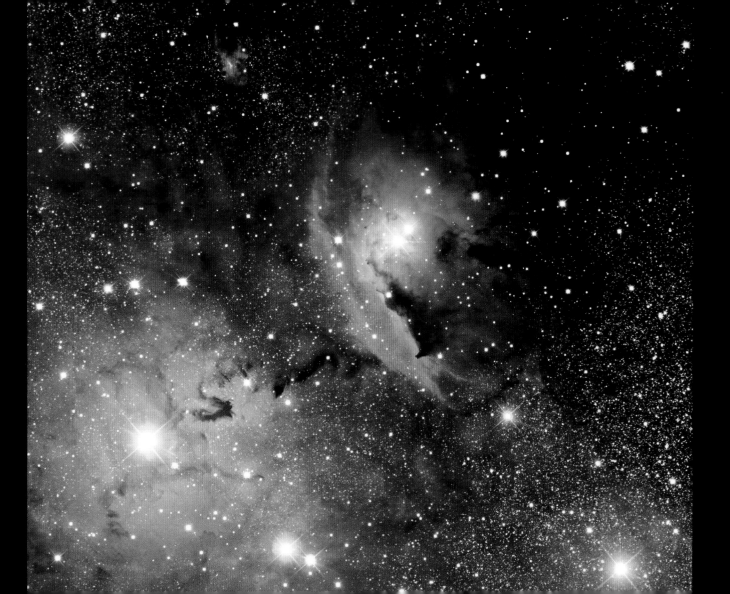

Apollo 17 Panorama

What would it be like to explore the surface of another world? In 1972, during the Apollo 17 mission, astronaut Harrison Schmitt found out firsthand. In that case, the world was Earth's own Moon. In this panorama of lunar photographs, originally taken by astronaut Eugene Cernan and compiled in 2004, the magnificent desolation of the barren Moon is apparent. Visible here are lunar rocks in the foreground, lunar mountains in the background, some small craters, a lunar rover in the distance (center), and astronaut Schmitt on his way back to the rover. A few days after this image was taken, humanity left the Moon. It has yet to return.

Credit: Apollo 17 Crew, NASA; mosaic assembled & copyright: M. Constantine (moonpans.com)

May 10

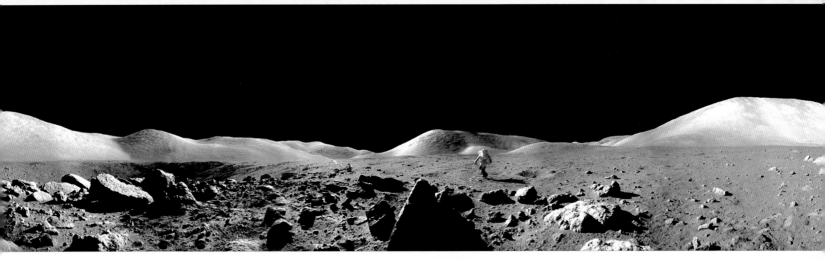

M13: The Great Globular Cluster in Hercules

M13 is one of the most prominent and best-known globular clusters. Visible with binoculars in the constellation Hercules, M13 is frequently one of the first objects found by curious skygazers seeking celestial wonders beyond normal human vision. M13 is a colossal home to over 100,000 stars, spans over 150 light-years, lies over 20,000 light-years distant, and is over 12 billion years old. At the 1974 dedication of Arecibo Observatory in Puerto Rico, a radio message about Earth was sent in the direction of M13.

Credit & copyright: Jim Misti & Robert Gendler

M27:
Not a Comet

While searching the skies above eighteenth-century France for comets, astronomer Charles Messier diligently recorded this object as number 27 on his list of things that are definitely not comets. So what is it? Well, twenty-first-century astronomers would classify it as a planetary nebula—but it is not a planet either, even though it may appear round and planet-like in a small telescope. Messier 27 (M27) is now known to be an excellent example of a gaseous emission nebula, created when a Sun-like star runs out of nuclear fuel in its core. The nebula forms as the star's outer layers are expelled into space. The visible glow is generated as atoms are excited by the dying star's intense but invisible ultraviolet light. Known by the popular name Dumbbell Nebula, the beautifully symmetrical interstellar gas cloud is about 1,200 light-years away in the constellation Vulpecula. This dazzling synthetic-color picture of M27 was produced during testing of one of the European Southern Observatory's Very Large Telescopes.

Credit: FORS Team, 8.2-meter VLT, ESO

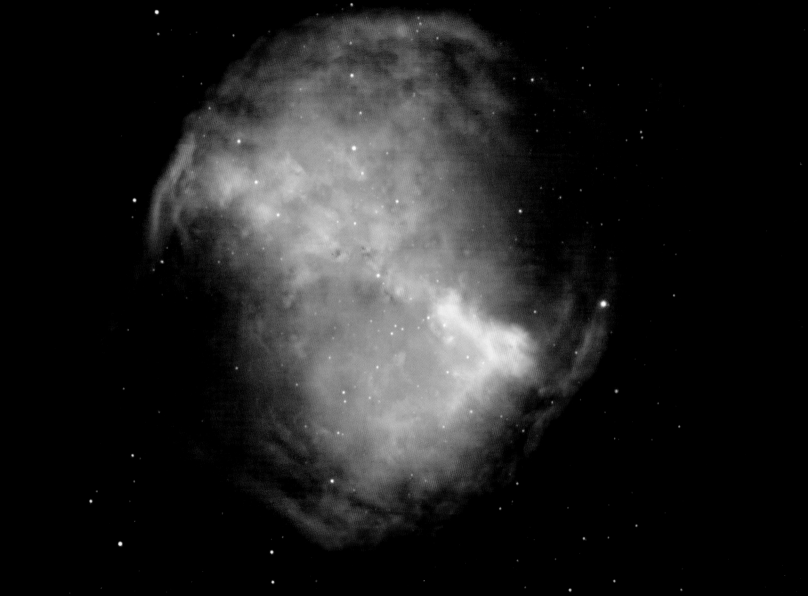

Comet C/2002 T7 (LINEAR)

Discovered by the Lincoln Near Earth Asteroid Research (LINEAR) project in October 2002, Comet C/2002 T7 (LINEAR) visited the inner solar system in 2004, making its closest approach to the Sun on April 23. Emerging from the solar glare, the comet was just visible to the unaided eye in the constellation Pisces, near the eastern horizon, in morning twilight two days earlier, when this gorgeous telescopic view was recorded before dawn. By then, the clearly active comet had developed a complex tail extending over 2 degrees in the anti-sunward direction, and a pronounced anti-tail or anomalous tail. The comet appeared brighter as it made its closest approach to planet Earth on May 19. During this time, it shared the southern skies with another comet visible to the naked eye, designated C/2001 Q4 (NEAT).

Credit: Svend & Carl Freytag, Adam Block (KPNO Visitor Program), NOAO, AURA, NSF

May 13

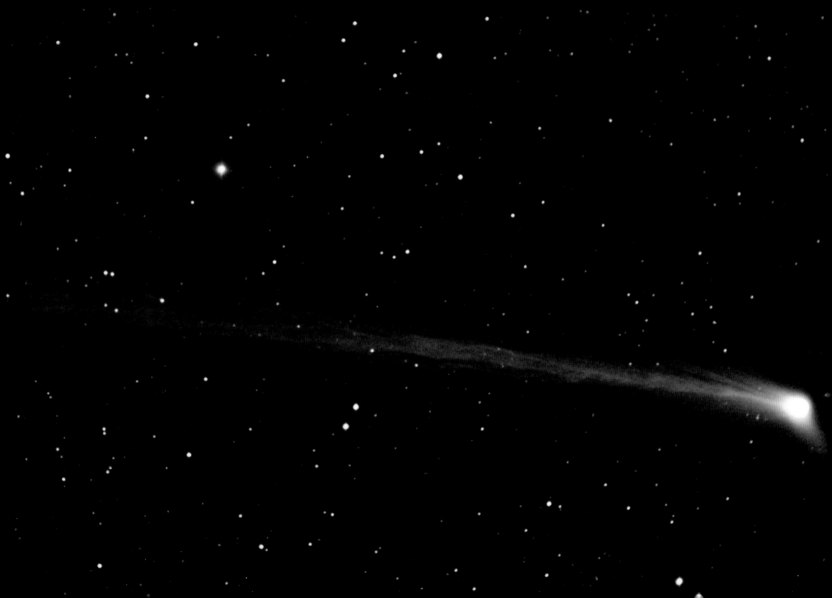

A Tale of Two Nebulae

This colorful telescopic view toward the northern constellation Lyra reveals dim outer regions around M57, popularly known as the Ring Nebula. While modern astronomers still refer to it as a planetary nebula, M57, at 1 light-year across, is not a planet but the gaseous shroud of a dying Sun-like star. Roughly the same apparent size as M57, the fainter, often overlooked barred spiral galaxy IC 1296 is at the lower right; in the early twentieth century, it would have been referred to as a spiral nebula. By chance, the pair are in the same field of view. While they appear to have similar sizes, they are actually very far apart. M57 lies at a distance of a mere 2,000 light-years, well within our own Milky Way Galaxy; extragalactic IC 1296 is more like 200 million light-years distant, or about 100,000 times farther away. Since they seem roughly similar in size, spiral nebula IC 1296 must also be about 100,000 times larger than planetary nebula M57.

Credit & copyright: Brian Lula

May 14

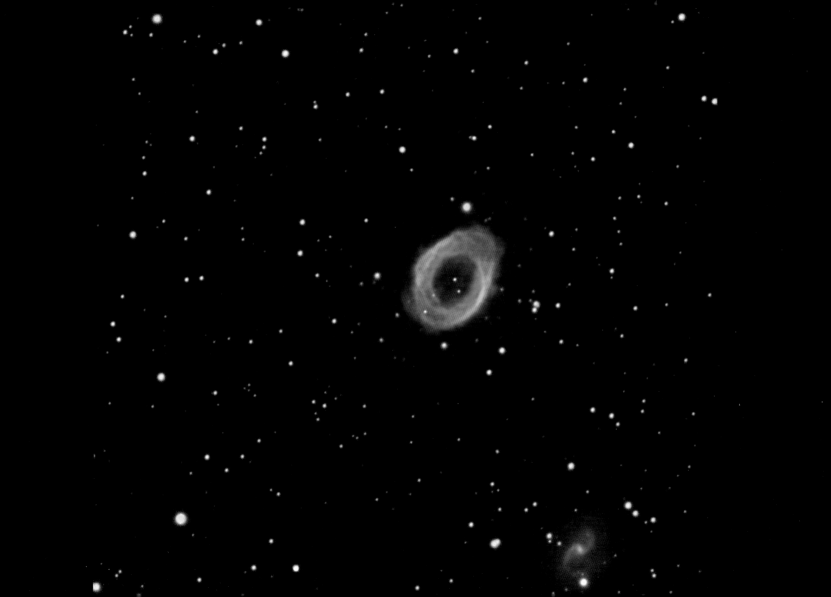

The Sombrero Galaxy in Infrared

This floating ring is the size of a galaxy. In fact, it is part of the photogenic Sombrero Galaxy, one of the largest galaxies in the nearby Virgo Cluster. The dark band of dust that obscures the midsection of the Sombrero Galaxy in optical light actually glows brightly in infrared light. This image shows the infrared glow, recorded by the orbiting Spitzer Space Telescope, superimposed in false color on an image taken by NASA's Hubble Space Telescope in optical light. The Sombrero Galaxy, also known as M104, spans about 50,000 light-years and lies 28 million light-years away. M104 can be seen with a small telescope in the direction of the constellation Virgo.

Credit: R. Kennicutt (Steward Observatory) et al., SSC, JPL, Caltech, NASA

May 15

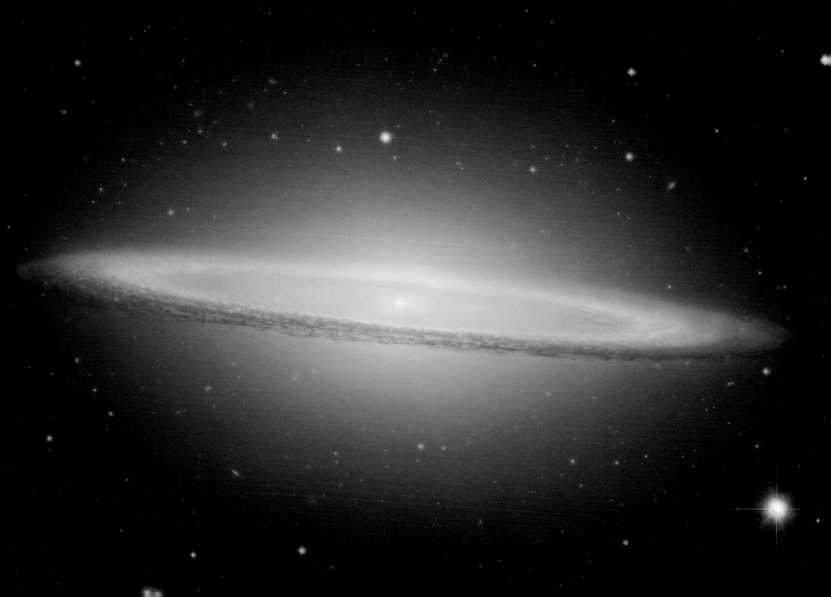

When the Moon
Was Young

On May 9, 2005, this slender crescent Moon was recorded at the tender age of 34 hours and 18 minutes. Well, okay . . . when calculating the lunar age during a lunation, or complete cycle of phases—from New Moon to Full Moon and back to New Moon again—the Moon never gets more than about 29.5 days old. Although a very young Moon is relatively faint and is easy to see only low in the west as the sky grows dark after sunset, it can be a rewarding sight even for casual skygazers. Lucky astronomer Stefan Seip was treated to a very dramatic telescopic view of an airliner flying in front of the distant sunlit crescent. At a high altitude, the jet's stunning contrails reflect the strongly reddened light of the sunset.

Credit & copyright: Stefan Seip

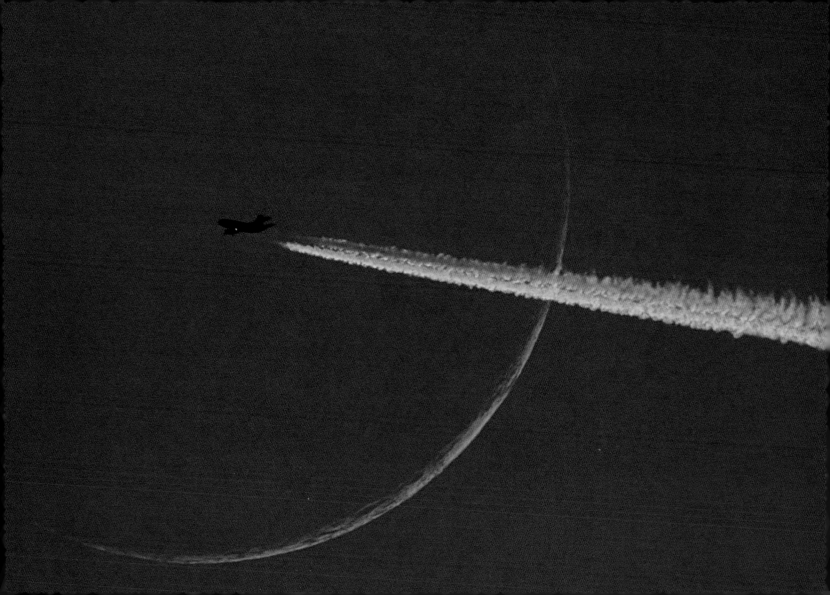

Galaxy Cluster Abell 1689 Warps Space

Two billion light-years away, galaxy cluster Abell 1689 is one of the most massive objects in the universe. In this view from the Hubble Space Telescope's Advanced Camera for Surveys, Abell 1689 is seen to warp space, as predicted by Einstein's theory of gravity—bending light from individual galaxies that lie behind the cluster, to produce multiple, curved images. The power of this enormous gravitational lens depends on its mass, but the visible matter, in the form of the cluster's yellowish galaxies, accounts for about only 1 percent of the mass needed to make the observed bluish arcing images of background galaxies. In fact, most of the gravitational mass required to warp space enough to explain this cosmic-scale lensing is in the form of still-mysterious dark matter. The dark matter's unseen presence is mapped out by the lensed arcs and distorted images of background galaxies.

Credit: N. Benitez (JHU), T. Broadhurst (Hebrew University), H. Ford (JHU), M. Clampin (STScI), G. Hartig (STScI), G. Illingworth (UCO/Lick), ACS Science Team, ESA, NASA

May 17

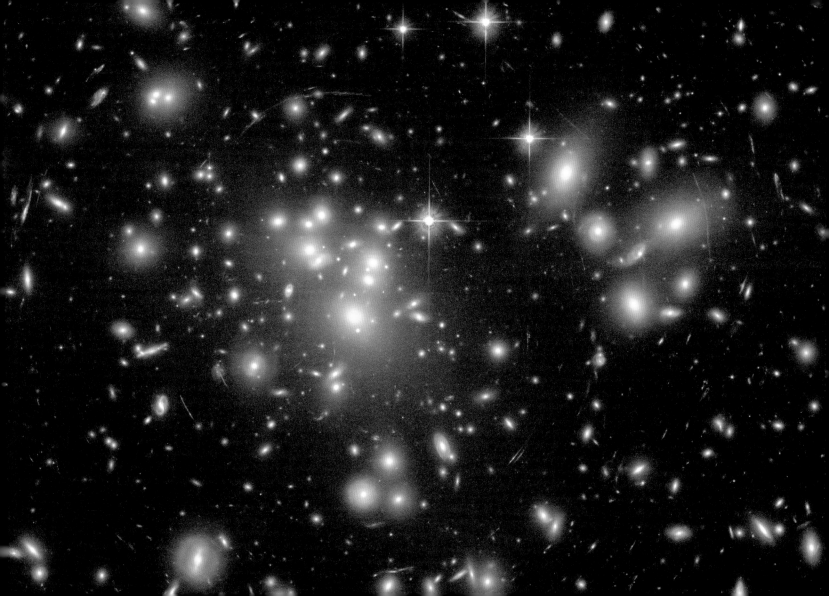

First U.S. Spacewalk

On June 3, 1965, astronaut Edward White made the first U.S. spacewalk, beginning over the Pacific Ocean near Hawaii and ending twenty-three minutes later above the Gulf of Mexico. Of course, the term "spacewalk" is a bit deceiving, as White, tethered to the Gemini IV capsule, was falling freely in low Earth orbit alongside his spacecraft, manned by fellow astronaut James McDivitt. In free fall, White was able to control his motion by firing bursts from the "zip gun" in his right hand until its supply of compressed gas ran out. He ultimately returned, exhausted but safe, to the two-man Gemini capsule. White was one of the three astronauts who died in the tragic 1967 Apollo program fire.

Credit: Gemini 4 Mission, NASA

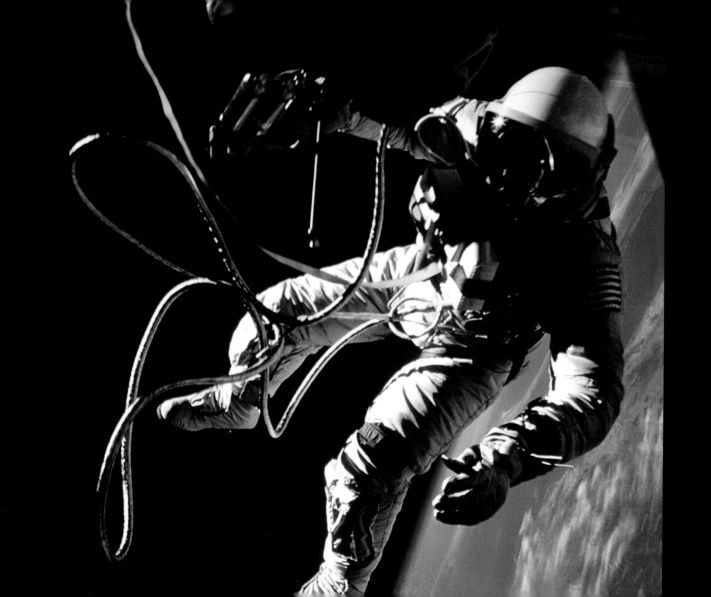

A Beautiful Trifid

The beautiful Trifid Nebula (aka M20), a photogenic study in cosmic contrasts, lies about 5,000 light-years away in the direction of the nebula-rich constellation Sagittarius. A star-forming region in the plane of our galaxy, the Trifid illustrates three basic types of astronomical nebulae: red emission nebulae, dominated by light from hydrogen atoms; blue reflection nebulae, whose light is produced by dust reflecting starlight; and dark absorption nebulae, where dense dust clouds appear in silhouette. The bright red emission nebula pictured is roughly separated into three parts by obscuring dust lanes, lending the Trifid its popular name. In this gorgeous wide view, the red emission region is also surrounded by the telltale blue haze of reflection nebulae. Light-year-long pillars and jets sculpted by newborn stars—visible here just below and to the left of the center of the emission nebula—appear in Hubble Space Telescope close-up images of the region.

Credit & copyright: Dean Jacobsen

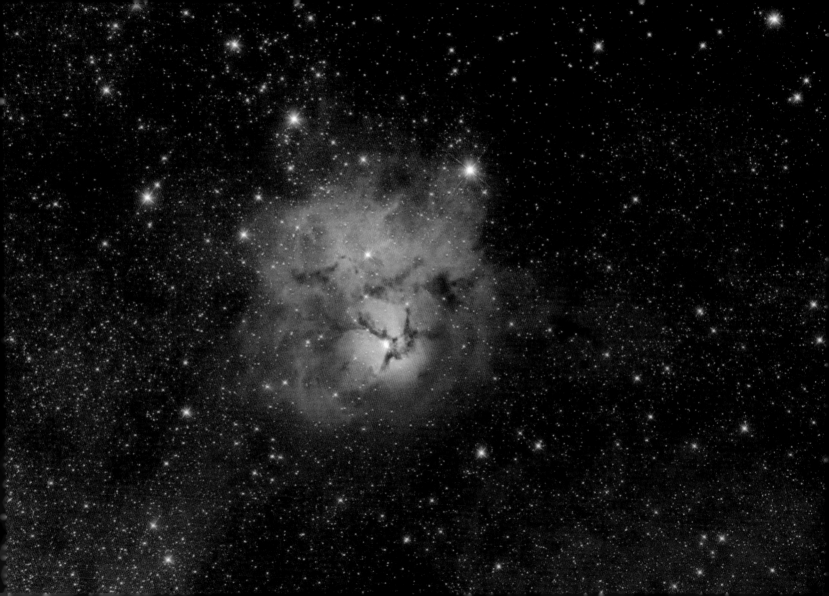

Zubenelgenubi and Friends

Moderately bright Zubenelgenubi is the star just off the upper right-hand limb (edge) of the eclipsed Moon in this telescopic view from Port Elizabeth, South Africa. Actually the second-brightest star in the constellation Libra, Zubenelgenubi is fun to pronounce (try zoo-BEN-al-je-NEW-bee) and rewarding to spot in the night sky, along with its fainter companion star, seen farther to the right. Astronomer François du Toit reports that both stars were visible to the unaided eye on the night of May 4, 2004, during the total eclipse phase. Orbiting a common center of gravity once every 200,000 years or so, each of the stars is larger and hotter than the Sun. About 77 light-years away, the stars are separated from each other by over 730 light-hours—about 140 times Pluto's average distance from the Sun. Zubenelgenubi was once considered the southern claw of the nearby, arachnologically correct constellation Scorpius. What star was the northern claw? Zubeneschamali, of course.

Credit & copyright: François du Toit

May 20

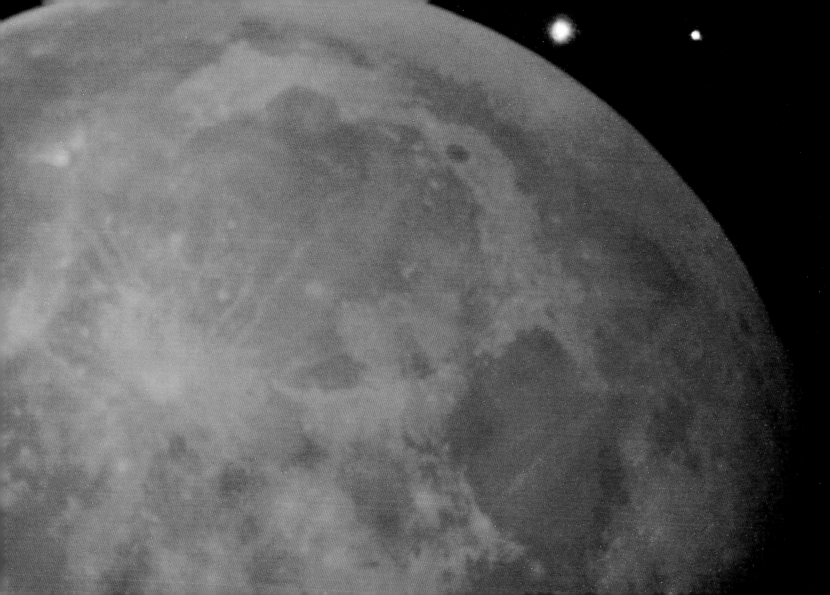

NGC 3372:
The Great
Nebula in Carina

In one of the brightest parts of the Milky Way lies a nebula where some of the oddest things occur. NGC 3372, known as the Great Nebula in Carina, is home to massive stars. Eta Carinae, the most energetic star in the Carina Nebula, was one of the brightest stars in the sky in the 1830s, but then it faded dramatically. The Keyhole Nebula, visible near the center, houses several of the most massive stars known and has also changed its appearance. The Carina Nebula spans over 300 light-years and lies about 10,000 light-years away in the constellation Carina. This image was taken from La Frontera in Alcohuaz, Chile. Eta Carinae, which has flared in brightness over just the past decade, might explode in a dramatic supernova within the next thousand years.

Credit & copyright: Loke Kun Tan (StarryScapes)

May 21

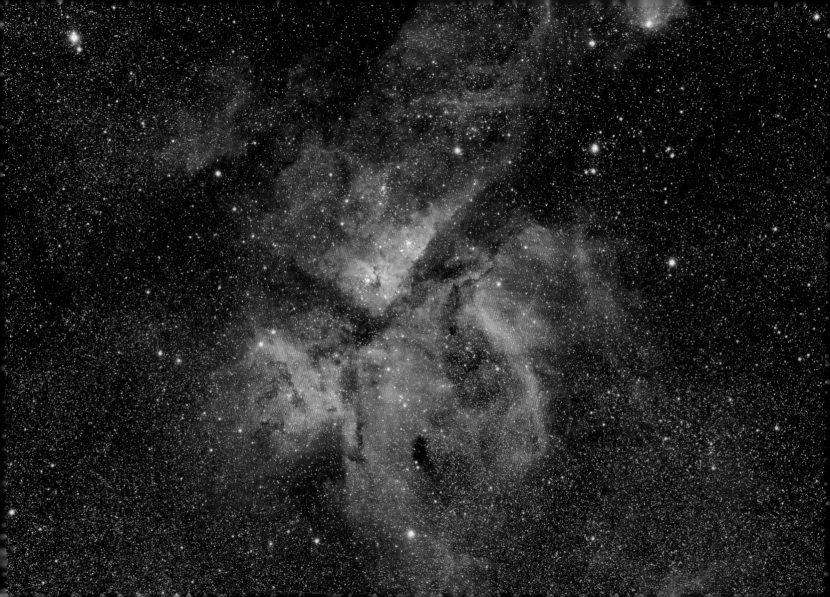

Supernova Remnant N132D

Thousands of years after a star exploded, its expanding remnant still glows brightly across the spectrum. Such is the case with N132D, a supernova remnant located in the neighboring Large Magellanic Cloud (LMC) galaxy. The expanding shell from this explosion now spans 80 light-years and has swept up about 600 Suns' worth of mass. N132D was imaged in optical light—and in great detail—by the Hubble Space Telescope. The Hubble image was then combined with a position-coincident detailed image in x-ray light, taken by the orbiting Chandra X-ray Observatory. The combination, shown here in representative colors, depicts a nearly spherical expanding shock wave highlighted by pink emission from hydrogen gas and purple emission from oxygen gas. A dense field of unrelated stars, also from the LMC, populates the image. This picture provides an opportunity to study material once hidden deep inside a star. N132D lies about 160,000 light-years away toward the constellation Dorado.

Credit: NASA, ESA, & the Hubble Heritage Team (STScI/AURA); acknowledgment: J. C. Green (University of Colorado) & the Cosmic Origins Spectrograph (COS) GTO team; NASA/CXO/SAO

May 22

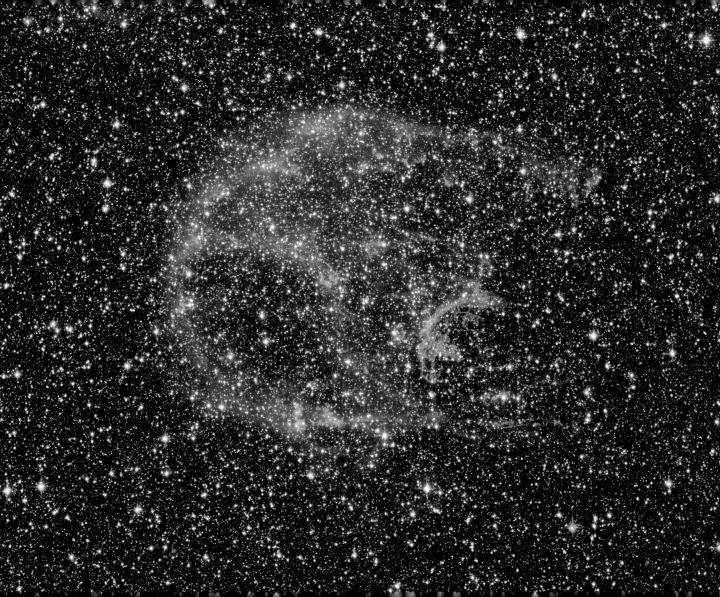

In the Vicinity of the Cone Nebula

Strange shapes and textures can be found in the neighborhood of the Cone Nebula. The unusual shapes originate from fine interstellar dust reacting in complex ways with the energetic light and hot gas being expelled by the young stars. The brightest star at the right of this picture is S Mon, while the region just above it has been nicknamed the Fox Fur Nebula for its color and structure. The blue glow directly surrounding S Mon results from reflection; neighboring dust reflects light from the bright star. The orange glow that encompasses the whole region is due not only to dust reflection but also to emission from hydrogen gas ionized by starlight. S Mon is part of a young open cluster of stars named NGC 2264, located about 2,700 light-years away toward the constellation Monoceros. The origin of the geometric Cone Nebula, visible at the far left, remains a mystery.

Credit & copyright: T. A. Rector (NRAO), NOAO, AURA, NSF

May 23

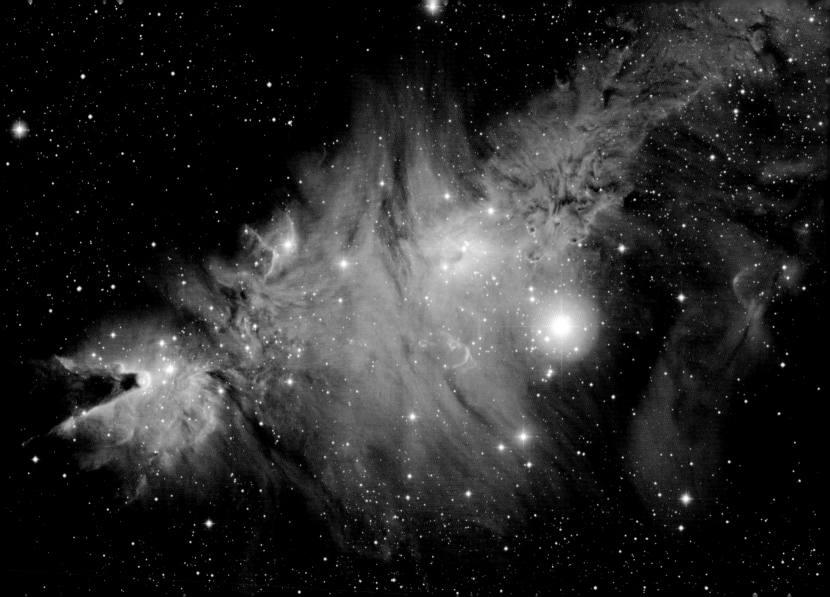

The Andromeda Deep Field

What can you learn from looking into the depths of space? In an effort to find out the true ages of stars in neighboring Andromeda Galaxy's halo, astronomers stared into the galactic giant with the Hubble Space Telescope's Advanced Camera for Surveys. The resulting exposure of over three days, shown here, was the deepest ever taken in visible light, though shorter in duration than the multiwavelength effort toward the Hubble Deep Field. The final image illuminated not only Andromeda (M31) but also the distant universe. Andromeda's halo stars turned out to have a wider range of ages than those of our Milky Way, likely indicating more encounters with small neighboring galaxies. Visible at right is one of Andromeda's globular star clusters, while literally thousands of background galaxies are seen in the distant universe, far beyond M31.

Credit: T. M. Brown (STScI) et al., ESA, NASA

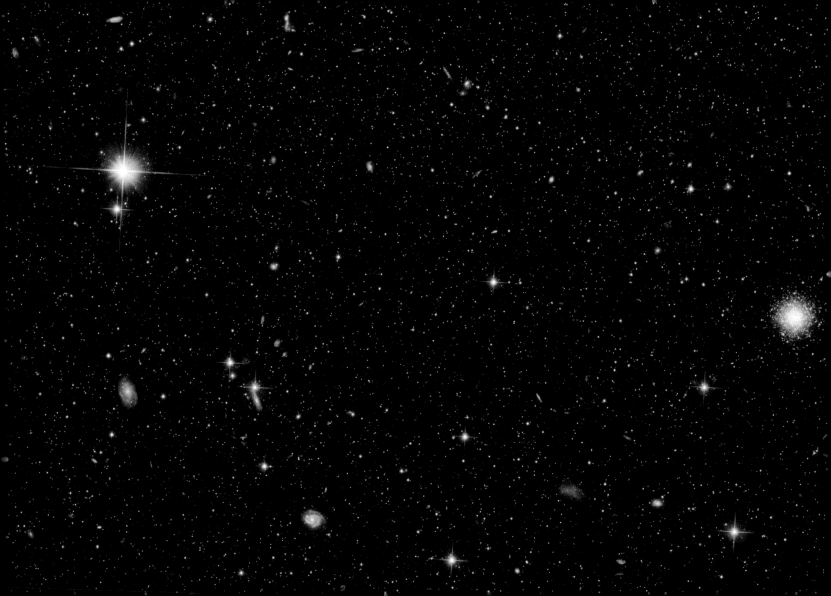

Moon and Planets by the Eiffel Tower

Before the great evening grouping of planets in early 2002 came to an end and they went their own separate directions, the Moon was kind enough to pose with some of them. The planets in this picture, taken in mid-May, are Venus (to the left of the Eiffel Tower) and Jupiter (below the Moon). Mars, Saturn, and even Mercury appeared to the lower right of Venus but were too dim to be seen. Over the next two weeks, the Moon rose later and later, passing a full phase on May 26. Venus and Jupiter continued to shine for a while longer, moving together until their closest approach on June 3. Long after this grouping, the Eiffel Tower is expected to remain right where it is.

Credit & copyright: Thierry Legault

Moon between
the Stones

Despite clouds and rain showers, astronomer Philip Perkins managed to spot a reddened, eclipsed Moon between the stones of this well-known monument to the Sun at Stonehenge, England, during the May 2004 total lunar eclipse. When he recorded this dramatic picture, the rising Moon was only about 5 degrees above the horizon, but he located it through a convenient gap in the circle of ancient stones. Although at first glance there appears to be an eerie, luminous pool of water in the foreground, Perkins notes that his daughter produced the artistic lighting effect: she illuminated a fallen stone and surrounding grass with a flashgun from her hiding place behind the large sarsen stone to the right of center. As the picture looks toward the southeast, the object just below the Moon is one of the inner bluestones, not the famous Heel Stone, which marks the northeast direction of the summer solstice sunrise.

Credit & copyright: Philip Perkins

May 26

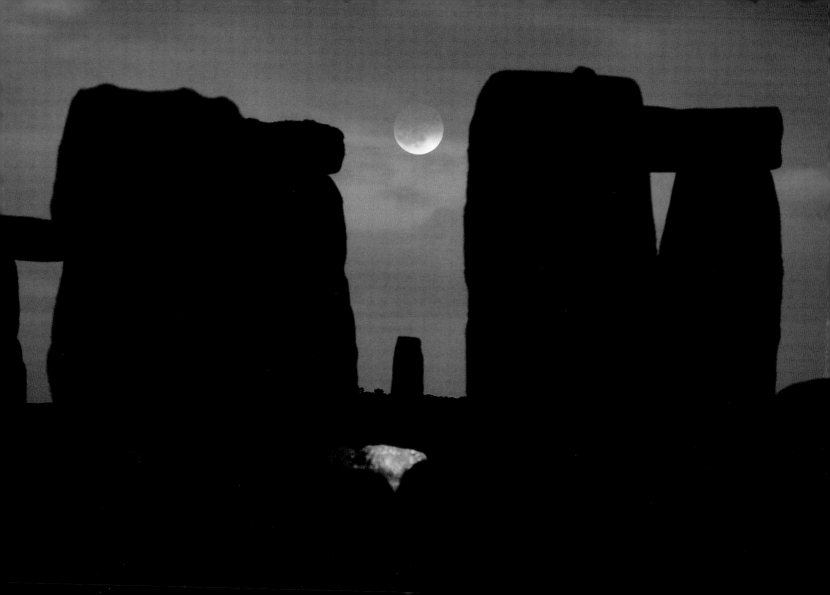

At the Summit of Olympus Mons

From Martian orbit, the Mars Express cameras looked down on the largest volcano in the solar system. The result was this stunningly detailed overhead view of the caldera, or summit crater region, of Olympus Mons. Fittingly named for the lofty abode of the gods of Greek mythology, Olympus Mons rises 21 kilometers above the surrounding plain—about three times the height of Mount Everest. The area pictured is 102 kilometers across, and the caldera pits are up to 3 kilometers deep. For comparison, Hawaiian volcanic calderas range up to 18 kilometers in diameter. Outlined by steep cliffs, Olympus Mons itself is about 600 kilometers in diameter.

Credit: G. Neukum (FU Berlin) et al., Mars Express, DLR, ESA

May 27

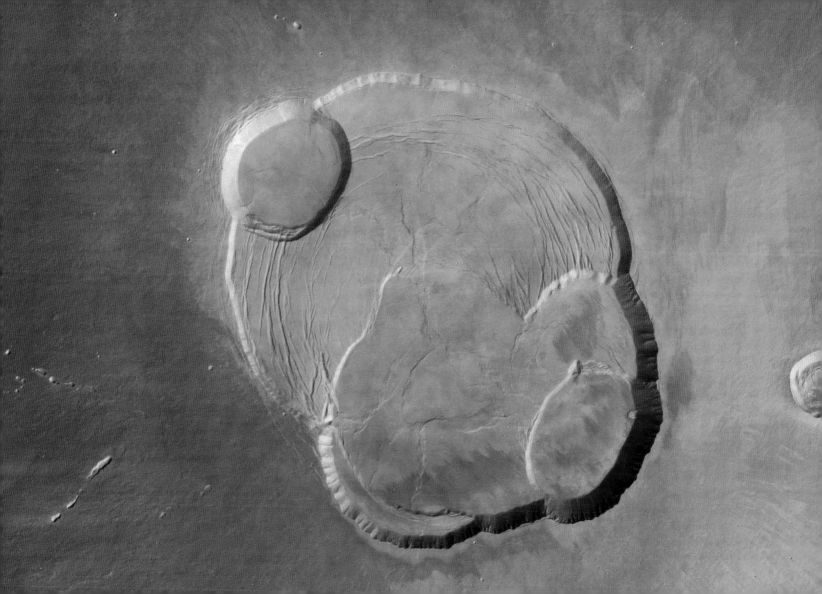

Two Comets in Southern Skies

Wielding a very wide-angle lens, astronomer Gordon Garradd was able to capture two naked-eye comets in one picture looking toward the west from Loomberah, New South Wales, Australia. At the far left is Comet C/2002 T7 (LINEAR), and at the far right, comet C/2001 Q4 (NEAT). Recorded on the night of May 20, 2004, the area around each of the comets has been separately enhanced here, making it easier to discern their extended tails streaming away from the Sun. Comet T7 (LINEAR) is the brighter of the two. With bright Venus near the center on the horizon and the lights of the nearby city of Tamworth glowing at the bottom right, the two comets are not alone in this heavenly view.

Credit & copyright: Gordon Garradd

May 28

The Edge of
Candor Chasma

Dive into a spectacular canyon on Mars. This daytime infrared view, recorded by the THEMIS camera on board the orbiting Mars Odyssey spacecraft, covers a 30-by-175-kilometer swath running along the canyon floor. The northern (left) end of the scene is poised at the edge of Candor Chasma, part of the great Valles Marineris canyon system. About 4,000 kilometers long and up to 6 kilometers deep, Valles Marineris is roughly five times the size of the Grand Canyon on planet Earth. The THEMIS camera data was recorded in three separate infrared bands and combined to make this striking false-color image. Resulting color differences along this intricate section of Martian terrain are attributed to differences in mineralogy, the chemical makeup and structure of the rocks, sediments, and surface dust.

Credit: THEMIS, Mars Odyssey Team, JPL, NASA

May 29

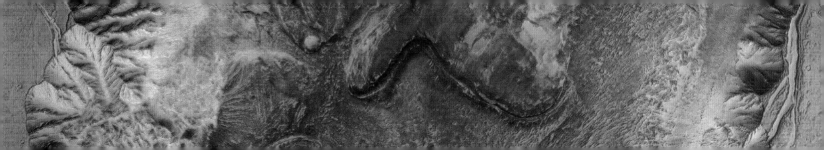

Frizion Illume

The picture of thin layers of forming ice crystals uses a scientific understanding of light's wave properties solely for artistic purposes. Titled *Illume*, the picture was created by astrophysicist Peter Wasilewski by illuminating the crystals with light shining through a polarizing filter—a filter that restricts the otherwise randomly oriented light waves to vibrate in only one direction. Different colors of the polarized light are refracted and reflected along slightly different paths by the delicate crystalline layers. Viewing the scene with a second polarizing filter brings out the wondrous display of structure and color. Painting with "light, the laws of physics, and an attitude," Wasilewski has created a series of these evocative ice images, which he refers to as Frozen Vision, or Frizion.

Credit & copyright: Peter Wasilewski (Goddard Space Flight Center)

Asteroid Itokawa

Astronomers suspect that asteroid Itokawa is a loose pile of rubble rather than a solid rock. The asteroid was visited in late 2005 by the Japanese spacecraft Hayabusa, which documented its structure and mysterious lack of craters. In November, Hayabusa actually touched down on one of the smoother patches, dubbed the MUSES Sea, and collected soil samples for eventual return to Earth to be analyzed. Unfortunately, the robot Hayabusa craft experienced communication problems, so its departure for Earth was delayed until 2007. Computer simulations show that the 500-meter asteroid Itokawa may strike Earth within the next few million years.

Credit & copyright: ISAS, JAXA

May 31

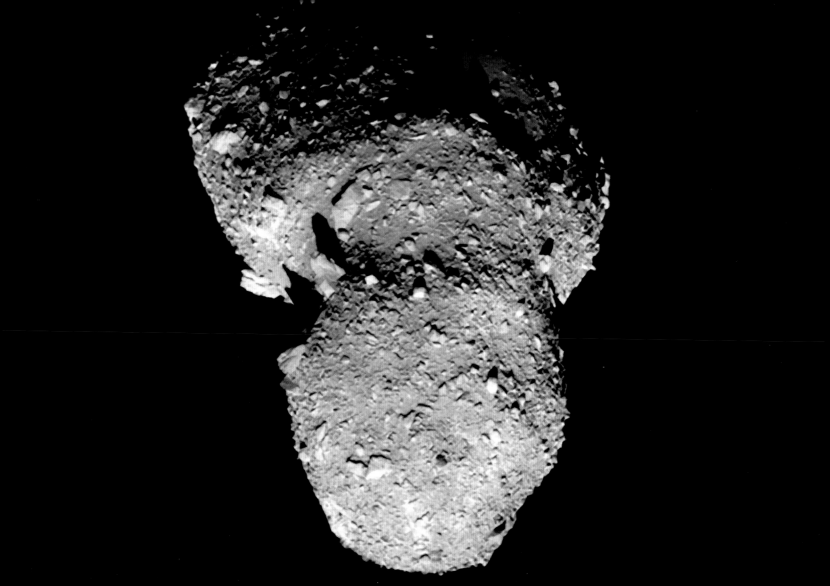

The Giant Radio Lobes of Fornax A

These radio lobes together span over 1 million light-years. What caused them? In the center of this picture—a radio image superimposed on an optical-survey image of the same part of the sky—is a large but peculiar elliptical galaxy dubbed NGC 1316. Detailed inspection of the NGC 1316 system indicates that it began absorbing a small neighboring galaxy about 100 million years ago. Gas from the galactic collision has fallen inward toward the massive central black hole, with friction heating the gas to 10 million degrees C. For reasons not yet well understood, two opposite-pointing, fast-moving jets of particles developed, eventually smashing into the ambient material on either side of the giant elliptical galaxy. The result is a huge reservoir of hot gas that emits radio waves, observed as the orange (false-color) radio lobes in this image. Strange patterns in the radio lobes likely indicate slight changes in the directions of the jets.

Credit: Ed Fomalont (NRAO) et al., VLA, NRAO, AUI, NSF

Globular Cluster M22

Globular cluster M22, pictured here, contains over 100,000 stars. They formed together and are gravitationally bound. Stars orbit the center of the cluster, and the cluster orbits the center of our galaxy. So far, about 140 globular clusters are known to exist in a roughly spherical halo around the galactic center. They do not appear spherically distributed as viewed from planet Earth, and this fact was a key point in the determination that our Sun is not at the center of our galaxy. Globular clusters are very old: there is a straightforward method of determining their age, and this nearly matches the 13.7 billion years of our entire universe.

Credit & copyright: Canada-France-Hawaii Telescope / J. C. Cuillandre / Coelum

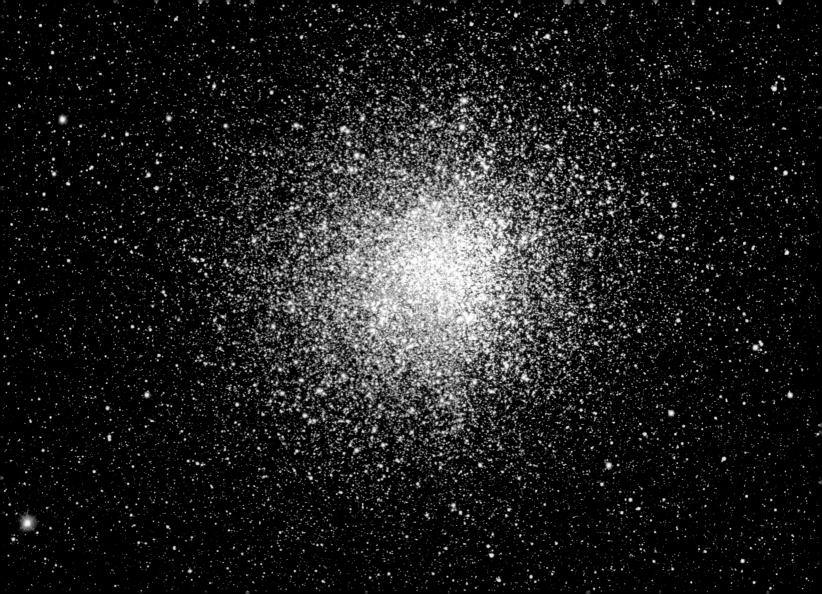

Tornado and Rainbow over Kansas

This scene might have been considered serene if it were not for the tornado. In June 2005, storm chaser Eric Nguyen photographed a budding Kansas twister in the light of a rainbow. The Sun, peeking through a clear patch of sky to the left of this vertical picture, illuminates some buildings in the foreground. Sunlight reflects off raindrops to form a rainbow—which, by coincidence, appears to support the tornado. Streaks in the image are hail being swept about by the high swirling winds. Over 1,000 tornadoes, the most violent type of storm known on planet Earth, occur every year.

Credit & copyright: Eric Nguyen (www.mesoscale.ws)

June 3

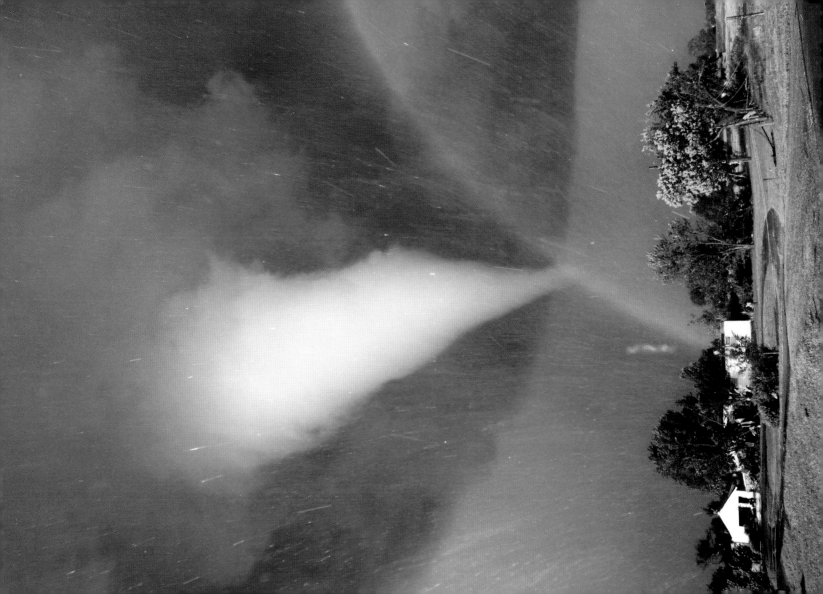

A Picturesque
Venus Transit

The rare Transit of Venus across the face of the Sun in June 2004 was one of the best-photographed events in sky history, with both scientific and artistic images made in Europe and much of Asia, Africa, and North America. Artistically, images might be divided into several categories. One captures the transit in front of a highly detailed Sun. Another adds a second coincidence, such as both Venus and an airplane simultaneously silhouetted, or Venus and the International Space Station in low Earth orbit. A third image type involves a fortuitous arrangement of interesting-looking clouds, such as the example here, taken from North Carolina, in which the distant orb of giant Venus might be mistaken, at first glance, for a small but unusually circular cloud.

Credit & copyright: David Cortner

June 4

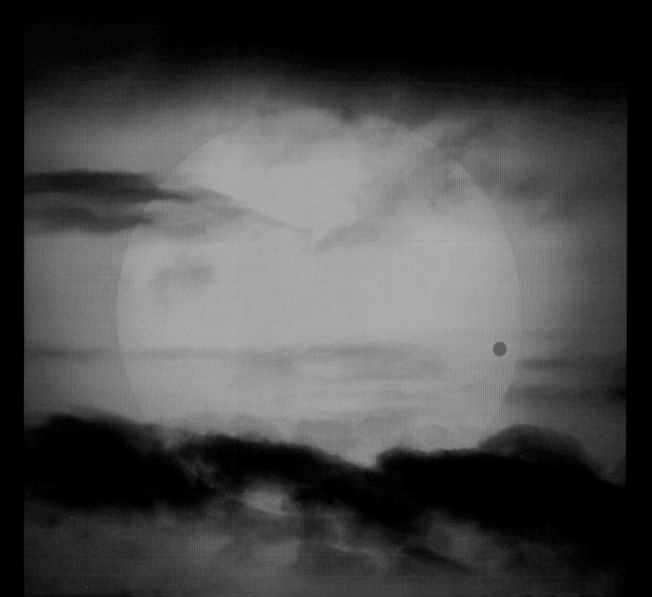

A Milky Way Band

Most bright stars in the Milky Way reside within a disk. Since our Sun also lies in this disk, these stars appear to us as a diffuse band that circles the sky. This panorama of a northern band of the Milky Way's disk covers 90 degrees and is a digitally created mosaic of independent exposures. Visible in the spectacular picture are many bright stars, dark dust lanes, red emission nebulae, blue reflection nebulae, and clusters of stars. In addition to all this matter that we can see, astronomers suspect the existence of even more dark matter that is invisible to us.

Credit & copyright: John P. Gleason (Celestial Images)

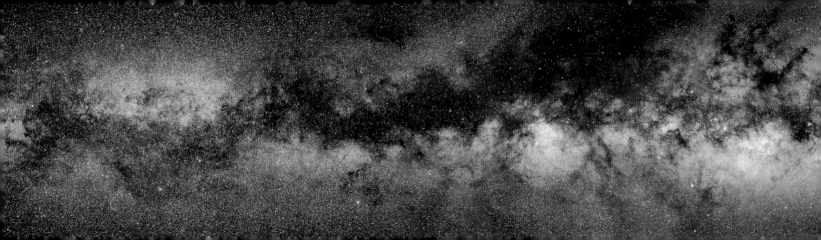

Saturn's Rings from the Other Side

What do Saturn's rings look like from the other side? From Earth, we usually see Saturn's rings from the same side of the ring plane that is illuminated by the Sun. Geometrically, in this picture taken in April 2005 by the robot Cassini spacecraft orbiting Saturn, the Sun is behind the camera but on the other side of the ring plane. Such a vantage point gives a breathtaking view of the most splendid ring system in the solar system. Strangely, the rings have similarities to a photographic negative of a front view. For example, the dark band in the middle is actually the normally bright B ring. The ring brightness as recorded from different angles indicates ring thickness and the density of ring particles. Images like these are also interesting for what they do not show: spokes. Not shown here are unexpected shadowy regions, first recorded by the Voyager missions when they passed Saturn in the early 1980s. Extra credit: Can you spot the small moon Prometheus among the rings? (Hint: Follow the thin, bright outer ring.)

Credit: Cassini Imaging Team, SSI, JPL, ESA, NASA

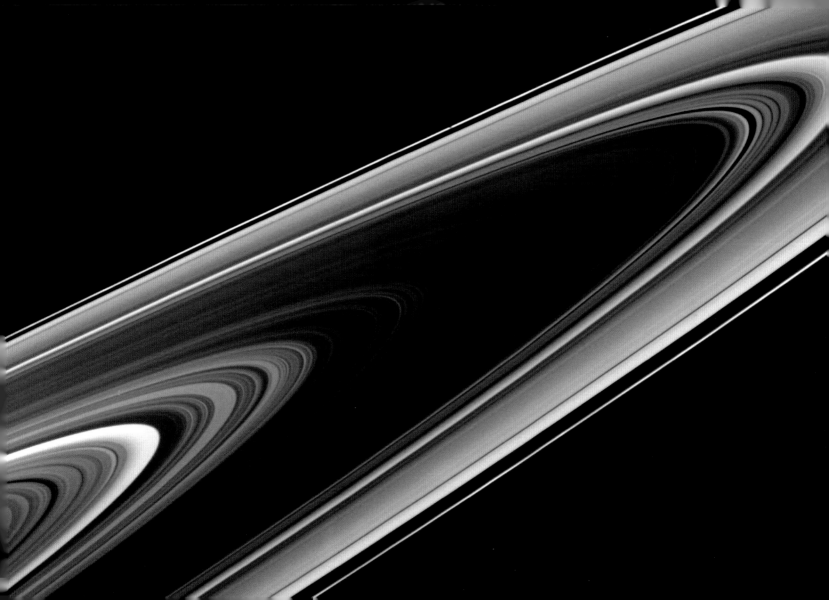

The Cygnus Wall of Star Formation

The North America Nebula in the sky can do what North Americans on Earth cannot—form stars. Specifically, in analogy to the Earth-confined continent (with south pointing to the left), the bright part that appears as Central America and Mexico is actually a hotbed of gas, dust, and newly formed stars known as the Cygnus Wall. This image, in representative colors, shows the star-forming wall lit and eroded by bright young stars and partly hidden by the dark dust they have created. The part of the North America Nebula (NGC 7000) shown spans about 15 light-years and lies about 1,500 light-years away in the direction of the constellation Cygnus.

Credit & copyright: Michael Sherick

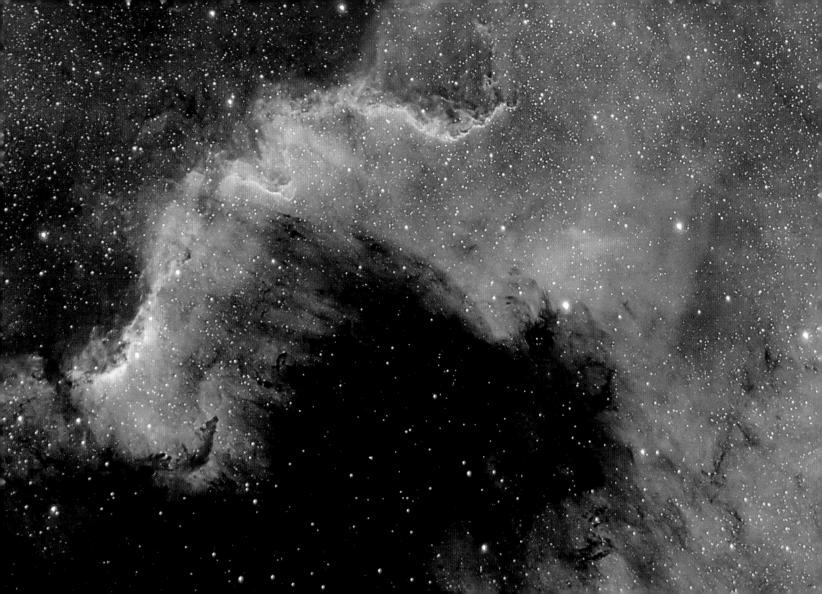

Saturn: Dirty Rings and a Clean Moon

Eating surface ice from Saturn's moon Enceladus might be healthier than eating ice from its rings—it certainly appears cleaner. From their apparent densities and reflectance properties, both Enceladus and the rings of Saturn are thought to be composed predominantly of water ice. For reasons that are not yet understood, however, many of the ring particles have become partly coated with some sort of relatively dark dust, while the surface of Enceladus appears comparatively bright and clean.

The contrast between the two can be seen in this 2005 image by the robot Cassini spacecraft orbiting Saturn. Enceladus shines in the background, in contrast to the darker foreground rings. Its brightness suggests that fresh water may be brought to its surface by water volcanoes.

Credit: Cassini Imaging Team, SSI, JPL, ESA, NASA

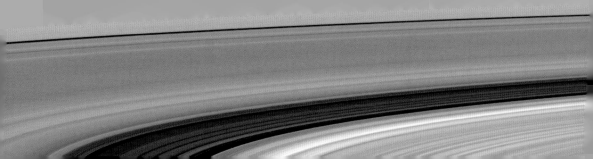

The Small Magellanic Cloud

Portuguese navigator Ferdinand Magellan and his crew had plenty of time to study the southern sky during the first circumnavigation of planet Earth. As a result, two celestial wonders easily visible for southern hemisphere skygazers are known as the Clouds of Magellan. These cosmic clouds are now understood to be dwarf irregular galaxies, satellites of our larger spiral Milky Way Galaxy. The Small Magellanic Cloud, pictured here, actually spans 15,000 light-years or so and contains several hundred million stars. About 210,000 light-years distant in the constellation Tucana, it is the fourth-closest of the Milky Way's known satellite galaxies, after the Canis Major and Sagittarius dwarf galaxies and the Large Magellanic Cloud. This gorgeous view also includes two foreground globular star clusters, NGC 362 (top left) and 47 Tucanae. Spectacular 47 Tucanae, a mere 13,000 light-years away, can be seen to the right of the Small Magellanic Cloud.

Credit & copyright: Josch Hambsch, Robert Gendler

Sunset over
Gusev Crater

What would it be like to see a sunset on Mars? To help find out, the robot Spirit rover was parked to serenely watch the Sun dip below the distant lip of Gusev Crater. It was a tough job, but some robot had to do it. On Earth, a red sunset is caused by blue light being preferentially scattered out of sunlight by oxygen and nitrogen molecules or by trace impurities (such as volcanic dust) in the atmosphere. Although Mars lacks oxygen and nitrogen, it is covered in red dust that is frequently hoisted into the atmosphere by fast but thin winds. Analyses of images like this show that at least some Martian days are capped by a sunset significantly longer and redder than is typical on Earth. For up to two hours after twilight, sunlight continued to reflect off Martian dust high in the atmosphere, casting a diffuse glow.

Credit: Mars Exploration Rover Mission, Texas A&M, Cornell, JPL, NASA

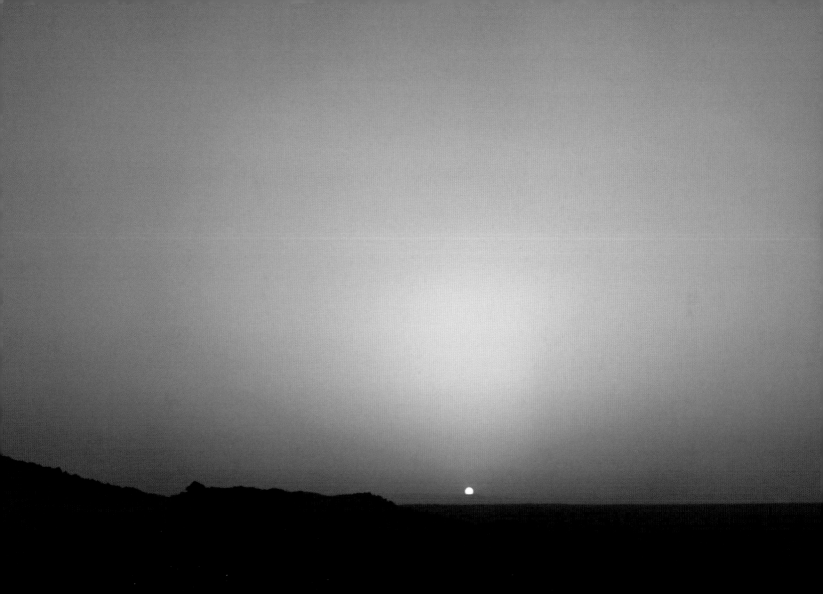

The Sun's Surface in 3-D

How smooth is the Sun? The Swedish 1-meter Solar Telescope, deployed in the Canary Islands, images objects less than 100 kilometers across on the Sun's surface. When it is pointed toward the Sun's edge, surface objects begin to block one another, indicating true three-dimensional information. Close inspection of this image reveals much vertical information, including spectacular light-bridges rising nearly 500 kilometers above the floor, at the level of the sunspots near the top of the image. Also visible are hundreds of bubbling granules, each about 1,000 kilometers across, and small, bright regions known as faculae.

Credit: G. Scharmer (ISP, RSAS) et al., Lockheed Martin Solar & Astrophysics Laboratory

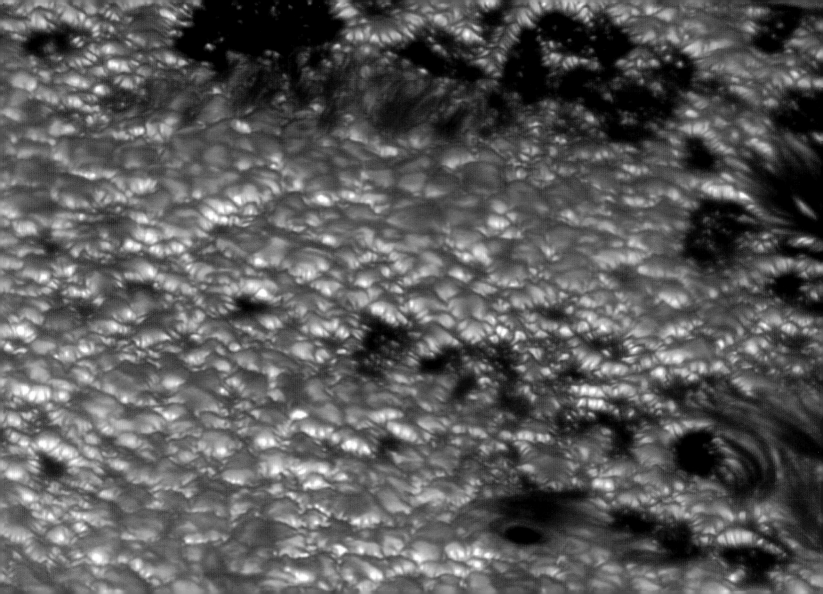

Zooming in on the First Stars

No known stars appear to be composed of truly primordial gas—all of the stars around us have too many heavy elements. Our own Sun is thought to be a third-generation star, and many second-generation stars are seen in globular clusters. Significant progress has been made in solving a perennial astronomical mystery, though, as computer codes are more accurately tracking the likely creation and evolution of the first stars in the early universe. Pictured here spanning 1 light-month, a computer-generated model resolves the size of the first stars, indicating clean cocoons that condensed into stars over thirty times the mass of our Sun. Stars like this quickly fused pristine gas into heavier elements and then exploded, seeding the universe with elements that would become part of the stars we know—and, ultimately, us.

Credit & copyright: Visualization: Ralf Kaehler (ZIB) & Tom Abel (KIPAC/Stanford); simulation: Tom Abel (KIPAC/Stanford), Greg Bryan (Columbia) & Mike Norman (UCSD)

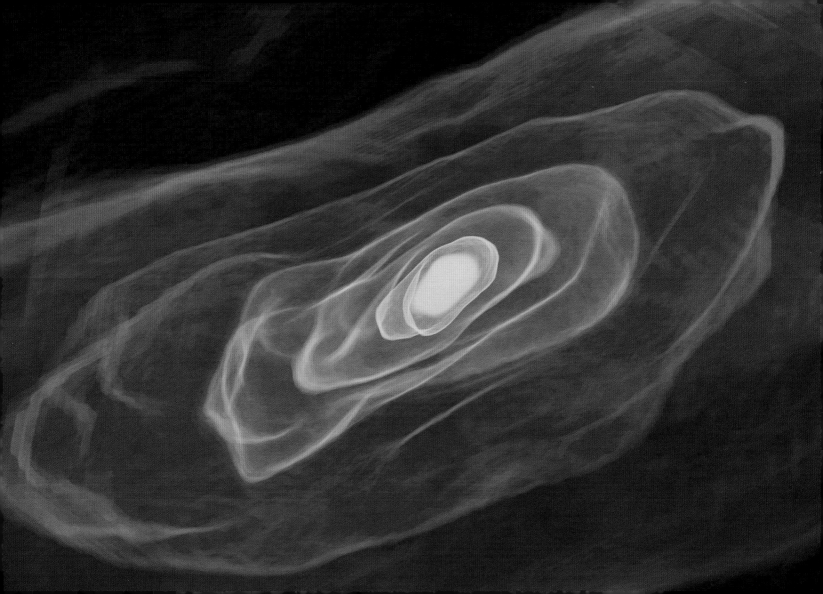

Sculpting the South Pillar

Eta Carinae, one of the most massive and unstable stars in the Milky Way Galaxy, has a profound effect on its environment. These fantastic pillars of glowing dust and gas with embedded newborn stars, found in the South Pillar region of the Carina Nebula, were sculpted by the intense wind and radiation from Eta Carinae and other massive stars. Glowing brightly in planet Earth's southern sky, the expansive Eta Carinae Nebula is a mere 10,000 light-years distant. Still, this remarkable cosmic vista is largely obscured by nebular dust and revealed here only in penetrating infrared light by the Spitzer Space Telescope. Eta Carinae itself is off the top left of the false-color image, with the bright-tipped dust pillars pointing suggestively toward the massive star's position. The Spitzer image spans almost 200 light-years at the distance of Eta Carinae.

Credit: Nathan Smith (University of Colorado) et al., SSC, JPL, Caltech, NASA

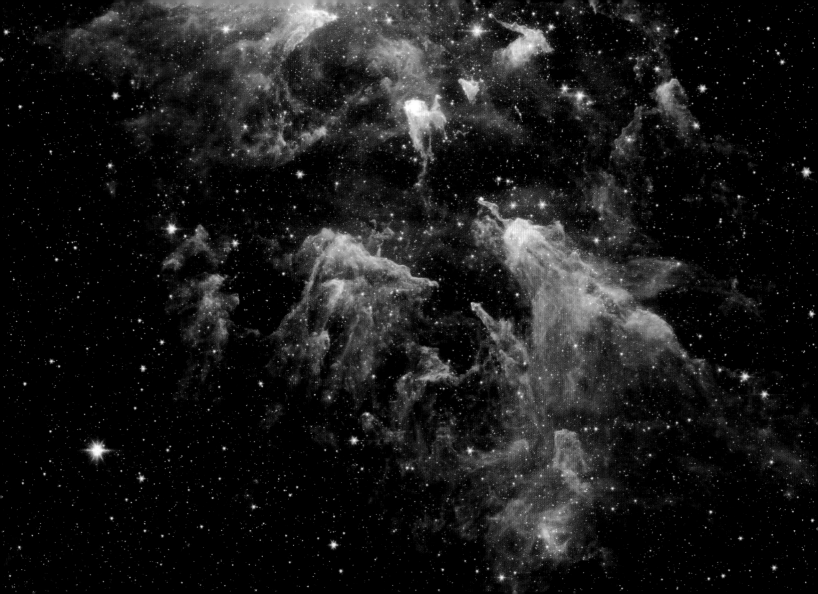

Phoebe: Comet Moon of Saturn

Was Saturn's moon Phoebe once a comet? Images taken from the robot Cassini spacecraft in 2004, when it was entering the neighborhood of Saturn, indicate that Phoebe may have originated in the outer solar system. Phoebe's irregular surface, retrograde orbit, unusually dark surface, assortment of large and small craters, and low average density appear consistent with the hypothesis that it was once part of the Kuiper belt of icy comets beyond Neptune before being captured by Saturn. Visible in this image of Phoebe are craters, streaks, and layered deposits of light and dark material. The image was taken about 30,000 kilometers out from this 200-kilometer-diameter moon.

The close-up image spans about 80 kilometers.

Credit: Cassini Imaging Team, SSI, JPL, ESA, NASA

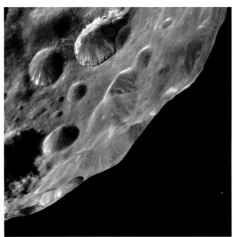

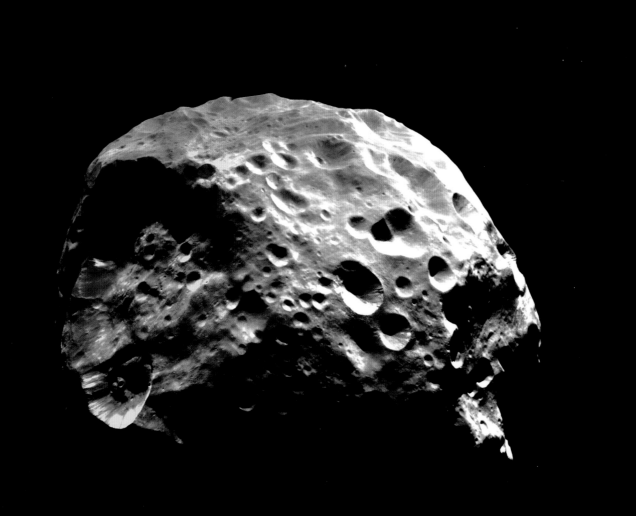

In the Center of NGC 6559

Bright gas and dark dust permeate the space between stars in the center of a nebula known as NGC 6559. The gas, primarily hydrogen, is responsible for the diffuse red glow of the emission nebula. As energetic light from neighboring stars ionizes interstellar hydrogen, protons and electrons recombine to emit light of very specific colors, including the red hue observed. Small dust particles reflect blue starlight efficiently and so create the blue reflection nebulosity seen near two of the bright stars. Dust also absorbs visible light, making the dark clouds and filaments visible. NGC 6559 lies about 5,000 light-years away toward the constellation Sagittarius.

Credit: Adam Block (KPNO Visitor Program), NOAO, AURA, NSF

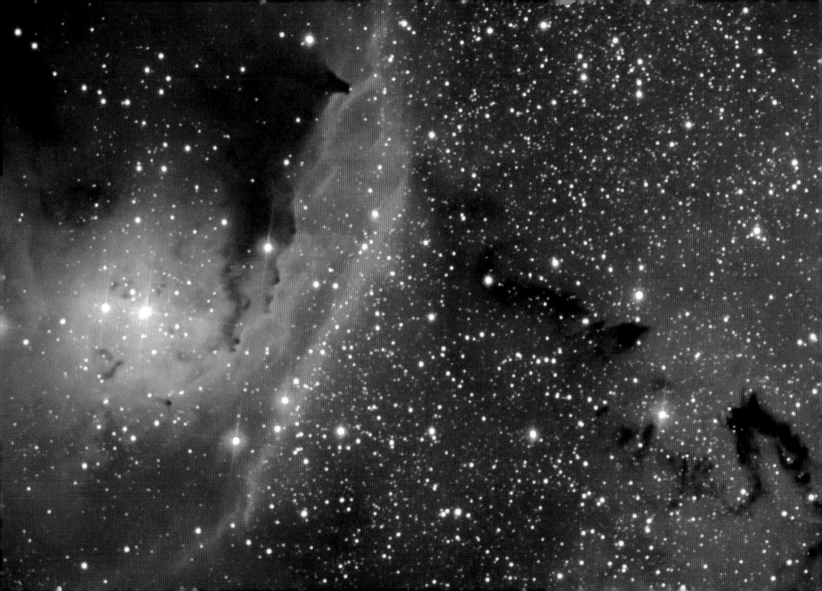

The Colorful Clouds of Rho Ophiuchi

The spectacular colors of the Rho Ophiuchi (OH-fee-yu-kee) interstellar clouds highlight the many processes that occur in and around them. The blue regions shine primarily by light from the star Rho Ophiuchi and nearby stars, which is reflected more efficiently than red light. (Earth's daytime sky appears blue for the same reason.) The red and yellow regions shine primarily because of emission from the nebula's atomic and molecular gas. Light from nearby blue stars—more energetic than the bright star Antares (at left), the brightest star in the frame—knocks electrons away from the gas, which then shines when the electrons recombine with the gas. The dark regions are caused by dust grains born in young stellar atmospheres, which effectively block light emitted behind them. The Rho Ophiuchi star clouds, well in front of the globular cluster M4 (at lower left), are even more colorful than humans can see—the clouds emit light in every wavelength band from the radio to the gamma-ray.

Credit: Adam Block (KPNO Visitor Program), NOAO, AURA, NSF

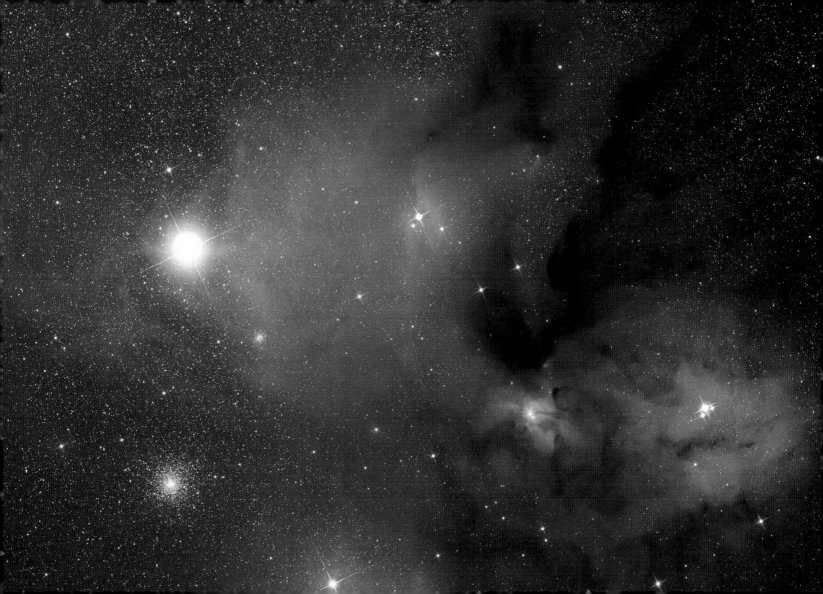

Planet Earth from SpaceShipOne

On June 21, 2004, pilot Mike Melvill made a historic flight in the winged craft dubbed SpaceShipOne—the first private manned mission to space. The spaceship reached an altitude of just over 62 miles (100 kilometers) on a suborbital trajectory, similar to the early space flights in NASA's Mercury program. So, how was the view? A video camera on an earlier test flight that climbed 40 miles recorded the inset picture looking west over the southern California coast and Earth's limb (edge). In the foreground, the nozzle of SpaceShipOne's hybrid rocket is visible along with the edge of the wing in a "feathered" configuration for reentry. In the larger photo, slung below White Knight, its equally innovative mother ship, SpaceShipOne rides above planet Earth during a flight test. SpaceShipOne was designed and built by Burt Rutan and his company, Scaled Composites. The team claimed the coveted $10 million X Prize for private spaceflight in 2005. The X Prize was modeled after the Orteig Prize, designed to inspire ocean-crossing airplane flights, which Charles Lindbergh won in 1927.

Credit & copyright: Courtesy of Scaled Composites, LLC

June 17

2 Million Galaxies

Our universe is filled with galaxies. These huge conglomerations of stars, gas, dust, and mysterious dark matter are the basic building blocks of the large-scale universe. Although distant galaxies move away from one another as the universe expands, gravity attracts neighboring galaxies toward each other, forming galactic groups, clusters of galaxies, and even larger expansive filaments. Some of these structures are visible on one of the most comprehensive maps of the sky ever made: the APM galactic survey map, completed in the early 1990s. Over 2 million galaxies are depicted in a region 100 degrees across, centered toward our Milky Way's south pole. Bright regions indicate more galaxies, while bluer colors denote larger average ones. Where bright local stars dominate the sky, they have been cut away, leaving dark ellipses. Many scientific discoveries resulted from analyses of the map data, including that the universe was surprisingly complex on large scales.

Credit & copyright: S. Maddox (Nottingham University) et al., APM Survey, Astrophysics Department, Oxford University

June 18

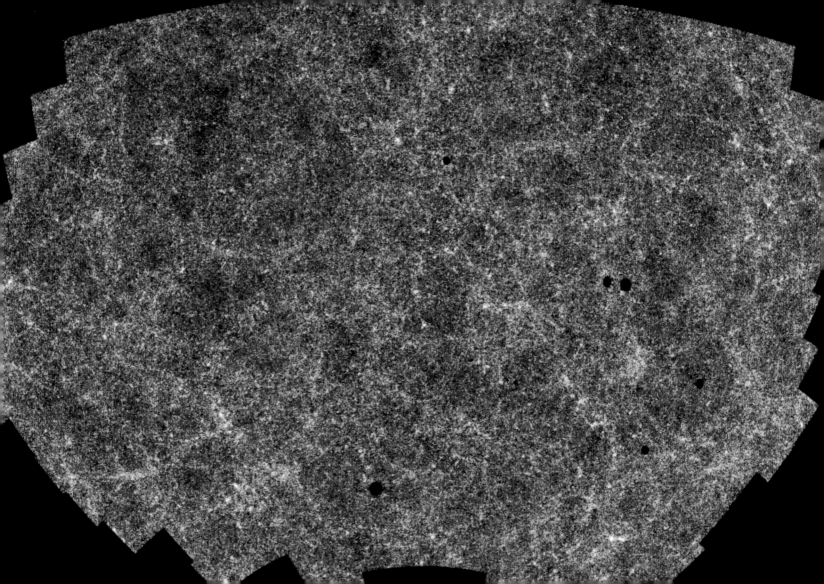

Spirit Reaches the Columbia Hills

The robot Spirit rover reached the Columbia Hills on Mars in mid-2004, and two of the hills are seen here on its approach toward the beginning of June. This true-color picture shows very nearly what a human would see from Spirit's vantage point. The red color of the rocks, hills, and even the sky is caused by pervasive rusting sand. By this time, Spirit had traveled over 3 kilometers since it bounced down onto the Red Planet in January. The robotic explorer, programmed and controlled remotely from Earth, moved on to investigate a rock called Pot of Gold. On the other side of Mars at the same time, Spirit's twin, Opportunity, was inspecting unusual rocks inside a pit dubbed Endurance Crater.

Credit: Mars Exploration Rover Mission, JPL, NASA

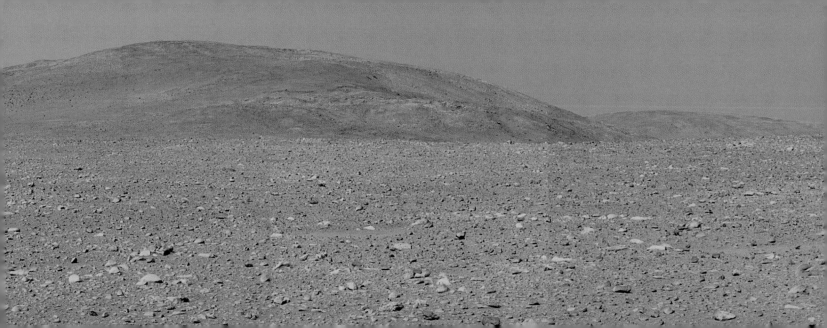

Clouds and the Moon Move to Block the Sun

High above a small church near Vienna, Austria, clouds and the Moon vied for position in front of the Sun during a partial solar eclipse in May 2003. The eclipse was visible throughout Europe and Asia. As the Moon neared the farthest point of its orbit around Earth, its angular size was too small to block the entire Sun. Doing so would have resulted in a total solar eclipse.

Credit & copyright: Peter Wienerroither (Universität Wien)

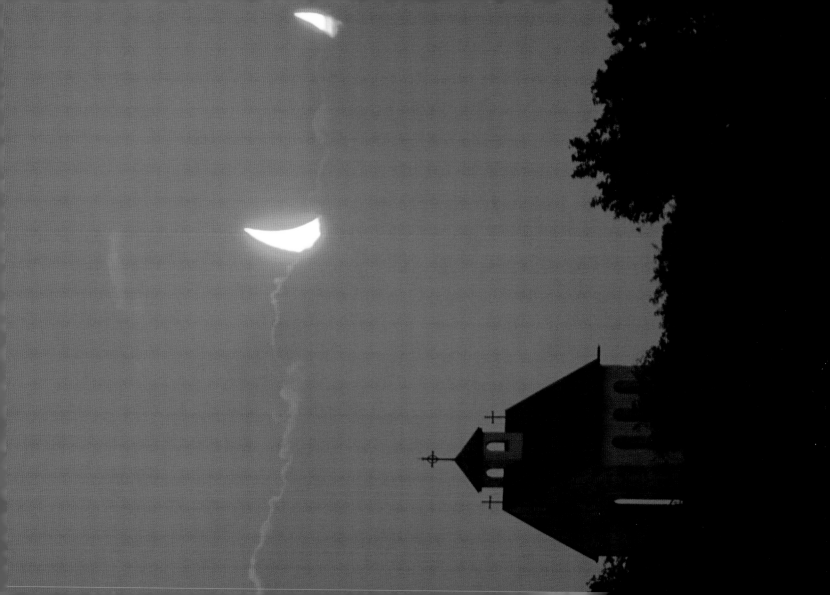

Analemma over Ancient Nemea

An analemma is that figure-eight curve you get when you mark the position of the Sun at the same time each day throughout planet Earth's year. Here, forty-four separate exposures (plus one foreground exposure) were recorded on a single piece of film to illustrate the regular solar motion—a Herculean task performed during the calendar year 2003. Appropriately, in the foreground are the ruins at ancient Nemea, where that hero of Greek mythology pursued the first of his Twelve Labors. Solstices correspond to the top and bottom of the figure-eight or the northern- and southernmost excursions of the Sun in the sky. The tilt of Earth's axis and the variation in speed as the planet moves around its orbit produce the graceful analemma curve.

Credit & copyright: Anthony Ayiomamitis

June 21

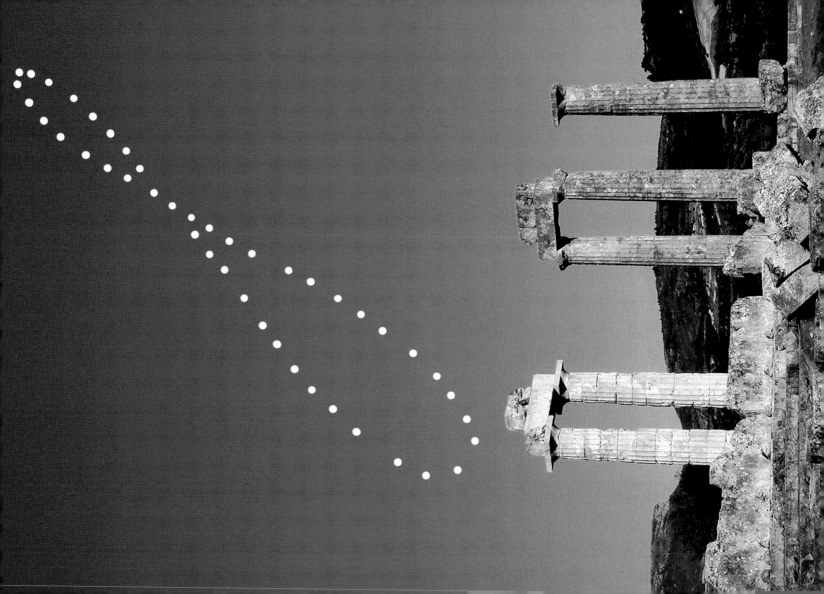

Comet NEAT and the Beehive Cluster

The unaided eye could see similar fuzzy patches. But when a bright comet passed in front of a bright star cluster in May 2004, binoculars and cameras were able to show off their marked differences in dramatic fashion. The comet, C/2001 Q4 (NEAT), reveals many details of its coma and tail, while far in the distance the Beehive open cluster, M44, shows many of its stars. Comet Q4 has long since faded from view, but M44 remains an impressive star cluster in the direction of the constellation Cancer.

Credit & copyright: Jimmy Westlake (Colorado Mountain College)

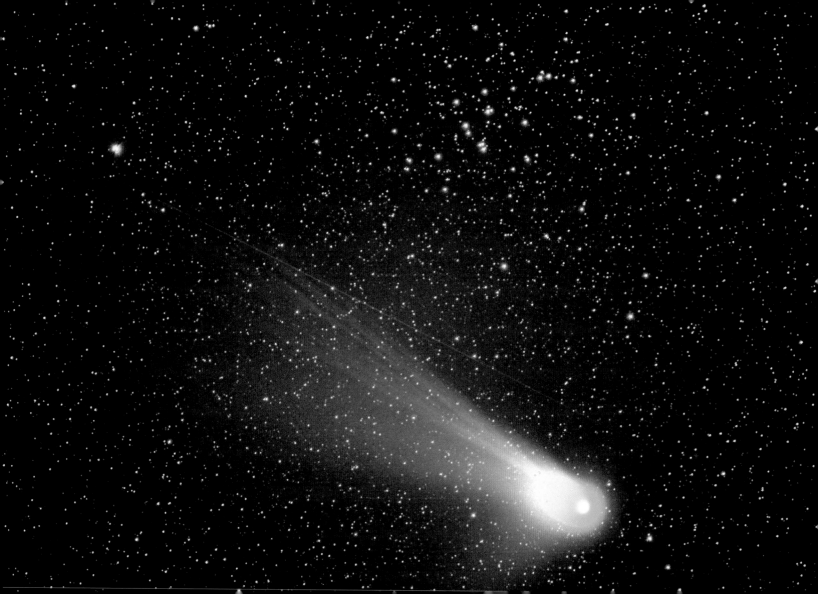

Mammatus Clouds over Mexico

Normally, cloud bottoms are flat because moist, warm air that rises and cools condenses into water droplets at a very specific temperature, which usually corresponds to a very specific height. After water droplets form, that air becomes an opaque cloud. Under some conditions, however, cloud pockets can develop containing large droplets of water or ice that fall into clear air as they evaporate. Such pockets may occur in turbulent air near a thunderstorm, being seen near the top of an anvil cloud, for example. Resulting mammatus clouds can appear especially dramatic if sunlit from the side. These were photographed over Monclova, Mexico.

Credit & copyright: Raymundo Aguirre

The Trifid Nebula

Clouds of glowing gas mingle with lanes of dark dust in the Trifid Nebula, a star-forming region in the direction of the constellation Sagittarius. The three huge dark dust lanes that give the Trifid its name all come together in the center of this image. Mountains of opaque dust appear at the right, while filaments of dust can be seen threaded throughout the nebula. A single massive star visible near the center causes much of the Trifid's glow. Also known as M20, the Trifid is only about 300,000 years old, making it among the youngest emission nebulae known. The nebula lies about 5,000 light-years away, and the portion pictured here spans about 10 light-years. This scientific-color image is a composite of several exposures taken by the Hubble Space Telescope.

Credit: Hubble Heritage Team (AURA/STScI), F. Yusef-Zadeh (Northwestern University) et al., ESA, NASA

June 24

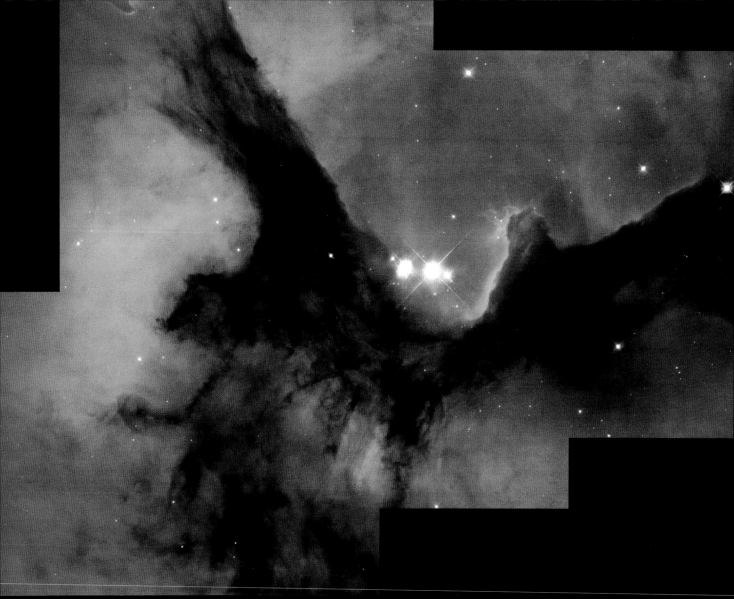

Genesis Mission's Hard Impact

A flying saucer from outer space crash-landed in the Utah desert in early September 2004, after being tracked by radar and chased by helicopters. No space aliens were involved, however. The saucer, pictured here, was the Genesis sample return capsule, part of the human-made robot Genesis spaceship launched three years earlier by NASA to study the Sun. The capsule's unexpectedly hard landing at over 300 kilometers per hour occurred because the parachutes did not open as planned. The Genesis mission had been orbiting the Sun collecting solar wind particles that are usually deflected away by Earth's magnetic field. Genesis team scientists and engineers soon began working hard on the damaged samples to recover information about the real composition of the Sun.

Credit: Genesis Mission, NASA

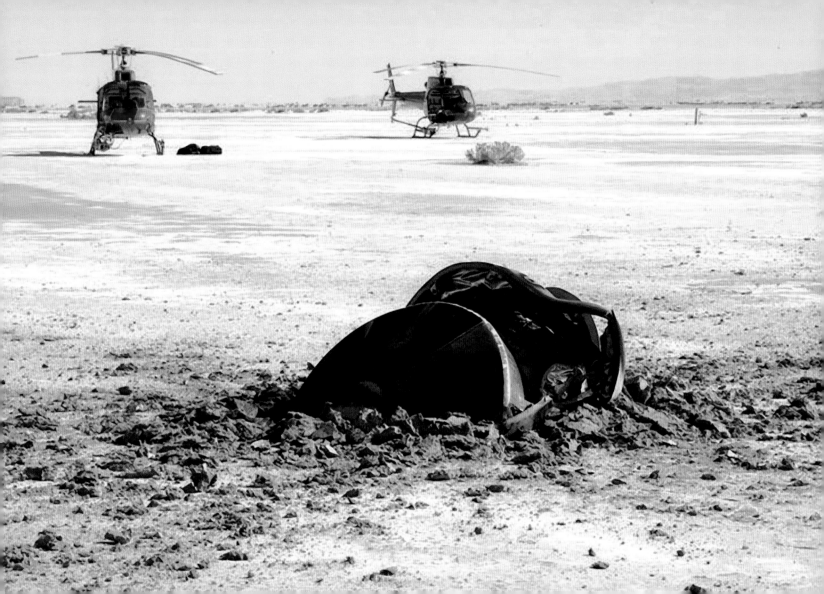

KamLAND
Verifies the Sun

After decades of searching for neutrinos from the nuclear reactions thought to power the Sun, leading astrophysicists now consider the mystery of the missing solar neutrinos solved. And it was solved, in part, by a triumphant failure in this large sphere built under Japan. The KamLAND sphere, shown here during construction in 2001, was unable to detect fundamental particles related to neutrinos, a result best explained by the theory that neutrinos are unstable, oscillating between different types. KamLAND's results bolster previous neutrino oscillation claims, including that from researchers at the Sudbury detector, a similar large sphere beneath Canada. While this finding has helped enhance humanity's understanding of the inner workings of the Sun, one challenge that replaces it is to find a new Standard Model for particle physics that fully explains neutrino oscillations.

Credit: KamLAND Collaboration

M87: A Peculiar Elliptical Galaxy

M87 is a type of galaxy that looks much different from our own Milky Way. Even for an elliptical galaxy, though, M87 is peculiar. It is much bigger than an average galaxy, appears near the center of a whole cluster of galaxies known as the Virgo Cluster, and shows an unusually high number of globular clusters. These are visible in this image as faint spots surrounding the bright center of M87. In general, elliptical galaxies contain similar numbers of stars as spirals but are ellipsoidal in shape (while spirals are mostly flat), have no spiral structure, and contain little gas and dust. This image of M87 was taken by the Canada-France-Hawaii Telescope, on top of the Mauna Kea volcano in Hawaii.

Credit & copyright: Canada-France-Hawaii Telescope / J. C. Cuillandre / Coelum

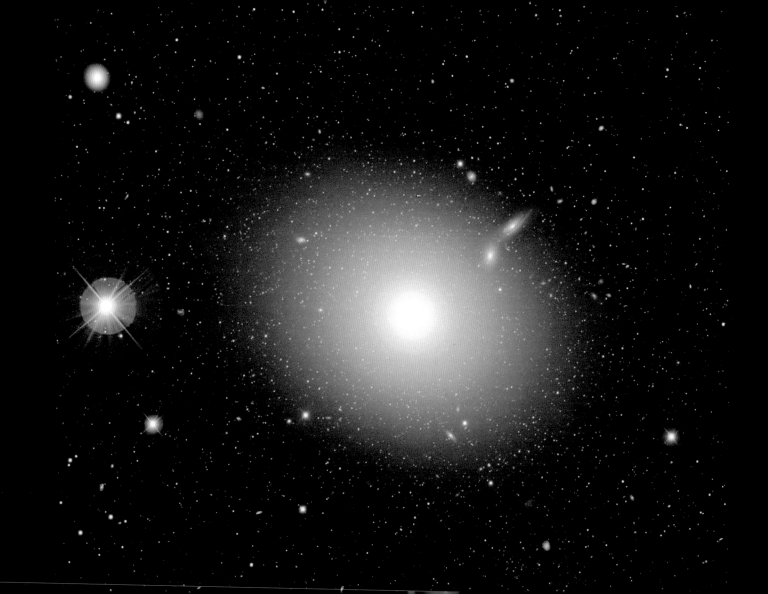

The Galaxy within Centaurus A

Peering deep inside Centaurus A, the closest active galaxy to Earth, the Spitzer Space Telescope's penetrating infrared cameras recorded this startling vista. About 1,000 light-years across, the twisted cosmic dust cloud apparently shaped like a parallelogram is likely the result of a smaller spiral galaxy falling into the giant Centaurus A. The parallelogram lies along the active galaxy's central band of dust and stars, visible in more familiar optical images. Astronomers believe that the striking geometric shape represents an approximately edge-on view of the infalling spiral galaxy's disk in the process of being twisted and warped by the interaction. Ultimately, debris from the ill-fated spiral galaxy should provide fuel for the supermassive black hole lurking at the center of Centaurus A.

Credit: J. Keene (SSC/Caltech) et al., JPL, Caltech, NASA

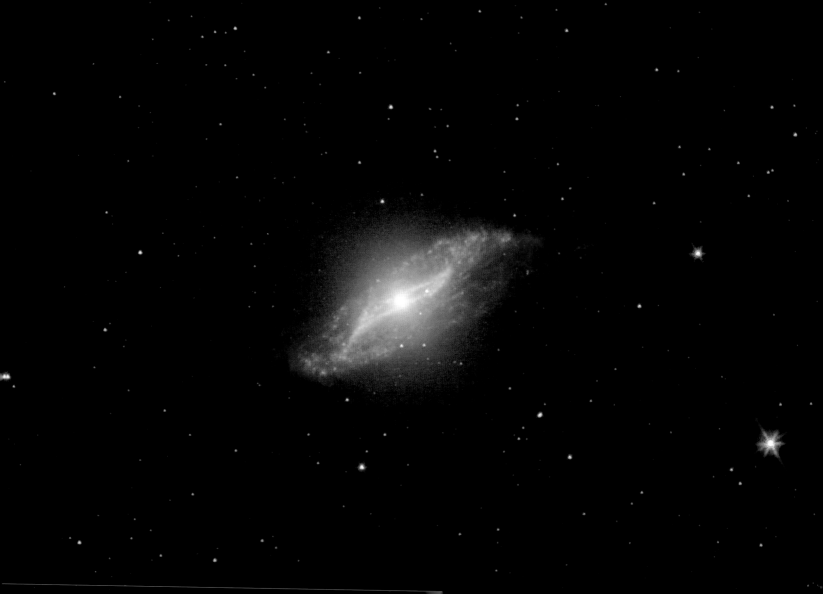

The Pencil Nebula Supernova Shock Wave

At 500,000 kilometers per hour, a supernova shock wave plows through interstellar space. This shock wave is known as the Pencil Nebula, or NGC 2736, and is part of the Vela supernova remnant, an expanding shell of a star that exploded about 11,000 years ago. Initially, the shock wave was moving at millions of kilometers per hour, but the weight of all the gas it has swept up has slowed it considerably. Pictured here, the shock wave moves from left to right, as can be discerned by the lack of gas at the left. The region shown spans nearly 1 light-year across, a small part of the over-100-light-year span of the entire Vela supernova remnant. The Hubble Space Telescope Advanced Camera for Surveys captured the image in October 2002.

Credit: Hubble Heritage Team (STScI/AURA), W. Blair (JHU) & D. Malin (David Malin Images), NASA

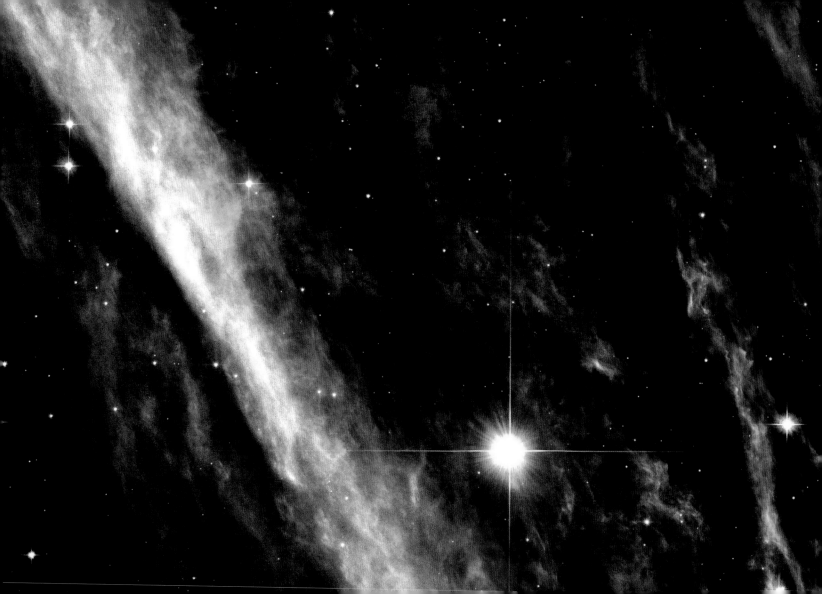

Venus and the Chromosphere

Enjoying the 2004 Transit of Venus from Stuttgart, Germany, astronomer Stefan Seip recorded this fascinating, detailed image of the Sun. Revealing a network of cells and dark filaments against a bright solar disk with spicules and prominences along the Sun's limb (edge), his telescopic picture was taken through an H-alpha filter. The filter narrowly transmits only the red light from hydrogen atoms and emphasizes the solar chromosphere—the region of the Sun's atmosphere immediately above its photosphere, or normally visible surface. Here, the dark disk of Venus seems to be imitating a giant sunspot that looks perhaps a little too round. But in H-alpha pictures like this one, sunspot regions are usually dominated by bright splotches (called plages) on the solar chromosphere.

Credit & copyright: Stefan Seip

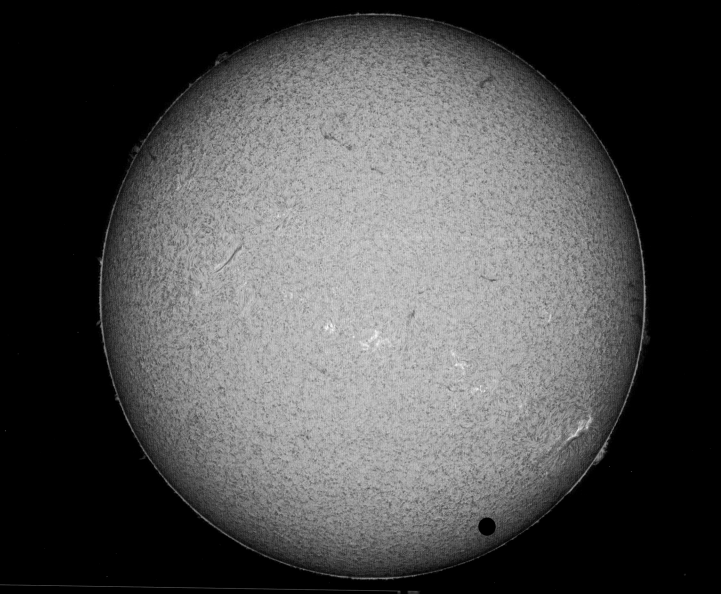

Tethys, Rings, and Shadows

Seen from the ice moon Tethys, rings and shadows would play across fantastic views of the Saturnian system. You have not dropped in on Tethys lately? Then this gorgeous ringscape from the Cassini spacecraft will have to do for now. Caught in sunlight just below and left of the center of this image, Tethys is about 1,000 kilometers in diameter and orbits not quite five Saturnian radii away from the center of the gas giant. At that distance (about 300,000 kilometers), it is well outside the planet's main bright rings, but Tethys is still one of five major moons that find themselves within the boundaries of the faint and tenuous outer E ring. Discovered in the 1980s, two very small moons, Telesto and Calypso, are locked in stable locations along the orbit of Tethys; Telesto precedes and Calypso follows Tethys as the trio circles Saturn.

Credit: Cassini Imaging Team, SSI, JPL, ESA, NASA

July 1

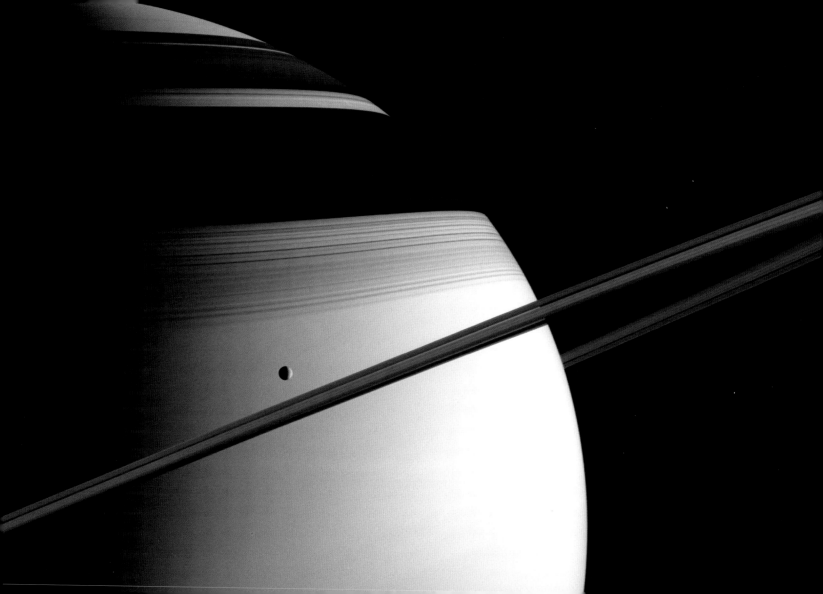

NGC 7331: A Galaxy So Inclined

If our own Milky Way were 50 million light-years away with its disk inclined slightly to our line of sight, it would look a lot like large spiral galaxy NGC 7331. In fact, NGC 7331, seen here in a false-color infrared image from the Spitzer Space Telescope, is interesting in part because it is thought to be so similar to the Milky Way. Light from older, cooler stars, shown in blue, dominates the central bulge of NGC 7331, while Spitzer data also indicate the presence of a black hole within this galaxy's central regions—about the same size as the black hole at our own galactic core. Shown in red and brown, radiation from complex molecules associated with dust traces NGC 7331's star-forming spiral arms. The arms span about 100,000 light-years, around the size of the Milky Way. Curiously, a further star-forming ring is visible in yellowish hues, 20,000 light-years or so from the center of NGC 7331, but it is not known if such a structure exists within our own galaxy.

Credit: M. Regan (STScI) et al., JPL, Caltech, NASA

Stars, Galaxies, and Comet Tempel 1

Faint Comet Tempel 1 sports a fuzzy blue-tinted tail, just right of center in this lovely field of stars. Recorded on May 3, 2005, slowly sweeping through the constellation Virgo, the periodic comet orbits the Sun once every 5.5 years. Also caught in the skyview are two galaxies at the upper left—NGC 4762 and NGC 4754—both members of the large Virgo Cluster of galaxies. Classified as a lenticular galaxy, NGC 4762 presents an edge-on disk as a narrow gash of light, while NGC 4754 is a football-shaped elliptical galaxy. Similar in apparent size, the galaxies and the comet make for an intriguing visual comparison, but Tempel 1 is only about 3 light-minutes from planet Earth; the two Virgo Cluster galaxies are 50 million light-years away. NASA's Deep Impact spacecraft encountered Tempel 1 on July 4, launching a probe that impacted the comet's nucleus.

Credit & copyright: Johannes Schedler (Panther Observatory)

July 3

Approaching the nucleus of Comet Tempel 1 at 10 kilometers per second, the Deep Impact probe's targeting camera recorded a truly dramatic series of images. Successive pictures improve in resolution and have been composited here at a scale of 5 meters per pixel—including images taken within a few meters of the surface moments before the July 4, 2005, impact. On impact, the probe was vaporized as it blasted out an expanding cloud of material. Analyzing the debris, researchers are directly exploring the makeup of a comet, a primordial chunk of solar system material. The list of Tempel 1's ingredients—tiny grains of silicates, iron compounds, complex hydrocarbons, and clay and carbonates thought to require liquid water to form—might be considered a recipe for a cosmic soufflé, as the nucleus is apparently porous and fluffy. Seen here, Tempel 1's nucleus is about 5 kilometers long.

This cloud of debris was photographed thirteen seconds after impact, part of a stunning series of frames documenting the event from the high-resolution camera on board the flyby spacecraft.

Credit: University of Maryland, JPL-Caltech, NASA

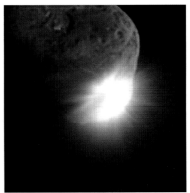

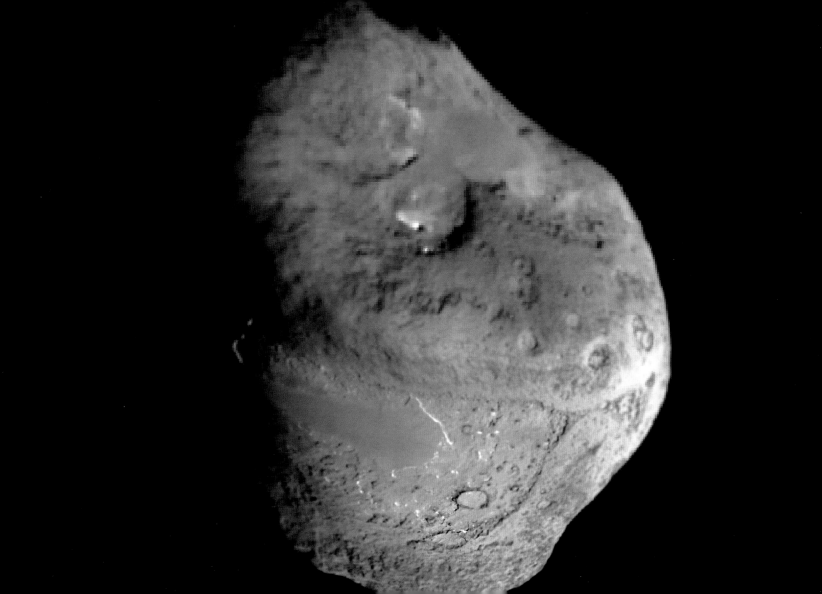

N49's Cosmic Blast

Scattered debris from a cosmic supernova explosion lights up the sky in this gorgeous composited image based on data from the Hubble Space Telescope. Cataloged as N49, these glowing filaments of shocked gas span about 30 light-years in our neighboring galaxy, the Large Magellanic Cloud. Light from the original exploding star reached Earth thousands of years ago, but N49 also marks the location of another energetic outburst—an extremely intense blast of gamma rays detected by satellites just over twenty-five years ago, on March 5, 1979. That date was the beginning of an exciting journey in astrophysics that led researchers to the understanding of an exotic new class of stars. The source of the March 5 event is now attributed to a magnetar—a highly magnetized, spinning neutron star also born in the ancient stellar explosion that created supernova remnant N49. The magnetar hurtles through the supernova debris cloud at over 1,200 kilometers per second.

Credit: Hubble Heritage Team (STScI/AURA), You-Hua Chu (University of Illinois at Urbana-Champaign) et al., NASA

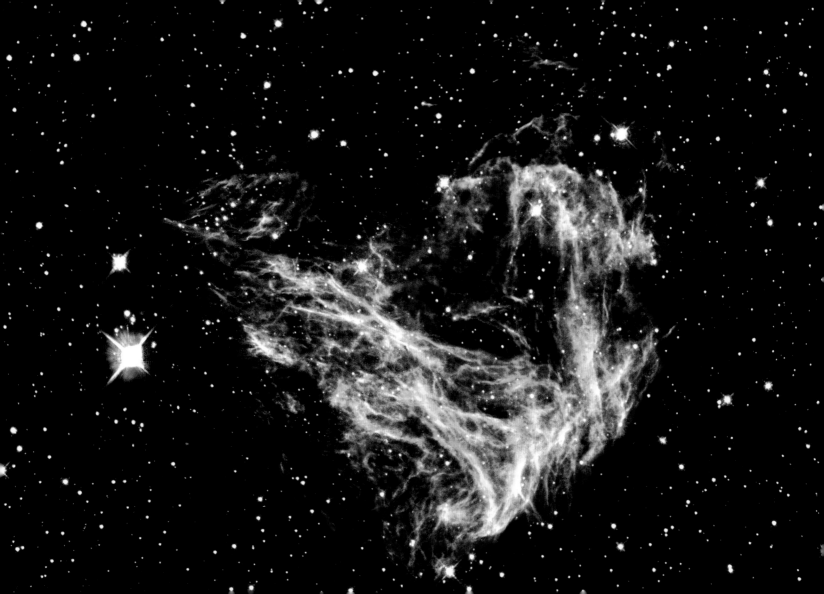

M106 in Canes Venatici

Close to the Great Bear (Ursa Major) and surrounded by the stars of the Hunting Dogs (Canes Venatici), this celestial nebula was discovered in 1781 by the French astronomer (and metric system pioneer) Pierre Mechain. Later, it was added to the catalog of his friend and colleague Charles Messier as M106. Modern deep telescopic views reveal it to be an island universe—a spiral galaxy some 30,000 light-years across and located only about 21 million light-years beyond the stars of the Milky Way. Youthful blue star clusters and reddish stellar nurseries trace the impressive spiral arms of M106. Seen so clearly in this beautiful image, the galaxy's bright core is also visible across the spectrum from radio to x-rays, making M106 a nearby example of the Seyfert class of active galaxies. The bright core of a Seyfert galaxy is believed to be powered by matter falling into a massive central black hole.

Credit: Bernie & Jay Slotnick, Adam Block (KPNO Visitor Program), AOP, NOAO, AURA, NSF

July 6

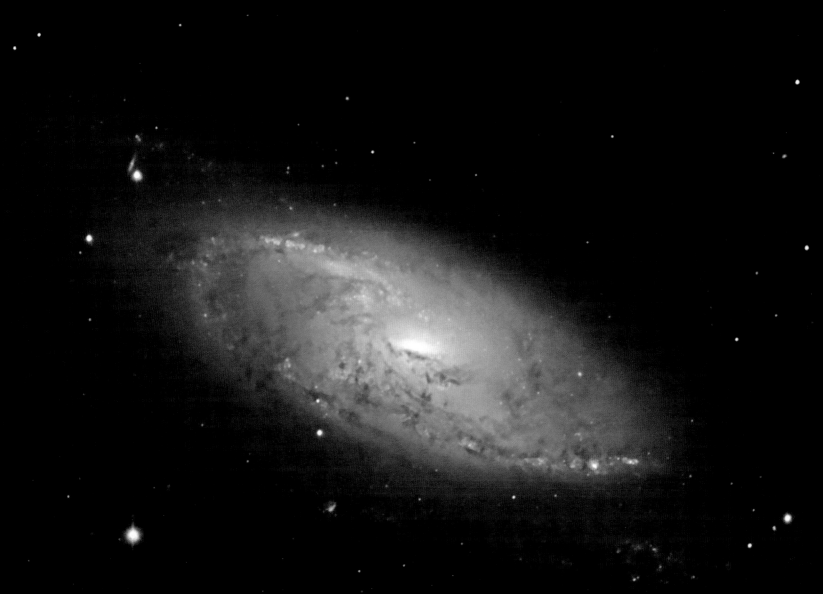

N11B: Star Cloud of the LMC

Massive stars, abrasive winds, mountains of dust, and energetic light sculpt one of the largest and most picturesque regions of star formation in the Local Group of galaxies. Known as N11, the region is visible in many images of its home galaxy, the Milky Way neighbor known as the Large Magellanic Cloud (LMC). The image actually highlights N11B, a part of the nebula that spans about 100 light-years and is particularly active. The entire emission nebula N11 is second in LMC size only to 30 Doradus. Studying the stars in N11B has shown that it actually houses three successive generations of star formation. Compact globules of dark dust containing emerging young stars are also visible, at the upper right.

Credit: Hubble Heritage Team (AURA / STScI), You-Hua Chu (University of Illinois at Urbana-Champaign) et al., ESA, NASA

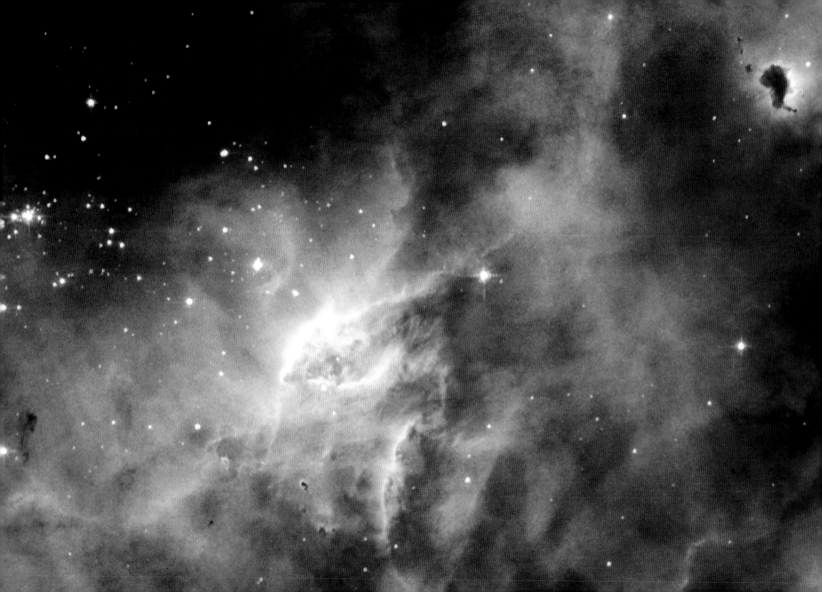

Southern Cross
Star Colors

Fix your camera to a tripod, lock the shutter open, and you can easily record an image of star trails, the graceful concentric arcs traced by the stars as planet Earth rotates on its axis. Gradually change the focus of the camera lens during the exposure, and you could end up with a dramatic picture like this one, in which the out-of-focus portion of the trail shows off the star's color. In this case, the subject is one of the most famous constellations in the night sky: Crux, the Southern Cross. Gacrux, or Gamma Crucis, is the bright red giant only 88 light-years distant that forms the top of the Cross (seen here near the top center). Acrux, the hot blue star at the bottom of the Cross, is about 320 light-years distant. Actually a binary star system, Acrux is the alpha star of the compact Southern Cross and lies along a line pointing from Gacrux to the south celestial pole, off the lower right edge of the picture. Adding a separate short exposure to the end of the step-focused trails to better show the positions of the stars themselves, astronomer Stefan Seip recorded this remarkable image in the dark night skies above Namibia.

Credit & copyright: Stefan Seip

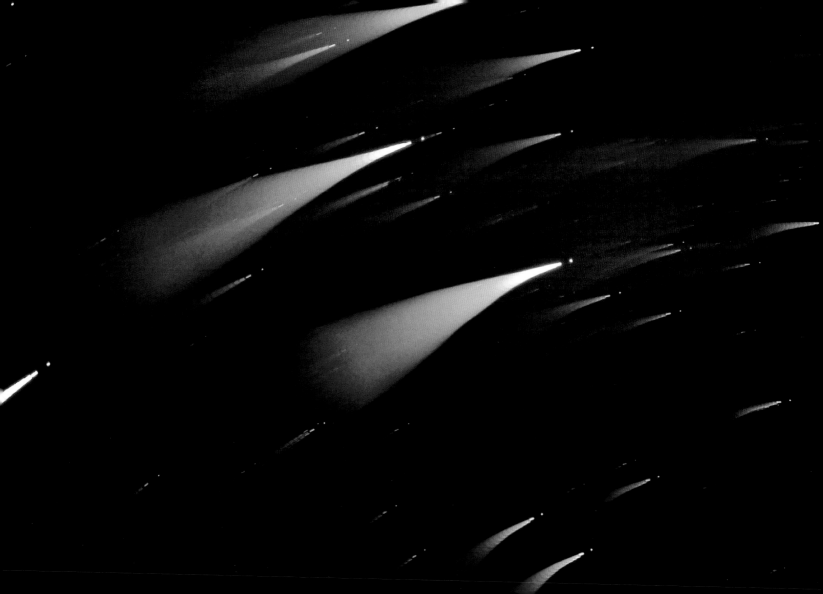

Water Ice in a Martian Crater

What lies on the floor of this Martian crater? It is a frozen patch of water ice, imaged by the robot Mars Express spacecraft in early February 2005. The ice pocket was found in a 35-kilometer-wide crater 70 degrees north of the Martian equator. The 300-meter-tall crater wall blocks sunlight from vaporizing the ice into the thin Martian atmosphere. The ice pocket may be as deep as 200 meters thick. Frost can be seen around the inner edge on the upper right part of the crater, while part of the lower left crater wall is bathed in sunlight. The existence of such water-ice pockets, inside craters near the Martian north pole, provides clues not only about surface conditions in the Martian past but also about possible places where future water-based astronauts might do well to land.

Credit: G. Neukum (FU Berlin) et al., Mars Express, DLR, ESA; image created for & copyright: Nature

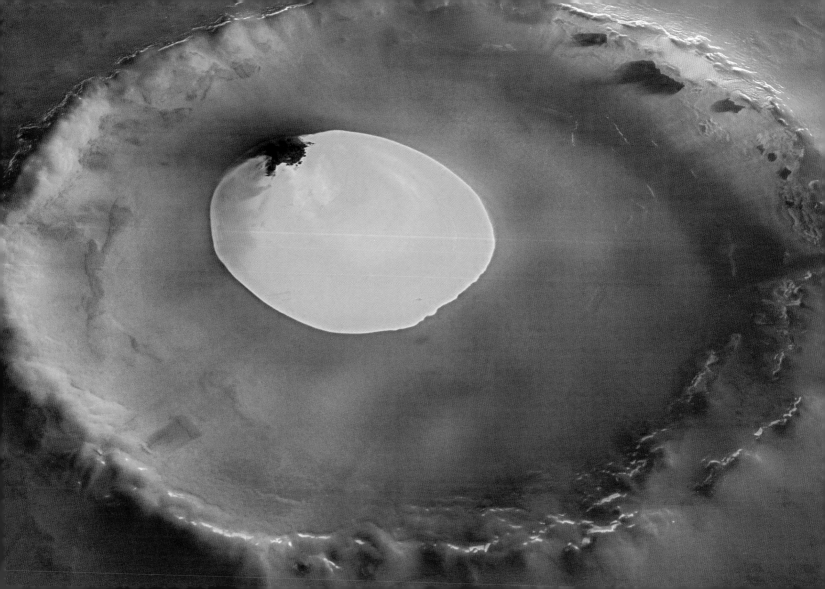

Sunrise over Kilimanjaro

A group hiking at 6:00 A.M. near the top of Tanzania's Mount Kilimanjaro watched the rising sun peek above the clouds and the horizon light up red. No need to worry—the highest volcano in Africa was not erupting. The spectacular sunrise colors are caused by light scattering off the atmosphere and small cloud particles. If all of the scattered light that makes the sky blue were added back into the scene, the sunrise would appear Sun-colored and not so red. A similar light-scattering effect involving small, airborne dust particles causes the redness of Martian sunsets and has been used to determine the size of particles in the rings of Saturn. During this trek in November 2000, a group of about thirty reached the Kilimanjaro summit after a six-day climb.

Credit & copyright: Clayton Hogen-Chin (University of Minnesota)

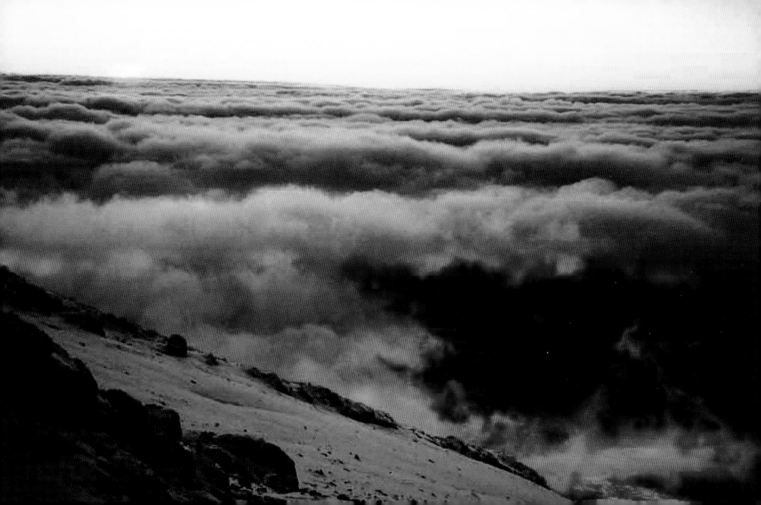

Saturn's Rings in Natural Color

What colors are Saturn's rings? Images from the Cassini spacecraft orbiting the planet confirm that the rings have slightly different hues. This image shows their sometimes-subtle variations in brightness and color. The ring particles, mostly light water ice, can be darkened by an unknown type of dirt. Thinner and more isolated rings also naturally look darker. The brightest section pictured is Saturn's B ring. If the rings were perfectly reflecting, they would appear the color of the Sun.

Credit: Cassini Imaging Team, SSI, JPL, ESA, NASA

July 11

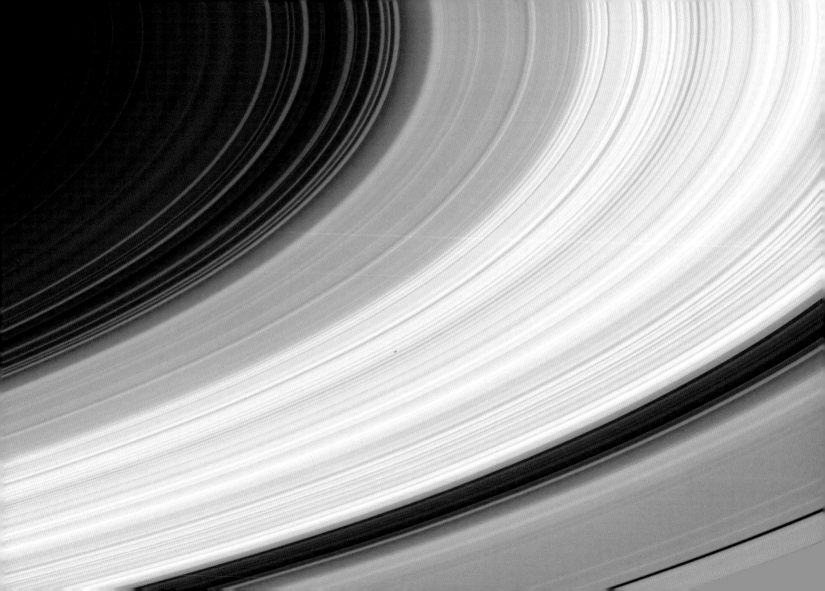

Acosmic dust cloud sprawls across a rich field of stars in this exquisite wide-field telescopic vista looking toward Corona Australis, the Southern Crown. Probably less than 500 light-years away and effectively blocking light from more distant background stars in the Milky Way, the densest part of the dust cloud is about 8 light-years long. At its tip (toward the lower left) is a series of lovely blue nebulae, cataloged as NGC 6726, 6727, and 6729, as well as IC 4812. Their characteristic blue color is produced as the cosmic dust reflects light from hot stars. The tiny but intriguing yellowish arc visible close to the blue nebulae marks young variable star R Coronae Australis. Magnificent globular star cluster NGC 6723 also can be seen here, below and left of the nebulae. While NGC 6723 appears to be just outside Corona Australis in the constellation Sagittarius, it actually lies nearly 30,000 light-years away, far beyond the Corona Australis dust cloud.

Credit: Loke Kun Tan (StarryScapes)

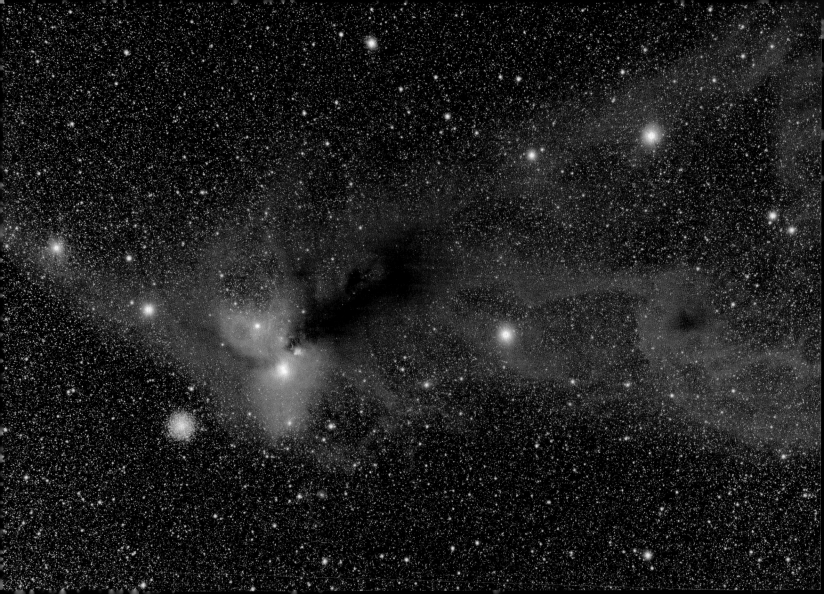

The Bubble

Blown by the wind from a star, this tantalizing ghostly apparition is cataloged as NGC 7635, but known simply as the Bubble Nebula. Astronomer Ken Crawford's striking view combines a long exposure through an H-alpha filter with color images to reveal the intricate details of this cosmic bubble and its environment. Although it looks delicate, the 10-light-year-diameter bubble offers evidence of violent processes at work. Above and left of the Bubble's center is a bright, hot star embedded in the telltale blue hues characteristic of dust-reflected starlight. A fierce stellar wind and intense radiation from the star, which likely has a mass ten to twenty times that of the Sun, have blasted out the structure of glowing gas against denser material in a surrounding molecular cloud. The intriguing Bubble Nebula lies a mere 11,000 light-years away toward the constellation Cassiopeia.

Credit & copyright: Ken Crawford

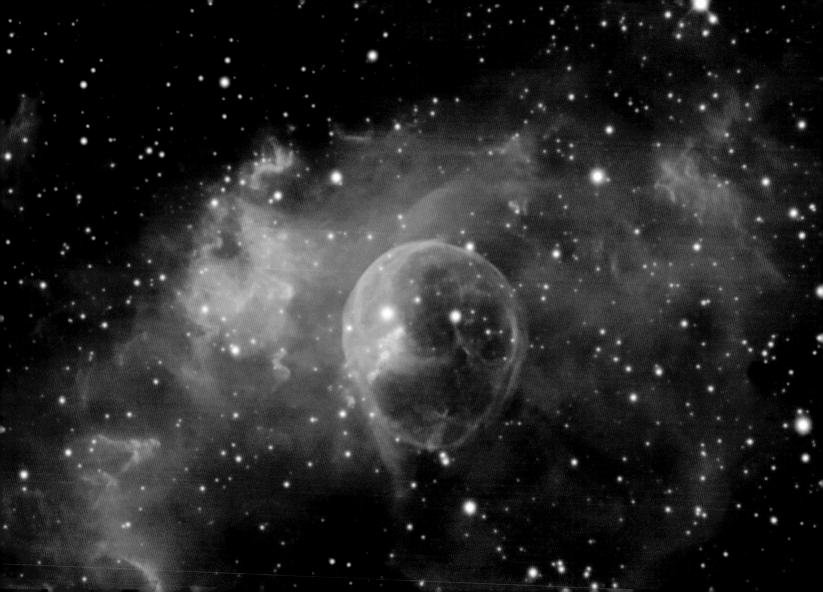

White Dwarf, Neutron Star, and Ancient Planet

A white dwarf, a neutron star, and a planet orbit one another in the giant globular star cluster M4, some 5,600 light-years away. The most visible member of the trio is the white dwarf star in this image from the Hubble Space Telescope, while the neutron star is detected at radio frequencies as a pulsar. A third body was known to be present in the pulsar/white dwarf system, and a detailed analysis of the Hubble data has indicated that it is indeed a planet, with about 2.5 times the mass of Jupiter. In such a system, the planet is likely to be about 13 billion years old. Compared to our solar system's tender 4.5 billion years and other identified planets of nearby stars, this truly ancient world is by far the oldest planet known, almost as old as the universe itself. Its discovery as part of an evolved cosmic trio suggests that planet formation spans the age of the universe, and that this newly discovered planet is likely only one of many formed in the crowded environs of globular star clusters.

Credit: H. Richer (University of British Columbia) et al., NASA, NOAO

July 14

Globular Cluster M4
Location of white dwarf
companion to pulsar B1620-26

Hubble Space Telescope • WFPC2

Apollo 11: Catching Some Sun

Bright sunlight glints and long, dark shadows dramatize this image of the lunar surface taken by Apollo 11 astronaut Neil Armstrong, the first human to walk on the Moon. Pictured are the mission's lunar module, the Eagle, and space-suited lunar module pilot Edwin "Buzz" Aldrin unfurling a long sheet of foil known as the Solar Wind Collector. Exposed facing the Sun, the foil trapped atoms streaming outward in the solar wind, ultimately catching a sample of material from the Sun itself. Along with Moon rocks and lunar soil samples, the Solar Wind Collector was returned for analysis in Earthbound laboratories.

Credit: Apollo 11, NASA (image scanned by Kipp Teague)

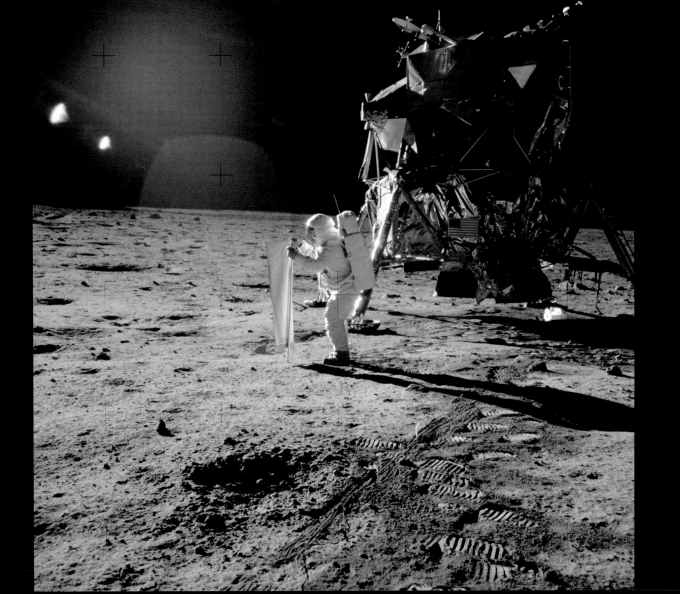

The Pelican Nebula Ionization Front

The light from young, energetic stars is slowly transforming the Pelican Nebula's cold gas to hot gas, with the advancing boundary between the two known as an ionization front. Most of these bright stars lie off the top of the image, but part of the ionization front crosses at the upper right, seen as the bright, whitish, linear feature. Particularly dense and intricate filaments of cold gas are visible along the front. Millions of years from now, this nebula might no longer be known as the Pelican, as the balance and placement of stars and gas will leave something that appears completely different. This image was taken with the 4-meter Mayall telescope at Kitt Peak National Observatory in Arizona. The faint circular feature near the center is an optical reflection, not part of the nebula itself. The nebula, also known as IC 5070, spans about 30 light-years and lies about 1,800 light-years away in the direction of the constellation Cygnus.

Credit: John Bally (University of Colorado) & Bo Reipurth (University of Hawaii), NOAO, AURA, NSF

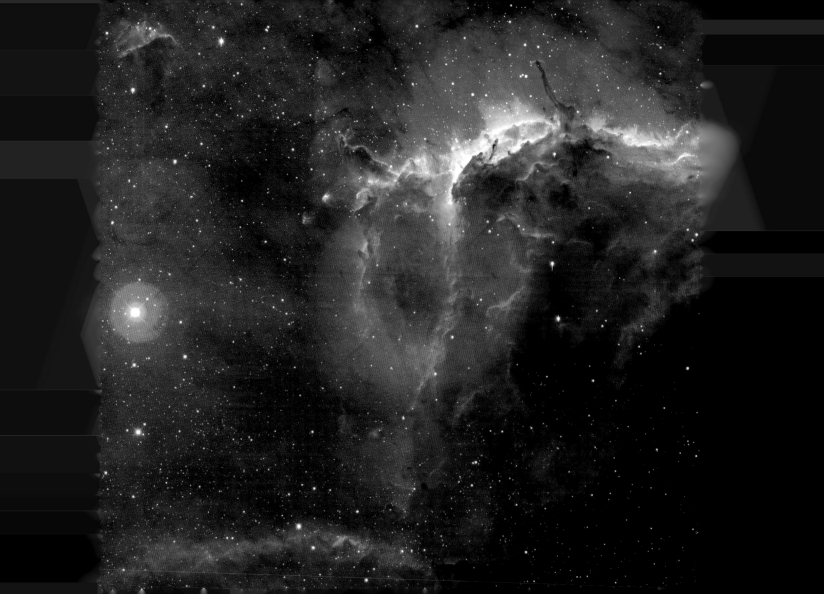

4,500 Kilometers above Dione

What does the surface of Saturn's moon Dione look like? To find out, the robot Cassini spacecraft orbiting Saturn flew right past the fourth-largest moon of the giant planet in October 2005. This image was taken about 4,500 kilometers above Dione's icy surface, spanning about 23 kilometers. Fractures, grooves, and craters in Dione's ice and rock are visible. In many cases, surface features are caused by unknown processes and can only be described. Many of the craters have bright walls but dark floors, indicating that fresher ice is brighter. Nearly parallel grooves run from the upper right to the lower left. Fractures sometimes run across the bottom of craters, indicating a relatively recent formation. The lip of a 60-kilometer-wide crater runs from the middle left to the upper center of the image, while the crater's center is visible at the lower right. Images such as this will continue to be studied to better understand Dione as well as Saturn's complex system of rings and moons.

Credit: Cassini Imaging Team, SSI, JPL, ESA, NASA

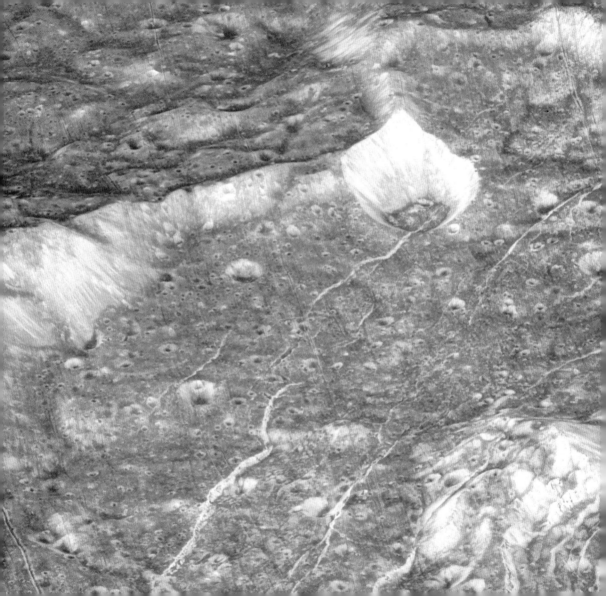

Orion in Infrared

Do you recognize the constellation Orion? This dazzling but unfamiliar-looking picture of the familiar Orion region of the sky was produced using survey data from the now-defunct Infrared Astronomical Satellite (IRAS). This image combines information recorded at three different invisible infrared wavelengths and covers about 30 by 24 degrees on the sky. Most of Orion's visually impressive stars do not stand out, but bright Betelgeuse does appear as the larger and brighter of the two dots at the lower left. The bright region at the right contains the Great Nebula in Orion, while the bright region just above the bottom of the image is the Rosette Nebula. Surrounding these regions is a jumble of chaotic glowing gas and dark dust jettisoned by stars forming and exploding over millions of years.

Credit: IRAS, IPAC, JPL/Caltech, NASA

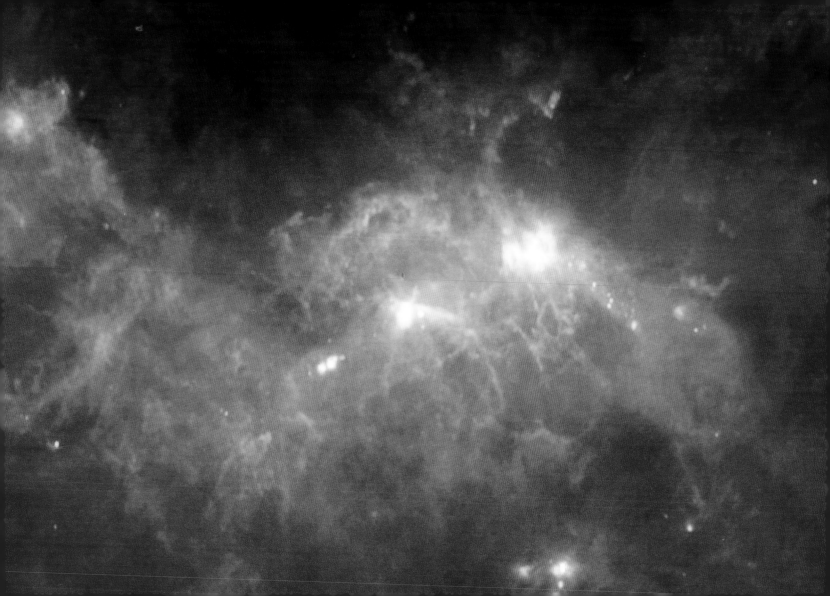

NGC 2359:
Thor's Helmet

NGC 2359 is a striking emission nebula with an impressive popular name: Thor's Helmet. Sure, its suggestive winged appearance might lead some to refer to it as the "Duck Nebula"—but if you were a nebula, which name would you choose? By any name, NGC 2359 is a bubble-like nebula some 30 light-years across, blown by energetic winds from an extremely hot star seen close to the center and classified as a Wolf-Rayet star. Such stars are rare massive blue giants that develop stellar winds with speeds of millions of kilometers per hour. Interactions with a nearby large molecular cloud are thought to have contributed to this nebula's more complex shape and curved bow-shock structures. NGC 2359 is about 15,000 light-years distant in the direction of the constellation Canis Major.

Credit: Christine & David Smith, Steve Mandel, Adam Block (KPNO Visitor Program), NOAO, AURA, NSF

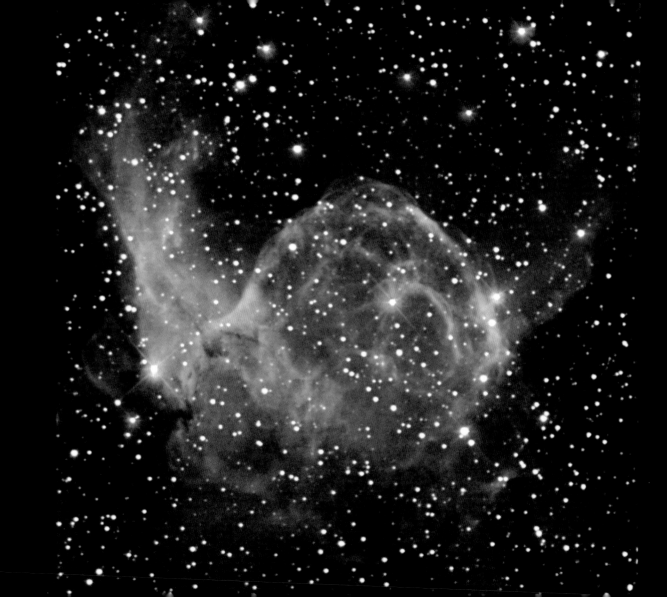

Apollo 17: Last on the Moon

In December 1972, Apollo 17 astronauts Eugene Cernan and Harrison Schmitt spent about seventy-five hours on the Moon, in the Taurus-Littrow Valley, while colleague Ronald Evans orbited overhead. Near the beginning of their third and final excursion across the lunar surface, Schmitt took this picture of Cernan flanked by an American flag and their lunar rover's umbrella-shaped high-gain antenna. The prominent Sculptured Hills lie in the background, while Schmitt's reflection can just be made out in Cernan's helmet. The Apollo 17 crew returned with 110 kilograms of rock and soil samples, more than from any of the other lunar landing sites. Over thirty years later—and thirty-seven years since the *first* Earthling stepped onto the Moon, on July 20, 1969—Cernan and Schmitt are still the last humans to walk on the Moon.

Credit: Apollo 17, NASA (image scanned by Kipp Teague)

July 20

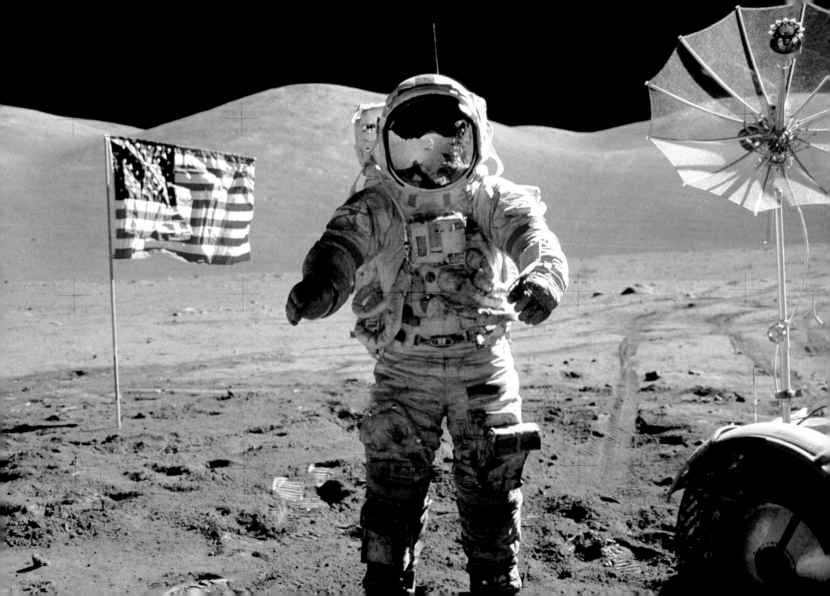

NGC 4565: Galaxy on the Edge

Magnificent spiral galaxy NGC 4565 is viewed edge on from planet Earth. Also known as the Needle Galaxy for its narrow profile, bright NGC 4565 is a stop on many telescopic tours of the northern sky, as it lies in the faint but well-groomed constellation Coma Berenices. This sharp color image reveals the galaxy's bulging central core, dominated by light from a population of older, yellowish stars. The core is dramatically cut by the obscuring dust lanes that lace NGC 4565's thin galactic plane. A large island universe similar to our own Milky Way Galaxy, NGC 4565 is only about 30 million light-years distant, but over 100,000 light-years in diameter. In fact, some consider NGC 4565 to be a prominent celestial masterpiece that Charles Messier missed in the eighteenth century.

Credit: Bruce Hugo & Leslie Gaul, Adam Block (KPNO Visitor Program), NOAO, AURA, NSF

July 21

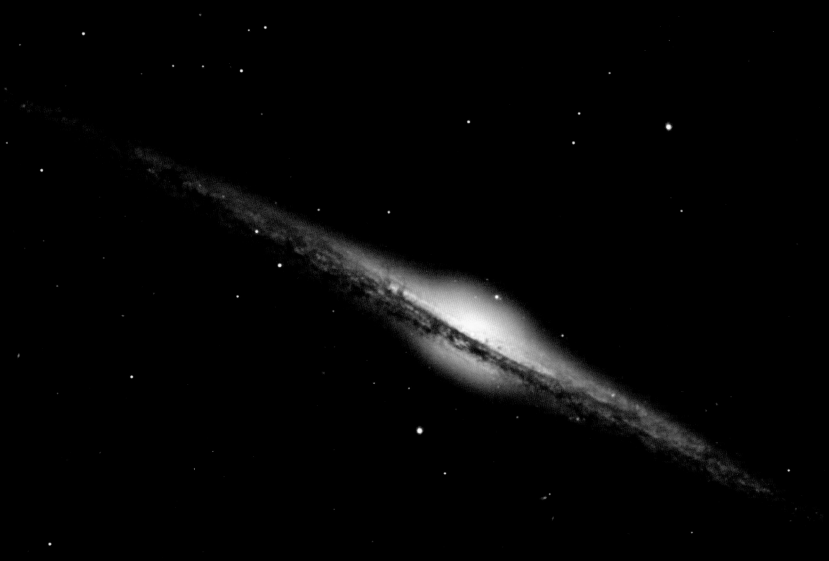

Io's Culann Patera Volcano

What causes the unusual colors surrounding Io's volcanoes? Io, the innermost large moon of Jupiter, is known to be the most tumultuous body in the solar system. Approximately the size of Earth's Moon, Io undergoes nearly continuous volcanic eruptions from an interior heated by gravitational tides from Jupiter and the planet's other large moons. NASA's robot Galileo spacecraft monitored the active volcano Culann Patera for a few years while orbiting Jupiter. These images that it took indicate that the volcano has produced not only red- and black-colored lava flows, but also yellow sulfur patches from explosive plumes. Green hues may arise when these processes affect the same terrain; white patches may be caused, in part, by sulfur dioxide snow. Its mission objectives fulfilled and low on maneuvering fuel, Galileo was deliberately crashed into Jupiter in 2003.

Credit: Galileo Project, JPL, NASA

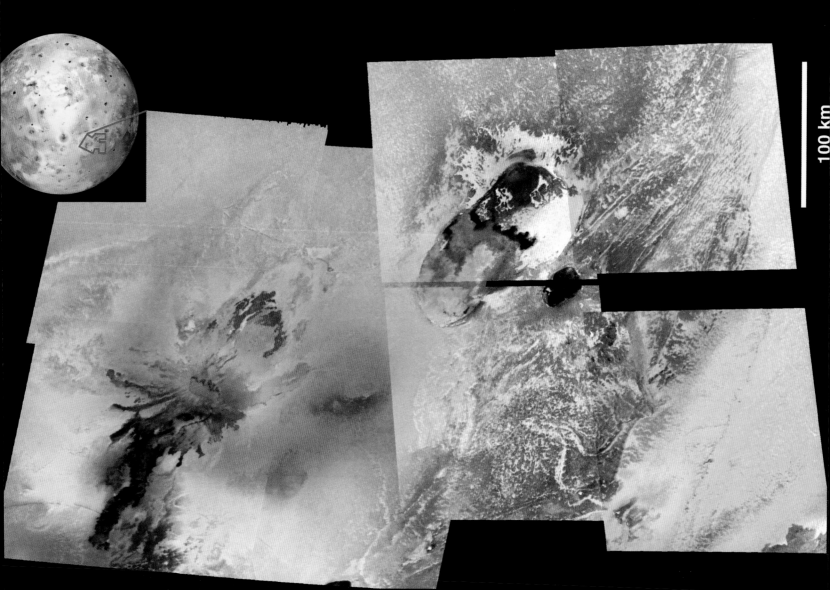

100 km

Tentacles of the Tarantula Nebula

The Tarantula Nebula is a giant emission nebula within the Large Magellanic Cloud, a galaxy neighboring our Milky Way. Inside this cosmic arachnid lies a huge central young cluster of massive stars, cataloged as R136 and partially visible at the upper right. The energetic light and winds from this cluster light up the nebula and sculpt the surrounding gas and dust into vast complex filaments. These "tentacles" give the Tarantula Nebula its name. In this impressive color image from the Wide-Field Imager camera on the European Southern Observatory's 2.2-meter telescope at La Silla astronomical observatory in Chile, intricacies of the nebula's complex array of dust and gas can be seen. The image shows a 300-light-year portion of the Tarantula Nebula, also dubbed 30 Doradus, which lies 180,000 light-years away in the direction of the constellation Dorado.

Credit & copyright: WFI, MPG/ESO 2.2-meter telescope, La Silla, ESO

July 23

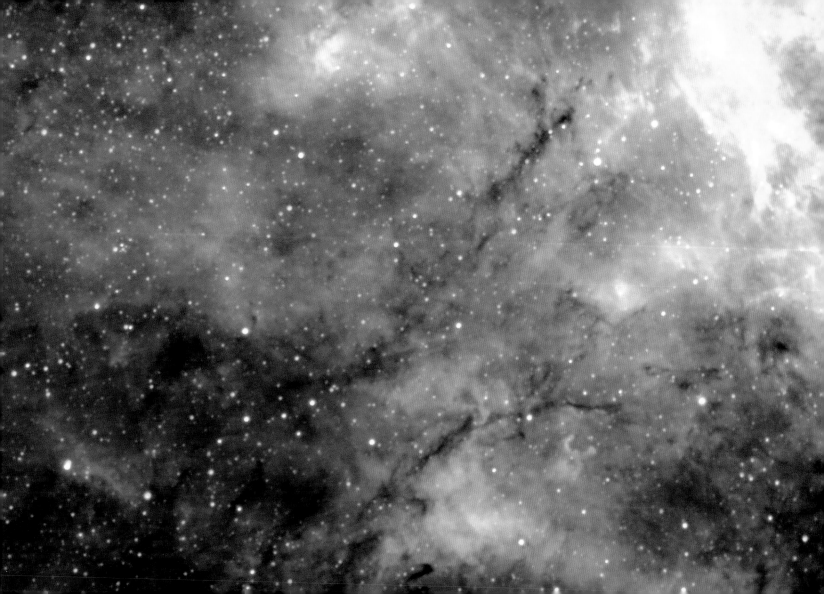

Mars at the Moon's Edge

The Red Planet wandered near the waning gibbous Moon in July 2003, passing behind the lunar orb when viewed from some locations in South and Central America, the Caribbean, and Florida. By digitally stacking and processing a series of telescopic images of the event, the Clay Center Observatory expedition to Bonita Springs, Florida, produced this evocative picture of Mars grazing the Moon's dark edge. With the cratered Moon in the foreground, the bright planet Mars seems alarmingly close, its global-scale features and white south polar cap easily visible.

Credit & copyright: Ron Dantowitz, Clay Center Observatory at Dexter and Southfield Schools

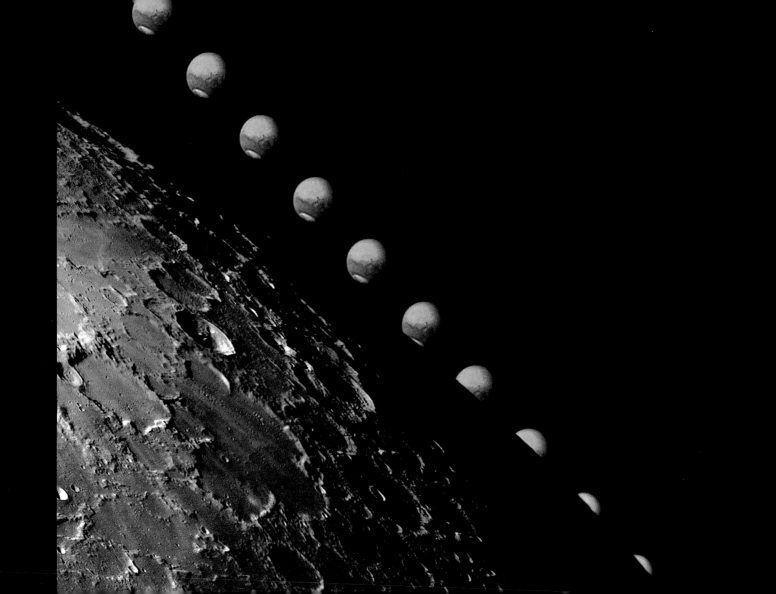

ISS and Discovery Transit the Sun

That large sunspot near the lower right edge of the Sun is actually not a sunspot at all. It is the International Space Station (ISS) and the space shuttle orbiter Discovery on mission STS-114. Many skygazers have spotted the space station and space shuttles as bright stars gliding through twilight skies, glinting in the sunlight while orbiting 200 kilometers or so above Earth's surface. But here, astronomer Anthony Ayiomamitis took advantage of a rare opportunity to record the spacefaring combination moving quickly in silhouette across the solar disk. He snapped the picture on July 28, 2005, from Athens, Greece. Launched just two days earlier, Discovery joined the ISS, making the already large space station seem to loom even larger.

Credit & copyright: Anthony Ayiomamitis

July 25

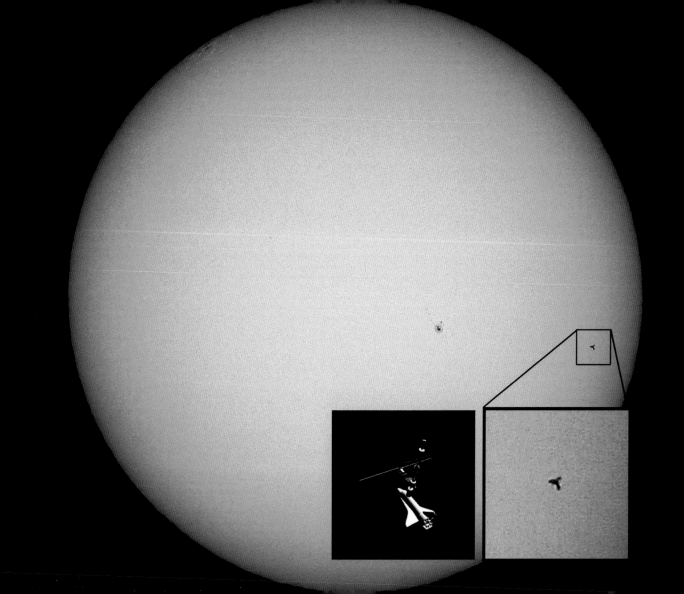

Galaxy Group
HCG 87

Posing for this cosmic family photo are the galaxies of HCG (Hickson Compact Group) 87, about 400 million light-years distant toward the amphibious constellation Capricornus. The large edge-on spiral near the center of the picture, the fuzzy elliptical galaxy immediately to its right, and the spiral close to the top of the image are identified members of the group, while the small spiral galaxy in the middle is likely a more distant background galaxy. In any event, a careful examination of the deep image reveals other galaxies that certainly lie far beyond HCG 87. While not exactly locked in a group hug, the HCG 87 galaxies are interacting gravitationally, influencing their fellow group members' structure and evolution. This 2003 image is from an instrument that was undergoing commissioning on the Gemini Observatory's South Telescope at Cerro Pachon, Chile. It compares favorably with views of this photogenic galaxy group recorded by the Hubble Space Telescope.

Credit: GMOS-S Commissioning Team, Gemini Observatory

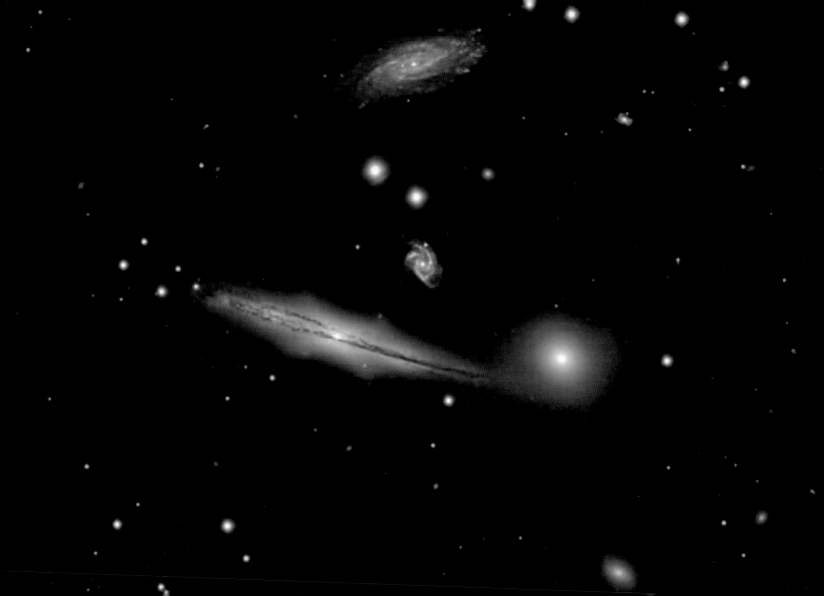

A Cygnus Star Field

In the constellation of the swan near the nebula of the pelican lies the gas cloud of the butterfly surrounding a star known as the hen. That star, given the proper name Sadr, is visible to the unaided eye but found here as the brightest object at the upper left. Sadr, at 1,500 light-years distant, is close to the center of the Butterfly Nebula (IC 1318), in a bright region given the comparatively staid label of IC 1318B. The fantastic star field that surrounds Sadr contains stars old and young, an open cluster of stars (NGC 6910, seen at the left of the image), vast clouds of hydrogen gas that glow red, and picturesque pockets and filaments of dark dust. This is a digital fusion of several different color images of the gamma Cygni (Sadr) region.

Credit & copyright: Steve Cannistra (StarryWonders)

July 27

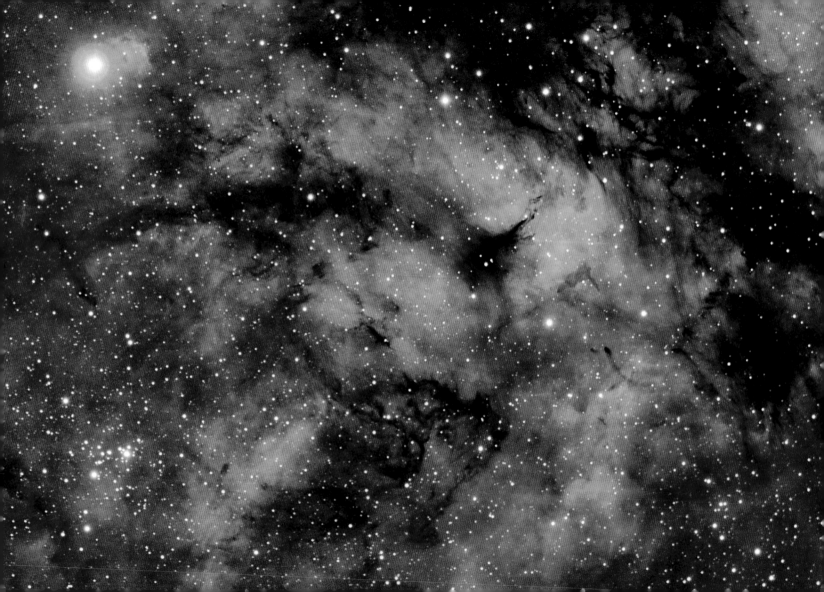

Reflections on the Inner Solar System

Only Mars is missing from this reflective view of the major rocky bodies of the inner solar system. Captured on July 8, 2005, the serene picture taken at dusk looks out over the Flat Tops Wilderness Area from near Toponas, Colorado. The Moon is in a young crescent phase about 3 degrees above bright planet Venus. Forest fires contribute to a layer of smoke in Earth's sky that almost hides planet Mercury, just visible very close to the horizon below the Moon. A week earlier, Venus and Mercury had been joined by the gas giant Saturn, forming a notable grouping in the west that was also enjoyed by skygazers across planet Earth.

Credit & copyright: Jimmy Westlake (Colorado Mountain College)

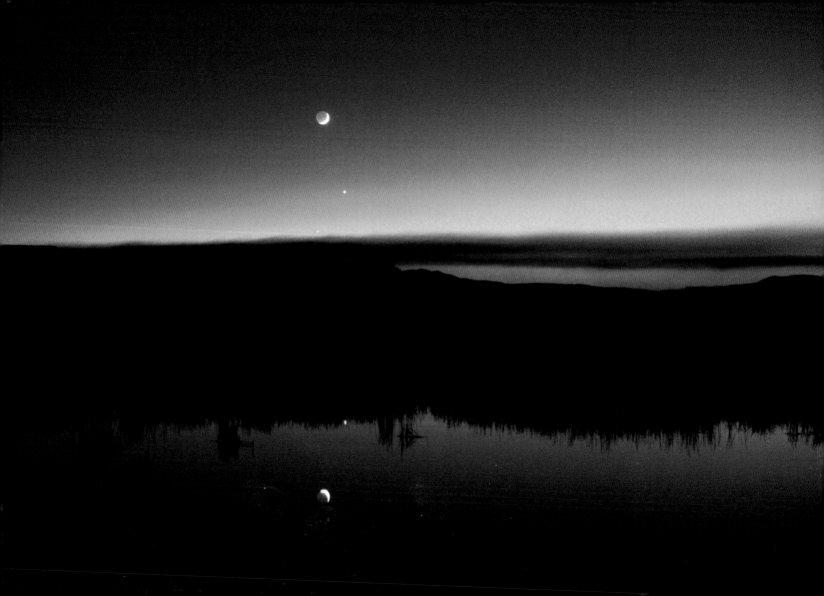

Northern Lights

While enjoying the spaceweather on a gorgeous summer evening in mid-July, astronomer Philippe Moussette captured this colorful view through a fish-eye lens looking north from the Observatoire Mont Cosmos, Quebec, Canada, planet Earth. In the foreground, lights along the northern horizon give an orange cast to the low clouds. But far above the clouds, at altitudes of 100 kilometers or more, are alluring green and purple hues of the aurora borealis, or northern lights, a glow powered by energetic particles at the edge of space. In the background are familiar stars of the northern sky. In particular, that famous celestial kitchen utensil, the Big Dipper (left), and the W-shaped constellation Cassiopeia (right) are easy to spot. Follow the pointer stars of the Big Dipper to Polaris, perhaps the most famous northern light of all.

Credit & copyright: Philippe Moussette (Observatoire Mont Cosmos)

July 29

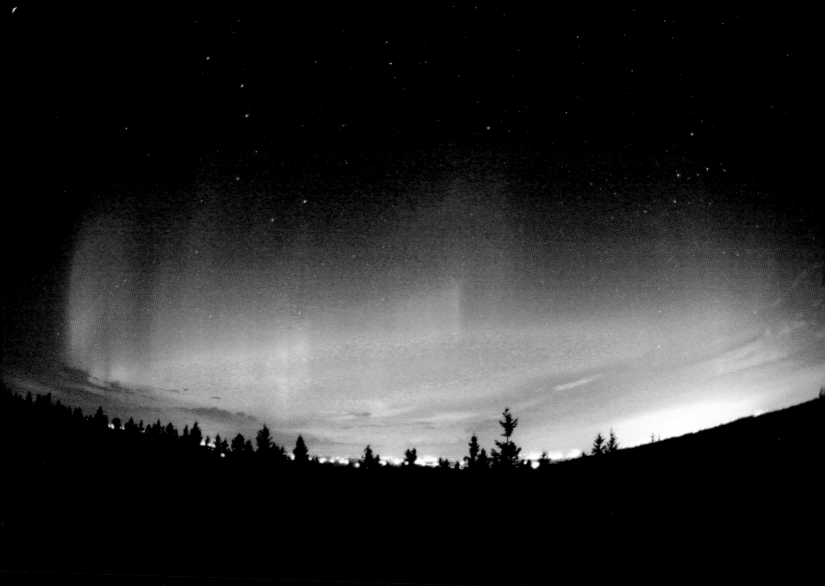

Over one year after its launch, robot geologist Opportunity was spending sols (Martian days) inching its way down the slopes of Endurance Crater. Littered with Martian "blueberries" (tiny gray spherules of iron and rock), the crater also contains some flat rocks that seem to have surprising razorbacks—narrow slabs sticking up along their edges. Like the blueberries, it is possible that these sharp, narrow features are related to water. They could be formed by minerals deposited by water in cracks, with the surrounding softer material subsequently eroded away. How narrow are they? The ones pictured here, in an enhanced-color image from Opportunity's panoramic camera, are actually only a few centimeters high and about half a centimeter wide.

Credit: Mars Exploration Rover Mission, JPL, NASA

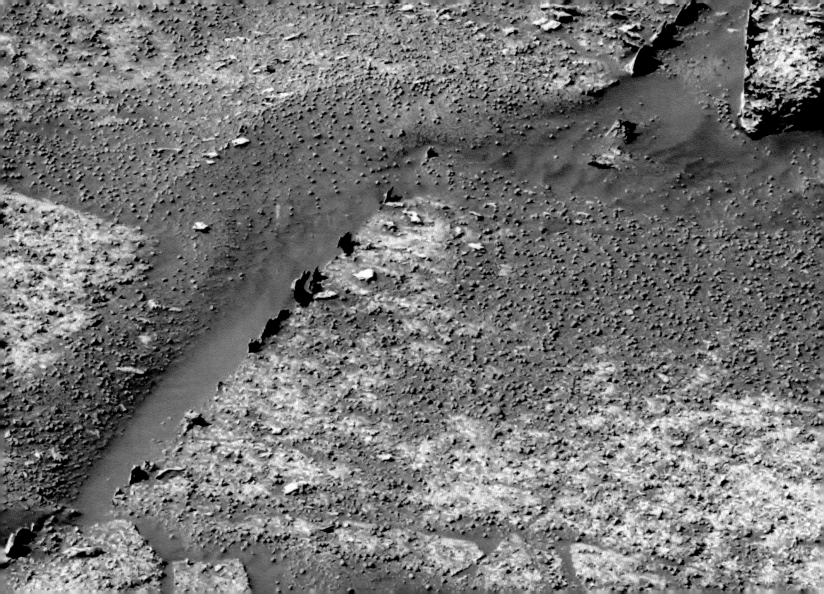

Analemma of the Moon

An analemma is that figure-eight curve you get when you mark the position of the Sun at the same time each day for one year. Imaging an analemma of the Moon is a bit trickier, as it is necessary to compensate for the fact that, on average, the Moon returns to the same position in the sky about fifty-one minutes later each day; photographing the Moon fifty-one minutes later on successive days, over one lunation, or lunar month, will trace out an analemma-like curve as the position of the Moon wanders compared to the average, due to the Moon's tilted and elliptical orbit. For this excellent demonstration of the lunar analemma, astronomer Rich Richins chose the lunar month containing the northern hemisphere summer solstice in 2005. The southernmost Full Moon rises at the lower right above the Organ Mountains in southern New Mexico, with the New Moon phase at the upper left. The multiple exposure required some digital manipulation, particularly to include thin crescent phases in daytime skies.

Credit & copyright: Rich Richins

A Shuttle Backflip at the Space Station

In 2005, crew members of the International Space Station (ISS) watched carefully as the space shuttle orbiter Discovery, guided by Commander Eileen Collins, performed a planned but unusual backflip upon approach. From a distance of about 200 meters, the ISS crew took detailed photographs of the dark heat-shield tiles on the shuttle's belly, which were analyzed to assess the heat shield's condition. Later the shuttle docked with the space station. The image shows Discovery's cargo bay doors, on the more usually photographed top side of the orbiter, open toward a distant Earth below.

Credit: ISS Expedition 11 Crew, STS-114 Crew, NASA

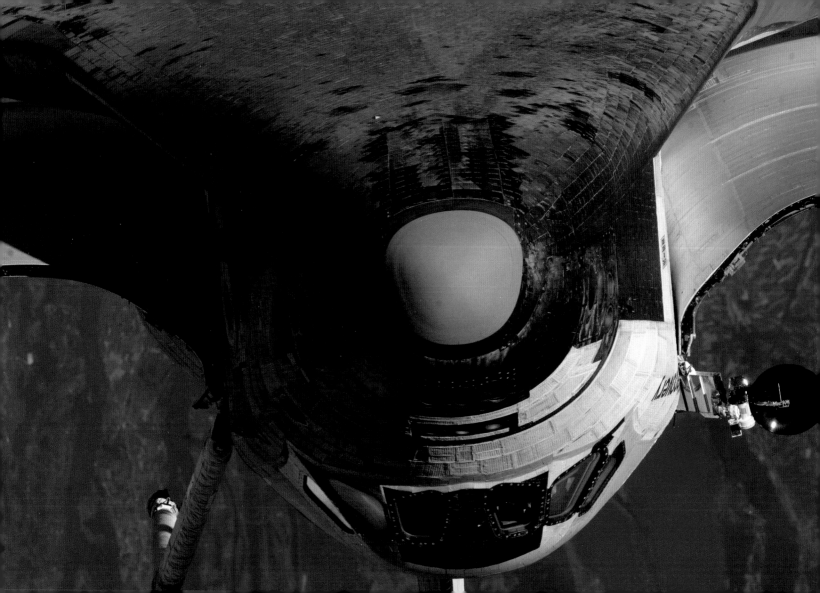

The Pacman Nebula

NGC 281 is a busy workshop of star formation. Prominent features include a small open cluster of stars, a diffuse red-glowing emission nebula, large lanes of obscuring gas and dust, and dense knots of dust and gas in which stars may still be forming. IC 1590, the open cluster of stars seen around the center of the image, has formed only in the last few million years. The brightest member of this cluster is actually a multiple-star system shining light that helps ionize the nebula's gas, causing the red glow observable throughout. The lanes of dust near the center are likely homes of future star formation. Particularly striking in this photograph are the dark Bok globules visible against the bright nebula. The NGC 281 system, dubbed the Pacman Nebula for its overall shape, lies about 10,000 light-years distant in the constellation Cassiopeia.

Credit & copyright: Steve Cannistra (StarryWonders)

August 2

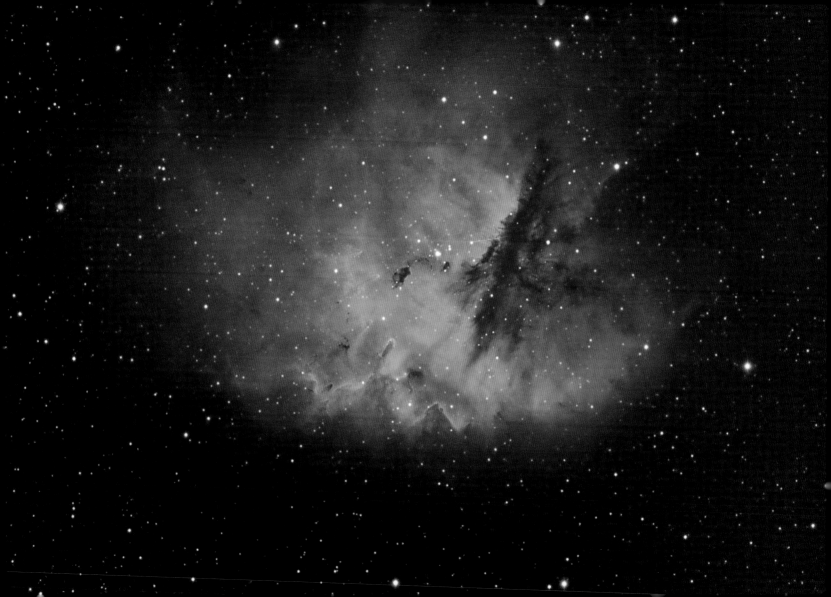

The International Space Station from Orbit

The International Space Station (ISS) is the largest human-made object ever to orbit Earth. Resupplied by the space shuttle orbiter Discovery in 2005, the station was operated from April 14 to October 10, 2005, by the Expedition 11 crew, consisting of a Russian and an American astronaut. After departing the ISS, the crew of Discovery captured this spectacular vista of the orbiting space habitat. Visible components include modules, trusses, and expansive solar arrays that gather sunlight, to be turned into needed electricity.

Credit: STS-114 Crew, NASA

August 3

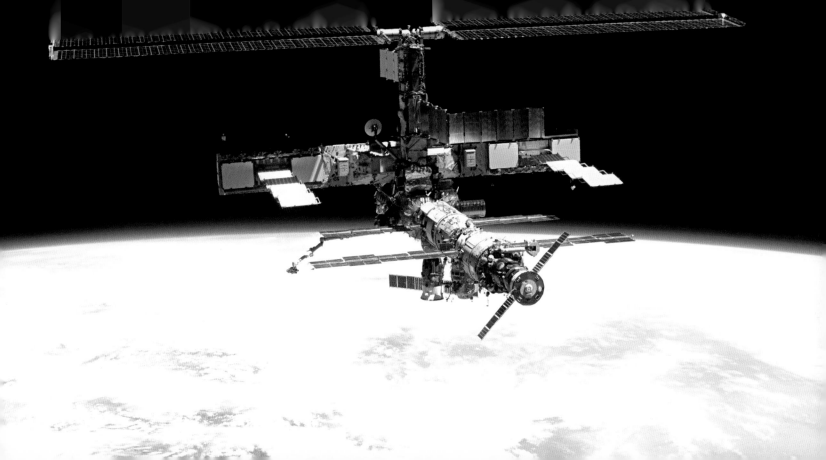

Alnitak, Alnilam, and Mintaka

Alnitak, Alnilam, and Mintaka are the bright bluish stars from east to west (left to right) along the diagonal in this gorgeous cosmic vista. Otherwise known as Orion's belt, these three blue supergiant stars are hotter and much more massive than the Sun. They lie about 1,500 light-years away, born of Orion's well-studied interstellar clouds. In fact, clouds of gas and dust adrift in this region have intriguing and some surprisingly familiar shapes, including the dark Horsehead Nebula and Flame Nebula near Alnitak at the lower left. The famous Orion Nebula itself lies off the bottom of this star field, which covers an impressive 4.4 by 3.5 degrees on the sky. The color picture is a composite made from digitized black-and-white photographic plates recorded through red and blue astronomical filters, with a computer-synthesized green channel. The plates were taken using the Samuel Oschin Telescope, a wide-field survey instrument at Palomar Observatory, between 1987 and 1991.

Credit: Digitized Sky Survey, ESA/ESO/NASA FITS Liberator;
color composite: Davide De Martin (www.skyfactory.org)

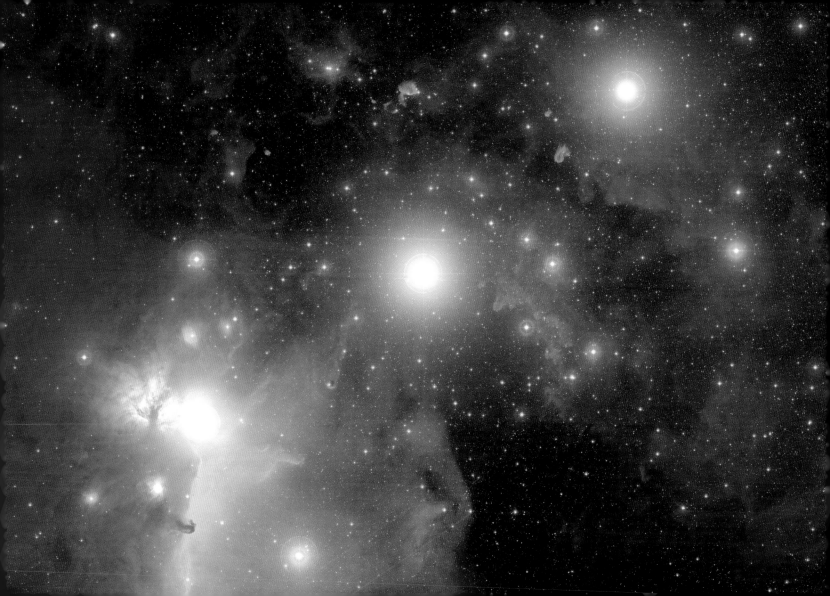

The Heart and Soul Nebulae

Are the heart and soul of our galaxy located in the constellation Cassiopeia? Possibly not, but that is where two bright emission nebulae with those nicknames can be found. The Heart Nebula, officially dubbed IC 1805 and visible at the right in this false-color image, has a shape reminiscent of a classical heart symbol; the Soul Nebula is more ethereal. Both nebulae shine brightly in the light of energized hydrogen. Several young open clusters of stars populate the image and can be seen in and around the nebula centers. Light takes about 7,500 years to reach us from these nebulae, which together span roughly 300 light-years. Studies of stars and clusters like those found in the Heart and Soul Nebulae have focused on how massive stars form and how they affect their environment.

Credit & copyright: Richard Crisp (www.narrowbandimaging.com)

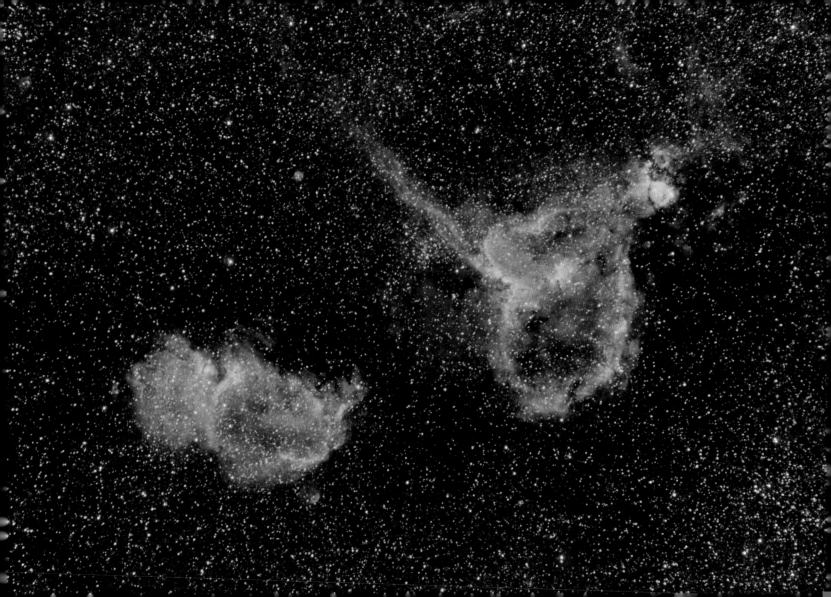

The Dotted Dunes of Mars

What are the black dots on Martian sand dunes? As spring begins across the northern hemisphere of the Red Planet, dunes close to the poles begin to defrost. Thinner regions of ice typically thaw first, revealing sand whose darkness absorbs the heat from sunlight and accelerates the thaw. By summer, the spots—and the thaw—will have expanded to encompass the entire dune area. The frozen carbon dioxide and water ice do not just melt in this thin atmosphere—they sublime directly into gas. Taken in mid-July 2005, this image shows a field of spotted polar dunes spanning about 3 kilometers near the Martian north pole.

Credit & copyright: Malin Space Science Systems, MOC, MGS, JPL, NASA

August 6

The Dark River
to Antares

Connecting the Pipe Nebula to the bright star Antares is a flowing dark cloud nicknamed the Dark River. The cause of its murkiness is the absorption of background starlight by dust, although the nebula contains mostly hydrogen and molecular gas. Antares, the brightest star in the frame, is embedded in the colorful Rho Ophiuchi Nebula clouds. The Dark River, across the upper left, spans over twenty times the angular diameter of the Moon and lies about 500 light-years distant. Also visible here are red emission nebulae and a blue reflection nebula.

Credit & copyright: Loke Kun Tan (StarryScapes)

August 7

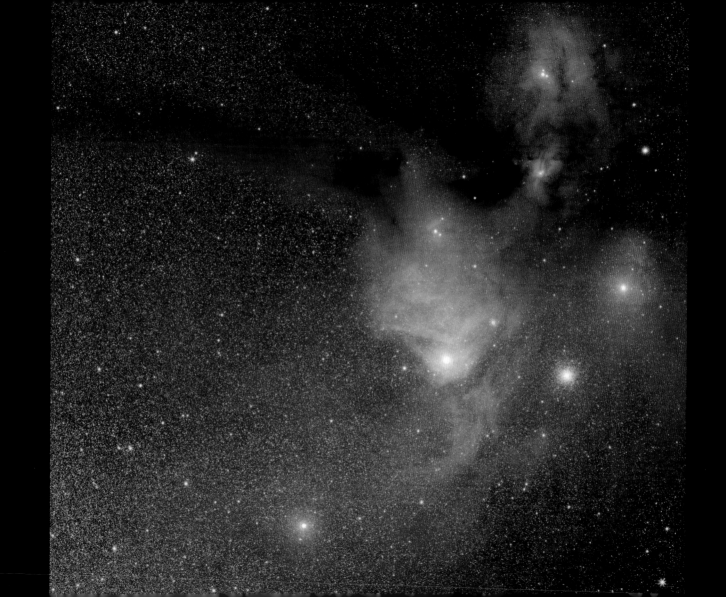

2003 UB313: A Tenth Planet?

Has a tenth planet been discovered? An object designated 2003 UB313, and located more than twice as far away as Pluto, is thought to be at least as large as that tiny world and probably larger, given current measurements. The object was discovered in January 2005 by M. E. Brown, C. A. Trujillo, and D. Rabinowitz following an analysis of image data recorded in 2003. The dimness and highly tilted orbit (44 degrees) of 2003 UB313 prevented it from being found sooner. Many astronomers speculate that numerous other icy objects larger than Pluto likely exist within the Kuiper belt, in the far distant solar system. If so, and if some are found to be closer than 2003 UB313, it may be premature to call that body the tenth planet. Illustrated here is an artist's drawing showing how 2003 UB313 might look in close-up. The unusually bright star at the right is the Sun, far in the distance.

Illustration, discovery credit: M. Brown (Caltech), C. Trujillo (Gemini), D. Rabinowitz (Yale), NSF, NASA

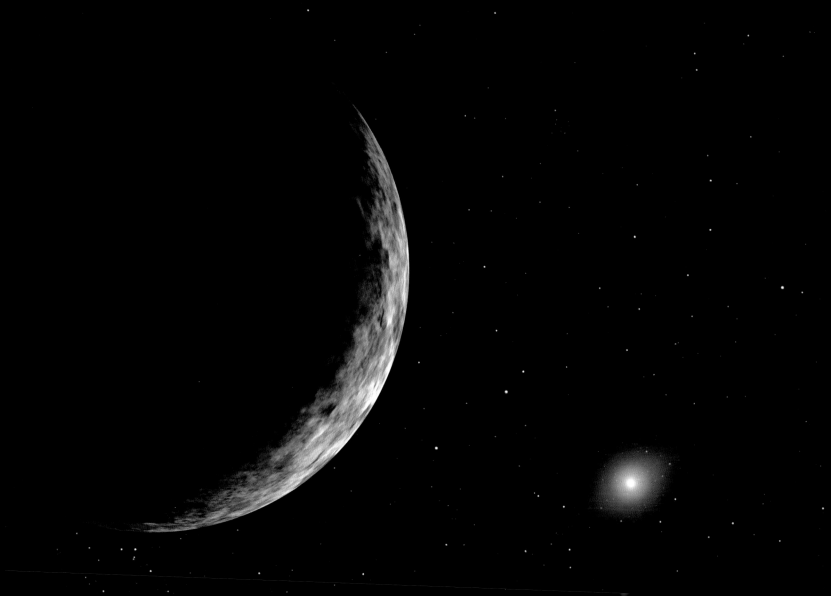

Supply Ship Approaches the Space Station

The crew on board the International Space Station sometimes needs supplies. With the space shuttle out of commission, a robot Progress supply vessel launched from Kazakhstan on May 27, 2004, made the trip. Stocked with over 2,500 kilograms of food, water, fuel, and other important items, the supply ship docked with the Zvezda Service Module while orbiting Earth more than 300 kilometers above central Asia.

Credit: ISS Expedition 9, NASA

August 9

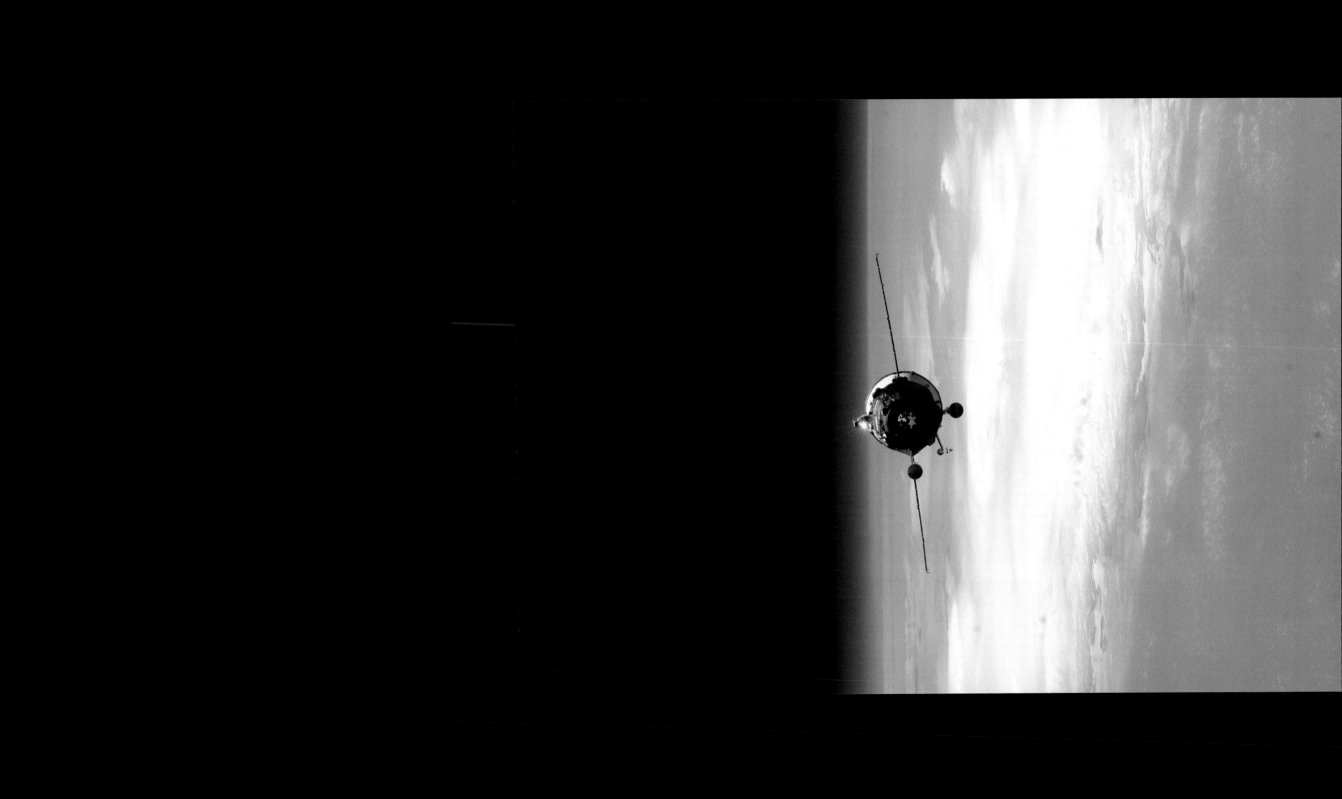

Titan's Double Haze

Most moons have no haze layer at all—why does Titan have two? Images from the Cassini spacecraft confirm that the solar system's most mysterious moon is surrounded not only by a thick atmosphere but also by two distinct spheres of haze. These layers are visible as purple in this false-color ultraviolet image. Titan's opaque atmosphere is similar to Earth's in that it is composed mostly of nitrogen. As energetic sunlight strikes high-level atmospheric nitrogen and methane, trace amounts of organic compounds such as ethane and carbon dioxide appear to form. These and other complex organic molecules likely populate the detached haze layer.

Credit: Cassini Imaging Team, SSI, JPL, ESA, NASA

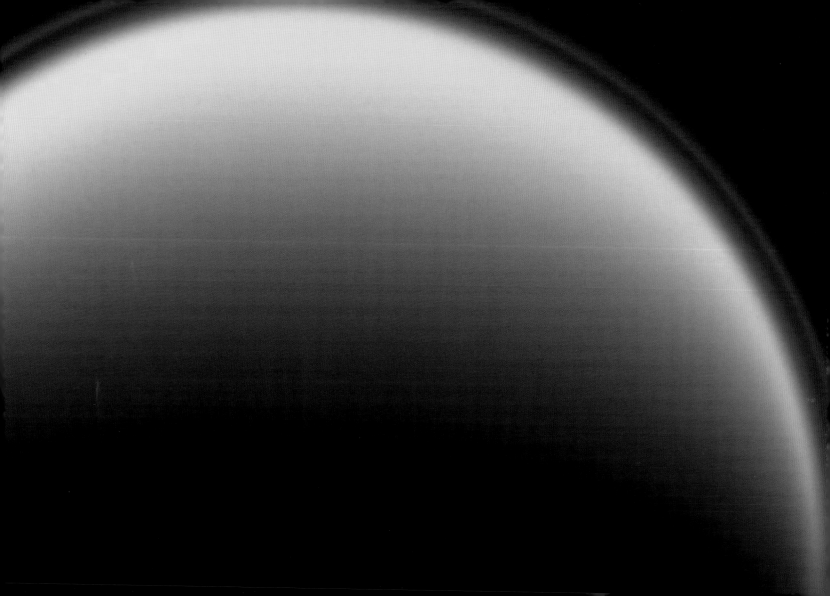

The Mineral Moon

Even if the Moon really were made of green cheese, it probably would not look this bizarre. Still, this mosaic of fifty-three images was recorded by the Jupiter-bound Galileo spacecraft as it passed near our own large natural satellite in 1992. The pictures were recorded through three spectral filters and combined in an exaggerated false-color scheme to explore the composition of the lunar surface; changes in mineral content produce subtle color differences in reflected light. The lunar near side, familiar to Earth dwellers, is at the left, but the space-based view looks down on the Moon's north pole, located in the upper half of the image close to the shadow line. Blue to orange shades indicate volcanic lava flows. The dark blue Mare Tranquillitatis, at the lower left, is richer in titanium-bearing minerals than the green and orange maria above it. Toward the bottom of the image and to the right of Tranquillitatis is the dark oval Mare Crisium, surrounded by shocking pink, indicating material of the lunar highlands.

Credit: Galileo Project, JPL, NASA

August 11

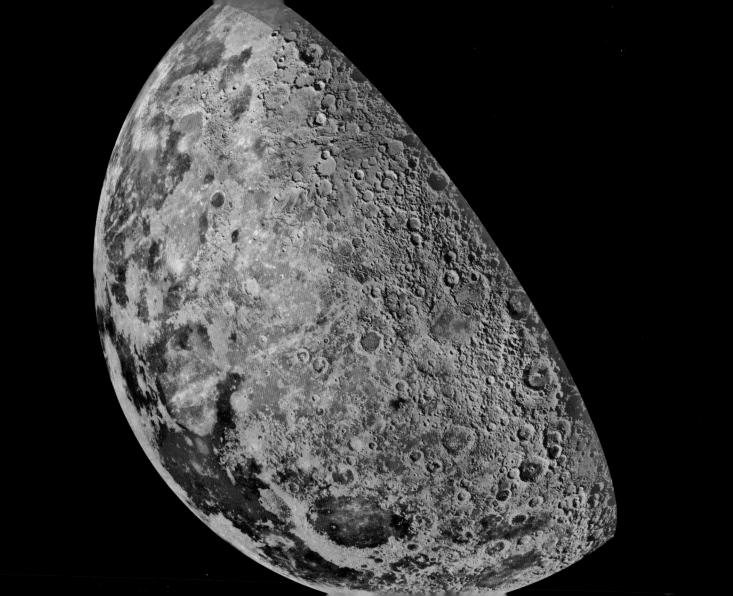

Zodiacal Light and the False Dawn

Once considered a false dawn, this triangle of light is actually zodiacal light—light reflected from interplanetary dust particles. The triangle is clearly visible at the bottom (right margin) of this vertical fish-eye skyview, taken in Namibia in May 2004. The Milky Way can be seen at the top of the picture. Zodiacal dust orbits the Sun predominantly in the same plane as the planets: the ecliptic. Zodiacal light is sunlight scattered by the dust band. It is easiest to see when the band is oriented nearly vertically at sunrise, so that the thick air near the horizon does not block out relatively bright reflecting dust.

Credit & copyright: Stefan Seip

August 12

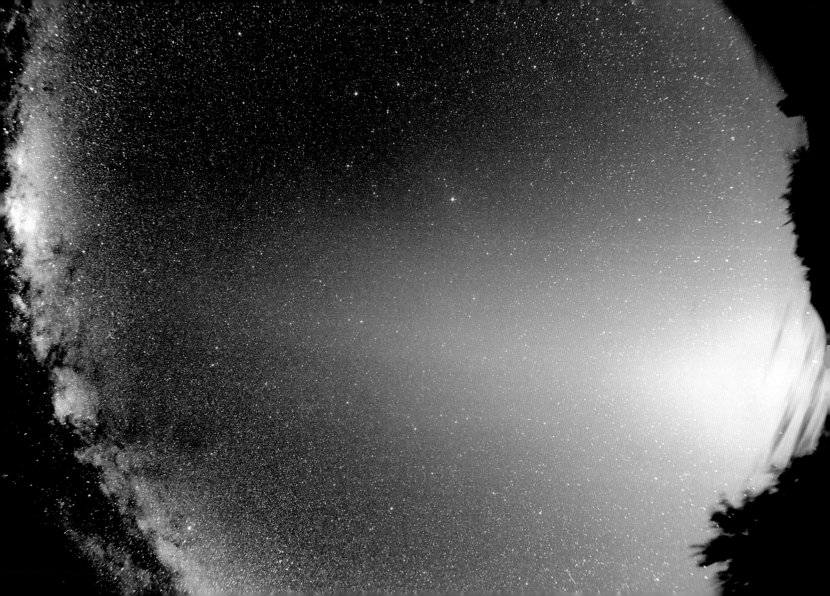

The Stars of NGC 300

Like grains of sand on a cosmic beach, individual stars of large spiral galaxy NGC 300 are resolved in this sharp image from the Hubble Space Telescope's Advanced Camera for Surveys. The inner region of the galaxy is pictured, spanning about 7,500 light-years. At its center is the bright, densely packed galactic core, surrounded by a loose array of dark dust lanes mixed with the stars in the galactic plane. NGC 300 lies 6.5 million light-years away and is part of a group of galaxies named for the southern constellation Sculptor. Hubble's unique ability to distinguish so many stars in NGC 300 can be used to hone techniques for making distance measurements on extragalactic scales.

Credit: Hubble Heritage Team (AURA/STScI), ESA, NASA

August 13

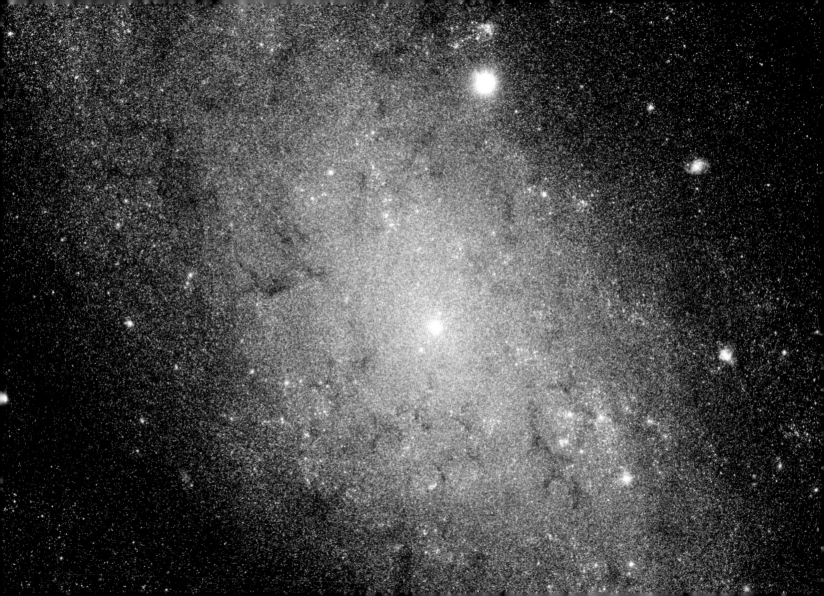

The Martian Landscape

What would it be like to climb a hill and look out over Mars? That opportunity was afforded the Spirit rover in August 2004 as it rolled to a high perch in the Columbia Hills. Peering out, the rolling robot spied the interior plains and distant rim of Gusev Crater, beyond an outcrop of rocks called Longhorn. Spirit continues to find evidence that many rock shapes were altered by ancient water. Both Spirit and her sister robot, Opportunity, completed their primary three-month mission in April 2004 but remained in good enough condition to continue to explore Mars.

Credit: Mars Exploration Rover Mission, JPL, NASA

August 14

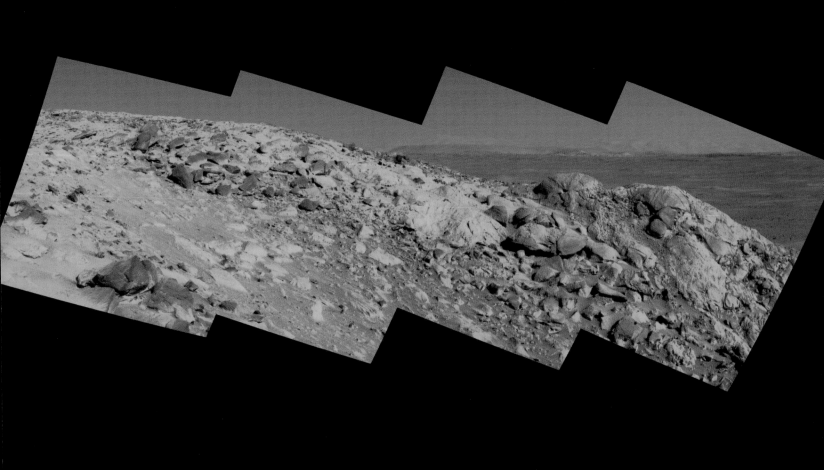

W hat could cause such dark rays in the sky? Caught in spectacular fashion above Utah in August 2005, they result from something surprisingly familiar: shadows. Clouds near the horizon can block sunlight from reflecting off the air, creating columns radiating outward from the Sun that appear unusually dark. Cloud shadows can be thought of as the complement to the more commonly highlighted crepuscular rays, also visible in this image, which are seen as reddened sunlight pours though holes in the clouds. Sometimes, on the opposite side of the sky, anticrepuscular rays can also be seen, apparently reconverging.

Credit & copyright: Jean Nesheim

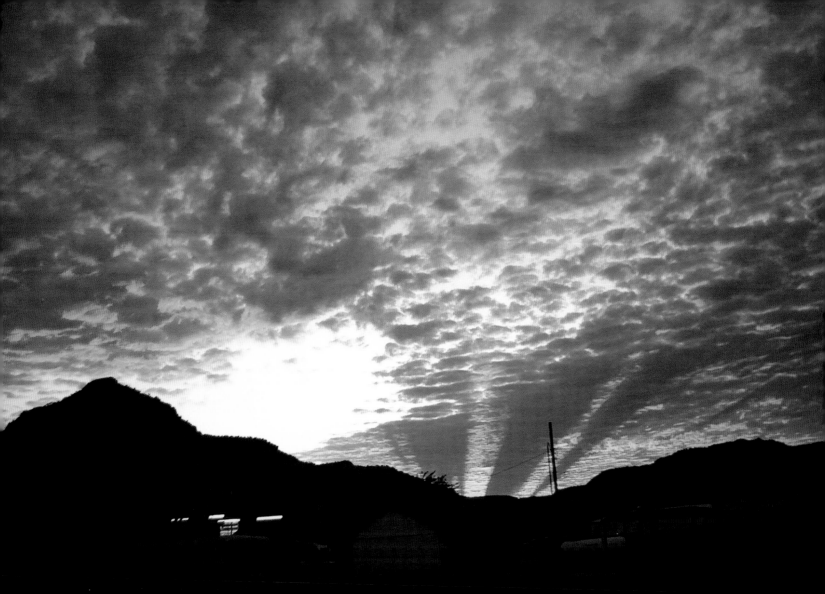

Barred Spiral
Milky Way

A survey of stars conducted with the Spitzer Space Telescope is convincing astronomers that our Milky Way is not just your ordinary spiral galaxy anymore. When we look out from within the galaxy's disk, the true structure of the Milky Way is difficult to discern. However, the penetrating infrared census of about 30 million stars indicates that the galaxy is distinguished by a very large central bar, some 27,000 light-years long. In fact, from a vantage point that viewed it head-on, astronomers in distant galaxies would likely see a striking barred spiral galaxy, as in this artist's illustration. While previous investigations have identified a small central barred structure, the survey results suggest that the Milky Way's large bar would make about a 45-degree angle with a line joining the Sun and the galaxy's center. DON'T PANIC. . . . Astronomers still place the Sun beyond the central bar region, about a third of the way in from the Milky Way's outer edge.

Credit: R. Hurt (SSC), JPL-Caltech, NASA; survey credit: GLIMPSE Team

Triple Sunset

Although it looks like fiction, this artist's vision of sunset on an alien world is based on fact—the discovery of a hot, Jupiter-sized planet orbiting in triple-star system HD 188753. Astronomer Maciej Konacki detected HD 188753's massive planet, only 149 light-years away in the constellation Cygnus, after analyzing detailed spectroscopic data from the Keck Observatory in Hawaii. The planet itself is depicted at the upper left in this imagined view from the well-illuminated surface of a hypothetical rocky moon. From this perspective, the closest, hottest, and most massive star in the triple system—a star only a little hotter than the Sun—has set below distant peaks. The two other suns approaching the horizon are both cooler and farther from the large planet. While other hot, Jupiter-like planets are known to orbit nearby stars, the "crowded" multiple-star nature of this system challenges current theories of planet formation.

Credit: Courtesy of JPL-Caltech, NASA

Raining Perseids

Comet dust rained down on planet Earth in August 2004, streaking through dark skies in the annual Perseid meteor shower. As it did, astronomer Fred Bruenjes, using a wide-angle lens, recorded a series of several thirty-second-long exposures spanning about six hours on the night of August 11–12. Combining those frames that captured meteor flashes, he produced this dramatic view of the Perseids of summer. Although the comet dust particles are traveling parallel to one another, the resulting shower meteors clearly seem to radiate from a single point in the sky, in the eponymous constellation Perseus. The radiant effect is due to perspective, as the parallel tracks appear to converge at a distance. Bruenjes notes that there are fifty-one Perseid meteors in the composite image, including one seen nearly head-on.

Credit & copyright: Fred Bruenjes

August 18

NGC 1999:
South of Orion

South of the large star-forming region known as the Orion Nebula lies the bright blue reflection nebula NGC 1999 (at left). Marked with a tiny, dark inverted T shape, it is in a broad cosmic vista that spans over 10 light-years. The dark shape is a dense cloud of gas and dust, or Bok globule, seen in silhouette against the bright nebula, and likely a site of future star formation. At the edge of the Orion molecular cloud complex some 1,500 light-years distant, NGC 1999's illumination is provided by the embedded variable star V380 Orionis. The region abounds with energetic young stars producing jets and outflows that create luminous shock waves, including HH (Herbig-Haro) 1 and 2 just below and left of NGC 1999, and the apparent cascade of reddish arcs and bow shocks beginning at the upper right. The stellar jets and outflows push through the surrounding material at speeds of hundreds of kilometers per *second*.

Credit & copyright: Robert Gendler

August 19

Elements of the Swan Nebula

In the depths of the dark clouds of dust and molecular gas known as M17, stars continue to form. The darkness of M17's molecular clouds, also known as the Omega Nebula and Horseshoe Nebula, results from background starlight being absorbed by thick filaments of carbon-based, smoke-sized dust. As bright, massive stars form, they produce intense and energetic light that slowly boils away the dark shroud. Colors in this image were picked to highlight specific elements that emit nebular light: red indicates emission from sulfur, green from hydrogen, and blue from oxygen. The Swan Nebula is visible with binoculars in the direction of the constellation Sagittarius, lies 5,000 light-years away, and spans 20 light-years.

Credit & copyright: Russell Croman

August 20

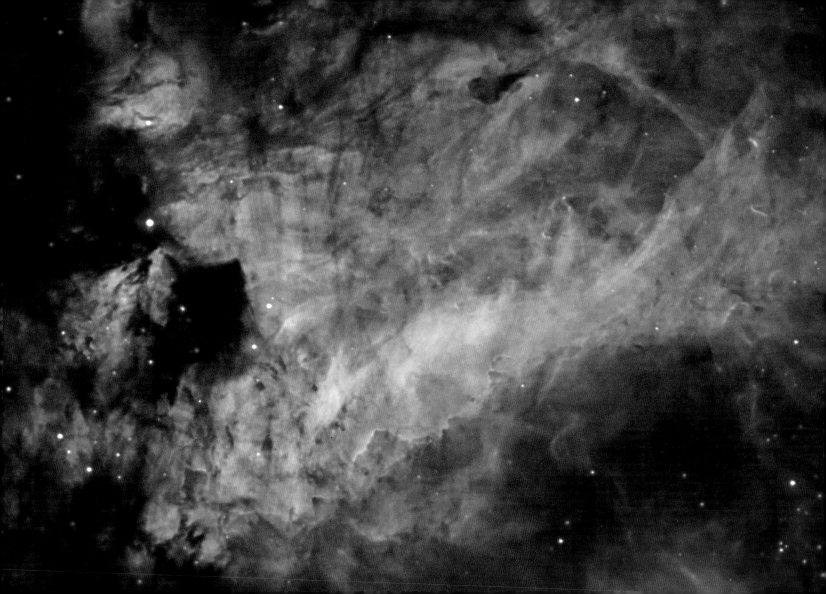

Shadow of a Martian Robot

What if you saw your shadow on Mars, and it was not human? Then you might be the robot Opportunity rover. Beginning in January 2004, Opportunity and sister robot Spirit probed the Red Planet, finding evidence of ancient water and sending breathtaking images across the inner solar system to Earth. In this view, Opportunity looks opposite the Sun into Endurance Crater and sees its own shadow. Two wheels are visible at the lower left and right, while the floor and walls of the crater can be seen in the background. Opportunity cautiously edged its way into the crater, searching for clues to the ancient past of our solar system's second-most-habitable planet.

Credit: Mars Exploration Rover Mission, JPL, NASA

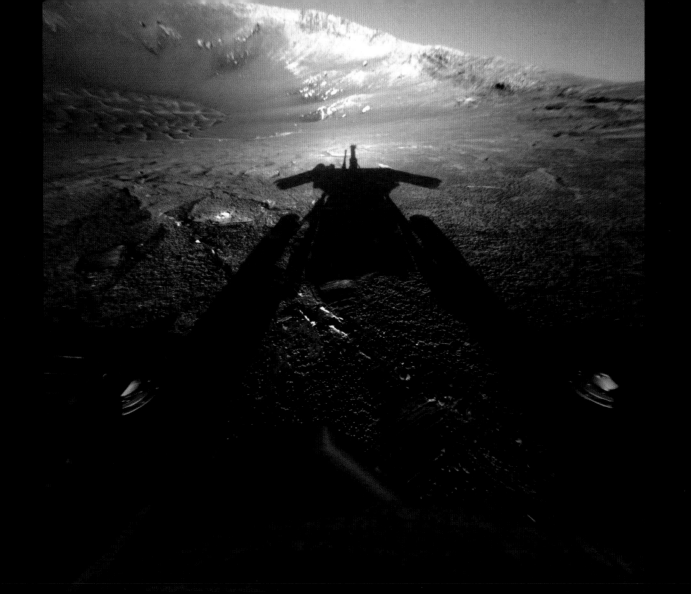

Dusty Galaxy
Centaurus A

Why is Centaurus A so dusty? Dramatic dust lanes that run across the peculiar galaxy's center are so thick they almost completely obscure it in visible light. This is particularly unusual, as Cen A's red stars and round shape are characteristic of a giant elliptical galaxy, a type usually low in dark dust. Also known as NGC 5128, Cen A also differs from other elliptical galaxies in its higher proportion of young blue stars and very strong radio emissions. Evidence indicates that Cen A is likely the result of the collision of two more typical galaxies, during which many young stars were formed; however, details of the creation of Cen A's unusual dust belts are still being researched. Cen A lies only 13 million light-years away, making it the closest active galaxy. It spans 60,000 light-years and can be seen with binoculars aimed in the direction of the constellation Centaurus.

Credit: Marina Rejkuba (ESO-Garching) et al., ISAAC, VLT ANTU telescope, ESO Paranal Observatory

Spicules: Jets on the Sun

Imagine a pipe as wide as a state and as long as half of planet Earth. Now imagine that this pipe is filled with hot gas moving at 50,000 kilometers per hour, and that it is made not of metal but of a transparent magnetic field. You are envisioning just one of thousands of young spicules on the active Sun. This is perhaps the highest-resolution image yet of these enigmatic solar flux tubes. Spicules dotting this view of solar active region 10380, which crossed the Sun in June 2005, are particularly evident as a carpet of dark tubes at the right. Time-sequenced images have shown that spicules last about five minutes, starting out as tall tubes of rapidly rising gas but then fading after the gas peaks and falls back down to the Sun. These images also indicate, for the first time, that the ultimate cause of spicules is soundlike waves that flow over the Sun's surface but leak into its atmosphere.

Credit: SST, Royal Swedish Academy of Sciences, LMSAL

August 23

Sedimentary Mars

High-resolution imaging of an area in the Schiaparelli Basin of Mars by the Mars Global Surveyor spacecraft's camera on June 3, 2003, produced this stunning example of layered formations within an old impact crater. On planet Earth, such structures would be seen in sedimentary rock—material deposited at the bottom of ancient lakes or oceans and then subsequently weathered away to reveal the layers. With the Sun shining from the bottom, the central layer appears to stand above the others within the 2.3-kilometer-wide crater. The crater could well have been filled with water in the Red Planet's distant past, perhaps resting at the bottom of a lake filling the Schiaparelli impact basin. Still, such layers might also have been formed by material settling out of the windy Martian atmosphere.

Credit: Malin Space Science Systems, MGS, JPL, NASA

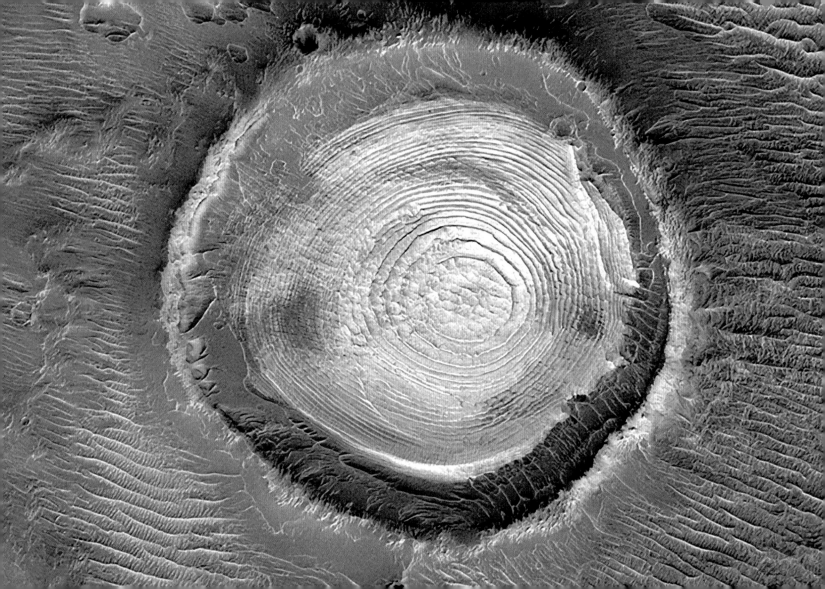

Close-up of the Lagoon Nebula

Stars are battling gas and dust in the Lagoon Nebula—and it is the photographers who are winning. Also known as M8, this photogenic nebula is visible even without binoculars, toward the constellation Sagittarius. The energetic processes of star formation create not only the colors but the chaos. The red-glowing gas results from high-energy starlight striking interstellar hydrogen gas. The dark dust filaments that lace M8 were created in the atmospheres of cool giant stars and in the debris from supernovae explosions. This spectacular portion of the Lagoon Nebula, taken by the Canada-France-Hawaii Telescope in Hawaii, was created from light emitted by hydrogen (shown in red) and by oxygen (shown in green). The light from M8 that we see today left there about 5,000 years ago, and light takes about 50 years to cross this section of M8.

Credit & copyright: Canada-France-Hawaii Telescope / J. C. Cuillandre / Coelum

August 25

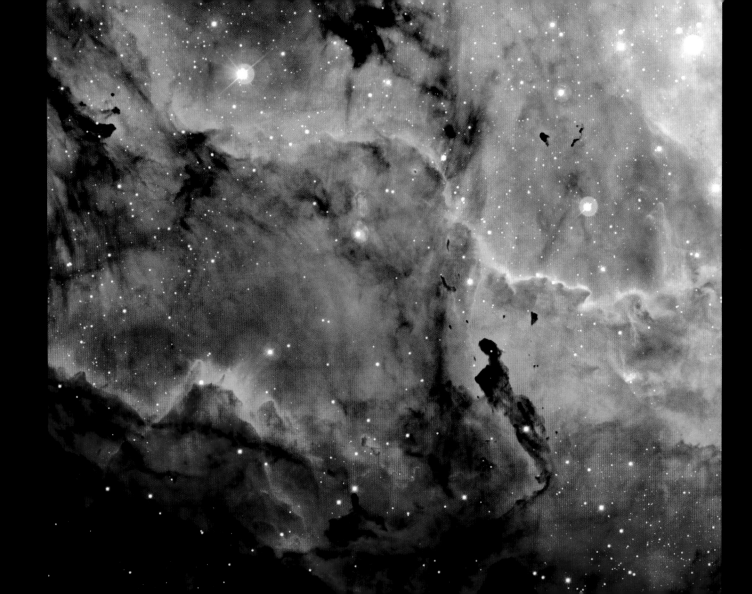

Mars Rising behind Elephant Rock

On August 27, 2003, at about 1000 Universal time (10:00 A.M.), Mars and Earth passed each other closer than they had in nearly 60,000 years. Mars, noticeably red, was the brightest object in the eastern sky just after sunset. The best views of it were from the robot spacecraft orbiting the Red Planet: the Mars Global Surveyor and the Mars Odyssey. In this image, however, Mars was photographed rising in the southeast behind Elephant Rock in the Valley of Fire State Park, Nevada.

Credit & copyright: Wally Pacholka (Astropics)

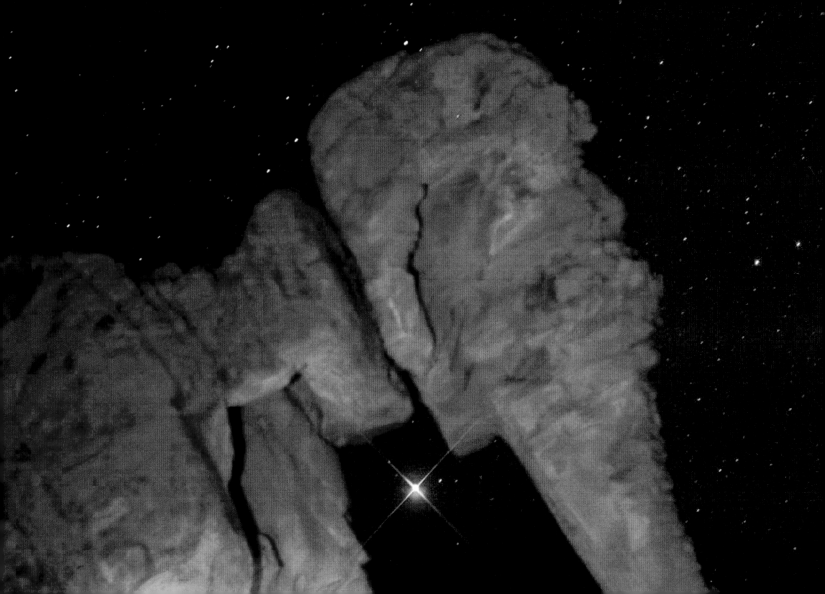

In the Center of the Virgo Cluster

The Virgo Cluster of galaxies is the nearest one to our Milky Way Galaxy. It is so close that it spans more than 5 degrees on the sky—about ten times the angle made by a Full Moon. It contains over 100 galaxies of many types—including spiral, elliptical, and irregular. The Virgo Cluster is so massive that it is noticeably pulling our galaxy toward it. The cluster contains not only galaxies filled with stars but also gas so hot that it glows in x-rays. Motions of galaxies in and around clusters indicate that they contain more dark matter than any visible matter we can see. Pictured here, the center of the Virgo Cluster, which might look like a human face to some people, includes bright Messier galaxies M86 at the top, M84 at the far right, NGC 4388 at the bottom, and NGC 4387 in the middle.

Credit & copyright: Canada-France-Hawaii Telescope / J. C. Cuillandre / Coelum

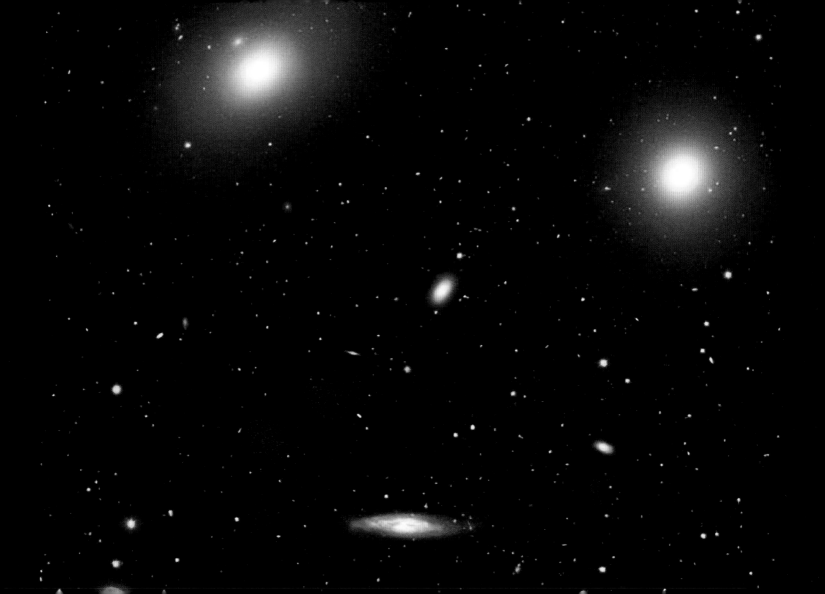

Stars, Young and Old

Galactic, or open-star, clusters are relatively young swarms of bright stars born together near the plane of our Milky Way Galaxy. Separated by about 1 degree on the sky, two nice examples are M46 (upper left), 5,400 light-years in the distance, and M47 (lower right), only 1,600 light-years away toward the nautical constellation Puppis. Some 300 million years young, M46 contains a few hundred stars in a region about 30 light-years across. Aged just 80 million years, M47 is a smaller but looser cluster of about fifty stars spanning 10 light-years. But this portrait of stellar youth also contains an ancient interloper. The small, colorful patch of glowing gas in M46 is actually the planetary nebula NGC 2438—the final phase in the life of a Sun-like star billions of years old. NGC 2438 is estimated to be only 3,000 light-years distant and likely represents a foreground object, appearing along our line of sight to youthful M46 only by chance.

Credit & copyright: Imaging the Cosmos, Astrophotography by Chris Hetlage (www.hetlage.com)

August 28

Young Suns of NGC 7129

Young suns still lie within dusty NGC 7129, which spans about 10 light-years and lies some 3,000 light-years away in the direction of the royal constellation Cepheus (King of Ethiopia). While these stars are at a relatively tender age, only about 1 million years old, it is likely that our own Sun formed in a similar stellar nursery some 5 billion years ago. Most noticeable in the striking image are the lovely bluish dust clouds that reflect the youthful starlight, but the smaller, deep red crescent shapes are also markers of energetic young stellar objects. Known as Herbig-Haro objects, their shape and color are characteristic of glowing hydrogen gas shocked by jets streaming away from newborn stars. Ultimately, the natal gas and dust in the region will be dispersed, the stars drifting apart as the loose cluster orbits the center of the galaxy.

Credit & copyright: Robert Gendler

August 29

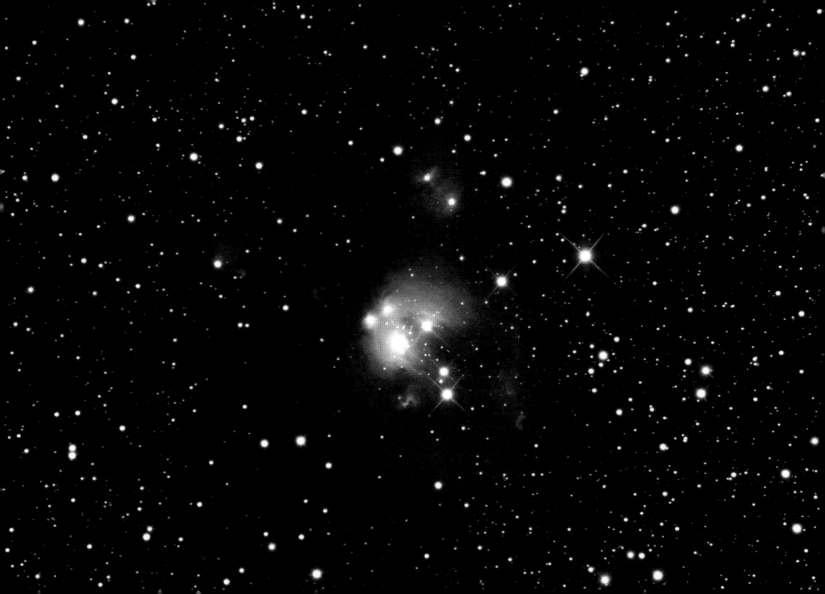

NGC 1
and NGC 2

The gorgeous nebulae, clusters, and galaxies that grace planet Earth's night sky are often known by their New General Catalog designation, or NGC number. That classic listing was compiled by John Louis Emil Dreyer, the remarkable director of the Armagh Observatory in Ireland from 1882 to 1916. NGC 2266, for example, is the 2,266th item in his New General Catalog of Nebulae and Clusters of Stars. Noting that "every book has a first page," modern-day astronomer Jay GaBany wondered what NGC 1 might look like—and he found it, in the direction of the constellation Pegasus, along with NGC 2, which is within that constellation. Pictured here, both are more or less typical-sized spiral galaxies (50,000–100,000 light-years across), with estimated distances of over 150 million light-years for NGC 1 (top) and about twice that for NGC 2. NGC ordering is based on an astronomical coordinate system, so these otherwise unremarkable spirals appear first in the NGC listing because their location in the sky translates to the smallest right ascension coordinate (analogous to longitude) in the catalog.

Credit & copyright: R. Jay GaBany (Cosmotography.com)

August 30

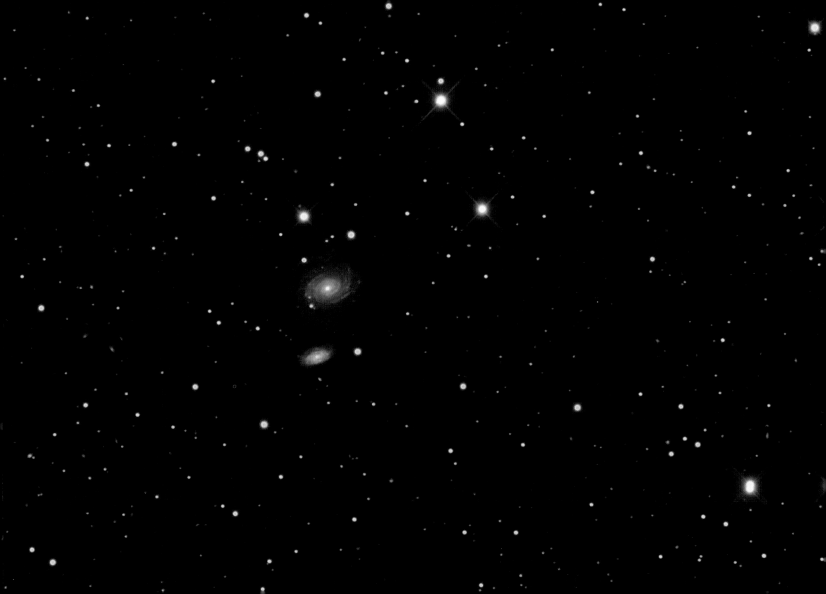

Albireo: A Bright and Beautiful Double

Sometimes, even a small telescope can help unlock a hidden beauty of the heavens. Such is the case of the bright double star Albireo. Seen at even slight magnification, Albireo unfolds from a bright single point into a beautiful double star of strikingly different colors. At 380 light-years distant, the two bright stars of Albireo are comparatively far from each other and take about 75,000 years to complete a single orbit. The brighter yellow star is itself a binary star system, but its components are too close together to be resolved even with a telescope. Albireo, the fifth-brightest star system in the constellation of the Swan (Cygnus), is easily visible to the unaided eye.

Credit & copyright: Richard Yandrick, 2005

IC 1396 H-Alpha
Close-up

Clouds of glowing hydrogen gas mingle ominously with dark dust lanes in this close-up of IC 1396, an active star-forming region some 2,000 light-years away in the constellation Cepheus. In this and similar emission nebulae, energetic ultraviolet light from a hot young star strips electrons from the surrounding hydrogen atoms. As the electrons and atoms recombine, they emit longer-wavelength, lower-energy light in a well-known characteristic pattern of bright spectral lines. At visible wavelengths, the strongest emission line in this pattern is in the red part of the spectrum and is known as "hydrogen-alpha," or just H-alpha. Part of IPHAS, a survey of H-alpha emission in our Milky Way Galaxy, this image spans about 20 light-years and highlights bright, dense regions within IC 1396, likely sites where massive new stars are born.

Credit: Nick Wright (University College London), IPHAS Collaboration

September 1

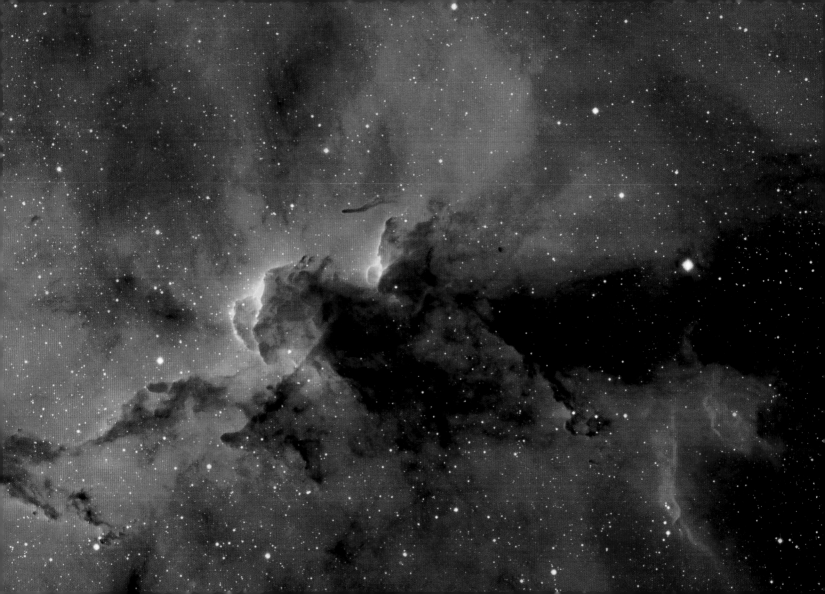

Stars and Dust of the Lagoon Nebula

The large, majestic Lagoon Nebula (also known as M8 and NGC 6523) is home to many young stars and a lot of hot gas. Spanning 100 light-years and lying only about 5,000 light-years distant, the Lagoon Nebula is so big and bright that it can be seen without a telescope in the direction of the constellation Sagittarius. A bright knot of gas and dust in its center is known as the Hourglass Nebula. Many bright stars are visible in NGC 6530, an open cluster that formed in the nebula only several million years ago. The band of dust to the left of the cluster's center is responsible for the nebula's name, Lagoon. This picture is a digitally sharpened composite of exposures taken in specific wavelengths of light emitted by sulfur (red), hydrogen (green), and oxygen (blue). Star formation continues in the Lagoon Nebula, as witnessed by the many globules that exist there.

Credit & copyright: Richard Crisp (www.narrowbandimaging.com)

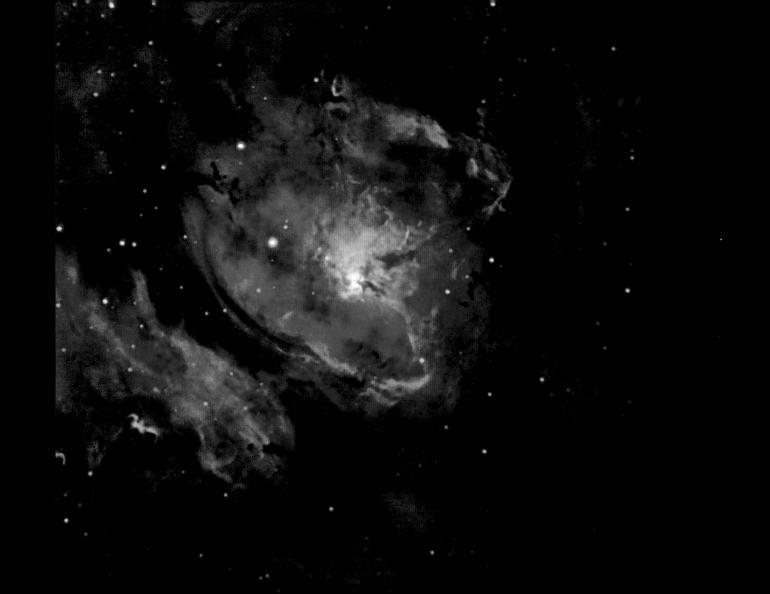

The tiger stripes visible in false-color blue on Saturn's moon Enceladus might be active. They could be spewing ice from the moon's interior into space, creating a cloud of fine ice particles over the moon's south pole, and forming Saturn's mysterious E ring. Recent evidence for this has come from the robot Cassini spacecraft now orbiting the planet. Cassini detected a marked increase in particle collisions during its July 2005 flyby only 270 kilometers over a south polar region of Enceladus. This high-resolution image of the moon is from that close flyby. Why Enceladus appears to be active remains a mystery, as the neighboring moon Mimas, approximately the same size, seems quite dead.

Credit: Cassini Imaging Team, SSI, JPL, ESA, NASA

An Unexplored Nebula

This cosmic dust cloud soaring some 300 light-years above the plane of the Milky Way reflects the combined light of the stars of our galaxy. Dubbed the Angel Nebula (by astronomer Steve Mandel's thirteen-year-old son), the dusty apparition is part of an expansive complex of dim and relatively unexplored diffuse nebulae, traced over large regions seen toward the north and south galactic poles. Along with the blue tint that is characteristic of more commonly observed reflection nebulae, the Angel Nebula and other dusty galactic cirrus also produce a faint reddish luminescence, as dust grains convert the Milky Way's invisible ultraviolet radiation to visible red light. Spanning 3 by 4 degrees on the sky in the constellation Ursa Major, this wide-angle, high-resolution image was recorded as part of the Unexplored Nebulae Project.

Credit & copyright: Steve Mandel, Galaxy Images

September 4

La Silla's Starry Night

On clear, moonless nights, the stars come out with a vengeance above the high-altitude La Silla astronomical observatory. Taking advantage of a visit to the first European Southern Observatory (ESO) site constructed in Chile, ESO software engineer Nico Housen recorded this stunning skyview. Difficult to see from light-polluted areas, faint stars and dark dust clouds along the plane of our Milky Way Galaxy arc across the gorgeous photo. In the foreground lies the highly polished 15-meter-diameter dish antenna of the Swedish-ESO Submillimeter Telescope (now decommissioned). Beyond it, silhouetted in starlight, is the dome of one of La Silla's large optical instruments, a 3.6-meter telescope. Dramatically reflected in the focusing, mirror-like surface of the dish, the vista behind the photographer appears inverted, with the dark horizon hanging above the Milky Way and the starry night.

Credit: Nico Housen, European Southern Observatory

September 5

The Colliding Galaxies of NGC 520

Is this one galaxy or two? Observations and simulations indicate that the jumble of stars, gas, and dust that is NGC 520 is actually the collision of two separate disk galaxies. Notable features of NGC 520, captured in spectacular fashion by the Gemini Observatory in Hawaii, include an unfamiliar-looking tail of stars at the bottom of the image and a perhaps more familiar-looking band of dust running diagonally across the center. A similar picture might be expected if our galaxy were to collide with our large galactic neighbor Andromeda (M31). The long-term collision that defines NGC 520 started about 300 million years ago and continues today. Although the stars are moving quickly, the distances are so vast that the interacting pair will surely not change its shape noticeably during our lifetimes. NGC 520, at visual magnitude 12, has been noted to be one of the brightest interacting galaxies in the sky, though not quite as bright as the ones known as the Antennae. Also known as Arp 157, NGC 520 lies about 100 million light-years distant, spans about 100,000 light-years, and can be seen with a small telescope in the constellation of the Fishes (Pisces).

Credit & copyright: Gemini Observatory, AURA, NSF

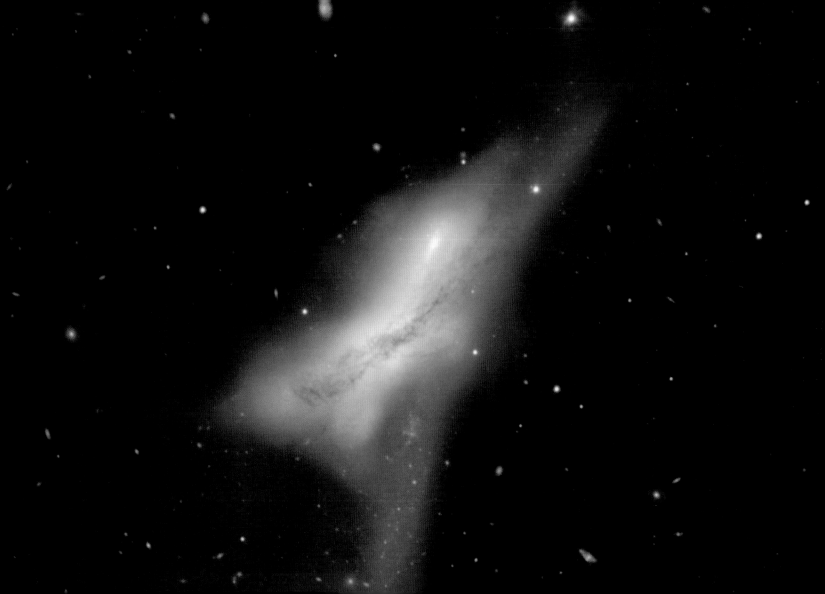

Light from the Heart

Sprawling across hundreds of light-years, emission nebula IC 1805 is a mix of glowing interstellar gas and dark dust clouds only about 7,500 light-years away. Stars were born in this region, whose nickname—the Heart Nebula—derives from its suggestive shape (seen here sideways). This lovely, deep telescopic image of the nebula is very colorful, but if you could travel there and gaze across these cosmic clouds with your own eyes, are these the colors you would see? The short answer is no, even though the image was made with visible light. Light from this and other glowing gas clouds surrounding hot young stars comes in very narrow bands of emission characteristic of energized atoms within the clouds. In fact, the nebular glow is often dominated by hydrogen atoms emitting light in only a small fraction of that broad region of the spectrum that we see as the color red. Adopting an artificial color scheme commonly used for narrow-band images of emission nebulae, this beautifully detailed view shows the light from sulfur atoms in red hues, with hydrogen in green, and oxygen atoms in blue.

Credit & copyright: Richard Crisp (www.narrowbandimaging.com)

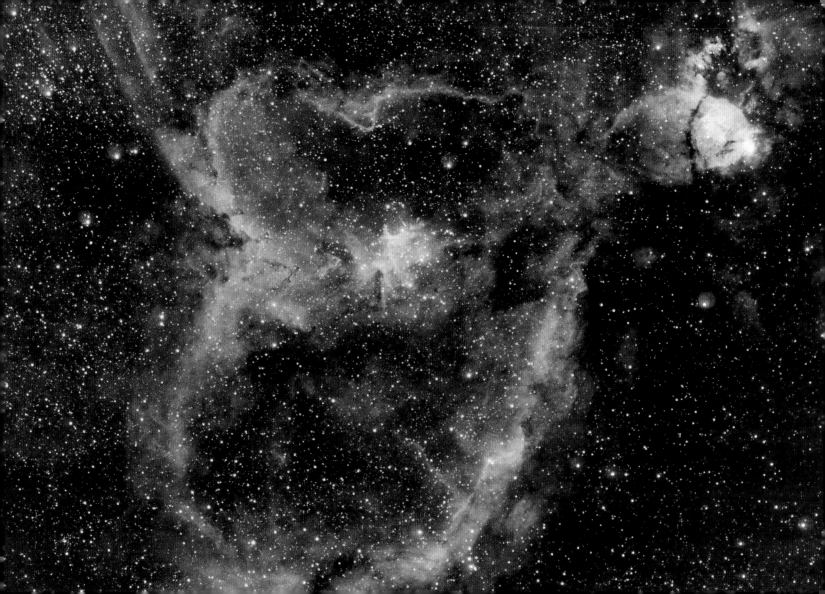

A Rocket Launch at Sunset

What kind of cloud is this? On September 22, 2005, a rocket launch lit up the sky at sunset and was photographed by enthusiasts as far as hundreds of miles away. Fuel particles and water droplets expelled from the rocket swirled in the winds of the upper atmosphere, creating an expanding helix. The lingering result was a photogenic rocket plume. The human-made noctilucent cloud was so high that it still reflected sunlight, while lower, actual clouds in the foreground appeared dark. This image also captures part of the launch plume reflecting sunlight as a rainbow or a colorful iridescent cloud. Below the plume is the planet Venus. Not everyone who saw the unusual plume after sunset knew that it was caused by a Minotaur rocket launched from Vandenberg Air Force Base in California.

Credit & copyright: Nick Hilton (fottostudio.com)

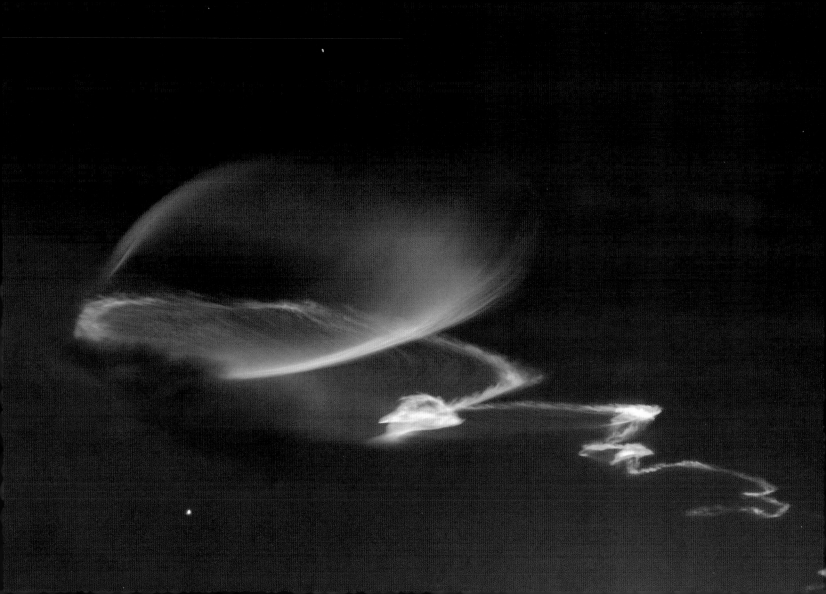

Composite Crab

The Crab Pulsar, a city-sized, magnetized neutron star spinning thirty times a second, lies at the center of this composite image of the inner region of the well-known Crab Nebula. The spectacular picture combines optical data (red) from the Hubble Space Telescope and x-ray images (blue) from the orbiting Chandra X-ray Observatory. Like a cosmic dynamo, the pulsar powers the x-ray and optical emission from the nebula, accelerating charged particles and producing the eerie, glowing x-ray jets. Ringlike structures are x-ray-emitting regions where the high-energy particles slam into the nebular material. The innermost ring is about 1 light-year across. With more mass than the Sun and the density of an atomic nucleus, the spinning pulsar is the collapsed core of a massive star that exploded, while the nebula is the expanding remnant of the star's outer layers. Historical records show that the supernova explosion was witnessed from Earth in the year 1054.

Credit: J. Hester (ASU) et al., CXC, HST, NASA

September 9

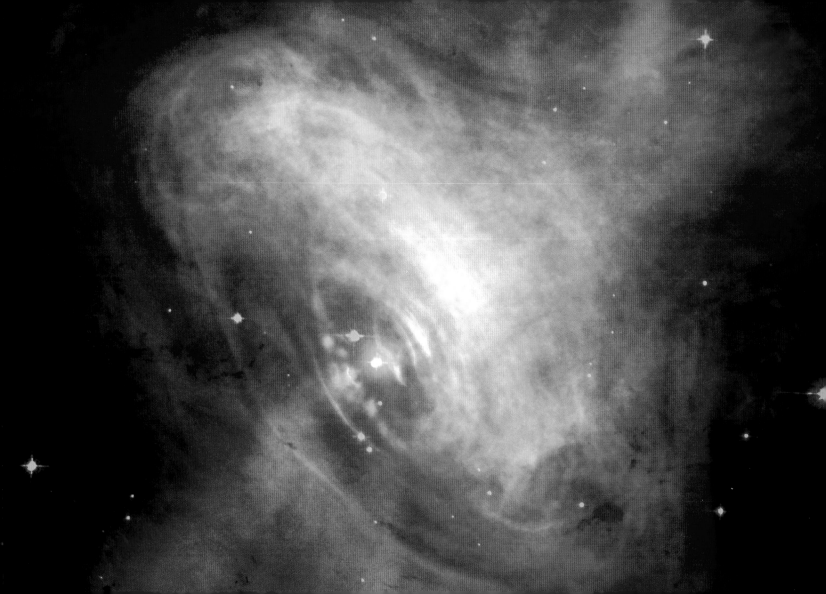

IC 1396
in Cepheus

Stunning emission nebula IC 1396 mixes glowing cosmic gas and dark dust clouds in the high and far-off constellation Cepheus. Energized by the bright, bluish central star seen here, this star-forming region sprawls across hundreds of light-years—spanning over 3 degrees on the sky while nearly 3,000 light-years from planet Earth. Among the intriguing dark shapes within IC 1396, the small winding Elephant's Trunk Nebula lies just below the central star. The dazzling color view is a composite of digitized black-and-white photographic plates recorded through red and blue astronomical filters. The plates were taken using the Samuel Oschin Telescope, a wide-field survey instrument at Palomar Observatory, between 1989 and 1993.

Credit: Digitized Sky Survey, ESA/ESO/NASA FITS Liberator; color composite: Davide De Martin (www.skyfactory.org)

September 10

Above the Eye of Hurricane Ivan

Tropical cyclones are called hurricanes in planet Earth's western hemisphere and typhoons in the eastern hemisphere. They get their immense energy from evaporated warm ocean water. As this water vapor cools and condenses, it heats the air, lowers pressure, and causes cooler air to come swooshing in. The swirling eye of Hurricane Ivan, whose powerful winds reached over 200 kilometers per hour, is seen here from the orbiting International Space Station as it passed over the Caribbean in 2004.

Credit: Expedition 9 Crew, International Space Station, NASA

September 11

The Star Pillars of Sharpless 171

Towering pillars of cold gas and dark dust adorn the central star-forming region of Sharpless 171. An open cluster of stars is being created there from the gas in cold molecular clouds. As energetic light emitted by young massive stars boils away the opaque dust, the region's fragments and picturesque pillars of the remnant gas and dust form and then slowly evaporate. The energetic light also illuminates the surrounding hydrogen gas, energizing it to glow as a red emission nebula. Pictured here is the active central region of the Sharpless 171 greater emission nebula. Sharpless 171 incorporates NGC 7822 and the active region Cederblad 214, much of which appears in this image. The area spans about 20 light-years, lies about 3,000 light-years away, and can be seen with a telescope in the direction of the northern constellation of the King of Ethiopia (Cepheus).

Credit: Nicolas Outters (Observatoire d'Orange)

September 12

Portrait of RY Tauri

A star emerges from its natal cloud of gas and dust in this tantalizing 2005 portrait of RY Tauri, a small stellar nursery at the edge of the Taurus molecular cloud, a mere 450 light-years away. Illuminating a region that spans only about two-thirds of a light-year, the youthful central star is large, cool, and known to vary in brightness. It is still collapsing; in a few million years, the star's winds will likely clear out the gas and dust clouds, as it settles down to become a steady main-sequence star like the Sun. What remains could well include a planetary system. The image data for RY Tauri is from the Gemini Observatory, on Mauna Kea, Hawaii—based on observations proposed by the Astronomy Club of Dorval, Quebec.

Credit: Gemini Observatory, Club d'astronomie de Dorval, S. Cote (HIA), T. A. Rector

(University of Alaska, Anchorage)

September 13

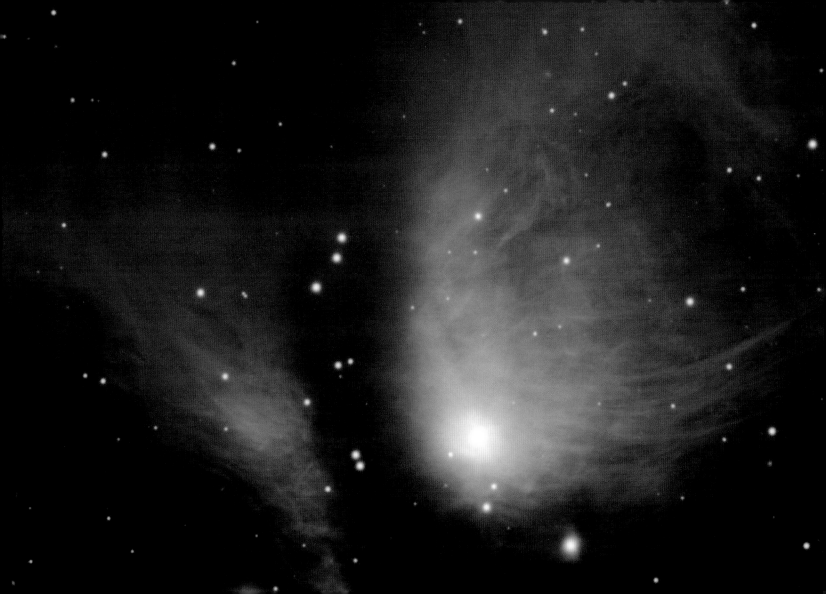

Moon River

Shortly after sunset on September 6, 2005, skygazers around the world were treated to a lovely crescent Moon in western skies—joined by bright planets Venus and Jupiter. In this colorful telephoto view from near the city of Quebec, Canada, the Moon is nestled just above the wide St. Lawrence River. Lights on the horizon are along the river's southern shore. Also known as the Evening Star, Venus is at the upper left; Jupiter is at the upper right. Another prominent celestial beacon, Spica, can be seen shining through the twilight below Venus. Spica—actually a very close pair of hot blue stars some 260 light-years away—is the brightest star in the constellation Virgo.

Credit & copyright: Jay Ouellet

September 14

Autumn Moon Encore

September 15, 2005, marked the noteworthy return of a gibbous Moon rising over the High Sierra in eastern California, part of the Sierra Nevada range. That scene was previously captured in Ansel Adams's famous photograph "Autumn Moon, the High Sierra from Glacier Point." Earlier in the year, Texas State University physicists Donald Olson and Russell Doescher, along with students, were able to pinpoint the exact location and (formerly uncertain) date of the original Adams photo: September 15, 1948. Their astronomical detective work predicted that the lunar alignment and waxing gibbous phase would be repeated on Thursday, September 15, 2005. They calculated that date based on the nineteen-year Metonic cycle. Named for an ancient Greek astronomer, the Metonic cycle is the period of time it takes for the same lunar phase to return to the same calendar date. September 15, 2005, was exactly three Metonic cycles after the original photograph was taken. On that day, about 300 photographers gathered at Glacier Point in Yosemite National Park to record an encore to Adams's "Autumn Moon."

Credit & copyright: Russell Doescher (Texas State University)

One-Armed
Spiral Galaxy
NGC 4725

While most spiral galaxies, including our own Milky Way, have two or more spiral arms, the peculiar galaxy NGC 4725 has only one. In this false-color Spitzer Space Telescope infrared image, the galaxy's solo *spira mirabilis* (logarithmic spiral) is seen in red, highlighting the emission from dust clouds warmed by newborn stars. The blue is light from NGC 4725's population of old stars. Also sporting a prominent ring and a central bar, this galaxy is over 100,000 light-years across and lies 41 million light-years away in the well-groomed constellation Coma Berenices. Computer simulations of the formation of single spiral arms suggest that they can be either leading or trailing arms with respect to a galaxy's overall rotation.

Credit: R. Kennicutt (University of Arizona), SINGS Team, JPL-Caltech, NASA

September 16

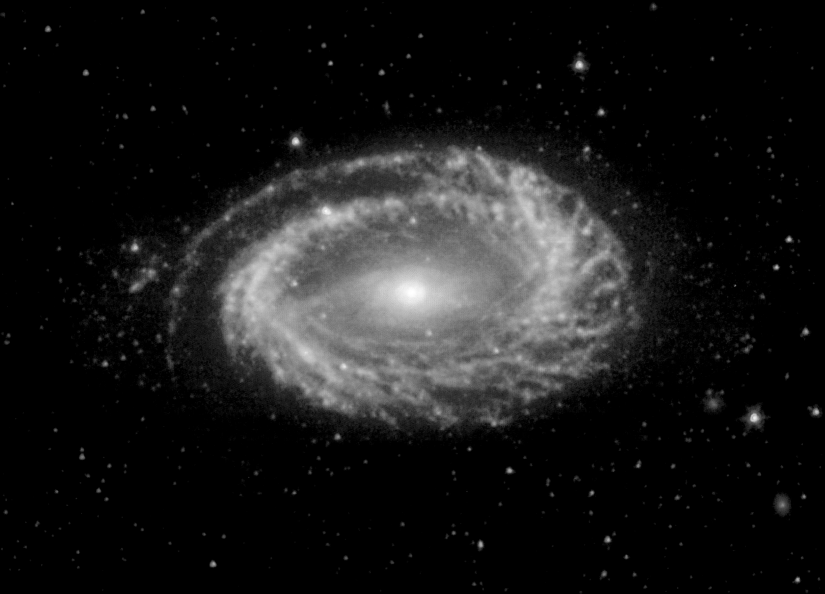

Mountains of Creation

This fantastic skyscape lies at the eastern edge of giant stellar nursery W5, about 7,000 light-years away in the constellation Cassiopeia. An infrared view from the Spitzer Space Telescope, it features interstellar clouds of cold gas and dust sculpted by winds and radiation from a hot, massive star outside the picture (just above and to the right). Still swaddled within the cosmic clouds, newborn stars are revealed by Spitzer's penetrating gaze, their formation also triggered by the massive star. Fittingly dubbed "Mountains of Creation," these interstellar clouds are about ten times the size of the analogous Pillars of Creation in M16, made famous in a 1995 Hubble Space Telescope view. W5 is also known as IC 1848; together with IC 1805, it is part of a complex region popularly dubbed the Heart and Soul Nebulae. The Spitzer image spans about 70 light-years at the distance of W5.

Credit: Lori Allen (Harvard-Smithsonian CfA) et al., JPL-Caltech, NASA

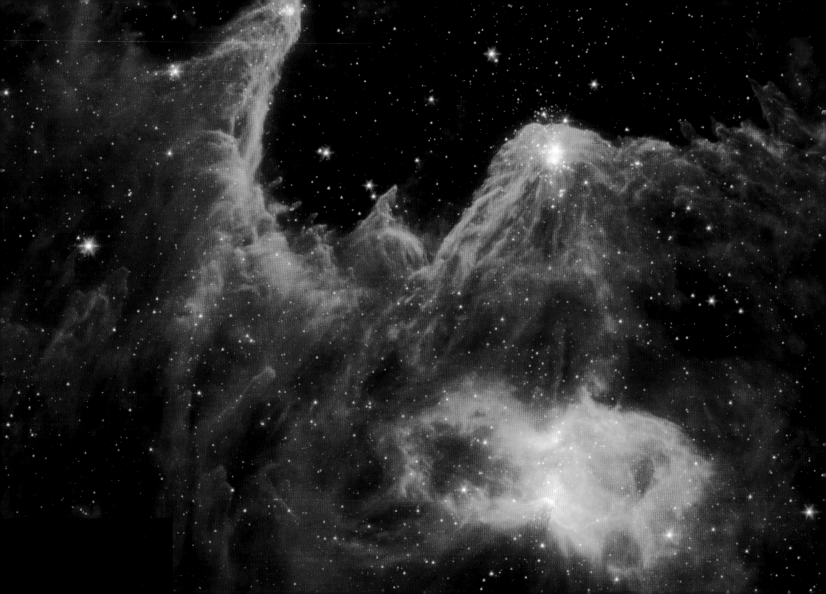

Logarithmic Spirals Isabel and M51

The uncomfortably close Hurricane Isabel in 2003 (left) and galaxy M51, 30 million light-years distant, actually do not have much in common. For starters, Isabel was only hundreds of miles across, while M51 (the Whirlpool Galaxy) spans about 50,000 light-years, making them vastly dissimilar in scale—not to mention the extremely different physical interactions that control their formation and evolution. But they do look amazingly alike here, both exhibiting the shape of a simple and captivating mathematical curve, known as a logarithmic spiral, whose separation grows geometrically with increasing distance from the center. Also known as the equiangular spiral, growth spiral, Bernoulli's spiral, and *spira mirabilis,* this curve's rich properties have fascinated mathematicians since its discovery by seventeenth-century philosopher René Descartes. Intriguingly, this abstract shape is abundant in nature. Logarithmic spirals also describe, for example, the pattern of seeds within a sunflower's head, the shape of nautilus shells, and the arrangement of cauliflower florets.

Credit: Comparison & M51 image copyright Brian Lula; Hurricane Isabel courtesy of GHCC, NASA

Are Saturn's rings transparent? The Cassini spacecraft, which entered orbit around Saturn in the late summer of 2004, confirmed that some of Saturn's rings are more transparent than others. Pictured here, Saturn's main A, B, and C rings can be seen, top to bottom, superposed against the gas giant planet. Although the B ring across the top is opaque, Saturn's cloud tops can be clearly seen through the lower C ring. The translucent nature of the C ring likely indicates that it is less densely populated with ring particles than the B ring. The image was taken on July 30, 2004, while Cassini was over 7 million kilometers from Saturn.

Credit: Cassini Imaging Team, SSI, JPL, ESA, NASA

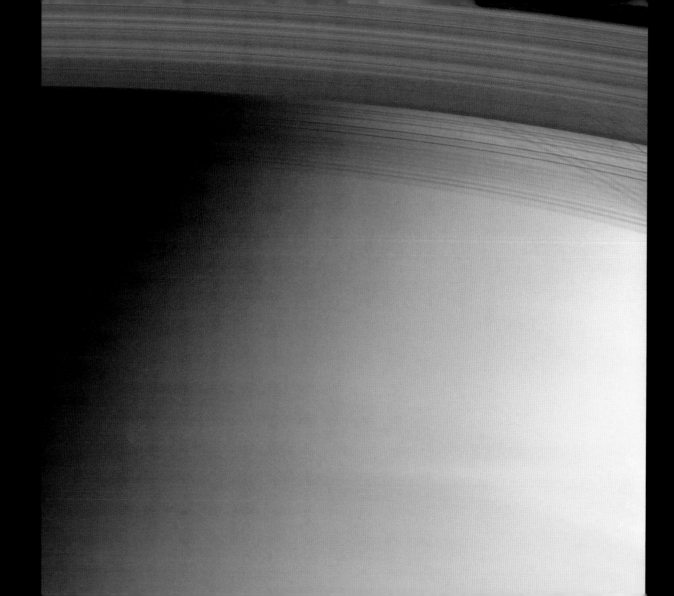

X-Ray Portrait of Trumpler 14

A wonder of planet Earth's southern sky, star cluster Trumpler 14 lies about 9,000 light-years away in the Carina complex—a rich star-forming region at the edge of a giant molecular cloud. This false-color x-ray portrait of Trumpler 14 from the orbiting Chandra X-ray Observatory spans over 40 light-years and reveals astonishing details of a cluster with one of the highest concentrations of massive stars in the galaxy. Profoundly affecting their environment, the hot cluster stars are themselves a mere 1 million years old. Energetic winds from the stars have cleared out a cavity in the dense cloud, filling it with shock-heated, x-ray-emitting gas. The next few million years will see these stellar prodigies rapidly exhausting their nuclear fuel and exploding violently in supernovae, flooding their cosmic neighborhood with gas rich in heavy elements.

Credit: L. Townsley (PSU) et al., CXC, NASA

September 20

Cat's Eye

Staring across interstellar space, the alluring Cat's Eye Nebula lies 3,000 light-years from Earth. A classic planetary nebula, the Cat's Eye (NGC 6543) represents a final, brief yet glorious phase in the life of a Sun-like star. This nebula's dying central star may have produced the simple outer pattern of dusty concentric shells by shrugging off layers in a series of regular convulsions. But the formation of the beautiful, more complex inner structures is not well understood. Seen so clearly in this sharp Hubble Space Telescope image, the truly cosmic eye is over half a light-year across. Of course, gazing into the Cat's Eye, astronomers may well be seeing the fate of our Sun, destined to enter its own planetary nebula phase of evolution . . . in about 5 billion years.

Credit: NASA, ESA, HEIC, & the Hubble Heritage Team (STScI/AURA)

September 21

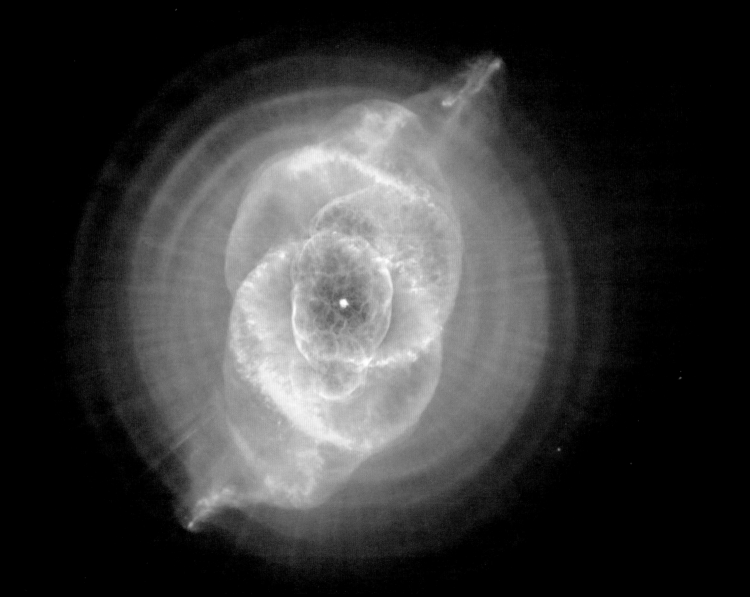

The small constellation Triangulum in the northern sky harbors this magnificent face-on spiral galaxy, M33. Known as the Triangulum or Pinwheel Galaxy, M33 spans over 50,000 light-years, making it third largest in the Local Group of galaxies after the Andromeda Galaxy (M31) and our own Milky Way. About 3 million light-years from the Milky Way, M33 lies very close to Andromeda; observers in these two galaxies would likely have spectacular views of each other's grand spiral star systems. As for the view from planet Earth, this sharp twenty-seven-frame mosaic nicely shows off the blue star clusters and pinkish star-forming regions that trace the galaxy's loosely wound spiral arms. In fact, the cavernous NGC 604 is the brightest star-forming region seen here, visible along an arm arcing above and to the right of the galaxy's center. Like M31, M33's population of well-measured variable stars have helped make this nearby spiral a cosmic yardstick for establishing the distance scale of the universe.

Credit & copyright: Robert Gendler

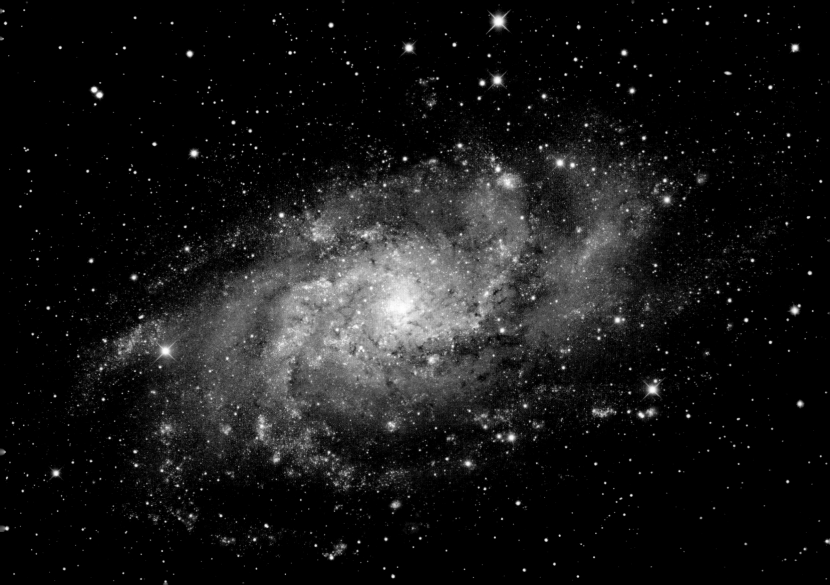

Orange Moon, Red Flash

This remarkable telescopic image highlights the deep orange cast of a waning gibbous Moon (not quite full) seen very close to the eastern horizon from Stuttgart, Germany, on September 19, 2005. While the long sight line through the atmosphere filters and reddens the moonlight, it also bends colors of light at slightly different angles, producing noticeable red (bottom) and faint green (top) lunar rims. Also captured here, floating just below the Moon, is a thin, red mirage—in this case, an atmospherically magnified and distorted image of the red rim. This tantalizing lunar "red flash" is related to the more commonly seen green flash of the Sun.

Credit & copyright: Stefan Seip

September 23

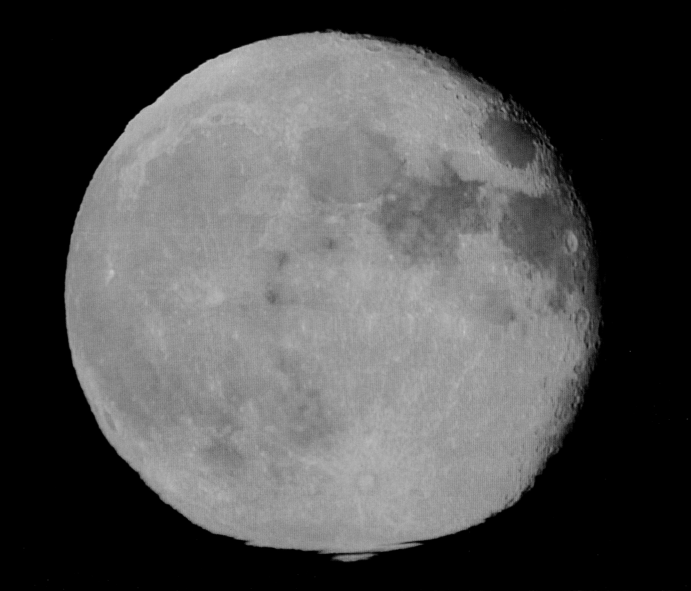

IC 1340 in the Eastern Veil

These ghostly filaments of interstellar gas are just a small part of the expansive Veil Nebula, seen against a rich field of background stars in the long-necked constellation Cygnus. Also known as the Cygnus Loop, the Veil Nebula is a supernova remnant, the expanding debris cloud created by a stellar explosion whose light first reached planet Earth between 5,000 and 10,000 years ago. About 1,400 light-years away, the entire nebula now appears to span over 3 degrees on the sky, nearly six times the apparent size of the Full Moon, but it is faint and can be difficult to see with small telescopes. The region captured in this beautiful, deep color image is located at the southern tip of the Veil's eastern crescent. It covers about 10 light-years at the distance of the Veil and is cataloged as IC 1340.

Credit & copyright: Loke Kun Tan (StarryScapes)

September 24

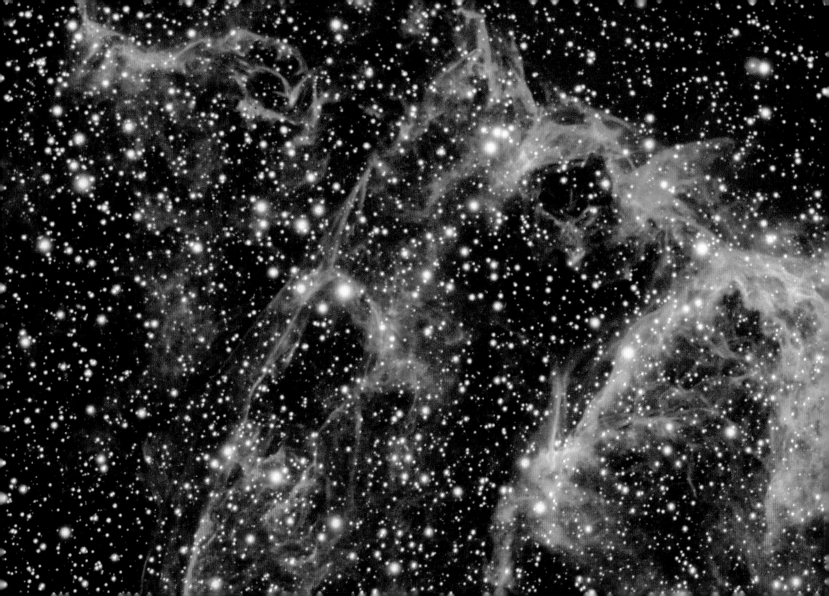

Northern Lights, September Skies

The aurora borealis, or northern lights, made some remarkable visits to the skies in September 2005. The reason, of course, is the not-so-quiet Sun. In particular, a large solar active region crossing the Sun's disk produced multiple, intense flares and a large coronal mass ejection that triggered widespread auroral activity. This colorful example of spectacular curtains of aurora was captured with a fish-eye lens in skies over Quebec, Canada, on September 11. Also featured is the planet Mars, the brightest object above and left of center. Seen near Mars (just below and to the right) is the tightly knit Pleiades star cluster. Although they can appear to be quite close, the northern lights actually originate at extreme altitudes, 100 kilometers or so above Earth's surface.

Credit & copyright: Philippe Moussette

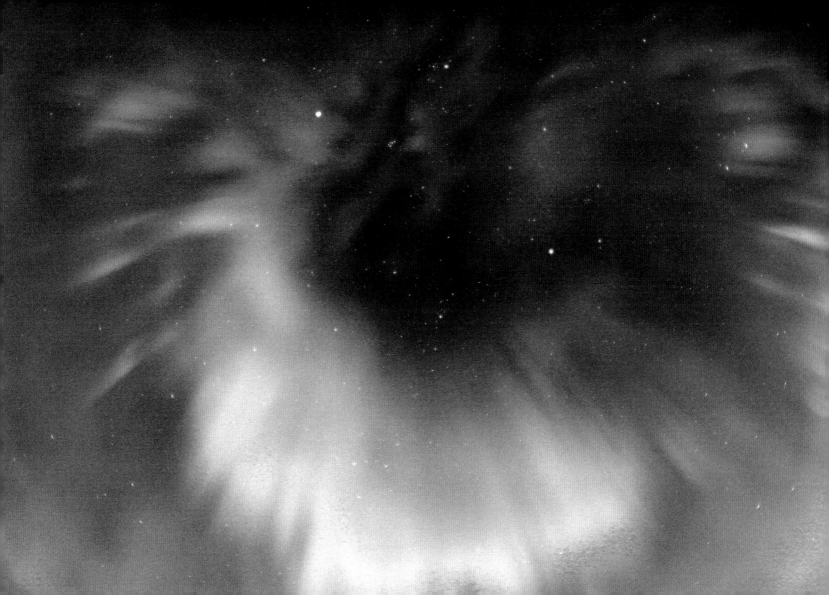

Sagittarius Triplet

These three bright nebulae are often featured in telescopic tours of the constellation Sagittarius and the view toward the center of our Milky Way Galaxy. In fact, eighteenth-century cosmic tourist Charles Messier cataloged two of them: M8, the nebula above and left of center, and colorful M20 at the lower left. The third, NGC 6559, to the right of M8, is separated from the larger nebula by a dark dust lane. All three are stellar nurseries about 5,000 light-years distant. The expansive M8, over 100 light-years across, is also known as the Lagoon Nebula, while M20's popular moniker is the Trifid. In this gorgeous digital composition, the dominant red color of the emission nebulae is due to glowing hydrogen gas energized by the radiation of hot young stars. The contrasting blue hues, most striking in the Trifid as well as NGC 6559, are due to dust-reflected starlight.

Credit & copyright: Robert Gendler

September 26

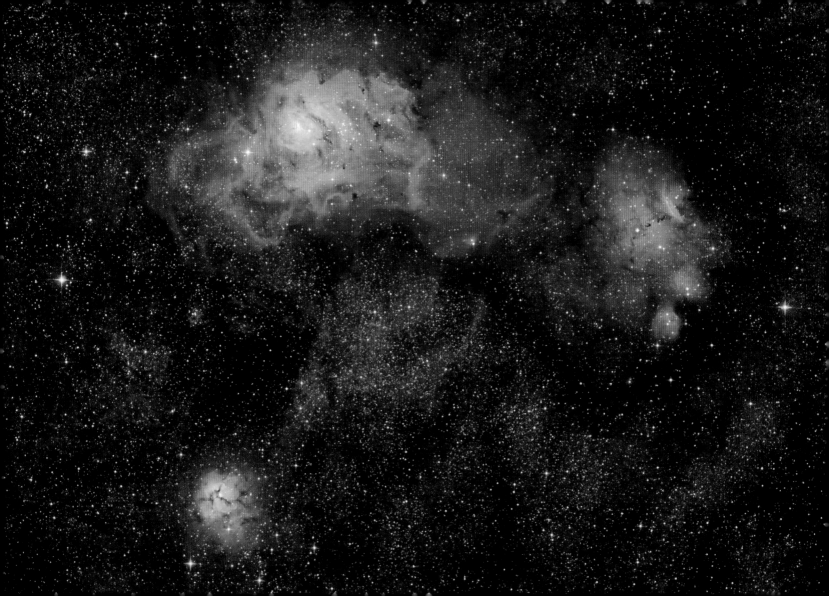

Cosmic Tornado
HH49/50

September 27

Light-years in length, this cosmic tornado is actually a powerful jet, cataloged as HH (Herbig-Haro) 49/50, blasting down from the top of a Spitzer Space Telescope view. Although such energetic outflows are well known to be associated with the formation of young stars, the exact cause of the spiraling structures apparent in this case is still mysterious. The embryonic star responsible for the 100-kilometer-per-second jet is located just off the top of the picture (left margin), while the bright star seen near the tip of the jet may just by chance lie along the line of sight. In this false-color infrared image, the tornado glows with infrared light generated as the outflow heats surrounding dust clouds. The color coding shows a trend from red to blue hues at the tornado's tip, indicating a systematic increase in emission at shorter wavelengths. The trend is thought to indicate an increase in molecular excitation closer to where the head of the jet is impacting interstellar gas. HH49/50 is about 450 light-years distant, located in the Chamaeleon I molecular cloud.

Credit: J. Bally (University of Colorado) et al., JPL-Caltech, NASA

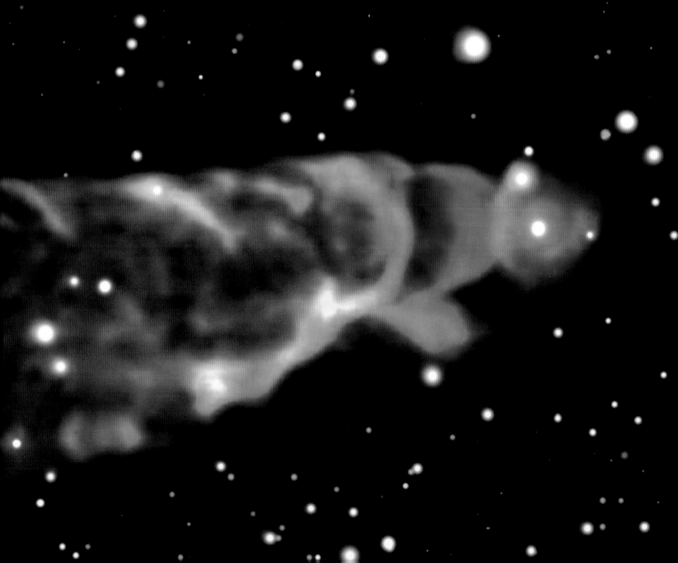

The Large Cloud of Magellan

Portuguese navigator Ferdinand Magellan studied the southern sky during the first circumnavigation of planet Earth, almost 500 years ago. As a result, two fuzzy cloudlike objects that southern hemisphere skygazers can easily see are known as the Clouds of Magellan. Of course, these star clouds are now understood to be dwarf irregular galaxies, satellites of our larger spiral Milky Way. The Large Magellanic Cloud (LMC) is only about 180,000 light-years distant, in the constellation Dorado. Spanning about 15,000 light-years, it is the most massive of the Milky Way's satellite galaxies and is the site of the closest supernova in modern times. The prominent red knot at the right is 30 Doradus, or the Tarantula Nebula, a giant star-forming region in the Large Magellanic Cloud.

Credit & copyright: Loke Kun Tan (StarryScapes)

September 28

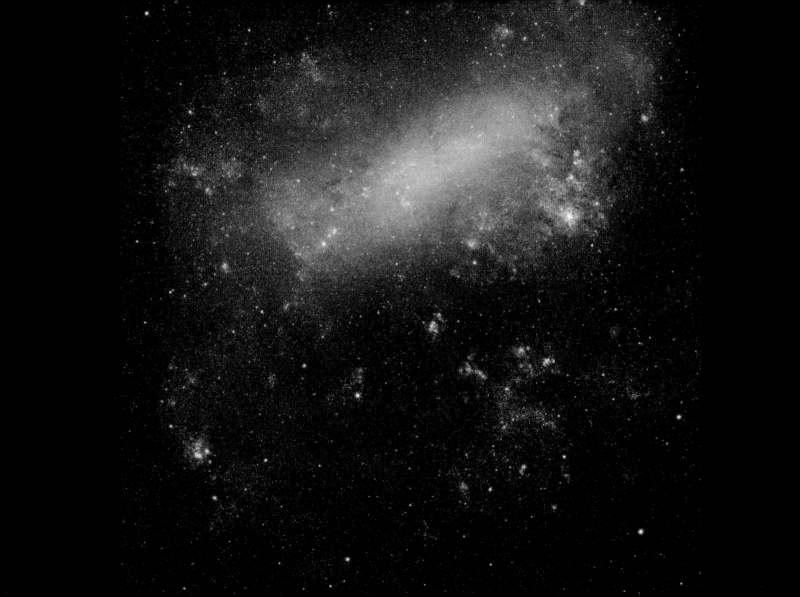

Ringside

Orbiting in the plane of Saturn's rings, Dione and the other icy Saturnian moons have a perpetual ringside view of the gas giant. Of course, while passing through the ring plane, the orbiting Cassini spacecraft also shares their stunning perspective. The rings themselves can be seen slicing across the bottom of this Cassini snapshot. Remarkably thin, the bright rings still cast arcing shadows across the planet's cloud tops. Pale Dione, in the foreground, is about 1,100 kilometers across and orbits over 300,000 kilometers from the visible outer edge of the A ring.

Credit: Cassini Imaging Team, SSI, JPL, ESA, NASA

September 29

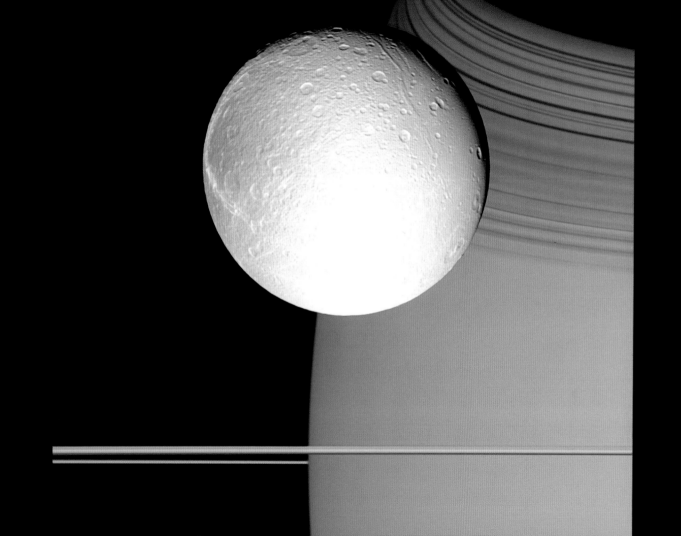

September 30

Where will Gemini take us tonight? It is dusk and Gemini North, one of the largest telescopes on planet Earth, prepares to peer into some portion of the distant universe. Gemini's flexible 8.1-meter mirror has already effectively taken humanity to distant stars, nebulae, galaxies, and quasars, telling us about the geometry, composition, and evolution of our universe. On the night of this picture, August 19, 2003, Gemini North took us only into the outer solar system, observing Pluto in an effort to better determine the composition of its thin atmosphere. It is actually a composite of over forty images taken while the Gemini dome rotated, as well as a subsequently added image of the star field taken from the same location. The Gemini dome is not transparent—it only appears so because it rotated during all the exposures. The constellations of Scorpius and Sagittarius can be seen above the dome, as well as the sweeping band of our Milky Way Galaxy, including the direction toward the galactic center. Gemini North is located on the Big Island of Hawaii. Gemini North's twin, Gemini South, resides in Cerro Pachon, Chile.

Credit: Gemini Observatory, Peter Michaud & Kirk Pu'uohau-Pummill

Red Moon Triple

On October 27, 2004, some people were concentrating on baseball and some were getting ready for Halloween; others, however, were entirely absorbed by a widely viewed total lunar eclipse. Sliding through Earth's shadow, the Moon turned haunting shades of red and orange during the eclipse's total phase. The reddish hues are caused by sunlight scattered and refracted by the atmosphere into Earth's otherwise dark central shadow region. Enjoying the show from Dunkirk, Maryland, astronomer Fred Espenak recorded the images used in this composite photo. The picture shows the Moon at the beginning (right), middle (center), and end (left) of totality, which lasted about eighty-one minutes. Although lunar eclipses can occur twice a year, this total lunar eclipse is perhaps remarkable for being the first one to occur during a World Series baseball game.

Credit & copyright: Fred Espenak (courtesy of www.MrEclipse.com)

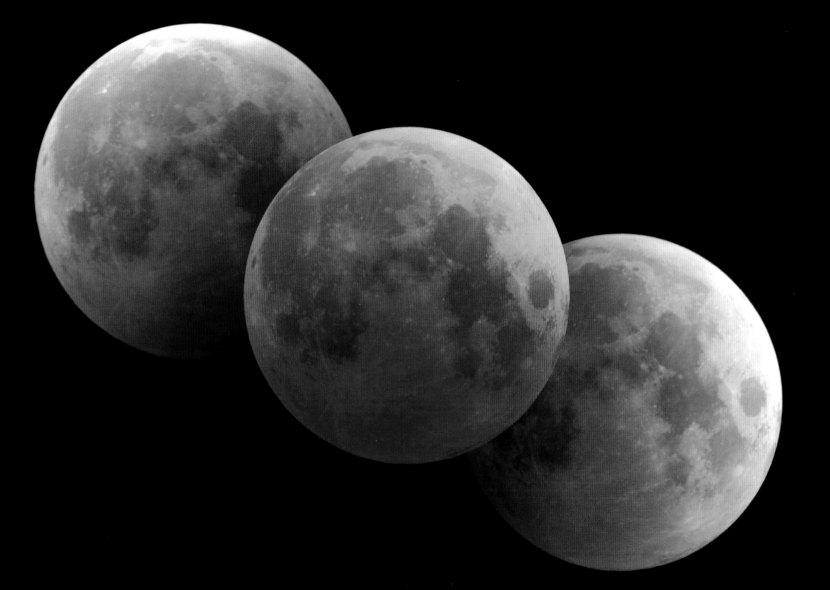

Lightning by Moonset

Moonsets are not often quite as exciting as this one. But amateur astronomer Marc-André Besel was impressed by the brilliant lighting displays that joined the first-quarter Moon and stars of the constellation Scorpius in western skies. On August 22, 2004, his view looked across the Gulf of Mexico from Anna Maria Island, Florida—a region that would experience even more stormy weather in the coming days. The alluring digital image is a time exposure, by chance capturing the details of a brief flash of lightning, along with an overexposed Moon and dramatic cloud formations. In fact, the exposure is long enough to show the background stars as short streaks or trails. The bright yellowish star trail just above and right of the lightning flash is the red giant star Antares.

Credit & copyright: Marc-André Besel

The Milky Way in Stars and Dust

The disk of our Milky Way Galaxy, home to billions of stars as well as hot nebulae and cold dust, can be seen from a dark location on Earth as a band of diffuse light across the sky. The band is crossing the sky in dramatic fashion in this series of wide-angle sky exposures from Chile. The deepness of the exposures also brings to light a vast network of complex dust filaments. The galactic center is visible as the thickest part of the disk. A particularly photogenic area of darkness above the galactic center is the Pipe Nebula. The plentiful dark dust is different from the mysterious dark matter that dominates our galaxy.

Credit & copyright: Serge Brunier

October 3

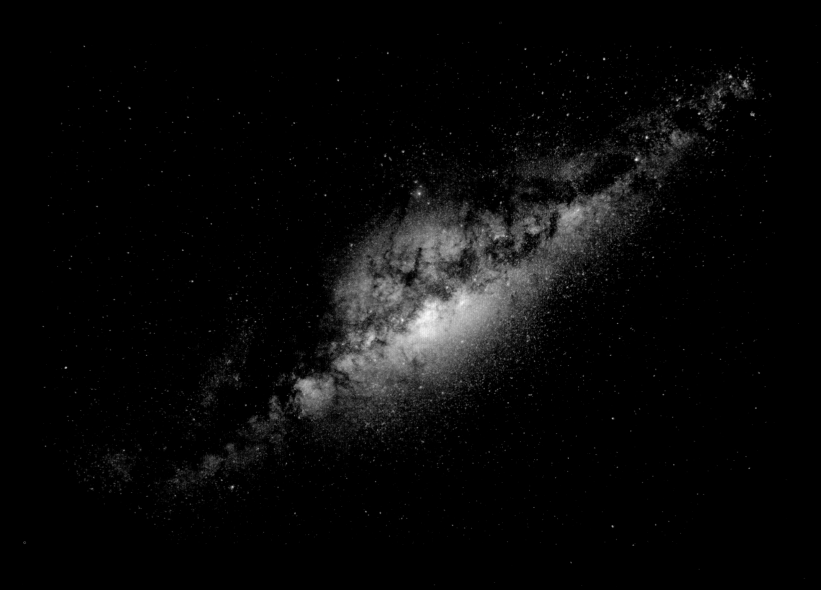

The Perseus Cluster of Galaxies

Here is one of the largest objects that anyone will ever see in the sky. Each of the fuzzy blobs in this picture is a galaxy, and together they constitute the Perseus Cluster, one of the closest clusters of galaxies to our own Milky Way. The cluster is seen through the foreground of faint stars in our galaxy. It takes light roughly 300 million years to get to Earth from this region of the universe, so we see this cluster as it existed before the age of the dinosaurs. Also known as Abell 426, the center of the Perseus Cluster is a prodigious source of x-ray radiation, and so it helps astronomers explore how clusters formed and how gas and dark matter interact. The Perseus Cluster is part of the Pisces-Perseus supercluster of galaxies, which spans over 15 degrees on the sky and contains over 1,000 galaxies.

Credit: Jim Misti (Misti Mountain Observatory)

October 4

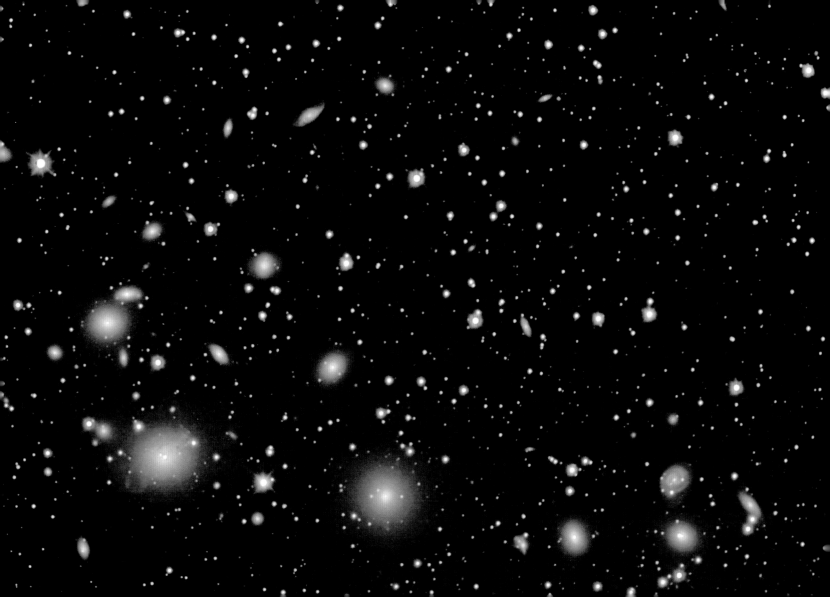

N11: A Giant Ring of Emission Nebulae

What seems to be one of the largest nebulae yet detected is actually a complex ring of emission nebulae, connected by glowing filaments. The unusual network, known as N11, spans over 1,000 light-years and is a prominent structure of the Large Magellanic Cloud, the largest satellite galaxy of our Milky Way. In the center of the image is open star cluster LH9, also known as NGC 1760, composed of about fifty bright blue stars. The radiation they emit has eroded a hole in their surroundings. A leading hypothesis for the origination of N11 is that it is made of shells of successive generations of stars being formed farther and farther out from the center. The bright region just above center is N11B, an explosive domain where stars are being created even today.

Credit & copyright: C. Smith & S. Points, CTIO, AURA, NOAO, NSF

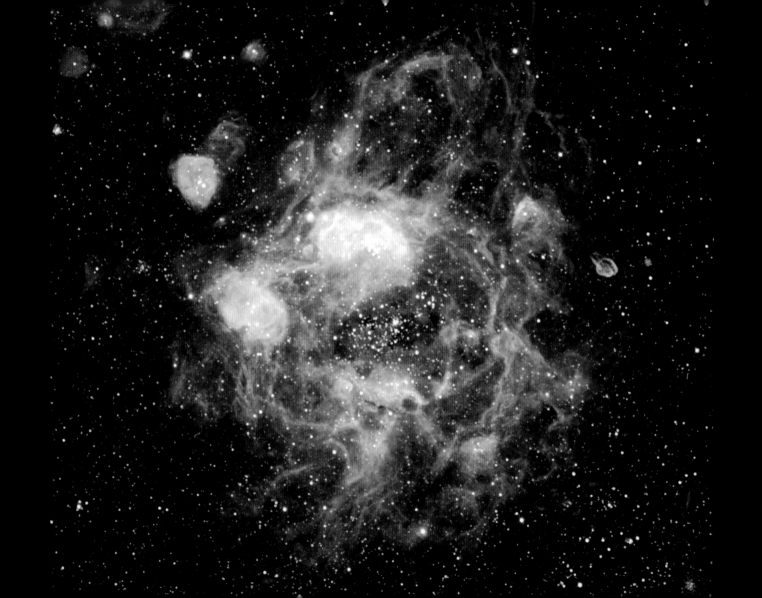

Tantalizing Titan

Normally hidden by a thick, hazy atmosphere, tantalizing features on Titan's surface appear in this false-color view. The image was recorded as the Cassini spacecraft approached its first close flyby of Saturn's smog-shrouded moon on October 26, 2004. Red and green colors represent specific infrared wavelengths absorbed by Titan's atmospheric methane, while bright and dark surface areas are revealed in a more penetrating infrared band. Ultraviolet data showing the extensive upper atmosphere and haze layers are seen as blue. Sprawling across the 5,000-kilometer-wide moon, the bright, continent-sized feature known as Xanadu is near the center of the picture, bordered at the left by contrasting dark terrain.

Credit: Cassini Imaging Team, SSI, JPL, ESA, NASA

October 6

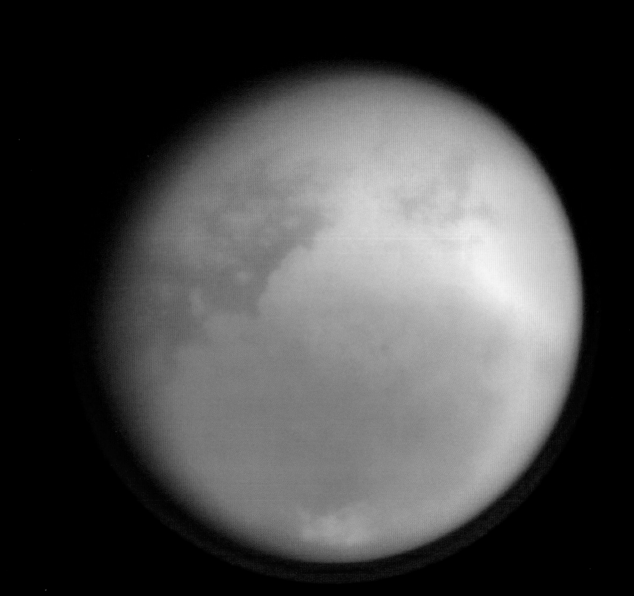

The SDSS 3-D Universe Map

The latest map of the cosmos indicates again that dark matter and dark energy dominate our universe. The Sloan Digital Sky Survey (SDSS) is on its way to measuring the distances to over 1 million galaxies. The distances of galaxies first identified on two-dimensional images, like the one shown at the right, are measured to create the 3-D map. The SDSS currently reports 3-D information for over 200,000 galaxies, now rivaling the 3-D galactic count of the Two-Degree Field sky map. The SDSS map at the left could show the galactic distribution that it does only if the universe were composed and evolved a certain way. After attempts to match many candidate universes to it, the Cinderella universe that best fit the map was found: it is composed of 5 percent atoms, 25 percent dark matter, and 70 percent dark energy. Such a universe was previously postulated because its rapid recent expansion can explain why distant supernovae are so dim, and its early evolution can explain the spot distribution on the very distant cosmic microwave background.

Credit & copyright: Sloan Digital Sky Survey Team, NASA, NSF, DOE

October 7

The Colorful Horsehead Nebula

While drifting through the cosmos, a magnificent interstellar dust cloud became sculpted by stellar winds and radiation to assume a recognizable shape. Fittingly named the Horsehead Nebula, it is embedded in the vast and complex Orion Nebula. The dark molecular cloud, roughly 1,500 light-years distant, is cataloged as Barnard 33 and is visible only because its obscuring dust is silhouetted against the bright emission nebula IC 434. The bright blue reflection nebula NGC 2023 is visible at the lower left. The prominent horsehead, a potentially rewarding object but difficult to view with a small telescope, is really just part of a larger cloud of dust that can be seen extending toward the bottom of the picture. This gorgeous representative-color image was taken by the large 3.6-meter Canada-France-Hawaii Telescope in Hawaii.

Credit & copyright: Canada-France-Hawaii Telescope / J. C. Cuillandre / Coelum

October 8

NGC 346 in the Small Magellanic Cloud

A satellite galaxy of the Milky Way, the Small Magellanic Cloud (SMC) is a wonder of the southern sky, a mere 210,000 light-years distant in the constellation Tucana. Found among the SMC's clusters and nebulae, NGC 346 is a star-forming region about 200 light-years across, seen in this Hubble Space Telescope image. Exploring NGC 346, astronomers have identified a population of embryonic stars strung along the dark, intersecting dust lanes visible to the right of center. The light from the stellar infants, still collapsing within their natal clouds, is reddened by the intervening dust. The SMC represents a type of small, irregular galaxy more common in the early universe, and thought to be building blocks for the larger galaxies present today. Within the SMC, stellar nurseries like NGC 346 are also thought to be similar to those found in the young universe.

Credit: A. Nota (ESA/STScI) et al., ESA, NASA

October 9

In this striking 41-by-38-inch quilt, astronomy enthusiast Judy Ross has interpreted some of the Hubble Space Telescope's best galactic and extragalactic vistas. Featured clockwise from the lower right are the Red Rectangle Nebula, the Eskimo Nebula, the Sleeping Beauty Galaxy, V838 Monocerotis—the Milky Way's most mysterious star—and supernova remnant N49. Remarkably skilled at portraying images of the cosmos in her quilts, Ross reports that she is still a little daunted by the intricacies of the Cat's Eye Nebula (see September 21) revealed thanks to the Hubble's sharp vision.

Credit & copyright: Judy W. Ross, Point Roberts, WA

Large Sunspot Groups 10484 and 10486

Two unusually large sunspot groups were captured crossing the face of the Sun in October 2003. Each group, roughly the size of Jupiter, was unusual not only for its size but because it was appearing over three years after solar maximum, the peak of solar surface activity. Sunspot group 10484 is visible near the center of the image, while sunspot group 10486 is just coming over the left limb (edge) of the Sun. By the time this image was taken, the active region associated with Sunspot 484 (the shorter nickname) had already jettisoned a large coronal mass ejection of particles out into the solar system. When striking Earth, radiation of this sort has the power to interrupt normal satellite operations while simultaneously providing beautiful auroras. Rotating with the Sun, Sunspots 484 and 486 took about thirty days to make one complete circle, slowly evolving in size and shape during this time. While using extreme care never to look directly at the Sun, the photographer created this image by holding a digital camera up to a small telescope.

Credit & copyright: Juan Carlos Casado

Dusty NGC 1333

NGC 1333 is seen as a reflection nebula in visible-light images, sporting bluish hues characteristic of starlight reflected by dust. But at longer infrared wavelengths, the interstellar dust itself glows—shown in red in this false-color Spitzer Space Telescope image. The penetrating infrared view also shows youthful stars that would otherwise still be obscured by the dusty clouds that formed them. Notably, greenish streaks and splotches that seem to litter the region trace the glow of cosmic jets blasting away from emerging young stellar objects as the jets plow into the cold cloud material. In all, the chaotic scene likely resembles the one in which our own Sun formed over 4.5 billion years ago. Dusty NGC 1333 is a mere 1,000 light-years distant in the constellation Perseus.

Credit: R. A. Gutermuth (Harvard-Smithsonian CfA) et al., JPL-Caltech, NASA

SN 1006: 1,000-Year-Old Supernova Remnant

This huge puffball was once a star. Exactly 1,000 years ago, in A.D. 1006, a new star was recorded in the sky; today, we know it was really the explosion of an existing star. The resulting gas from the supernova is still visible with telescopes today, continues to expand a millennium later, and now spans over 70 light-years. SN 1006 glows in every type of light. This x-ray image was captured by the orbiting Chandra X-ray Observatory. Even today, not everything about the SN 1006 is understood—for example, why particle shocks that produce the bright blue filaments are visible only at some locations. SN 1006 is thought to have once been a white dwarf that exploded when gas being dumped onto it by its binary star companion caused it to go over the Chandrasekhar limit (the mass limit for a stable white dwarf star). This image also shows foreground stars that have nothing to do with the supernova.

Credit: J. Hughes (Rutgers University) et al., CXC, NASA

October 13

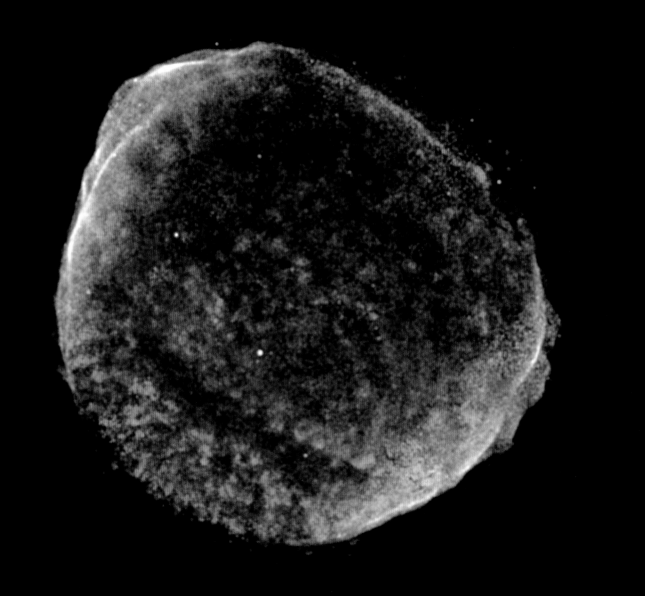

The Last
Moon Shot

In 1865, Jules Verne predicted the invention of a capsule that could carry people into space; in his science-fiction novel *From the Earth to the Moon,* he outlined his vision of a cannon in Florida so powerful that it could shoot a "Projectile-Vehicle" carrying three adventurers to the Moon. Over 100 years later, NASA, guided by Wernher von Braun's vision, produced the Saturn V rocket. From a spaceport in Florida, this rocket turned Verne's fiction into fact, launching nine Apollo lunar missions and allowing twelve astronauts to walk on the Moon. Pictured is the last moon shot, Apollo 17, awaiting its December 1972 night launch. Spotlights play on the rocket and launchpad at dusk. Humans have not walked on the lunar surface since its return.

Credit: The Apollo Program, NASA (image scanned by J. L. Pickering)

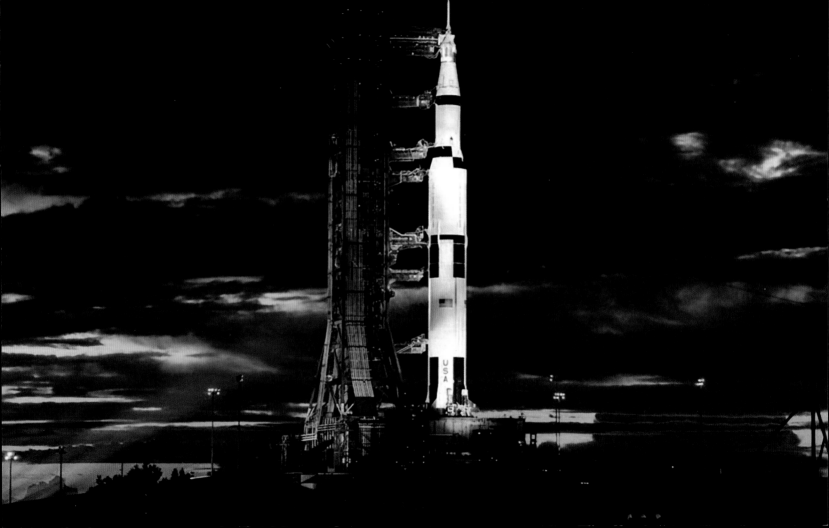

Star Trails above Mauna Kea

Is there a road to the stars? Possibly there are many, but the physical road pictured here leads up to the top of a dormant volcano that is a premier spot on planet Earth for observing stars and astronomical phenomena. At the top of Hawaii's Mauna Kea are some of the largest optical telescopes on Earth, including the Keck telescopes, Gemini, Subaru, CFHT, and the IRTF. Together, these 10-meter eyes have made many universe-redefining discoveries, among them detailing that most of the universe is made not of familiar matter but of mysterious dark matter and dark energy. This picture was compiled from over 150 one-minute exposures by a digital camera. During that time, the rotation of the planet made the stars far in the distance appear to have long star trails. The foreground landscape was illuminated by the Moon.

Credit & copyright: Peter Michaud (Gemini Observatory), AURA, NSF

October 15

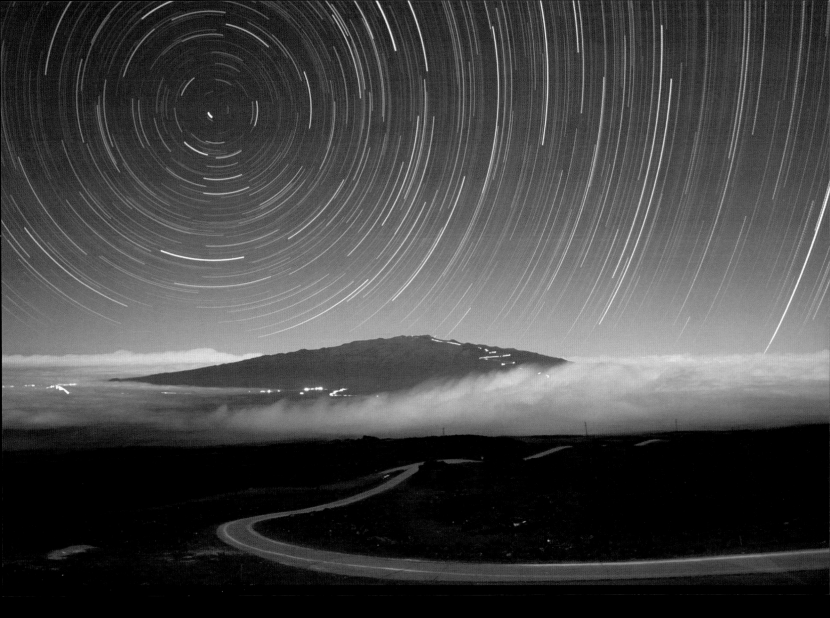

The Cocoon Nebula

The Cocoon Nebula, cataloged as IC 5146, is a strikingly beautiful one located about 4,000 light-years away toward the constellation Cygnus. Inside the nebula is a newly developing open cluster of stars. Like other stellar nurseries, the Cocoon is simultaneously an emission nebula, a reflection nebula, and an absorption nebula. Speculation based on recent measurements holds that the massive star in the center of the image opened a hole in an existing molecular cloud through which much of the glowing material flows. The same star, which formed about 100,000 years ago, now provides the energy source for much of the emitted and reflected light from this nebula.

Credit & copyright: Canada-France-Hawaii Telescope / J. C. Cuillandre / Coelum

A Lunar Rille

What could cause a long indentation on the Moon? First discovered over 200 years ago with a small telescope, rilles (rhymes with "pills") appear all over the Moon. Three types of rilles are now recognized: sinuous, which have many meandering curves; arcuate, which form sweeping arcs; and straight, like the Ariadaeus Rille pictured here. Sinuous rilles are thought to be remnants of ancient lava flows, but the origins of the other two types are still a topic of research. Some, such as the Ariadaeus Rille, are very long, extending for hundreds of kilometers. This photograph was taken by the Apollo 10 crew in 1969 during their historic approach to only 14 kilometers above the lunar surface. Two months later, Apollo 11, incorporating much knowledge gained from Apollo 10, landed on the Moon.

Credit: Apollo 10, NASA

October 17

Hyperion: A Moon with Strange Craters

What lies at the bottom of Hyperion's strange craters? Nobody knows. To help find out, the robot Cassini spacecraft orbiting Saturn swooped past that planet's sponge-textured moon again in late 2005 and took an image of unprecedented detail. That image, shown here in false color, reveals a remarkable world strewn with unusual craters and a generally odd surface. The slight variations in color likely mean differences in surface composition. At the bottom of most craters lies some type of unknown dark material. Inspection of the image shows bright features indicating that the dark material might be only tens of meters thick in some places. Hyperion is about 250 kilometers across, rotates chaotically, and has a density so low that it might house a vast system of caverns inside.

Credit: Cassini Imaging Team, SSI, JPL, ESA, NASA

October 18

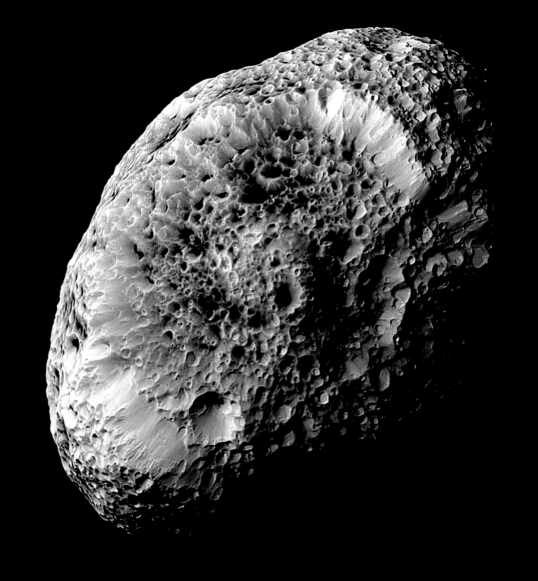

On another October 19, back in 1899, a seventeen-year-old named Robert Goddard climbed a cherry tree on a beautiful autumn afternoon in Worcester, Massachusetts. Inspired by H. G. Wells's novel *War of the Worlds*, young Goddard gazed out across a meadow and imagined it would be wonderful to make a device that had the possibility of ascending to Mars. Forever after, he felt his life had a purpose, and in the following years his diary entries record October 19 as "Anniversary Day"—the anniversary of his ascent into the cherry tree. By 1926, Robert Goddard had designed, built, and flown the world's first liquid-fuel rocket. Mars is just visible through the trees at the lower right in this dramatic skyview, also featuring the Moon and Venus—all of which have been visited by liquid-fuel rockets constructed on principles that Goddard developed.

Credit & copyright: Fred Espenak (courtesy of www.MrEclipse.com)

October 19

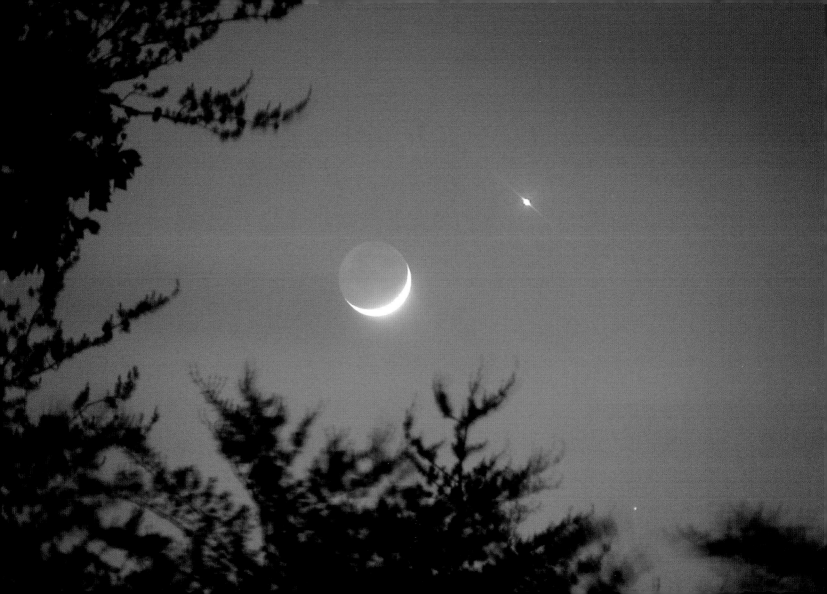

Contrail Clutter over Georgia

The long, thin cloud streaks that dominate this satellite photograph of Georgia are contrails, cirrus clouds created by airplanes. The exhaust of an airplane engine can create a contrail by saturating the surrounding air with extra moisture. The wings of a plane can similarly create contrails by dropping the temperature and causing small ice crystals to form. Contrails have become more than an oddity—they may be significantly increasing the cloudiness of Earth, reflecting sunlight back into space by day, and heat radiation back to the planet even at night. These artificial clouds may become so common that they change Earth's climate.

Credit: MODIS, Terra Satellite, NASA

October 20

Spiral Galaxy NGC 1350

This gorgeous island universe lies about 85 million light-years distant in the southern constellation Fornax. Inhabited by young, blue star clusters, the spiral arms of NGC 1350 seem to join in a circle around its large, bright nucleus—giving the galaxy the appearance of a limpid cosmic eye. NGC 1350 is about 130,000 light-years across, making it as large as, or slightly larger than, our own Milky Way. For Earth-based astronomers, NGC 1350 is seen on the outskirts of the Fornax cluster of galaxies, but its estimated distance suggests that it is not itself a member of the cluster. The sharp image also reveals many background galaxies, some visible right through NGC 1350.

Credit: H. Boffin, H. Heyer, E. Janssen (ESO), FORS2, European Southern Observatory

October 21

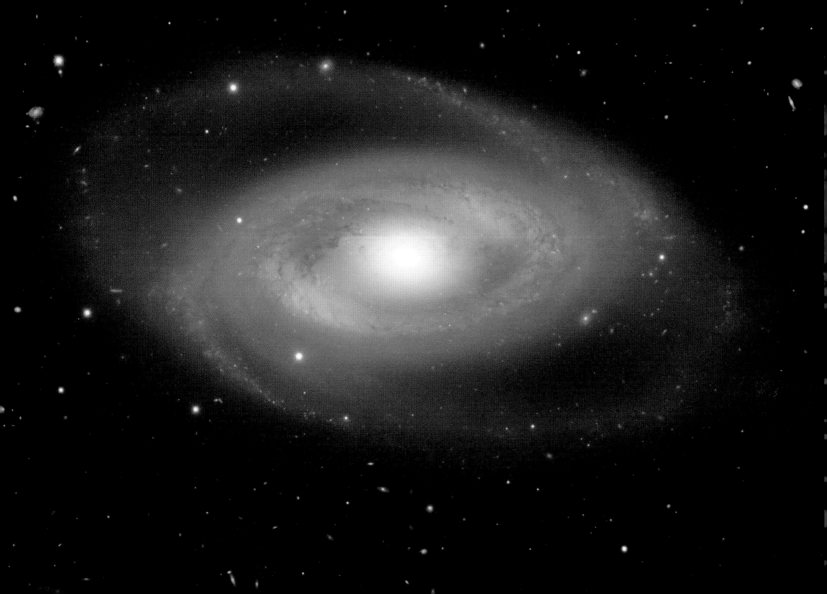

Cloud-Sculpting Star Cluster

Star cluster NGC 6823 is ready for its close-up. The center of the open cluster, visible at the upper right, formed only about 2 million years ago and is dominated in brightness by a host of young blue stars. Outer parts of the cluster, visible in the center of the image as the stars and pillars of emission nebula NGC 6820, contain even younger stars. The elongated shape of the huge pillars of gas and dust is likely caused by erosion from hot radiation emitted from the brightest cluster stars. Striking dark globules of gas and dust are also visible across the bottom of this image, taken by the twenty-five-year-old Canada-France-Hawaii Telescope in Hawaii. Open star cluster NGC 6823 spans about 50 light-years and lies about 6,000 light-years away in the direction of the constellation Vulpecula (the Fox).

Credit & copyright: Canada-France-Hawaii Telescope / J. C. Cuillandre / Coelum

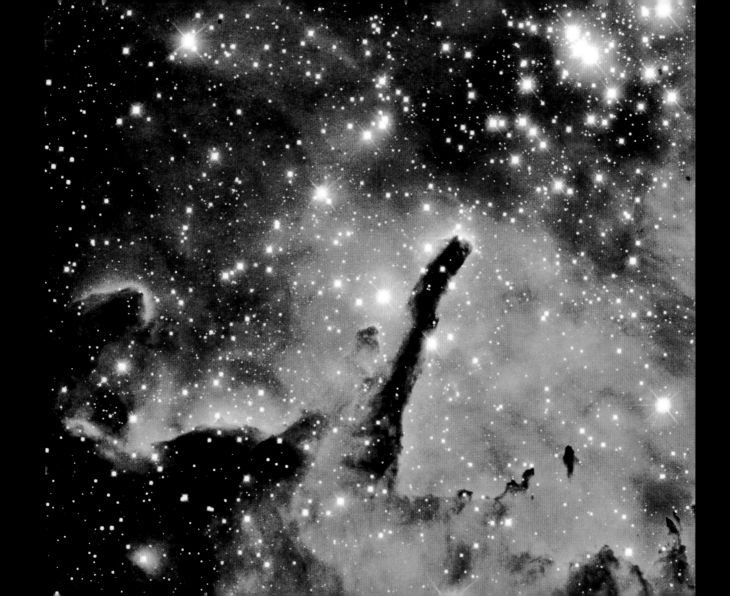

Ring of Fire

On October 3, 2005, a sizable portion of the Sun went missing. This was no cause for concern, however—the Moon was only momentarily in the way. The event was not a total eclipse of the Sun for any Earthbound sky enthusiast but rather, at best, an annular eclipse, in which the Moon blocks most of the Sun. Because of the relatively large distance from Earth to the Moon during this alignment of the three bodies, the Moon did not have a big enough angular size to block the entire Sun. But those who witnessed the solar eclipse from a narrow path through Portugal, Spain, and part of Africa were lucky enough to see the coveted Ring of Fire, a dark Moon completely surrounded by the brilliant light of the distant Sun. Pictured here is a Ring of Fire captured above Spain in unusually high resolution. The resulting image shows details of the granular solar surface as well as many prominences around the Sun.

Credit & copyright: Stefan Seip

October 23

Night MAGIC

Is it magic? On a rare foggy night, mysterious laser beams seem to play across the Major Atmospheric Gamma Imaging Cherenkov (MAGIC) telescope at Roque de los Muchachos, on the Canary Island of La Palma. The lasers are actually part of a system designed to automatically adjust the focusing of the innovative, 17-meter-wide, multi-mirrored instrument. The MAGIC telescope itself is intended to detect gamma rays—photons with over 100 billion times the energy of visible light. As the gamma rays impact the upper atmosphere, they produce showers of high-energy particles. The MAGIC camera records in detail the brief flashes of optical light, called Cherenkov light, created by the particles, which ultimately correspond to cosmic sources of extreme gamma rays. This dramatic picture shows the nearly completed instrument in October 2003; it became operational in 2004.

Credit: Robert Wagner (Max-Planck-Institut für Physik, München), MAGIC Telescope Project

October 24

The Fomalhaut Dust Disk

One of the brightest stars in the night sky likely has planets. Fomalhaut, actually the seventeenth-brightest star, is a mere 22 light-years away but only a fraction of the age of our Sun. Observations in far-infrared light with a detector cooled to near absolute zero indicate that a dust disk surrounding Fomalhaut has a hole in the center and a warped edge. The hole suggests that dust has fallen onto interior planets—possibly similar to Earth—while the warp at the edge points to the gravitational pull of a planet like Jupiter or Saturn. The discovery image was taken with the SCUBA instrument through the James Clerk Maxwell Telescope in Hawaii. This illustration shows what the Fomalhaut dusty planetary system might look like from the vicinity of the large planet.

Credit: David A. Hardy, ROE, ATC, NSF, NASA

October 25

The Belt of Venus over the Valley of the Moon

Although you have surely seen it, you might not have noticed it: during a cloudless twilight, just before sunrise or after sunset, part of the atmosphere above the horizon appears slightly pink. Called the Belt of Venus, this off-color band between the dark, eclipsed sky and the blue sky above can be seen opposite the Sun. The blue sky is normal sunlight reflecting off the atmosphere. In the Belt of Venus, however, the atmosphere, reflecting light from the setting or rising Sun, is seen as redder. The Belt of Venus can be seen from any location with a clear horizon. This photograph of it was taken above morning fog in the Valley of the Moon, a famous wine-producing region in northern California.

Credit & copyright: Christine Churchill

Kepler's SNR

Light from the stellar explosion that created this energized cosmic cloud was first seen on planet Earth in October 1604, a mere 400 years ago. The supernova produced a bright new star in early-seventeenth-century skies within the constellation Ophiuchus. It was studied by astronomer Johannes Kepler and his contemporaries—without the benefit of a telescope—as they searched for an explanation of the heavenly apparition. Armed with a modern understanding of stellar evolution, early-twenty-first-century astronomers continue to explore the expanding debris cloud, but now they can use orbiting space telescopes to survey Kepler's supernova remnant (SNR) across the spectrum. In this tantalizing composite image, x-rays, visible light, and infrared radiation recorded by NASA's astrophysical observatories—the Chandra X-ray Observatory and Hubble and Spitzer space telescopes—are combined to give a more comprehensive view of the still-enigmatic SNR. About 13,000 light-years away, Kepler's supernova represents the most recent stellar explosion seen to occur within our Milky Way Galaxy.

Credit: R. Sankrit & W. Blair (JHU) et al., ESA, NASA; graphic: courtesy of STScI

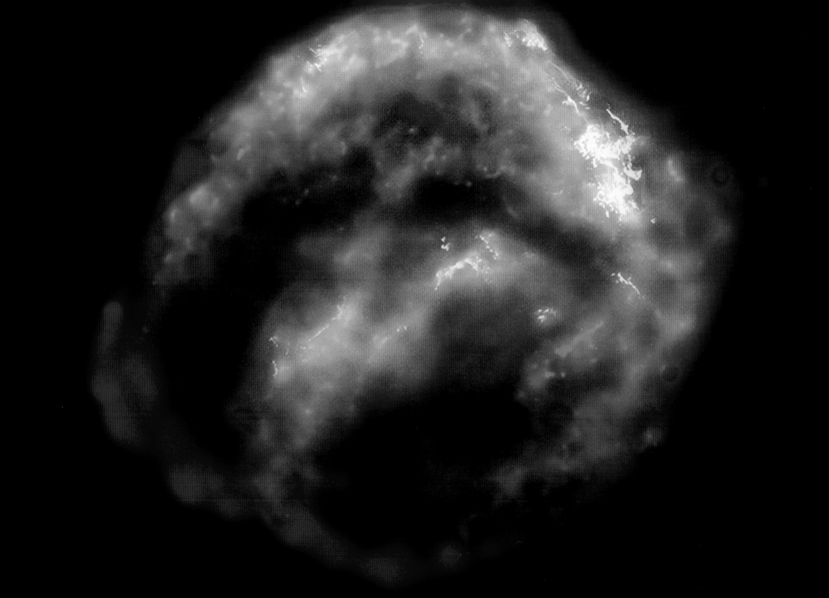

Iridescent Clouds over Aiguille de la Tsa

Before the sun rose over the mountains of southwestern Switzerland, iridescent colors danced across the sky. This unexpected light show in early September 2003 was caused by a batch of iridescent clouds. Such clouds contain patches of water droplets of nearly identical size that can therefore diffract sunlight in an almost uniform manner. Different colors will be deflected by varying amounts and so come to the observer from slightly different directions. Iridescent clouds are best seen outside the glare of the direct Sun, although they can occasionally be seen to encircle the Sun. The image was taken in Arolla, Valais Canton; the peak in the foreground is Aiguille de la Tsa.

Credit & copyright: Ute Esser (University of Heidelberg)

October 28

The Andromeda Galaxy

Andromeda is the nearest major galaxy to our own Milky Way, and the two are thought to look much like each other. They are the dominant members of the Local Group of galaxies. The diffuse light from Andromeda is caused by the hundreds of billions of stars that compose it. Andromeda seems to be surrounded by several distinct stars, but they are actually stars in our galaxy and well in front of the background object. Andromeda is frequently referred to as M31, because it is the thirty-first object on Charles Messier's eighteenth-century list of diffuse sky objects. M31 is visible to the unaided eye but so distant that it takes about 3 million years for its light to reach us. This image is a digital mosaic of twenty frames taken with a small telescope.

Credit & copyright: Robert Gendler

October 29

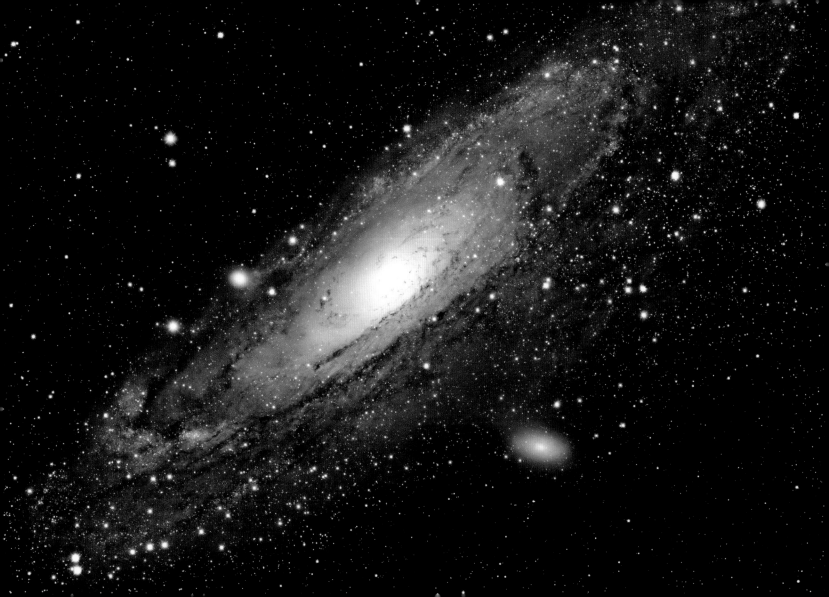

At the center of our galaxy lies a black hole with over 2 million times the mass of the Sun. Once a controversial claim, this astounding conclusion is now virtually inescapable, based on observations of stars orbiting very close to the galactic center. Using one of the Paranal Observatory's Very Large Telescope units and the sophisticated infrared camera NaCo, astronomers patiently followed the orbit of a particular star, designated S2, as it came within about 17 light-hours (only about three times the radius of Pluto's orbit) of the center of the Milky Way. Their results convincingly show that S2 is moving under the influence of the enormous gravity of an unseen object that must be extremely compact—a supermassive black hole. This deep NaCo near-infrared image shows the crowded inner 2 light-years of the Milky Way. NaCo's ability to track stars so close to the galactic center can accurately measure the black hole's mass and perhaps even provide an unprecedented test of Einstein's theory of gravity, as astronomers watch a star orbit a supermassive black hole.

Credit: Rainer Schödel (MPE) et al., NAOS-CONICA, ESO

This picture, taken as the Apollo 11 astronauts orbited the Moon in 1969, depicts the stark lunar surface around the 50-mile-wide (80-kilometer) Daedalus Crater on the lunar far side. Images of a Moon devoid of life are familiar to denizens of the space age. Contrary to this modern perception, life on the Moon was reported in August 1835 in a series of sensational stories first published by the *New York Sun*—apparently intended to improve the newspaper's circulation. These descriptions of lunar life were given broad credence and became one of the most spectacular hoaxes in history. Supposedly based on telescopic observations, the stories featured full, lavish accounts describing a Moon with oceans and beaches that teemed with plant and animal life, and climaxing with reported sightings of winged, furry, human-like creatures resembling bats! Within a month, the trick had been revealed, but the newspaper continued to enjoy increased readership. As for today, if any bats come to your door on Halloween, you can be confident they are not from the Moon!

Credit: Apollo 11, NASA

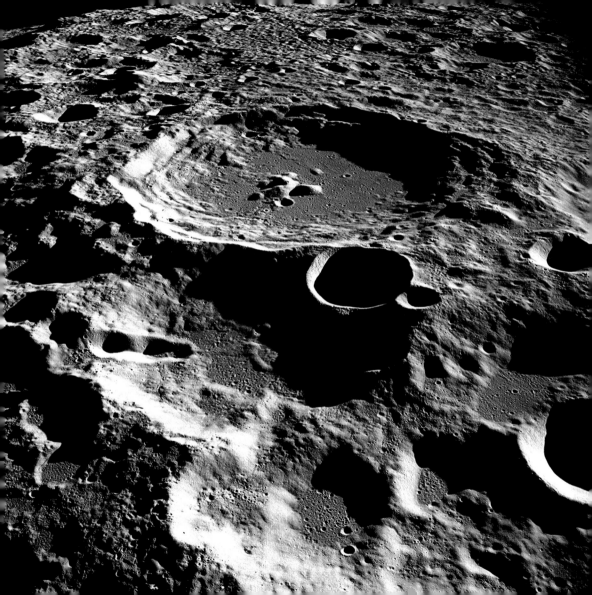

X-Rays from the Galactic Core

Using the orbiting Chandra X-ray Observatory, astronomers have taken this long look at the core of our Milky Way Galaxy, some 26,000 light-years away. The spectacular false-color view spans about 60 light-years. It reveals an energetic region rich in x-ray sources, highlighted by the central source, Sagittarius A*, known to be a supermassive black hole with over 2 million times the mass of the Sun. Given its tremendous mass, Sagittarius A* is amazingly faint in x-rays, even during its frequent x-ray flares, in comparison to central black holes observed in distant galaxies. This suggests that the supermassive black hole has been starved by a lack of infalling material. In fact, this sharp Chandra image shows clouds of multimillion-degree gas dozens of light-years across flanking (upper right and lower left) the central region—evidence that violent events have cleared much material from the vicinity of the black hole.

Credit: Fred Baganoff (MIT), Mark Morris (UCLA), et al., CXC, NASA

November 1

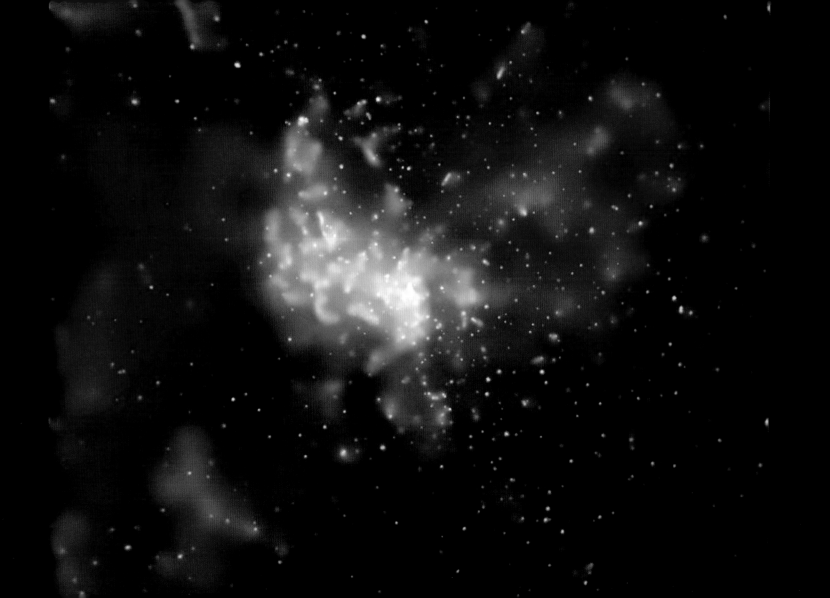

Supernova Remnant Imaged in Gamma Rays

November 2

Gamma rays are the most energetic form of light. With up to a billion times the energy of ordinary medical x-rays, they easily penetrate telescope lenses and mirrors, making it very difficult to create gamma-ray images of cosmic sources. Still, an array of large telescopes designed to detect gamma-ray-induced atmospheric flashes—the HESS (High Energy Stereoscopic System) experiment—produced this historic, resolved image of a supernova remnant at extreme gamma-ray energies in 2004. Astronomers note that the premier gamma-ray view of the expanding stellar debris cloud is clearly similar to x-ray images of the remnant and convincingly supports the idea that these sites of powerful shock waves are also sources of cosmic rays within our galaxy. The gamma-ray intensity is color-coded, with dark contour lines that trace levels of x-ray emission from the object. At an estimated distance of 3,000 light-years, the supernova remnant measures about 50 light-years across and lies near the galactic plane.

Inset at left: This HESS gamma-ray telescope in Namibia, inaugurated in 2002, is adorned with 382 separate mirrors, each 60 centimeters in diameter, and equipped with a fast camera. The camera records in detail the brief flashes of optical light created by showers of high-energy particles that are produced when gamma rays impact the upper atmosphere of Earth.

Credit: HESS Collaboration

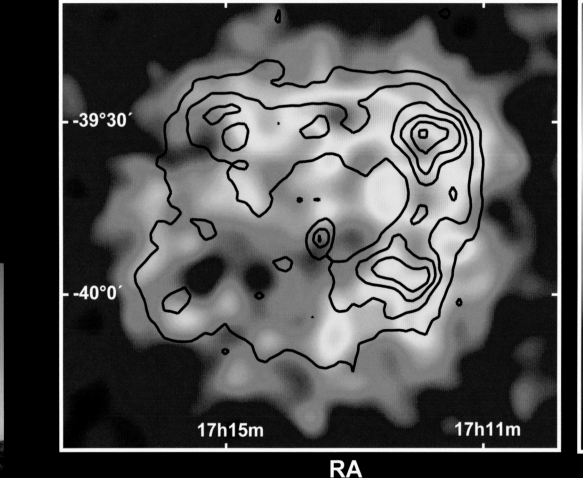

These sharp views of tilted gas giant Uranus show dramatic details of the planet's atmosphere and ring system. The remarkable ground-based images were made using a near-infrared camera and the Keck Adaptive Optics system to reduce the blurring effects of Earth's atmosphere. Recorded in July 2004, the pictures show two sides of Uranus. In both views, high, white cloud features are seen mostly in the northern (right-hand) hemisphere, with medium-level cloud bands in green and lower-level clouds in blue. The artificial color scheme lends a deep reddish tint to the otherwise faint rings. Because of the severe tilt of its rotational axis, seasons are extreme and last nearly twenty-one Earth years on the distant planet. Uranus is now slowly approaching its southern autumnal equinox—the beginning of fall in the southern hemisphere—which will occur in 2007.

Credit: L. A. Sromovsky, P. M. Fry (University of Wisconsin), Keck Observatory

November 3

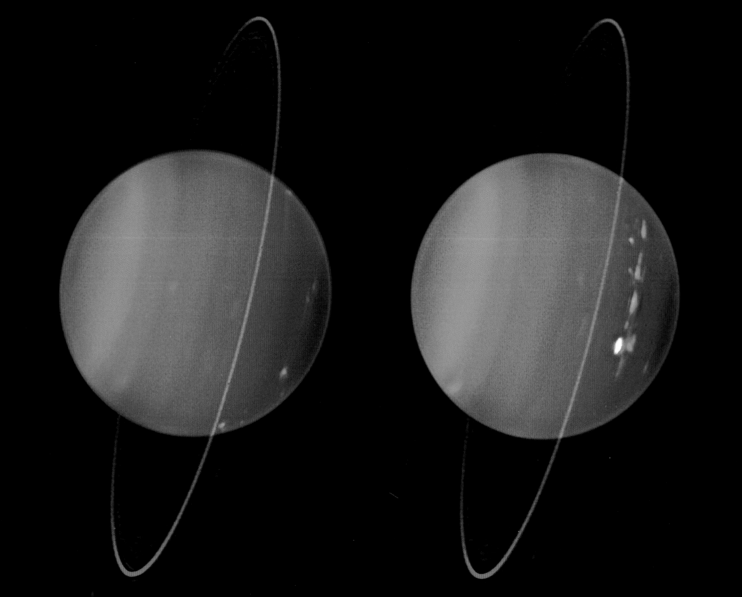

A Multicolored Full-Sky Auroral Corona

On some nights, the sky is the most interesting show in town. This fish-eye view captures a particularly active and colorful auroral corona that occurred over l'Observatoire de la Découverte in Val Belair, near Quebec, Canada. This spectacular aurora has an unusually high degree of detail, range of colors, and breadth across the sky. The vivid green, red, and blue colors are caused by high atmospheric atoms and molecules reacting to incoming electrons. Auroras are triggered by magnetically induced explosions from a solar active region.

Credit & copyright: Philippe Moussette (Observatoire Mont Cosmos)

November 4

NGC 2683: Spiral Seen Edge On

This gorgeous island universe, cataloged as NGC 2683, lies a mere 16 million light-years distant in the northern constellation Lynx. A spiral galaxy comparable to our own Milky Way, NGC 2683 is seen nearly edge on in this cosmic vista, with more distant galaxies scattered in the background. Blended light from a large population of old yellowish stars forms the remarkably bright galactic core. Starlight silhouettes the dust lanes along winding spiral arms, dotted with the telltale pink glow of ionized hydrogen gas from this galaxy's star-forming regions.

Credit & copyright: Doug Matthews & Adam Block, NOAO, AURA, NSF

November 5

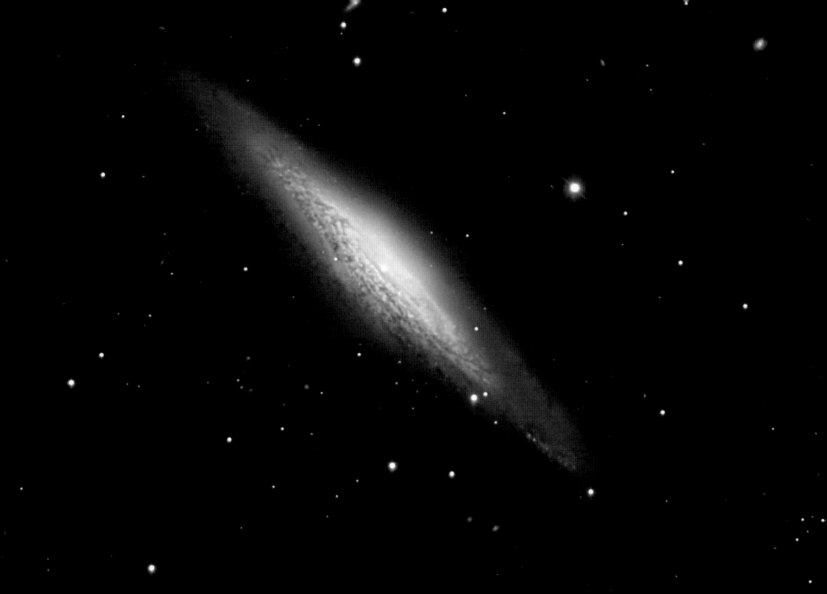

The 37 Cluster

For the mostly harmless denizens of planet Earth, the brighter stars of open cluster NGC 2169 seem to form a cosmic 37. (Did you expect 42?) Of course, the improbable numerical asterism appears solely by chance, at an estimated distance of 3,600 light-years toward the constellation Orion. As far as galactic or open star clusters go, NGC 2169 is a small one, spanning about 7 light-years. Formed at the same time from the same cloud of dust and gas, the stars of NGC 2169 are only about 8 million years old. Such clusters are expected to disperse over time as they encounter other stars and interstellar clouds, and experience gravitational tides, while traveling through the galaxy. Over 4 billion years ago, our own Sun was likely formed in a similar open cluster of stars.

Credit & copyright: Noel Carboni

November 6

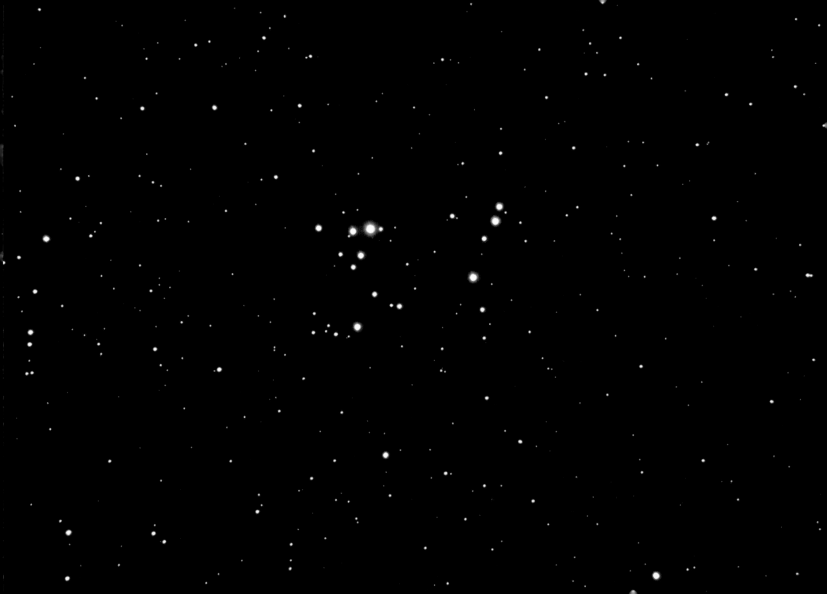

Pastel Planet, Triple Eclipse

This false-color image of banded gas giant Jupiter shows a triple eclipse in progress on March 28, 2004—a relatively rare event, even for a large planet with many moons. Captured by the Hubble Space Telescope's near-infrared camera are shadows of Jupiter's moons Ganymede (left edge), Callisto (right edge), and Io, three black spots crossing the sunlit Jovian cloud tops. In fact, Io itself is visible as a white spot near the center of the picture, with a bluish Ganymede above and to the right, but Callisto is off the right-hand edge of the scene. Viewed from Jupiter's perspective, these shadow crossings would be seen as solar eclipses, analogous to the Moon's shadow crossing the sunlit face of planet Earth. Historically, timing the eclipses of Jupiter's moons allowed astronomer Ole Roemer to make the first accurate measurement of the speed of light, in 1676.

Credit E. Karkoschka (University of Arizona), NASA

November 7

Aristarchus Plateau

Anchored in the vast lava flows of the Moon's Oceanus Procellarum lies the Aristarchus Plateau. Recorded from a backyard observatory on planet Earth, this sharp, amazingly colorful view nicely captures the geologically diverse area, including the brownish plateau, Aristarchus and Herodotus craters, and the meandering Vallis Schroteri. The bright impact crater at the lower corner of the plateau is Aristarchus, a young crater 42 kilometers wide and 3 kilometers deep, surrounded by a radial system of light-colored rays. Only slightly smaller, the lava-flooded Herodotus Crater is above and to the left. A valley or rille likely carved by rapidly flowing lava or a collapsed lava tunnel, Vallis Schroteri begins just to the right of Herodotus and winds across the plateau for about 160 kilometers, eventually turning toward the top of the picture and the shadow of the lunar terminator. Aristarchus Plateau itself is like a rectangular island about 200 kilometers across, about 2 kilometers above the smooth surface of the lunar Ocean of Storms.

Credit & copyright: Russell Croman

November 8

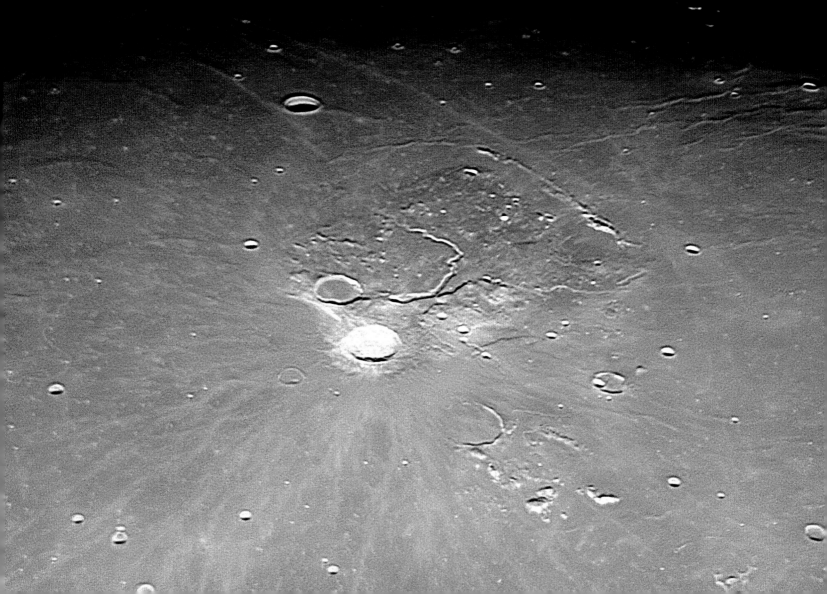

IC 405: The Flaming Star Nebula

Rippling dust and gas lanes give the Flaming Star Nebula its name. The red and purple colors of the nebula are present in different regions and created by different processes. The bright star AE Aurigae, visible near the center of the image, is so hot it is blue, emitting light so energetic that it knocks electrons away from surrounding gas. When a proton recaptures an electron, red light is frequently emitted. The purple region's color is a mix of this red light and blue light emitted by AE Aurigae but reflected to us by surrounding dust. The two regions are referred to as an emission nebula and reflection nebula, respectively. Officially known as IC 405, the Flaming Star Nebula lies about 1,500 light-years distant, spans only about 5 light-years, and is visible with a small telescope in the direction of the constellation Auriga.

Credit & copyright: Robert Gendler

November 9

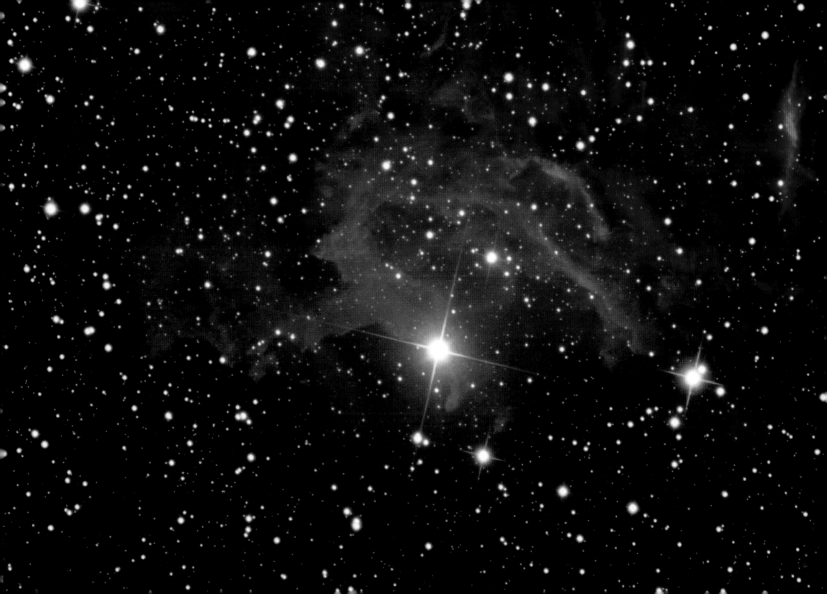

A Glimpse of the Veil

After 5,000 years, the magnificent Veil Nebula is still turning heads. Cataloged as NGC 6992, these glowing filaments of interstellar shocked gas are part of a larger spherical supernova remnant known as the Cygnus Loop, or the Veil Nebula—expanding debris from a star that exploded over 5,000 years ago. This color digital image of a bit of the Veil has been processed and enhanced to reveal fascinating details in the diaphanous cosmic cloud. Seen from our perspective against a rich Milky Way star field, the Veil Nebula is now known to lie some 1,400 light-years away toward the constellation Cygnus. At that distance, witnesses to the original stellar explosion would have seen a star in the heavens increase in brightness to about −8 magnitude, roughly corresponding to the brightness of the crescent Moon.

Credit & copyright: Steve Mandel, Hidden Valley Observatory

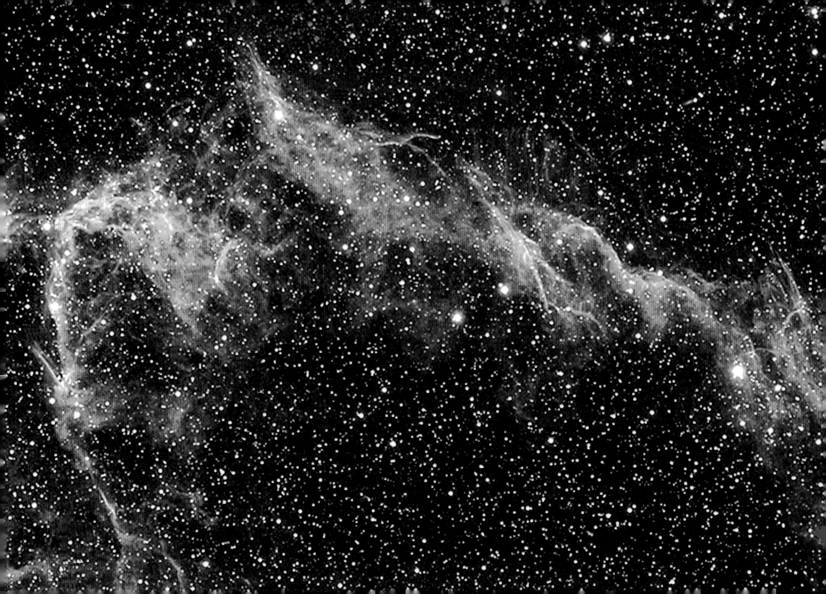

The Long Shadow of the Moon

During the second solar eclipse of 2003, the long shadow of the Moon fell across the continent of Antarctica on November 23. In this view from orbit, based on data from the MODIS instrument on board the Earth-observing Aqua satellite, the Moon's shadow stretches for almost 500 kilometers. Recorded between 2315 and 2320 Universal time (11:15 and 11:20 P.M.), the shadow was cast by a lunar disk silhouetted by the Sun, hanging only about 15 degrees above the Antarctic horizon. Observers within the central dark portion of the oval-shaped shadow could view the totally eclipsed sun. Shadows of mountains and clouds are also visible over Queen Maud Land, Antarctica, with the south pole just beyond the upper right corner of the image.

Credit: Courtesy of J. Descloitres, MODIS Rapid Response Team, GSFC, NASA

Portrait of Jupiter

Every day is a cloudy day on Jupiter, the solar system's reigning gas giant. And swirling cloud tops are all you see in this stunningly detailed true-color image, a portion of a large digital mosaic portrait of Jupiter recorded from the Cassini spacecraft during its Jovian flyby in December 2000. The smallest features visible are about 60 kilometers across. Jupiter's composition is dominated by hydrogen, and the clouds contain hydrogen compounds such as ammonia, hydrogen sulfide, and even water. A truly giant planet, Jupiter's diameter is more than eleven times that of Earth; the smallest storms visible in this portrait are similar in size to large terrestrial hurricanes.

Credit: Cassini Imaging Team, Cassini Project, NASA

November 12

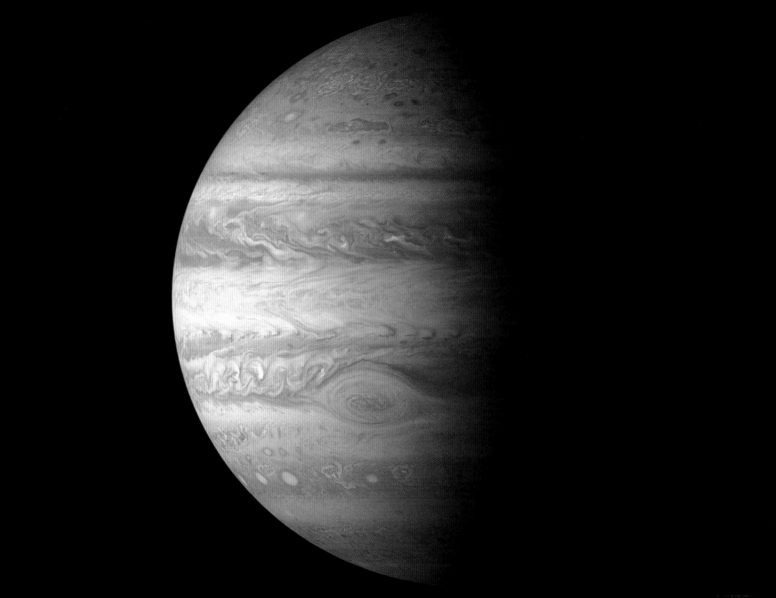

Mountain Surprise

This stunning aerial view actually shows the rugged snow-covered peaks of a Himalayan mountain range in Nepal. The seventh-highest peak on the planet, Dhaulagiri, is the high point on the horizon at the left, while in the foreground lies the southern Tibetan Plateau of China. Contrary to appearances, this picture was not taken from an airliner cruising at 30,000 feet. Instead, it was taken with a 35mm camera and telephoto lens by the Expedition 1 crew aboard the International Space Station—orbiting 200 nautical miles above Earth. The Himalayan mountains were created by crustal plate tectonics on our planet some 70 million years ago, as the Indian plate began a collision with the Eurasian plate. Himalayan uplift continues today, at a rate of a few millimeters per year.

Credit: Expedition 1, ISS, EOL, NASA

November 13

Cratered Cliffs of Ice on Saturn's Tethys

The surface of Saturn's moon Tethys is riddled with icy cliffs and craters. The most detailed images ever taken of Tethys were captured in September 2005 as the robot Cassini spacecraft swooped past the moon of frozen ice. This image, taken from about 32,000 kilometers away, shows a jagged landscape of long cliffs covered with craters. At the bottom of many craters appears some sort of unknown light-colored substance, in contrast to the unknown dark substance apparent at the bottom of Saturn's moon Hyperion. Tethys is one of the larger moons of Saturn, spanning about 1,000 kilometers. Its density indicates a composition almost entirely of water ice. Tethys is thought to have been predominantly liquid sometime in its distant past, creating some of its long ice cliffs as it cracked during freezing.

Credit: Cassini Imaging Team, SSI, JPL, ESA, NASA

November 14

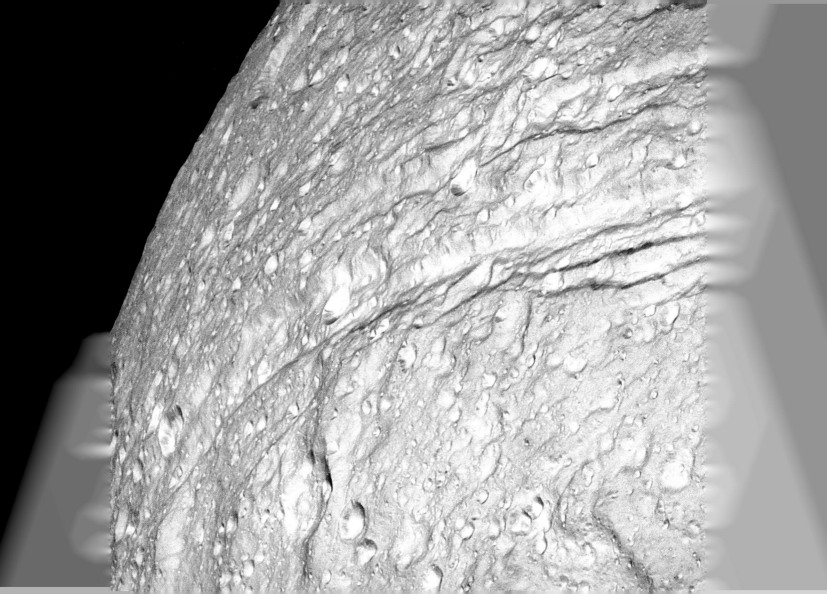

Flare Well, AR 10486

Almost out of view from our fair planet, rotating around the Sun's western edge, giant sunspot region AR 10486 lashed out with another intense solar flare, followed by a large coronal mass ejection (CME), on November 4, 2003, at about 1950 Universal time (7:50 P.M.). The flare itself is seen here at the lower right, in an extreme ultraviolet image from the sun-staring SOHO spacecraft's Extreme ultraviolet Imaging Telescope (EIT) camera. Saturating the EIT camera pixels and detectors on other satellites, this giant X-class flare—the third such historic blast from AR 10486 within a two-week period—was among the most powerful ever recorded since the 1970s. While energetic particle radiation from the flare did cause substantial radio interference on Earth, the associated CME did not subsequently trigger extremely widespread auroras as it glanced off the magnetosphere and did not register a direct hit. This farewell image shows the mighty AR 10486 almost out of view as it rotates toward the Sun's far side.

Credit: SOHO–EIT Consortium, ESA, NASA

November 15

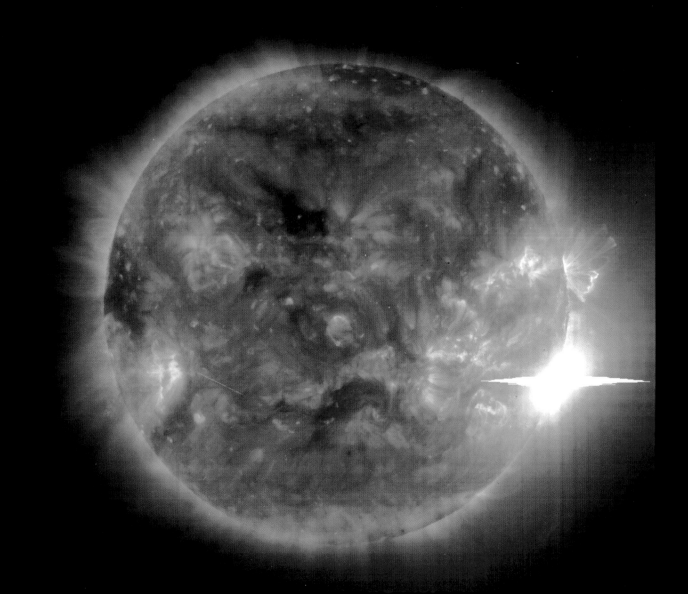

What could cause a star to have such a large spot? Our Sun itself frequently has sunspots, relatively cool, dark magnetic depressions that move across its surface. HD 12545, however, exhibits the largest star spots yet observed. Doppler imaging—the use of slight changes in color caused by the rotation of the star—was employed to create this false-color image. The vertical bar at the right gives a Kelvin temperature scale (related to Celsius but starting at absolute zero). This giant, binary, RS CVn star, also known as XX Trianguli, is visible with binoculars in the constellation Triangulum. The star spot is thought to be caused by large magnetic fields that inhibit hot matter from flowing to the surface.

Credit & copyright: K. Strassmeier (Universität Wien), Coude Feed Telescope, AURA, NOAO, NSF

November 16

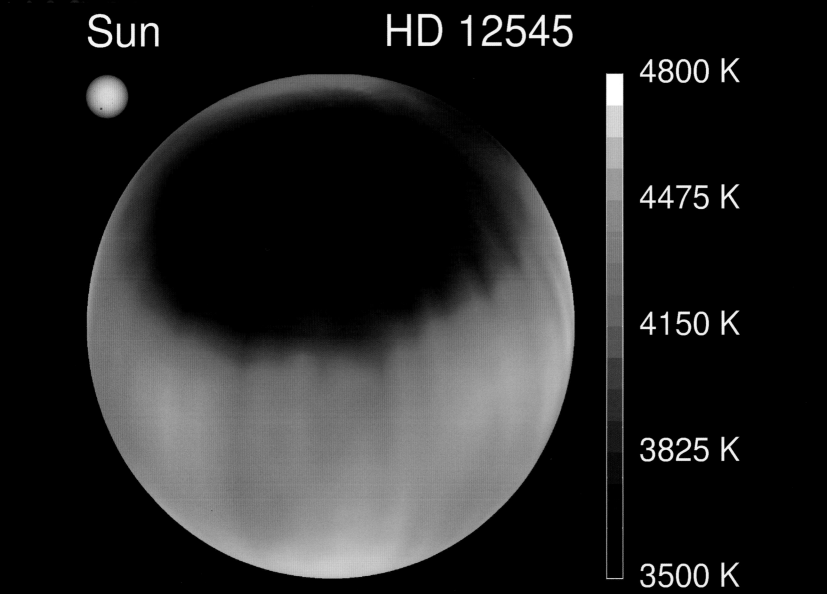

Sun

HD 12545

4800 K

4475 K

4150 K

3825 K

3500 K

The Andromeda Galaxy in Infrared

What is the Andromeda galaxy really like? To find out, astronomers looked at our largest galactic neighbor in a different light: infrared. Astronomers trained the orbiting Spitzer Space Telescope at the Messier monster (M31) for over eighteen hours, creating a mosaic that incorporated 11,000 separate exposures. The result, pictured here, shows M31 in greater infrared detail than ever before. Infrared light in this twenty-four-micron color band is particularly sensitive to dust heated up by stars. Previously undiscovered features, including intricate structure in the spiral arms, a spiral arc near the center, an off-center ring of star formation, and an unusual hole in the galaxy's disk, are all visible. In contrast, the Andromeda Galaxy appears much smoother in visible light and even ultraviolet light. Analyses of this image and comparison to others will likely yield clues not only to the violent past of M31 but to our own Milky Way Galaxy as well.

Credit: K. Gordon (University of Arizona), JPL-Caltech, NASA

November 17

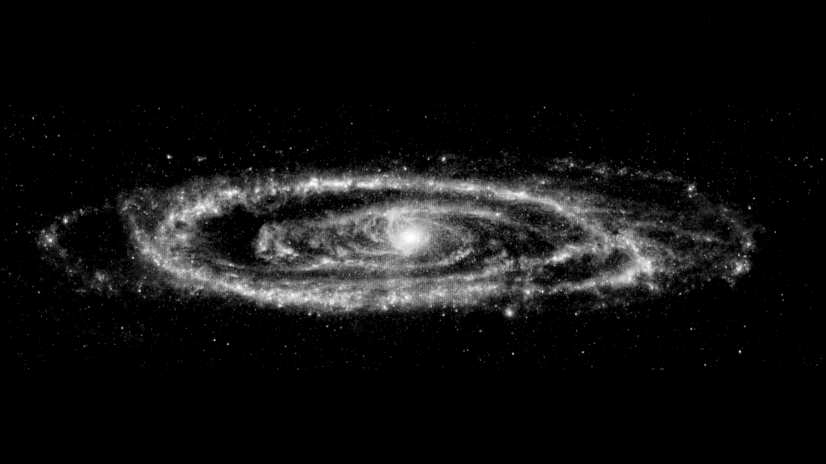

November 18

One of the sharpest views ever of the surface of the Sun, this stunning image shows remarkable and mysterious details near the dark central region of a planet-sized sunspot. The picture was made using the Swedish Solar Telescope on the Canary Island of La Palma. Along with features described as hairs and canals are dark cores visible within the bright filaments that extend into the sunspot, representing previously unknown and unexplored solar phenomena. The filaments' newly revealed dark cores are seen to be thousands of kilometers long, but only about 100 kilometers wide. The ability to resolve objects of this size is a milestone in solar astronomy and was achieved here using sophisticated adaptive optics, digital image stacking, and processing techniques to counter the blurring effect of Earth's atmosphere. At optical wavelengths, these images are sharper than even current space-based solar observatories can produce. Recorded on July 15, 2002, the sunspot shown is the largest of the group of sunspots cataloged as solar active region AR 10030.

Credit: SST, Royal Swedish Academy of Sciences

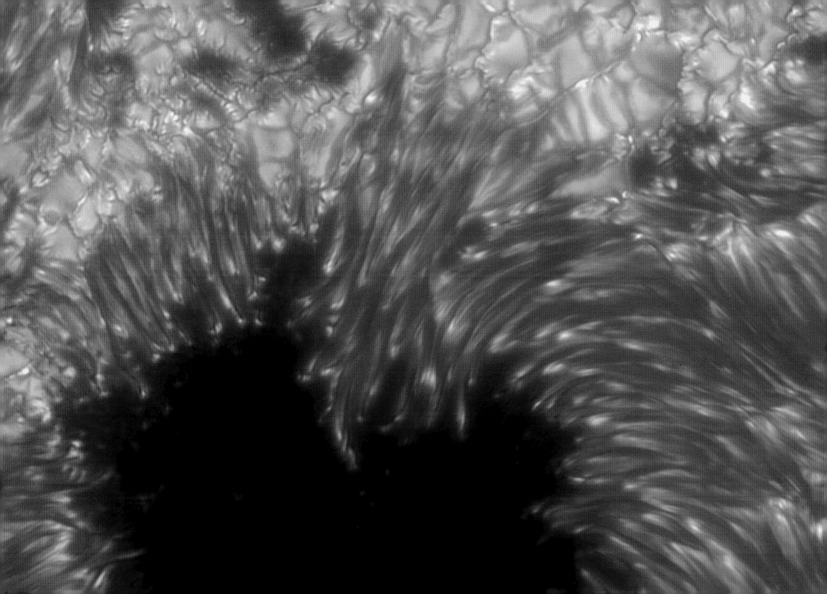

The Cat's Eye Nebula (NGC 6543) is one of the best-known planetary nebulae in the sky. Its haunting symmetries are seen in the very central region of this exquisite false-color picture, processed to reveal the enormous but extremely faint halo of gaseous material, over 3 light-years across, that surrounds the brighter, familiar planetary nebula. Made with data from the Nordic Optical Telescope in the Canary Islands, the composite picture shows emission from nitrogen atoms as red and from oxygen atoms as green and blue shades. Planetary nebulae have long been appreciated as a final phase in the life of a Sun-like star. Only much more recently however, have some planetary nebulae been found to have halos such as this one, likely formed of material shrugged off during earlier, active episodes in the star's evolution. While the planetary nebula phase is thought to last for about 10,000 years, astronomers estimate the age of the outer filamentary portions of this halo to be 50,000 to 90,000 years.

Credit: R. Corradi (Isaac Newton Group), D. Gonçalves (Instituto de Astrofísica de Canarias)

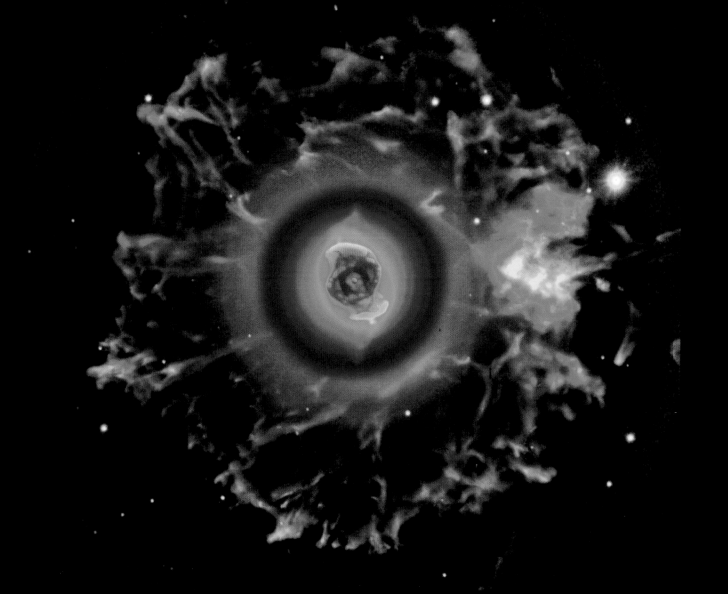

Doomed Phobos

This moon is doomed. Mars, the planet named for the Roman god of war, has two tiny moons, Phobos and Deimos, whose names are derived from the Greek for "fear" and "panic." They may well be captured asteroids originating in the main asteroid belt between Mars and Jupiter or perhaps from even more distant reaches of the solar system. The larger one, Phobos, is indeed seen to be a cratered, asteroid-like object in this splendid color image from the Mars Express spacecraft, recorded at a resolution of about 7 meters per pixel. Phobos orbits extremely close to the Red Planet—about 5,800 kilometers above the surface, compared to 400,000 kilometers between our Moon and Earth—and gravitational tidal forces are dragging it ever closer. In 100 million years or so, it is likely that either Phobos will crash into the surface of Mars or stress caused by the relentless tidal forces will shatter the moon, with its debris then forming a ring around the planet.

Credit: G. Neukum (FU Berlin) et al., Mars Express, DLR, ESA

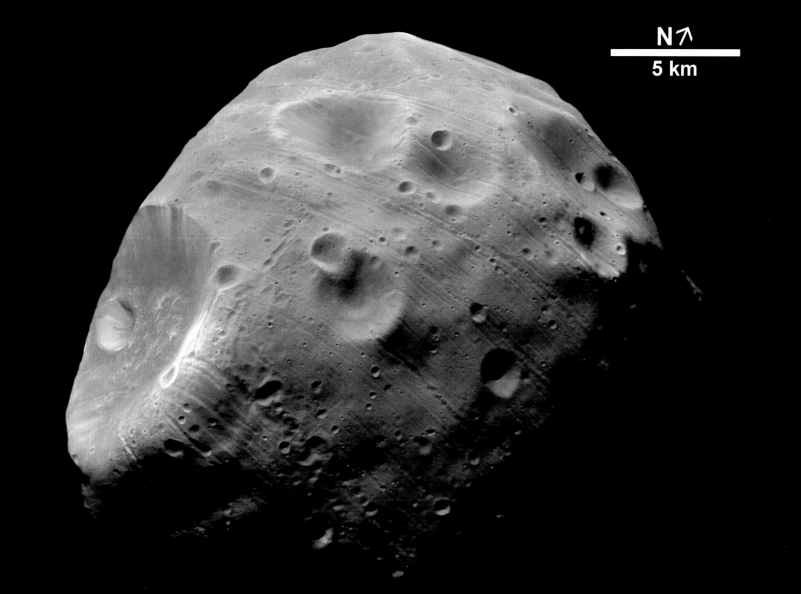

N↗
5 km

Aurora Iowa

Very early one Sunday in May 2005, stars were not the only lights in Iowa skies. The northern lights also shone from the heavens, extending across the midwestern United States and other locations not often graced with auroral displays. The wide-ranging auroral activity was triggered as a coronal mass ejection—an energetic cloud of particles that had blasted outward from the Sun a few days earlier—collided with planet Earth's magnetosphere. Alerted to conditions ripe for aurora, photographer Stan Richard recorded this apparition over Saylorville Lake, near Des Moines. Bright planet Mars in the constellation Aquarius is above the horizon toward the center of the eastward-looking view. While the colorful rays seem to end just above the water, they are actually at altitudes of 100 kilometers or more.

Credit & copyright: Stan Richard (www.nightskyevents.com)

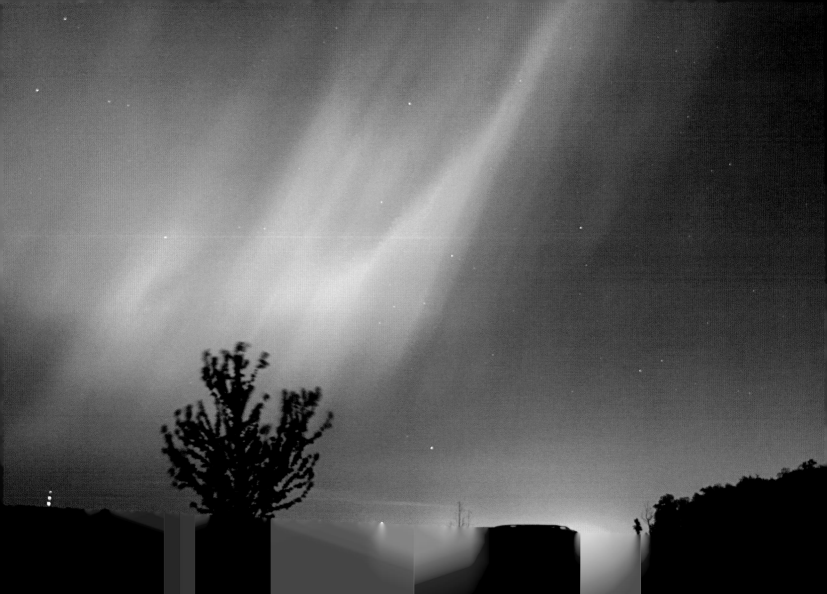

Aurora
Oklahoma

N estled in the central United States, Oklahoma is noted for its gorgeous prairie skies and wide-open spaces, but not for frequent visitations of the northern lights. Still, following intense solar activity, an aurora did come sweeping down the plains on October 29, 2003, and skywatcher Dave Ewoldt managed to catch up with this photogenic apparition 40 miles northwest of Oklahoma City at about 3:00 A.M. Central time. Anticipating aurora sightings, Ewoldt had spent the evening photographing nighttime views of small towns in the area while keeping an eye toward the north. He reports, "I was just about ready to call it a night when the show started. When it did, it was like someone turned on a light switch. I wish it would have lasted longer. . . . [It] seemed like it was completely done in about twenty-five minutes." Watery reflections of the colorful show highlight the foreground in this image, while stars of the Big Dipper and the northern sky shine behind the dazzling auroral display.

Credit & copyright: D. Ewoldt (weatherstock.com)

November 22

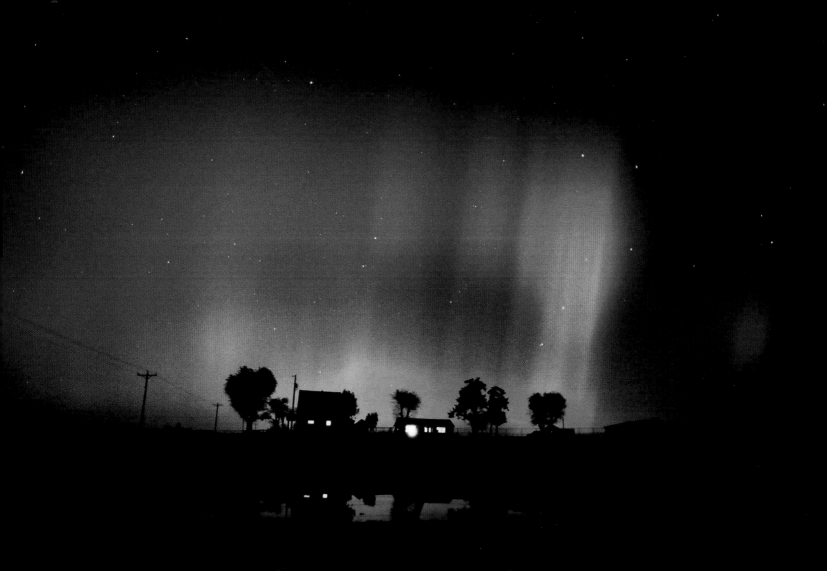

Voyager at 90 AU

Launched in 1977, Voyager 1 (above) was about 12 light-hours, or 90 astronomical units (AU), from the Sun when this illustration was done in 2003, making that spacecraft humanity's most distant ambassador to the cosmos. Well beyond the orbits of the outer planets, Voyager 1 is believed to be entering the realm of deep space beyond the heliosphere, the region dominated by the solar wind and magnetic field. Causing debate, results from instruments still operating gave some indications that the spacecraft could finally be encountering a fluctuating boundary known as the solar wind's termination shock at the edge of the heliosphere. The bubble-shaped termination shock is produced when the wind from the Sun slows dramatically and piles up as it runs into the tenuous interstellar gas. Still farther out, beyond the heliopause (the edge of the darker ellipse), solar wind and interstellar gas begin to mix, while the heliosphere's motion through interstellar space creates a bow shock (at left), analogous to what happens when a boat moves through water. Estimates are that Voyager 1 and the later Voyager 2 (below) each have enough power and fuel to operate until about the year 2020. Both spacecraft continue to coast toward interstellar space at over 3 AU per year.

Credit: Walt Feimer, NASA

November 23

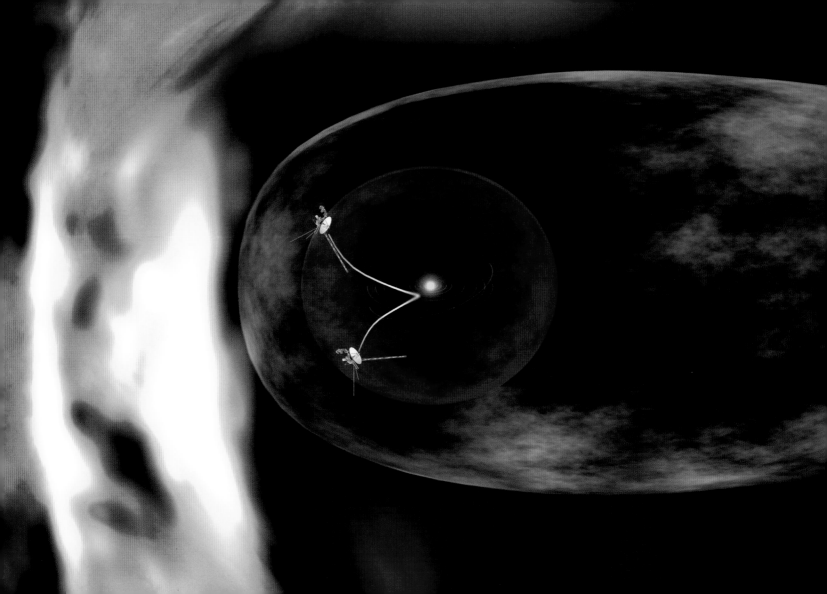

SN 1987A's Cosmic Pearls

In February 1987, light from the brightest stellar explosion seen in modern times—supernova SN 1987A—reached Earth. This Hubble Space Telescope image from the sharp Advanced Camera for Surveys, taken in November 2003, shows the explosion site over sixteen years later. The snapshot indicates that the supernova blast wave continues to affect a pre-existing, 1-light-year-wide ring of material, and the nascent central supernova remnant is still expanding. Like pearls on a cosmic necklace, bright hot spots produced as the blast wave heats material up to millions of degrees began to appear on the ring in the mid-1990s, and astronomers have followed them across the spectrum ever since. Supernova SN 1987A lies in the Large Magellanic Cloud, a neighboring galaxy some 180,000 light-years away. That means the explosive event—the core collapse and detonation of a star about twenty times as massive as the Sun—actually occurred 180,000 years before February 1987.

Credit: P. Challis, R. Kirshner (CfA), & B. Sugerman (STScI), NASA

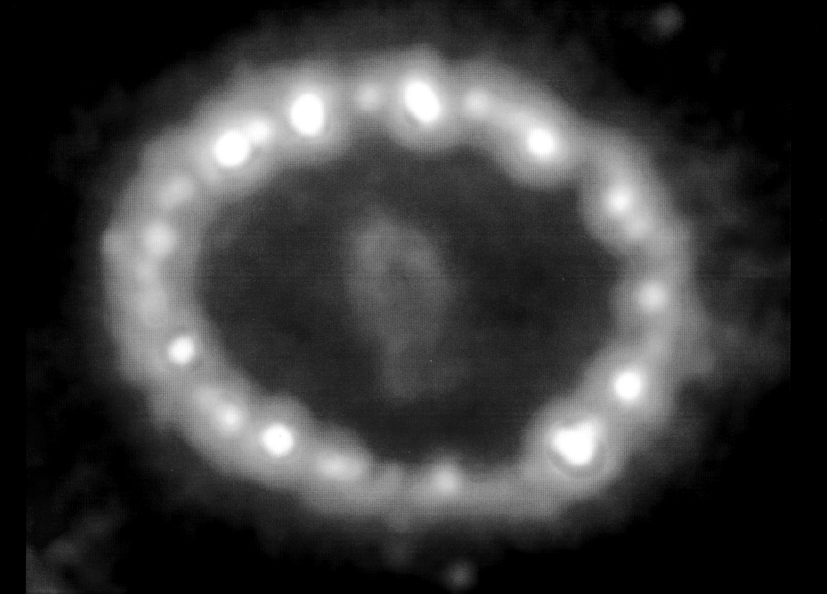

Moon and Sun

This composite image was made from twenty-two separate pictures of the Moon and Sun, all taken from Chisamba, Zambia, during the total phase of the June 21, 2001, solar eclipse. The multiple exposures were digitally processed and combined to simultaneously show a wealth of detail that no single camera exposure or naked-eye observation could easily reveal. Most striking are the incredible flowing streamers of the Sun's outer atmosphere, or solar corona, notoriously difficult to see except when the New Moon blocks the bright solar disk. Features on the darkened near side of the Moon can also be made out, illuminated by sunlight reflected from a full Earth. A giant solar prominence seems to hang just beyond the Moon's eastern (left) edge, while about one diameter farther east of the eclipsed Sun is the relatively faint (4th magnitude) star 1 Geminorum.

Credit & copyright: Fred Espenak (courtesy of www.MrEclipse.com)

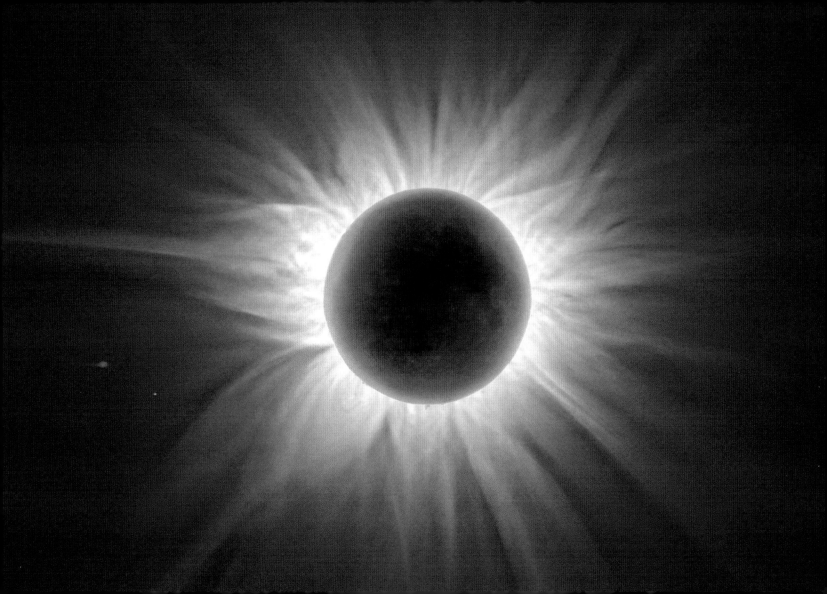

Pandora: A Shepherd Moon of Saturn

What does Saturn's small moon Pandora look like? To help find out, the robot Cassini spacecraft now orbiting Saturn passed about 50,000 kilometers from the unusual moon in early September 2005. One result is the highest-resolution image of Pandora ever taken, shown here in representative colors. Features as small as 300 meters can be discerned on the 80-kilometer-wide Pandora. Craters on this moon seem to be covered over by some sort of material, providing a smoother appearance than spongelike Hyperion, another small Saturnian moon. Curious grooves and ridges also cross the surface of the small moon. Pandora is interesting in part because, along with its companion moon Prometheus, it helps shepherd the particles of Saturn's F ring into a distinct ring.

Credit: Cassini Imaging Team, SSI, JPL, ESA, NASA

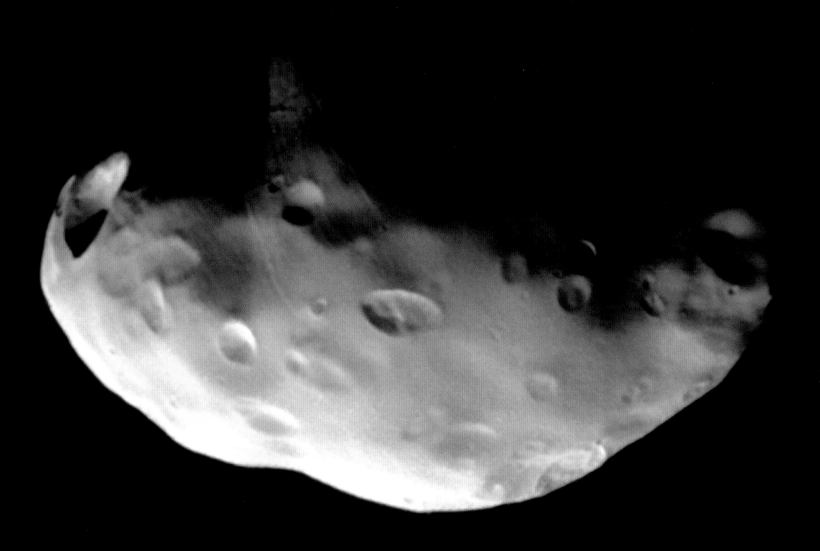

One Small Hop for Surveyor

This panorama of the cratered lunar surface was constructed from images returned by the U.S. Surveyor 6 lander. Surveyor 6 was not the first spacecraft to accomplish a soft landing on the Moon—but it was the first to land and then lift off again. After the spacecraft touched down close to the center of the Moon's near side in November 1967, NASA controllers commanded it to hop. Briefly firing its rocket engine and lifting itself some 4 meters above the surface, Surveyor 6 moved about 2.5 meters to one side before setting down again. The hopping success of Surveyor 6 essentially marked the completion of the Surveyor series' main mission—to determine if the lunar terrain was safe for the planned Apollo landings.

Credit: Surveyor Project, NASA

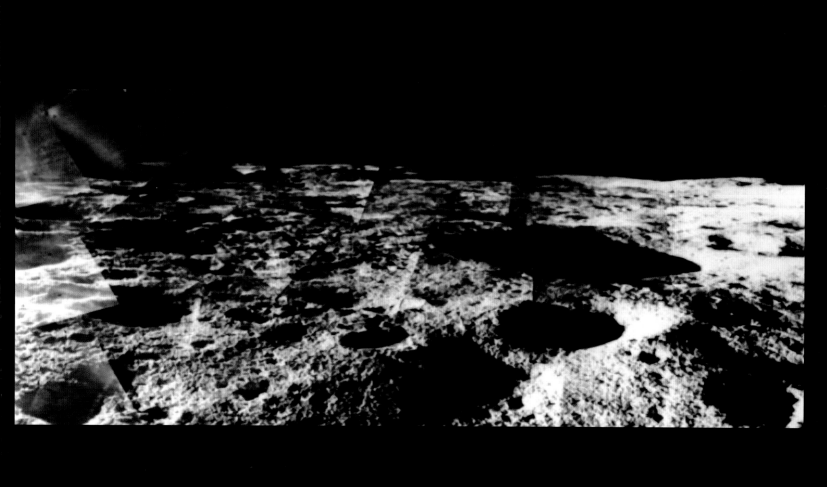

Leonids and Leica

This lovely view from northern Spain, at Cape Creus on the easternmost point of the Iberian Peninsula, looks out across the Mediterranean and up into the stream of the 2002 Leonid meteor shower. The vertical picture is a composite of thirty separate one-minute exposures taken through a fish-eye lens close to the Leonids' first peak, at about 400 Universal time (4:00 A.M.) on November 19. Over seventy Leonid meteors are visible here, some seen nearly head-on, with bright Jupiter positioned just to the right of the shower's radiant in Leo. Perched on the moonlit rocks at the bottom right, the photographers' dog seems to be watching the ongoing celestial display and adds a surreal visual element to the scene. What's the dog's name? Leica, of course.

Credit & copyright: Juan Carlos Casado & Isabel Graboleda

November 28

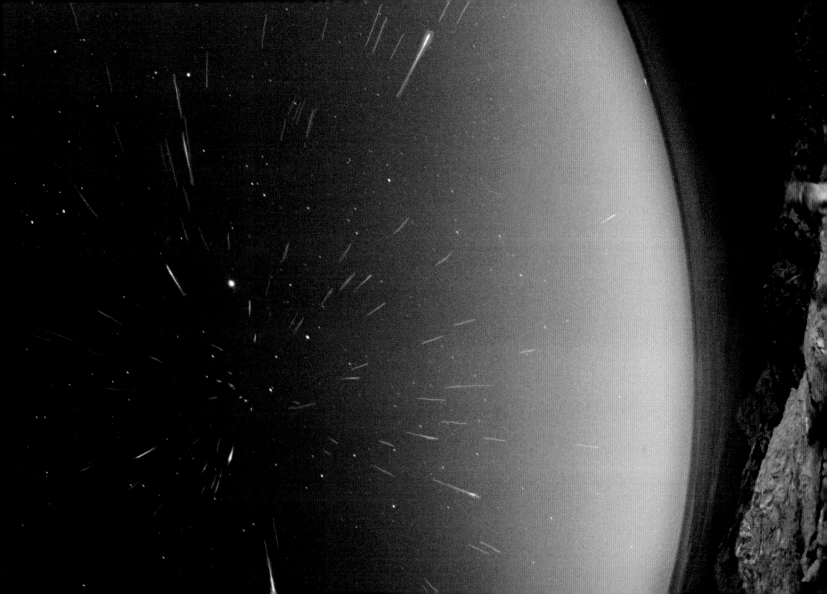

Earth's Magnetic Field

Why does Earth have a magnetic field? The electrical conductivity of the molten plasma of Earth's core should be able to damp the current magnetic field in only thousands of years. Yet our 5-billion-year-old Earth clearly causes magnets to point to (defined) north. The mystery is still being studied but recently has been thought related to motions in the planet's liquid outer core. Specifically, as portions of the outer core cool and fall inward, oceans of the liquid iron-rich magma rise outward, forced into a helical motion by the spin of Earth. This motion, many geologists now believe, regenerates Earth's magnetism. In this vertical picture (top is at left), a computer simulation shows the resulting magnetic field lines out to two Earth radii, with blue lines directed inward and yellow lines directed outward.

Credit & copyright: Gary A. Glatzmaier (UCSC)

Galileo's Europa

Launched in 1989 and looping through the Jovian system since late 1995, NASA's Galileo spacecraft finally came to the end of its voyage when it plunged directly into Jupiter on September 21, 2003, at about 30 miles per second. Its components were vaporized in the gas giant's outer atmosphere. While Galileo's long voyage of exploration resulted in a spectacular scientific legacy, the spacecraft's ultimate fate is related to perhaps its most tantalizing discovery—strong evidence for a liquid ocean beneath the frozen surface of Jupiter's moon Europa. As Galileo ran low on fuel for maneuvers, an intentional collision with Jupiter was arranged to prevent any unintentional future collision with Europa—and the possibility of contaminating the Jovian moon with microbes from Earth hardy enough to survive in interplanetary space. Color image data from the Galileo mission recorded between 1995 and 1998 was used to create this depiction of Europa's cracked and icy surface. The inset enlarges dark reddish, disrupted regions at lower right dubbed Thera and Thrace.

Credit: Galileo Project, University of Arizona, JPL, NASA

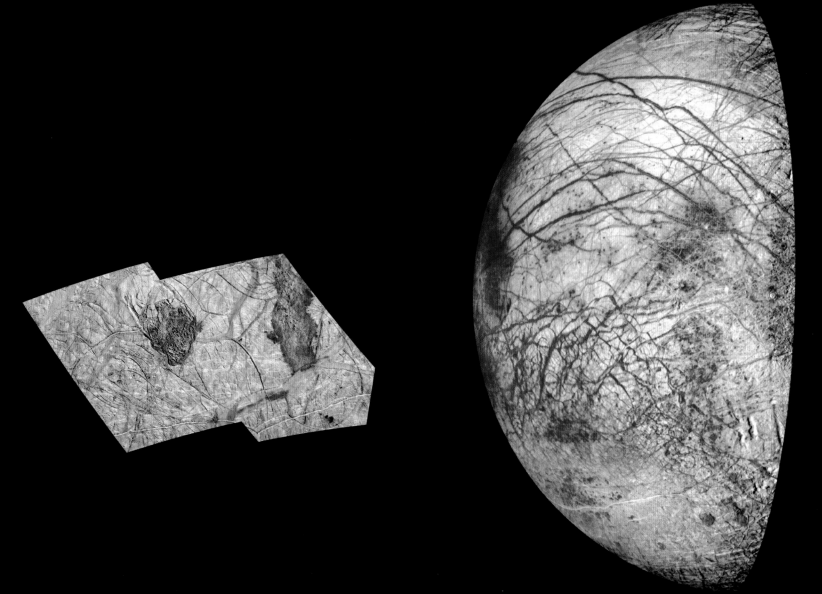

Andromeda's
Core

The center of the Andromeda Galaxy is beautiful but strange. Andromeda, indexed as M31, is so close to our own Milky Way that it gives a unique perspective into the composition of galaxies by allowing us to see into its core. Billions of stars swarm around a center that has two nuclei and likely houses a supermassive black hole over 5 million times the mass of our Sun. M31 is about 3 million light-years away and visible with the unaided eye in the direction of the constellation Andromeda, the princess. Pictured here, dark knots of dust are seen superposed on the inner 10,000 light-years of M31's core. The brighter stars are foreground stars located in the Milky Way Galaxy.

Credit & copyright: Robert Gendler

December 1

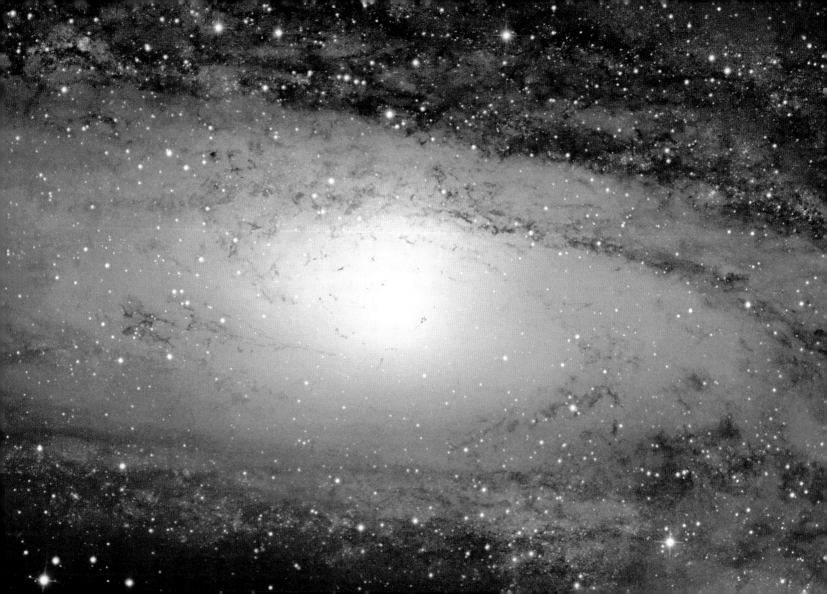

Prometheus and the Rings of Saturn

In Greek mythology, Prometheus was known for stealing fire from the gods. Ironically, in a story for more modern times, Prometheus may also become known for theft, but this time it is icy particles from Saturn's rings. This eerie close-up from the Cassini spacecraft shows the 100-kilometer-long Saturnian moon Prometheus orbiting near the inner edge of that planet's F ring. The dramatic view clearly resolves the potato-shaped moon and multiple strands of the narrow F ring. It also reveals a faint strand of material connecting Prometheus with the rings. One possibility is that the tiny moon's gravity is indeed drawing off particles from the rings and influencing the formation of the gaps and kinks seen in the ring structure.

Credit: Cassini Imaging Team, SSI, JPL, ESA, NASA

December 2

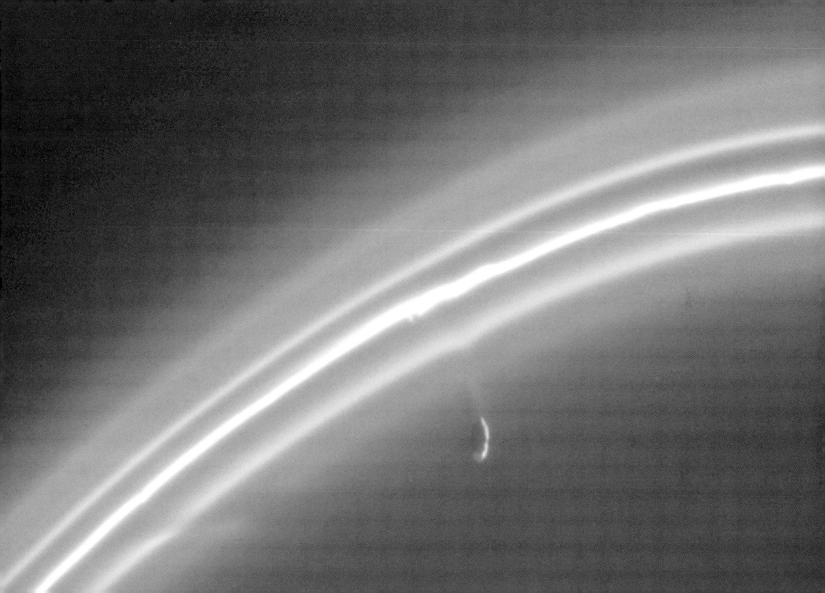

The Arms of NGC 7424

The grand, winding arms are almost mesmerizing in this face-on view of NGC 7424, a spiral galaxy with a prominent central bar. About 40 million light-years distant in the headlong constellation Grus, this island universe is also about 100,000 light-years across, making it remarkably similar to our own Milky Way. Following along the winding arms, we can spot many bright bluish clusters of massive young stars. The star clusters themselves are several hundred light-years in diameter. And while massive stars are born in the arms of NGC 7424, they also die there. Notably, this galaxy was home to a powerful stellar explosion, supernova SN 2001ig, which faded before this deep European Southern Observatory image was recorded.

Credit: VIMOS/VLT, European Southern Observatory

December 3

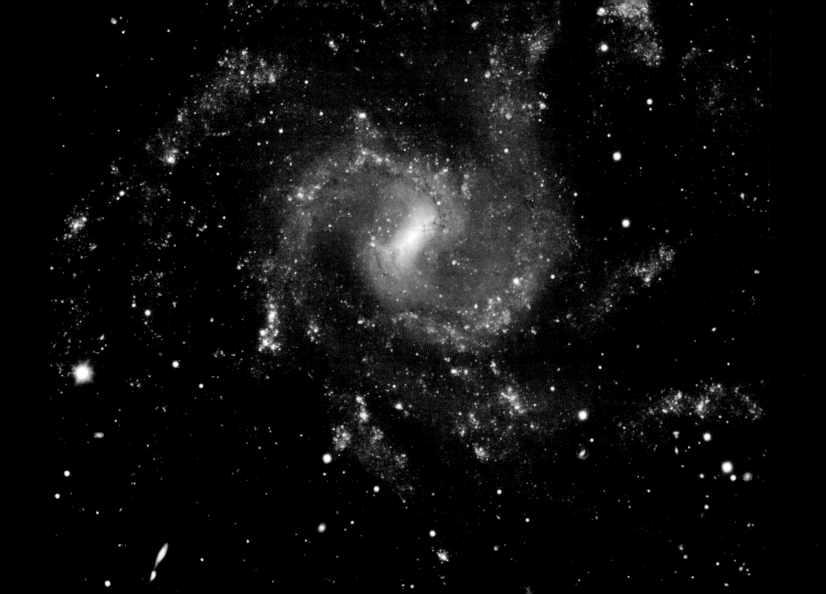

In November 2003, the Sun, the Moon, and two photographers all lined up in Antarctica during a total eclipse of the Sun. Even given the extreme location, a group of enthusiastic eclipse chasers ventured near the bottom of the world to experience the surreal momentary disappearance of the Sun behind the Moon. One of the treasures collected was this picture—four separate images digitally combined to realistically simulate how the adaptive human eye saw the eclipse. As the image was taken, the Moon and the Sun both peeked over an Antarctic ridge. In the sudden darkness, the magnificent corona of the Sun became visible around the Moon. Quite by accident, a photographer was caught in one of the images checking his video camera. Visible to his left are an equipment bag and a collapsible chair.

Credit & copyright: Fred Bruenjes (moonglow.net)

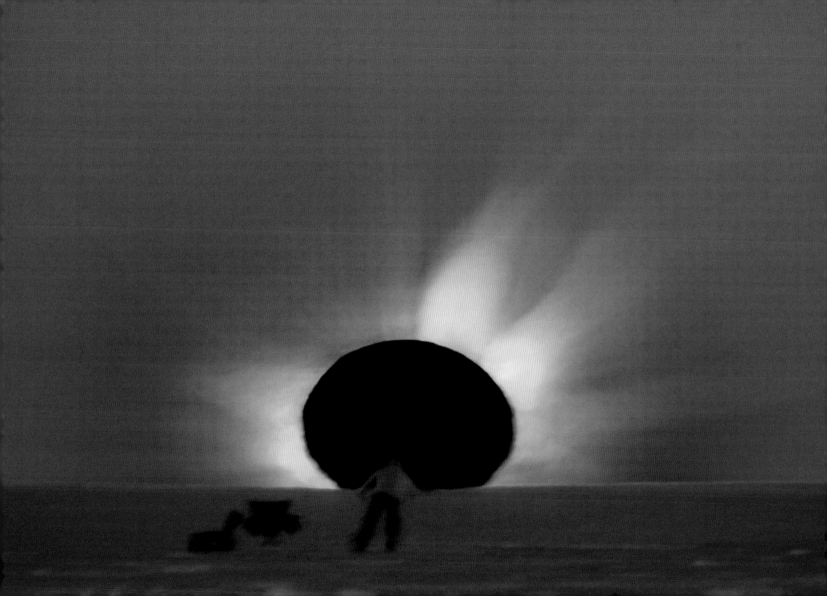

In the Center of the Heart Nebula

What powers the Heart Nebula? The large emission nebula, dubbed IC 1805, looks, in its entirety, like a human heart. The nebula glows brightly in red light emitted by its most prominent element: hydrogen. The red glow and the larger shape are all created by a small group of stars near the nebula's center. Many of these stars are shown in this close-up, spanning about 30 light-years, that was taken by the Canada-France-Hawaii Telescope in Hawaii. This open cluster contains a few bright stars almost fifty times the mass of our Sun, many dim stars only a fraction of the Sun's mass, and an absent micro-quasar that was expelled millions of years ago. The Heart Nebula is located about 7,500 light-years away toward the constellation Cassiopeia.

Credit & copyright: Canada-France-Hawaii Telescope/J. C. Cuillandre/Coelum

December 5

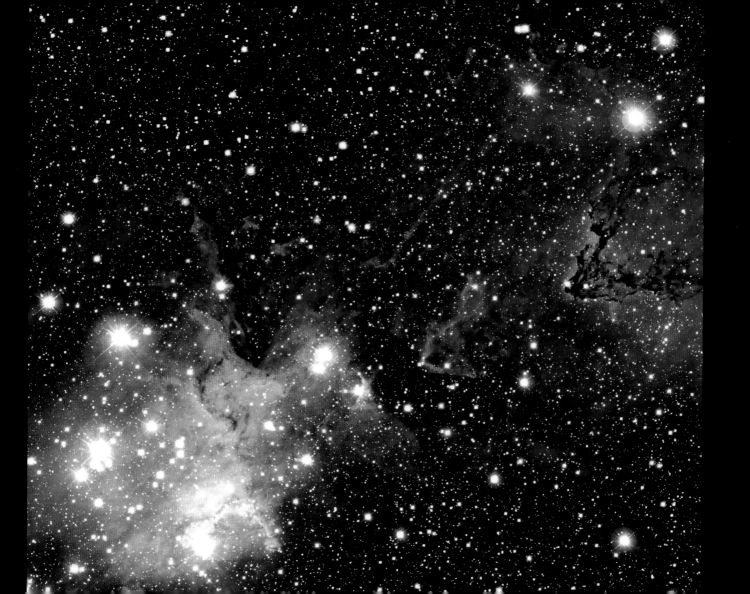

Kemble's Cascade

A picturesque chain of unrelated stars is visible with strong binoculars in the direction of the constellation Camelopardalis. Known as Kemble's Cascade, the asterism (toward the upper right in this pretty star field) contains about twenty stars almost in a row, stretching over five times the width of a Full Moon. Made popular by astronomy enthusiast Lucian Kemble, these stars appear as a string only from our direction in the Milky Way Galaxy. This photograph of Kemble's Cascade was made with a small telescope in New Mexico. The bright object near the bottom left of the cascade is the relatively compact open cluster of stars known as NGC 1502.

Credit & copyright: Walter MacDonald

December 6

Mimas, Rings, and Shadows

Caught in sunlight, the icy moon Mimas (at right) shines above a broad shadow across gas giant Saturn in a remarkable image from the Cassini spacecraft. The broad shadow is cast by Saturn's dense B ring; intriguing threadlike shadows from the planet's inner C ring are arrayed below. While the B and C rings are otherwise not visible here, the very narrow outer F ring lies toward the bottom of the image, as well as a section of the partly transparent A ring and its 300-kilometer-wide Encke gap crisscrossing the ring shadows. Sunlight streaming through the much larger Cassini gap that separates the A and B rings is responsible for the bright band seen above Mimas. The Cassini gap itself is just off the bottom of this cropped view. Orbiting well beyond Saturn's F ring, Mimas is a mere 400 kilometers in diameter.

Credit: Cassini Imaging Team, SSI, JPL, ESA, NASA

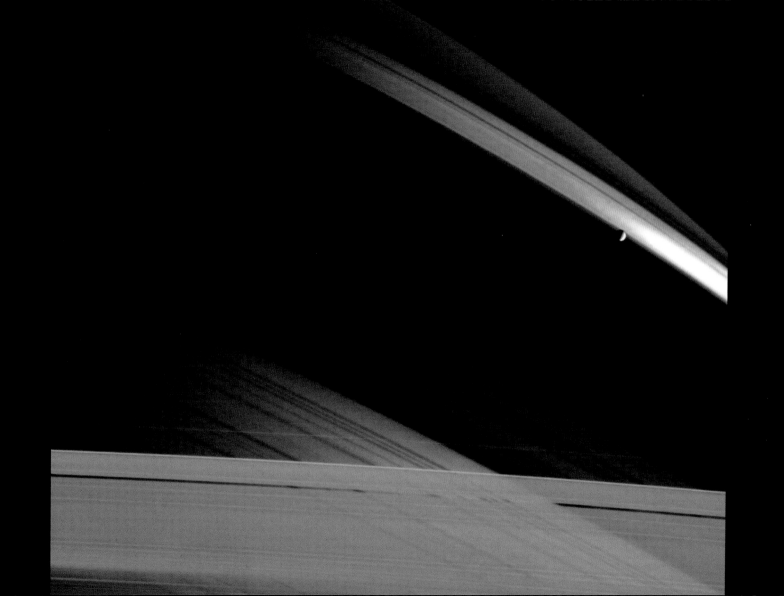

Portrait of
Saturn

This high-resolution picture of big, beautiful, ringed Saturn was pieced together from 126 images recorded by the Cassini spacecraft on October 6, 2004, at a distance of only 6 million kilometers. The image represents the largest, most detailed portrait of the planet and rings. Along with shadows of the rings cast across the face of the gas giant, Cassini's cameras also view Saturn's nightside and the shadows it cast across the rings.

Credit: Cassini Imaging Team

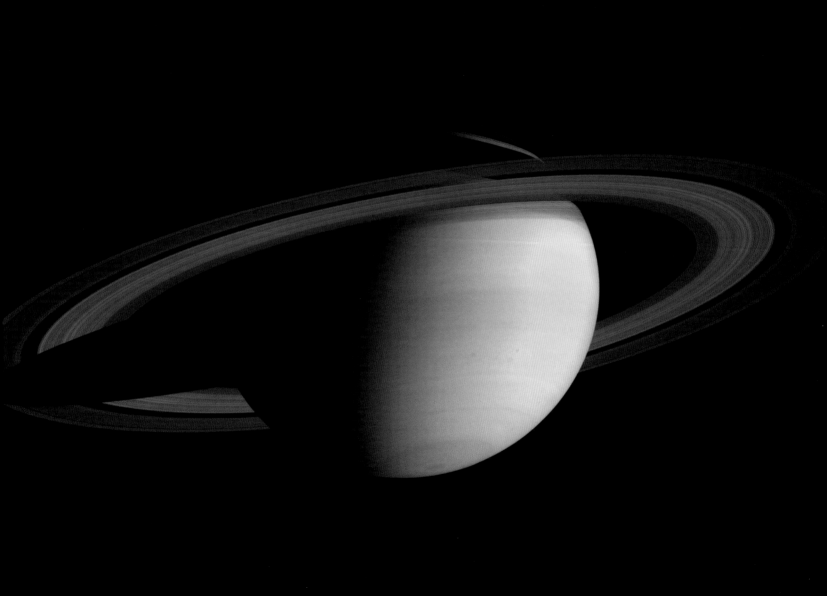

Dust Devils on Mars

What caused the streaks in this Martian crater? Since the image shows them occurring both inside and outside the crater, they were surely formed after the impact that created it. Newly formed trails like these presented researchers with a tantalizing Martian mystery, but they have now been identified as likely the work of miniature wind vortices known to occur on the Red Planet—Martian dust devils. Another example of wind processes on an active Mars, dust devils had been detected passing near the Viking and Mars Pathfinder landers. Such spinning columns of rising air heated by the warm surface are common in dry and desert areas on planet Earth. Typically lasting only a few minutes, they become visible as they pick up loose dust. On Mars, dust devils can be up to 8 kilometers high and leave dark trails as they disturb the bright, reflective surface dust.

Credit: Malin Space Science Systems, MGS, JPL, NASA

Vista inside
Gusev Crater

What is the geologic history of Mars? To help find out, the robot Spirit rover explored the terrain en route to the top of Husband Hill and took pictures along the way. Earthbound team members later combined images from one camera with colors from another to create this semi-realistic vista from near the summit of the rugged hill. Many rock faces were imaged and probed during Spirit's journey to the hilltop. This image captures not only a high and distant Mars inside Gusev Crater, but also more of the refrigerator-sized Spirit rover than other similar vistas. Visible technology includes a wide array of energy-absorbing solar panels, a sundial, and the circular high-gain communications antenna.

Credit: Marco Di Lorenzo et al., courtesy of Aviation Week, Mars Exploration Rover Mission, Cornell, JPL, NASA

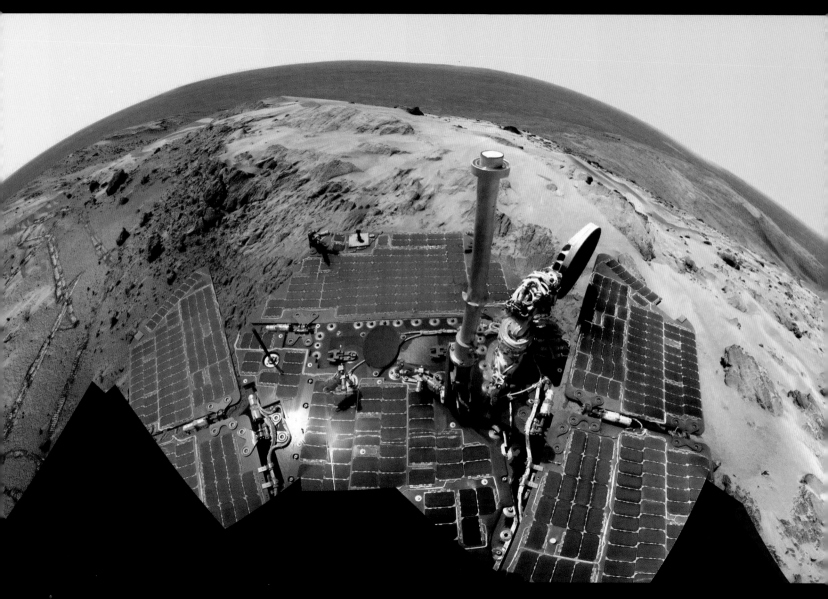

Where is the best place on Earth to find meteorites? Although meteors fall all over the world, they usually just sink to the bottom of an ocean, are buried by shifting terrain, or are easily confused with terrestrial rocks. At the bottom of the planet, however, in East Antarctica, dark rocks are easy to spot on the huge sheets of pure and barren blue ice. Small teams of snowmobiling explorers so far have found thousands of these rocks, which have a high probability of being true meteorites—likely pieces of another world. An explosion or impact might have catapulted them from the Moon, Mars, or even an asteroid, potentially providing valuable information about these distant worlds and our early solar system. Pictured here, ice trekkers search a field 25 kilometers in front of Otway Massif in the Transantarctic Mountain Range during the Antarctic summer of 1995–96.

Credit & copyright: Ralph P. Harvey (CWRU), Antarctic Search for Meteorites Program, NASA, NSF

December 11

The Boomerang Nebula in Polarized Light

How did the Boomerang Nebula form? The symmetrical cloud dubbed the Boomerang appears to have been created by a high-speed wind of gas and dust blowing from an aging central star at speeds of nearly 600,000 kilometers per hour. What confines the wind remains a mystery—it may be a central disk of dense gas or a magnetic field. The rapid expansion itself, however, has cooled molecules in the nebular gas to about 1 degree above absolute zero—colder than even the cosmic background radiation—making it the coldest known region in the distant universe. Shining with light from the central star reflected by dust, the Boomerang Nebula is believed to be a star or stellar system evolving toward the planetary nebula phase. To help better understand its origin, astronomers are studying this image, which was taken in polarized light and color-coded by an angular direction associated with the polarization. Different progenitor scenarios create varying amounts and patterns of polarized light. This image was taken by the Hubble Space Telescope's Advanced Camera for Surveys. The Boomerang Nebula spans about 1 light-year and lies about 5,000 light-years away in the direction of the constellation Centaurus.

Credit: Hubble Heritage Team, J. Biretta (STScI) et al. (STScI/AURA), ESA, NASA

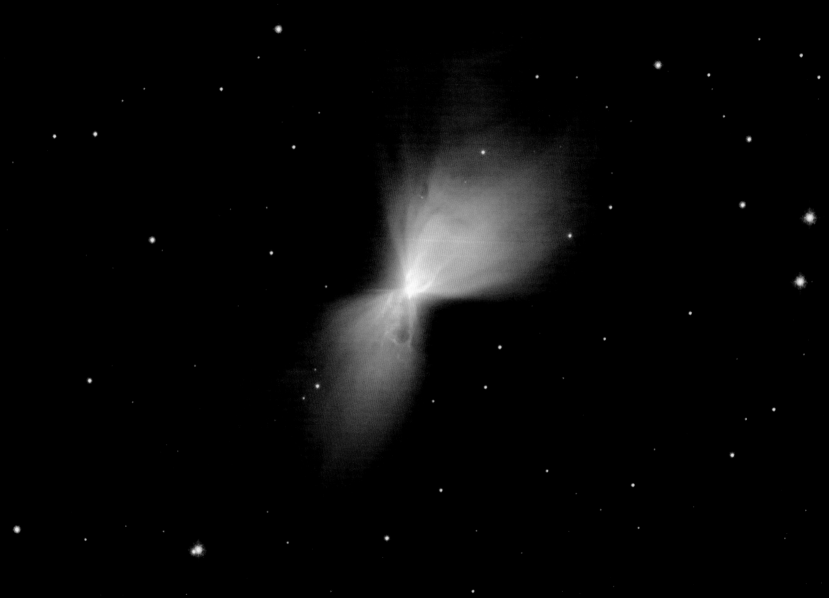

Galactic Collision in Cluster Abell 1185

What is a guitar doing in a cluster of galaxies? Colliding. Clusters are sometimes packed so tight that the galaxies composing them collide. A prominent example occurs on the left of this image of the rich cluster of galaxies known as Abell 1185. There, at least two galaxies, cataloged together as Arp 105 and dubbed "the Guitar" for their familiar appearance, are pulling each other apart gravitationally. Most of Abell 1185's hundreds of galaxies are elliptical, although spiral, lenticular, and irregular ones are all clearly evident. Many of the spots on this image are entire galaxies themselves, containing billions of stars, but some spots are actually foreground stars in our own Milky Way Galaxy. Recent observations of Abell 1185 have found unusual globular clusters of stars that appear to belong only to the galactic cluster and not to any individual galaxy. Abell 1185 spans about 1 million light-years and lies 400 million light-years distant.

Credit & copyright: Canada-France-Hawaii Telescope / J. C. Cuillandre / Coelum

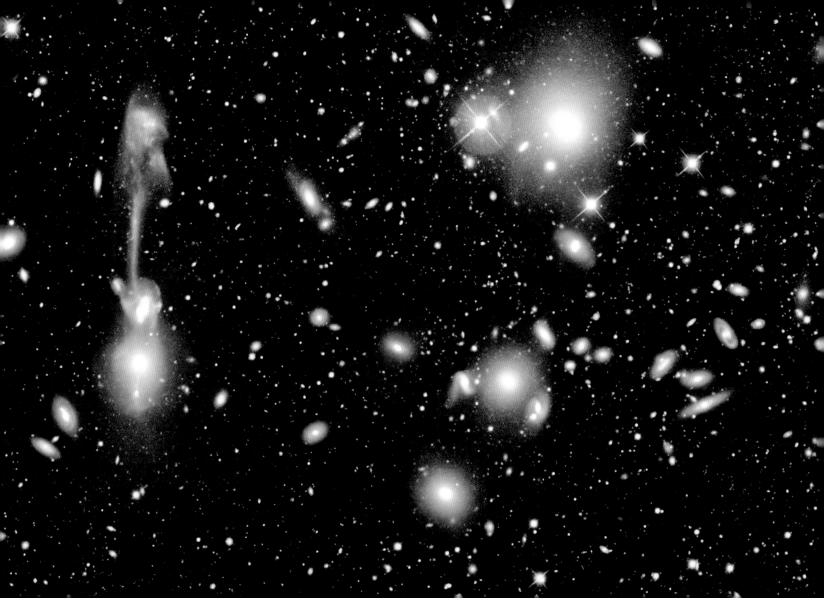

The Flight
of Helios

An example of solar-powered air travel, NASA's Helios aircraft flew almost 100 years after the Wright brothers' historic flight on December 17, 1903. Pictured here at 10,000 feet in skies northwest of Kauai, Hawaii, in August 2001, the remotely piloted Helios is traveling at about 25 miles per hour. Essentially an ultralight flying wing with fourteen electric motors, the aircraft was built by AeroVironment Inc. Covered with solar cells, Helios had an impressive 247-foot-wide wing—exceeding the wingspan and even the overall length of a Boeing 747 jet. Climbing during daylight hours, the prototype aircraft ultimately reached an altitude just short of 100,000 feet, breaking records for non-rocket-powered flight. Helios was intended as a technology demonstrator, but in the extremely thin air 100,000 feet above Earth's surface, the flight of Helios also approached conditions for winged flight in the atmosphere of Mars.

Credit: Carla Thomas, courtesy of DFRC, NASA

The Helix Nebula from Blanco and Hubble

How did a star create the Helix Nebula? The shapes of planetary nebula like the Helix are important because they likely hold clues to how stars like the Sun end their lives. Observations by the orbiting Hubble Space Telescope and the 4-meter Blanco Telescope in Chile, however, have shown that this nebula is not really a simple helix. Rather, it incorporates two nearly perpendicular disks, as well as arcs, shocks, and other features that are not well understood. How a single Sun-like star created such beautiful, geometric complexity is a topic of research. The Helix, the nearest planetary nebula to Earth, lies only about 700 light-years away toward the constellation Aquarius and spans about 3 light-years.

Credit: C. R. O'Dell (Vanderbilt) et al., ESA, NASA

December 15

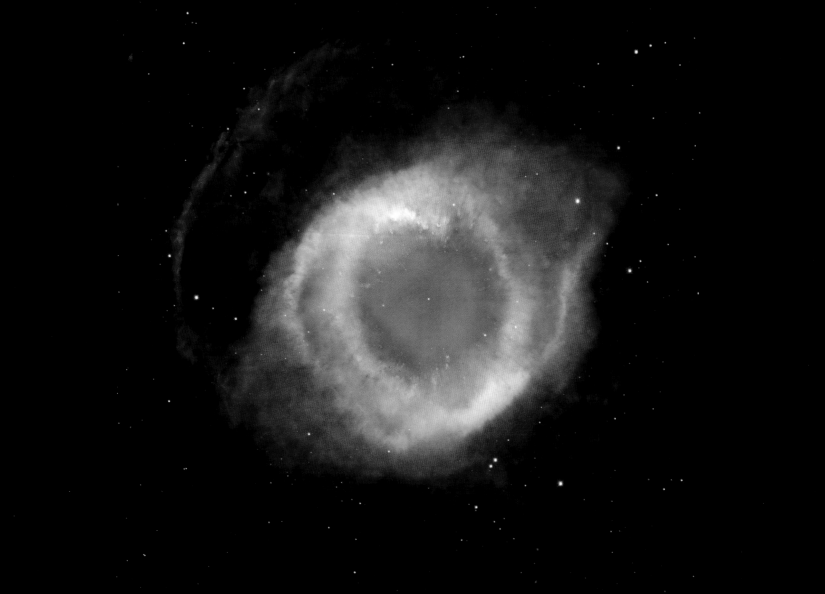

Retrograde Mars

Why would Mars appear to move backward? Most of the time, the apparent motion of Mars in Earth's sky is in one direction, slow but steady in front of the far distant stars. About every two years, however, Earth passes Mars as they orbit around the Sun. During the pass that occurred in August 2003, Mars loomed particularly large and bright. Also during this time, Mars seemed to move backward in the sky, a phenomenon called retrograde motion. Pictured here is a series of images digitally stacked so that all of the background stars' images coincide; Mars appears to trace out a loop in the sky. At the top of the loop, Earth passed Mars and the retrograde motion was the highest. Retrograde motion can also be seen with other planets in the solar system. In fact, by coincidence, the dotted line to the right of center is Uranus doing the same thing.

Credit & copyright: Tunç Tezel

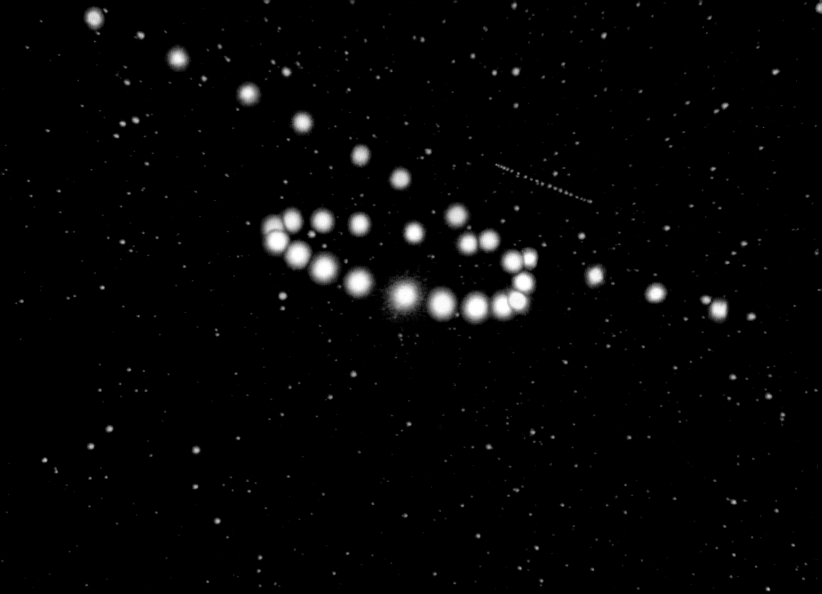

A Lenticular Cloud over Hawaii

Can a cloud do this? Actually, this picture shows several clouds all stacked up into one striking lenticular cloud. Normally, air moves much more horizontally than it does vertically. Sometimes, however, such as when wind comes off a mountain or a hill, relatively strong vertical oscillations take place as the air stabilizes. The dry air at the top of an oscillation may be quite stratified in moisture content, and therefore it forms clouds at each layer where the air saturates with moisture. The result can be a lenticular cloud with a strongly layered appearance. The picture was taken near Mauna Kea, Hawaii.

Credit & copyright: Peter Michaud (Gemini Observatory)

Filaments across the Sun

These unusually long filaments crossing the Sun are actually relatively cool and dark prominences of solar plasma held up by the Sun's magnetic field but seen against the bright solar disk. It would take twenty Earths, set end to end, to match the length of one of them. Such filaments typically last a few weeks. Also visible are bright, hot regions called plages and the carpet of hundreds of granules that provide the Sun's texture. This image was taken through a small telescope in a very specific red color of light emitted primarily by hydrogen.

Credit & copyright: Greg Piepol (www.sungazer.net)

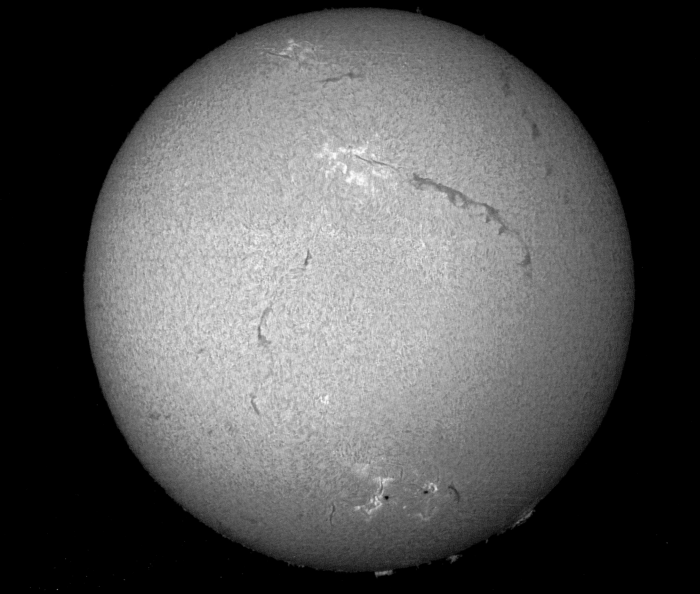

Colorful Clouds
of Orion

This stunning, color-enhanced mosaic details the region surrounding the Great Nebula in Orion. As seen here, the clouds of Orion are dominated by the reddish emission nebula M42 at right, with blue reflection nebulae, including NGC 1977, at left. Strewn with dust lanes and dark nebulae, the striking cosmic apparitions surrounding Orion's stellar nurseries are about 1,500 light-years away and are themselves several light-years across. Located at the edge of a giant molecular cloud complex spanning hundreds of light-years, these nebulae represent only a small, but very visible, fraction of this region's wealth of interstellar material. Astronomers have also identified what appear to be numerous infant solar systems within these colorful clouds.

Credit & copyright: Robert Gendler

December 19

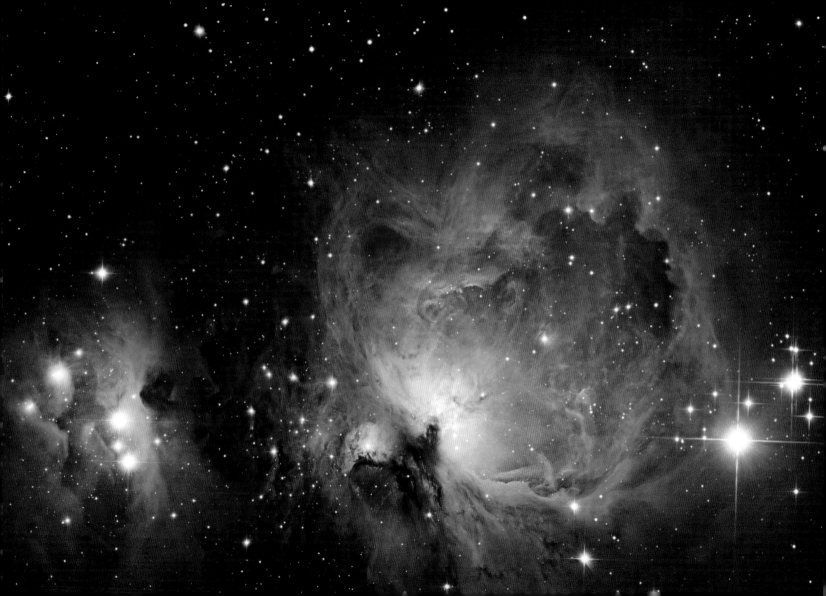

Eclipse over Acacia

On June 21, 2001, astronomer Fred Espenak recorded the series of exposures used to construct this dramatic composite image. The sequence follows the first total solar eclipse of the third millennium from start to finish above a thorny acacia tree near Chisamba, Zambia. The Sun moves down and to the left in this vertical picture, with the total eclipse phase close to the center. During the eclipse, the Moon's shadow tracked for 12,000 kilometers across southern Africa and Madagascar. Observers directly in the shadow's path caught two to five minutes of the eclipse at its total phase.

Credit & copyright: Fred Espenak (courtesy of www.MrEclipse.com)

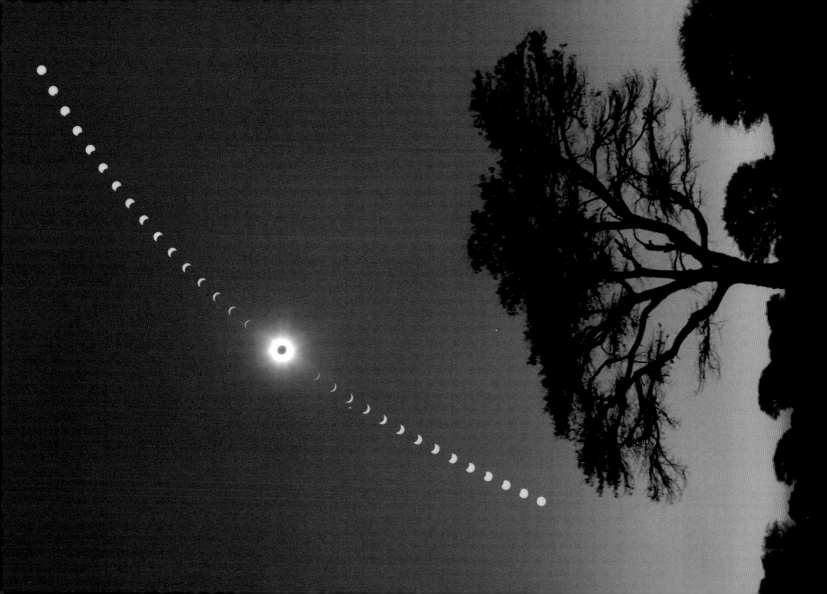

Open clusters of stars can be near or far, young or old, diffuse or compact. Open clusters may contain anywhere from 100 to 10,000 stars, all of which formed at almost the same time. Bright blue stars frequently distinguish younger open clusters. M35, pictured at the upper left, is relatively close at 2,800 light-years distant, relatively young at 150 million years old, and relatively diffuse, with about 2,500 stars spread out over a volume 30 light-years across. An older and more compact open cluster, NGC 2158, can be seen at the lower right. NGC 2158 is four times more distant than M35, over ten times older, and much more compact, containing many more stars in roughly the same volume of space. NGC 2158's bright blue stars have self-destructed, leaving cluster light to be dominated by older and yellower stars. Both clusters are visible toward the constellation Gemini—M35 with binoculars and NGC 2158 with a small telescope.

Credit & copyright: Canada-France-Hawaii Telescope / J. C. Cuillandre / Coelum

December 21

Arp 81: 100 Million Years Later

From planet Earth, we view this strongly interacting pair of galaxies, cataloged as Arp 81, as they were only about 100 million years after their mutual closest approach. The havoc wreaked by gravity during their ominous encounter is detailed in this color composite image from the Hubble Space Telescope, showing twisted streams of gas and dust, a chaos of massive star formation, and a tidal tail stretching for 200,000 light-years or so as it sweeps behind the cosmic wreckage. Also known as NGC 6622 (left) and NGC 6621, the galaxies are roughly equal in size but are destined to merge into one large galaxy in the distant future, making repeated approaches until they finally coalesce. Located in the constellation Draco, the galaxies are 280 million light-years away. The dark vertical band that seems to run through NGC 6621's location is an image flaw.

Credit: W. Keel (University of Alabama), K. Borne (George Mason University), NASA

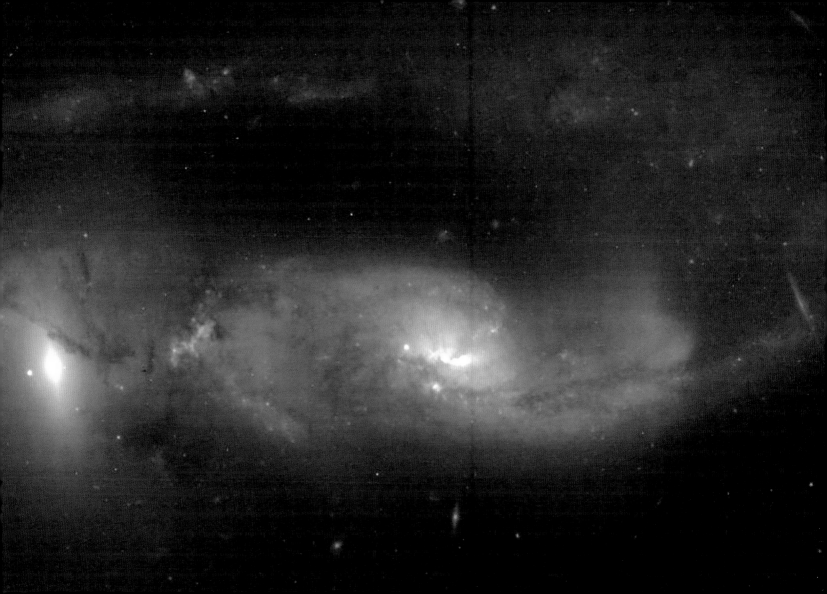

A Year of Assessing Astronomical Hazards

Could an asteroid destroy civilization on Earth? Mountain-sized space rocks could potentially impact the planet, causing global effects, and perhaps even be mistaken for a nuclear blast of terrestrial origin. While such large impacts are rare, they do happen, so modern telescopes and projects such as Spacewatch and Spaceguard scan the skies for signs of approaching celestial hazards. They have discovered previously unknown asteroids that pass near Earth, but such projects are still rather modest. In June 2002, the 100-meter asteroid 2002 MN was discovered only after it whizzed by our planet, crossing even within the orbit of the Moon. In fact, 2002 brought much discussion within the astronomical community of expanding technology with the aim of discovering more large Near Earth Objects and increasing the time between discovery and impact for all potential astronomical hazards. This illustration depicts a busy planetary system, showing the view of a planet ringed with space debris from a recently formed crater of an orbiting moon.

Credit: Dan Durda (SWRI)

Mars Roving

Landing on Mars in January 2004, NASA's twin rovers Spirit and Opportunity have spent their sols (Martian days) roving the surface of the Red Planet. The golf-cart-sized robots have operated much longer than planned. Ranging across the floor of Gusev Crater, the Spirit rover climbed the Columbia Hills. Half a planet away, Opportunity has toured Meridiani Planum and explored the 130-meter-wide Endurance Crater. Opportunity returned this panoramic view of rock outcrops and steep crater walls in late 2004. Both rovers have uncovered strong evidence that ancient salty oceans left their mark on the alluring Red Planet.

Credit: Mars Exploration Rover Mission, JPL, NASA

December 24

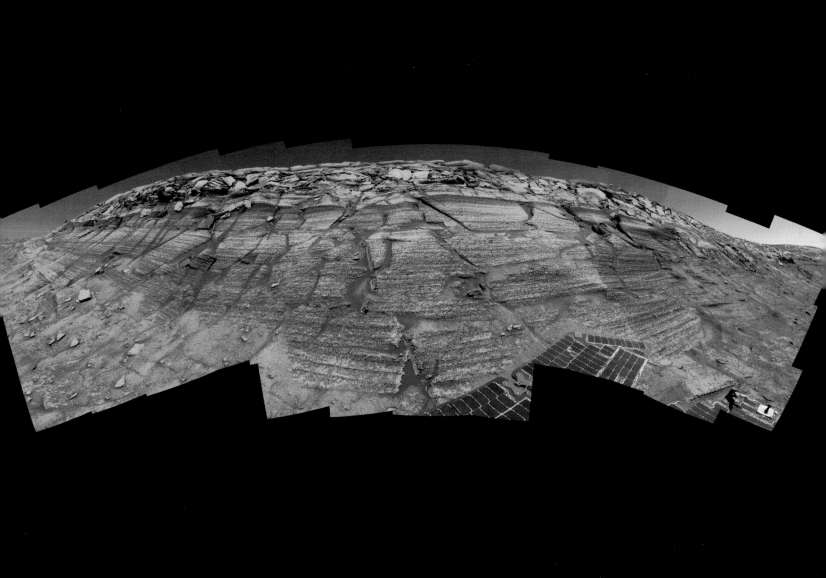

The Andromeda Galaxy from GALEX

Why does the Andromeda Galaxy have a giant ring? Viewed in ultraviolet light, the closest major galaxy to our Milky Way looks more like a ring galaxy than a spiral. The ring, spanning 150,000 light-years, is highlighted beautifully in this mosaic of Andromeda (M31) taken by the Galaxy Evolution Explorer (GALEX), a satellite launched into Earth orbit in April 2003. Ultraviolet colors have been digitally shifted to the visual in this image, in which young blue stars dominate, indicating the star-forming ring as well as other regions of star formation even farther from the galactic center. The origin of the huge ring is unknown but likely related to gravitational interactions with small satellite galaxies that orbit near the galactic giant. M31 lies about 3 million light-years distant and is bright enough to be seen without binoculars in the direction of the constellation Andromeda.

Credit: GALEX team, Caltech, NASA

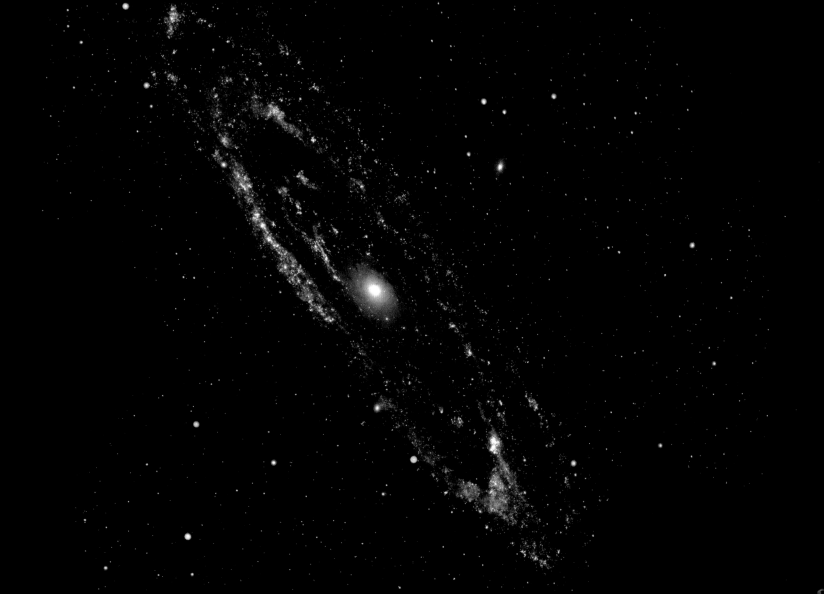

SNR 0103-72.6:

Oxygen Supply

A supernova explosion, a massive star's inevitable and spectacular demise, blasts back into space debris enriched in the heavy elements forged in its stellar core. Incorporated into future stars and planets, these are the elements ultimately necessary for life. Seen here in a false-color x-ray image, supernova remnant SNR 0103-72.6 is revealed to be just such an expanding debris cloud in the neighboring galaxy called the Small Magellanic Cloud. Judging from the measured size of the expanding outer ring of shock-heated gas, about 150 light-years, light from the original supernova explosion would have first reached Earth about 10,000 years ago. Hundreds of supernova remnants have been identified as much-sought-after astronomical laboratories for studying the cycle of element synthesis and enrichment, but the x-ray data also show that the hot gas at the center of this particular supernova remnant is exceptionally rich in neon and oxygen.

Credit: S. Park, D. Burrows (Pacific State University), et al., Chandra, NASA

Orion Rising

Orion always comes up sideways . . . and was caught in the act by astronomer Jimmy Westlake, stargazing eastward over the Rocky Mountains north of Leadville, Colorado. To make this gorgeous image, Westlake placed his camera on a tripod for two exposures. The first lasted for eighteen minutes, allowing the stars to trail as they rose above the mountain range. After a minute-long pause, the second exposure began; it lasted only twenty-five seconds, decorating the end of each trail with a celestial point of light. The three bright stars in Orion's belt stand in a nearly vertical line just above the mountain peak right of center. Hanging from his belt, the stars and nebulae of the Hunter's sword follow the slope down and to the right. A festive yellow-orange Betelgeuse is the brightest star above the peak just left of center; brighter still, planet Saturn shines near the upper left corner. In the foreground on planet Earth, a frozen lake and snowy mountains are lit by a four-day-old crescent Moon.

Credit & copyright: Jimmy Westlake (Colorado Mountain College)

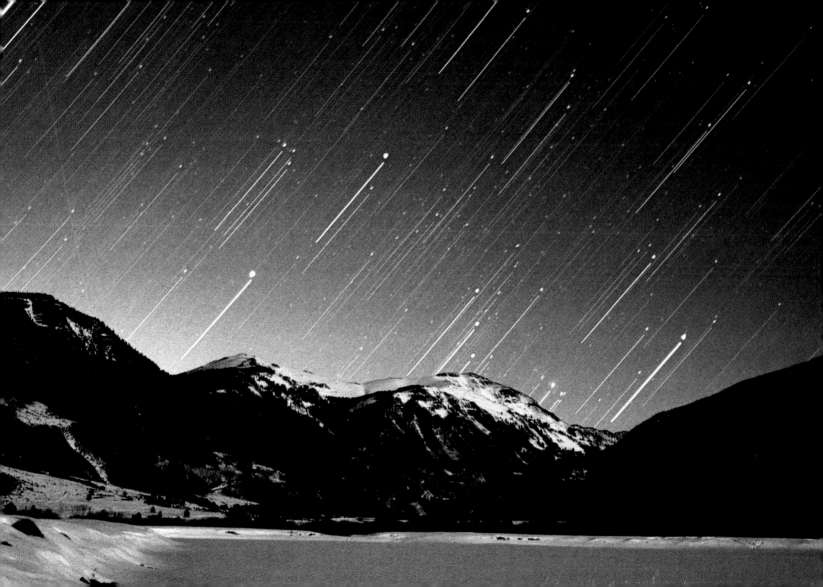

NGC 604:
Giant Stellar
Nursery

Stars are sometimes born in the midst of chaos. About 3 million years ago in the nearby galaxy M33, a large cloud of gas spawned dense internal knots, which gravitationally collapsed to form stars. NGC 604 was so large, however, that it could form enough stars to make a globular cluster. Many young stars from this cloud are visible in this image from the Hubble Space Telescope, along with what is left of the initial gas cloud. Some stars were so massive that they have already evolved and exploded in a supernova. The brightest stars that are left emit light so energetic that they create one of the largest clouds of ionized hydrogen gas known, comparable to the Tarantula Nebula in our Milky Way's close neighbor, the Large Magellanic Cloud.

Credit: NASA & the Hubble Heritage Team (AURA/STScI)

December 28

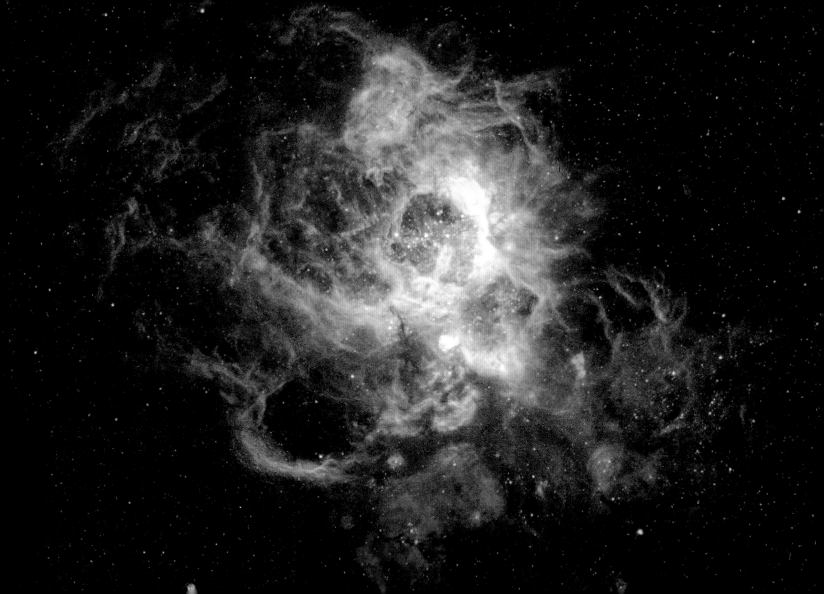

A Double Open Cluster

Most star clusters are singularly impressive. Open clusters NGC 869 and NGC 884, however, are doubly impressive. Also known as "h and chi Persei," this unusual "double cluster" is bright enough to be seen from a dark location without even binoculars. Although their discovery surely predates written history, the Greek astronomer Hipparchus notably cataloged the double cluster in the second century B.C. The clusters are over 7,000 light-years distant in the direction of the constellation Perseus, but they are separated by only hundreds of light-years.

Credit & copyright: Michael Fulbright (MSFAstro.net)

December 29

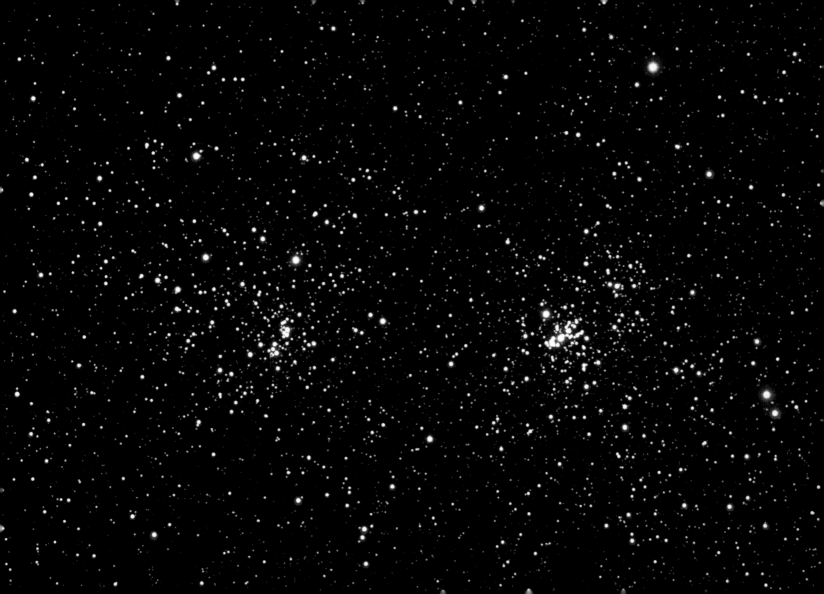

The Tadpoles
of IC 410

This close-up view shows a portion of the otherwise faint emission nebula IC 410 in striking false colors. It also shows two remarkable denizens of the glowing gas cloud at the right: the "tadpoles" of IC 410. The picture is a composite of images taken through narrow-band filters intended to trace atoms in the nebula. Emission from sulfur atoms is shown in red, hydrogen atoms in green, and oxygen in blue. Partly obscured by foreground dust, the nebula itself surrounds NGC 1893, a young galactic cluster of stars that energizes the glowing gas. The tadpoles, composed of denser, cooler gas and dust, are about 10 light-years long. Sculpted by wind and radiation from the cluster stars, their tails trail away from the cluster's central region. IC 410 lies some 12,000 light-years away, toward the constellation Auriga. At that distance, this image spans about 70 light-years.

Credit & copyright: Ken Crawford (Rancho Del Sol Observatory)

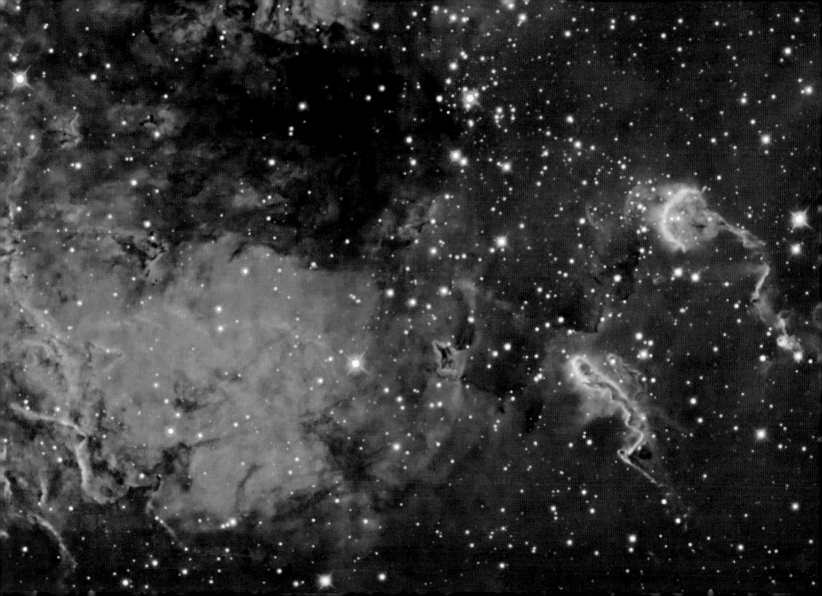

A Year of Resolving Cosmology

In 2003, we learned that the universe is 13.7 billion years old—a result of precision cosmology primarily due to information gathered by a small satellite, the Wilkinson Microwave Anisotropy Probe (WMAP). Constructed from the first release of WMAP data, this sky map reveals the complete cosmic microwave background divided into two hemispheres, in detail never before resolved. Besides indicating the age of the universe, the new data and analyses of the spots on the cosmic microwave background bolstered existing thinking that the universe is composed predominantly of a strange and mysterious type of dark energy (73 percent). The remaining matter is only about 4 percent in familiar atoms, with 23 percent in a somewhat mysterious type of dark matter. Much cosmological research has shifted from trying to find the parameters that define our universe to trying to use these parameters to understand how it evolved.

Credit: WMAP Science Team, NASA

Glossary

ASTEROID | A large rocky body in our solar system that orbits the Sun but is much smaller than a planet. Some asteroids may contain much water, in the form of ice, and could act as way stations for future astronauts.

BLACK HOLE | An object so compact that light cannot escape its gravity. If our Sun could be compressed inside 3 kilometers, it would become a black hole.

COMA | The gas and dust that surround the head of a comet as it nears the Sun. Comas can extend up to a million miles from the nucleus. The coma and tail of a comet are the easiest parts to see.

COMET | A chunk of frozen gases, ices, and rocky debris that orbits the Sun. When a comet nears the Sun, heat vaporizes the icy material, producing a cloud of gaseous material surrounding the nucleus (see Coma). As the nucleus begins to disintegrate, it also produces a trail of dust or dust tail in its orbital path and a gas or ion tail pointing away from the Sun. Comet tails can be millions of miles long.

COMET NUCLEUS | The solid core of a comet, composed of icy, rocky material. A comet nucleus is comparable in size to a mountain on Earth.

CONSTELLATION | A historically recognized grouping of stars often thought of as representing a person or object. There are eighty-eight constellations, which cover the entire sky.

CORONA | The hot, tenuous outer atmosphere of the Sun. The solar corona is most easily seen from Earth during a solar eclipse.

CREPUSCULAR RAY | Sunlight that pours through a gap in the clouds. While crepuscular rays extend away from the Sun, anticrepuscular rays are seen to converge in the sky opposite the Sun.

DISK (OR GALACTIC DISK) | A relatively thin disk of stars and gas surrounding the center of a spiral galaxy. We live in the disk of the Milky Way Galaxy.

EDGE ON | When the disk of a spiral galaxy is seen with its edge pointing to the observer. A piece of paper seen edge on is hard to see.

GALACTIC CENTER | The center of our Milky Way Galaxy. The more we learn about the galactic center, the stranger it appears.

GALAXY | A system of about 100 billion stars. Our Sun is a member of the Milky Way Galaxy. There are billions of galaxies in the observable universe.

ELLIPTICAL GALAXY | A football-shaped type that can appear as an ellipse on the sky. Elliptical galaxies typically have little or no dust and gas.

SPIRAL GALAXY | A type composed of stars, gas, and dust, and having a disk

with prominent spiral arms. Our Milky Way is a spiral galaxy.

GAMMA RAY | The most energetic form of light. Gamma rays are hazardous to living organisms but are stopped by Earth's atmosphere. Gamma rays are produced in energetic, violent environments in the universe and can be detected by orbiting spacecraft.

GLOBULAR CLUSTER | A spherical grouping of 10,000–1 million stars. Globular clusters are among the oldest objects known in our galaxy.

HH | The identifier for objects in the Herbig-Haro catalog, compiled by astronomers George Herbig and Guillermo Haro. For example, HH-4 is the fourth entry in the catalog. HH objects are likely regions associated with stars in the process of formation.

IC | The identifier for objects in the Index Catalog, compiled as a supplement to the New General Catalog (see NGC).

INFRARED | A band of the electromagnetic spectrum between the visible and the microwave—light that is so red humans cannot see it. Photons of infrared light are less energetic than photons of visible light.

ION | An atom or group of atoms that carries an electric charge.

KUIPER BELT | A doughnut-shaped region in the outer solar system, named for astronomer Gerard Kuiper. The inner edge of the Kuiper belt begins just beyond the orbit of Neptune. The Kuiper belt is home to small, icy planet-like objects. Pluto is an example of a Kuiper belt object. Since 1992, over 800 Kuiper belt objects have been discovered.

LOCAL GROUP OF GALAXIES | The group of galaxies to which our Milky Way belongs. The Local Group is dominated by our galaxy and M31, the Andromeda Galaxy.

M | The identifier for objects in Charles Messier's 1774 catalog of nebulae and star clusters. For example, M31 is the thirty-first entry in this catalog.

NEBULA | A cosmic cloud of gas and dust.

ABSORPTION NEBULA (also **DARK NEBULA**): A type that consists of dense clouds of interstellar dust viewed against a bright background. The dust absorbs background light and appears dark in pictures.

EMISSION NEBULA | A type that shines primarily by emitting light when electrons recombine with protons to form hydrogen atoms. Emission nebulae typically appear red in pictures.

PLANETARY NEBULA | An emission nebula produced by a Sun-like star near the end of its life. Planetary nebulae are called this because they often appear round and planet-like in a small telescope.

REFLECTION NEBULA | A type that shines primarily by interstellar dust reflecting starlight. Reflection nebulae often appear blue in pictures.

NEUTRINO | A type of elementary particle that has no electric charge and is suspected of having an extremely small mass. Neutrinos can pass

through enormous amounts of material unaffected. Neutrinos are produced in nuclear reactions at the centers of stars and in stellar explosions known as supernovae.

NEUTRON STAR | The imploded core of a massive star, produced in a supernova explosion (with a typical mass of 1.4 times that of the Sun, a radius of about 10 kilometers, and the density of a neutron). Astronomer Frank Shu says, "A sugar cube of neutron-star stuff on Earth would weigh as much as all of humanity! This illustrates again how much of humanity is empty space." Neutron stars can be observed as pulsars.

NGC | The identifier for objects in the New General Catalog of Nebulae and Clusters of Stars by Sir John Herschel, revised in 1888 by J. L. E. Dreyer. For example, NGC 1232 is the 1,232nd entry in this catalog.

PLANET | A spherical ball of rock and/or gas that orbits a star. Earth is a planet. Our solar system has nine planets; in order of increasing distance from the Sun, they are Mercury, Venus, Earth, Mars, Jupiter, Saturn, Uranus, Neptune, and Pluto.

QUASARS | A contraction of QUASi-stellAR object. Quasars appear star-like in pictures. They actually lie at cosmological distances and are thought to be supermassive black holes at the centers of active galaxies. Among the brightest sources in the universe, quasars are likely powered by material falling into the central black hole.

SOLAR SYSTEM | The system of objects that surrounds our Sun. Earth is a member of the solar system in good standing.

STAR | A ball of mostly hydrogen and helium gas that shines extremely brightly. Our Sun is a star. A star is heated by nuclear reactions that occur in its dense, hot interior.

STELLAR NURSERY | A place where stars are forming. These places are violent, energetic, and frequently very beautiful.

SUPERNOVA | The death explosion of a massive star, resulting in a sharp increase in brightness followed by a gradual fading. At peak light output, supernova explosions can outshine a galaxy. The outer layers of the exploding star are blasted out in a radioactive cloud. This expanding cloud, visible long after the initial explosion fades from view, forms a supernova remnant.

ULTRAVIOLET | A band of the electromagnetic spectrum between the visible and the x-ray—light that is so blue humans cannot see it. Photons of ultraviolet light are more energetic than photons of visible light.

WHITE DWARF | The end state for low-mass stars like our Sun. Most white dwarfs have a mass near that of our Sun but a size near that of planet Earth.

X-RAY | A type of light that is more energetic than the visible light humans can see but less energetic than gamma rays. X-rays are just energetic enough to travel through human skin but not human bone, making them useful medically.

PROJECT MANAGER Deborah Aaronson
EDITOR Richard Slovak (with Sharon AvRutick)
DESIGN BTDNYC
PRODUCTION MANAGERS Maria Pia Gramaglia, Anet Sirna-Bruder

LIBRARY OF CONGRESS CATALOGING-IN-PUBLICATION DATA

Bonnell, Jerry T.
 Astronomy : 365 days | Jerry T. Bonnell, Robert J. Nemiroff.
 p. cm.
 Includes index.
 ISBN 10: 0-8109-5715-9 (paper over board)
 ISBN 13: 978-0-8109-5715-2
1. Astronomy—Pictorial works. I. Nemiroff, Robert J. II. Title.

QB68.B66 2006
520—DC22
 2006005808

Printed and bound in China
10 9 8 7 6 5 4 3 2 1

HNA
harry n. abrams, inc.
a subsidiary of La Martinière Groupe
115 West 18th Street
New York, NY 10011
www.hnabooks.com

FRONT COVER The Sombrero Galaxy in Infrared (see May 15).
CREDIT R. Kennicutt (Steward Observatory) et al., SSC, JPL, Caltech, NASA

BACK COVER Moon between the Stones (see May 26).
CREDIT & COPYRIGHT Philip Perkins